PHOTOHISTORICA
LANDMARKS IN PHOTOGRAPHY

Dedicated to John Dudley Johnston, RPS Curator from 1925-1955, without whose efforts and energy and exquisite taste the RPS would not have the great Collection it now has and to all previous RPS Curators, and all who have been involved with the Collection over the last 50 years, who have carried on his work with enthusiasm. Also to Debbie Ireland without whose initial impetus this book would not have happened.

In memory of Valerie Lloyd (1945-1999), RPS Curator from 1978-1980.

OPPOSITE & OVERLEAF | Salted paper print of a leaf taken by
William Henry Fox Talbot *circa* 1843–5.

First published by Scriptum Editions
565 Fulham Road, London, SW6 1ES
in association with The Royal Photographic Society.

Created by Co & Bear Productions (UK) Ltd.
Copyright © Co & Bear Productions (UK) Ltd. 2000
Text copyright © Co & Bear Productions (UK) Ltd. &
The Royal Photographic Society of Great Britain 2000
Co & Bear Productions (UK) Ltd. identify Pam Roberts,
Curator of The Royal Photographic Society Collection, as author of the work.
Preface copyright © Paul McCartney 2000. Paul McCartney asserts his moral rights.
Photographs & illustrations copyright © The Royal Photographic Society of
Great Britain unless otherwise specified (see picture credits on page 328).

Published by Artisan
A Division of Workman Publishing, Inc.
708 Broadway
New York, New York 10003
www.workman.com

Library of Congress Cataloging-in-Publication Data
Roberts, Pam
 PhotoHistorica : landmarks in photography : rare images from the collection of the
 Royal Photographic Society / Pam Roberts.—1st ed.
 p. cm.
 Simultaneously published in Great Britain under title: Photogenic
 ISBN 1-57965-169-0
 1. Royal Photographic Society of Great Britain—Photograph collections—
 Catalogs. 2. Photograph collections—England—London—Catalogs. I. Roberts,
 Pam. Photogenic. II. Royal Photographic Society of Great Britain. III. Title.

 TR6.G72 L666 2000
 779'.074421—dc21
 00-038615

Printed and bound in Italy, at Officine Grafiche De Agostini.
Color reproduction by Bright Arts Graphics, Singapore.

First edition
10 9 8 7 6 5 4 3 2 1

Design by David Mackintosh

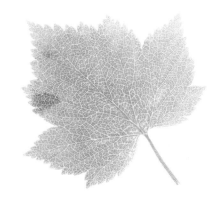

PhotoHistorica
LANDMARKS IN PHOTOGRAPHY

RARE IMAGES FROM THE COLLECTION OF
THE ROYAL PHOTOGRAPHIC SOCIETY

TEXT BY PAM ROBERTS

ARTISAN | NEW YORK

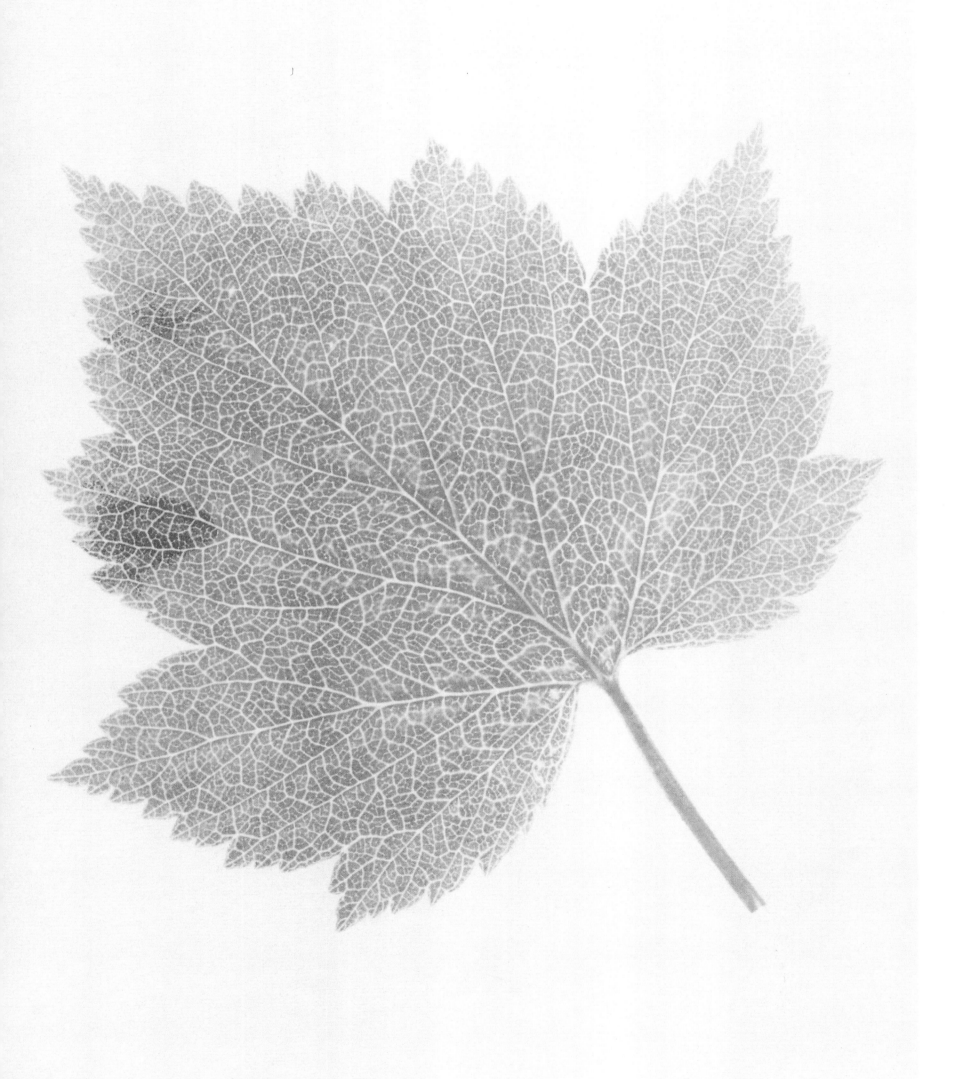

CONTENTS

PREFACE

BY PAUL McCARTNEY

OPPOSITE | Linda McCartney took thousands of portraits of others but rarely any (published) of herself. She died of cancer soon after taking this 1997 self-portrait of seemingly quiet acquiescence. Photography lost one of its greatest enthusiasts, supporters and practitioners and the world, most especially Linda's immediate family and friends, lost a woman whose spirit and vitality was an encouragement and a catalyst to many.

I WAS HAPPY TO BE ASKED TO WRITE THE PREFACE to *PhotoHistorica* because The Royal Photographic Society Collection is one of the greatest in the world and a well illustrated publication such as this will bring it to the attention of a much wider international audience.

My involvement with The Royal Photographic Society began in 1987 when Linda was invited to have an exhibition of her work. Subsequently, the Society honoured her with a second exhibition in 1992, making her the first photographer to have two exhibitions in their galleries in Bath. In 1998, she was delighted to be made an Honorary Fellow of the Society.

On the occasion of her second exhibition 'The Sixties' in 1992, the RPS also asked her to curate an accompanying exhibition of her choice giving her free range to select the photographs from their extensive archives. Linda chose work by one of her photographic heroes, Edward J. Steichen. This turned out to be a very exciting project as we were granted access to the vast and very fine RPS Collection of over 270,000 photographs, including their 90 or so vintage Steichen photographs.

On a personal level, I would like to thank the RPS not only for recognising Linda's great talent as an artist and lover of photography, but also for continuing its excellent work in promoting the art of photography both in this country and internationally, through touring exhibitions of contemporary photography and of historical work drawn from the Collection.

The photographs in this book have been chosen not only to illustrate those 'great' names in photography's history – William Henry Fox Talbot, Julia Margaret Cameron, Alfred Stieglitz, Edward Steichen, Albert Renger-Patzsch, Edward Weston and others – but also to show work, by lesser known photographers.

If a picture is worth a thousand words then the almost 300 photographs reproduced in this book must open our eyes to the wealth of astonishing images that photography has achieved since its inception and how visually and emotionally bereft our lives would be without it and without the riches of the RPS Collection.

INTRODUCTION

IT ALL STARTED WITH A HONEYMOON IN ITALY. On 7 October 1833, William Henry Fox Talbot (1800–1877) and his bride, Constance Mundy, sat sketching on the shores of Lake Como. Constance's sketch was a delicate and skilful watercolour. Her husband's pencil sketch, drawn by tracing carefully around the image presented to his eye by Wollaston's Camera Lucida, an optical device employing a glass prism, was a sad scribble by comparison. Talbot was an early-Victorian Renaissance man, with astounding expertise in all branches of the sciences and the arts, but he could not draw. So he exchanged his pencil of lead for a pencil of light, or, as he later called it, 'The Pencil of Nature' – photography.

Over the next few years, he identified ways of registering that fugitive, frustrating, untraceable image onto ordinary writing paper made light sensitive by the application of various chemicals. Initially, Talbot placed translucent objects, like leaves, feathers and lace, onto his light-sensitive paper and exposed them to the sun. Where the sensitised paper was not covered by the object, it would blacken. Underneath the object, protected from the sun, the paper stayed white. He found a way to stop further chemical reaction, using a fixer to prevent the paper darkening once the object had been removed. The sun's darkening action on the light-sensitive paper created a negative image from which an infinite number of positives could then be printed. Very soon, he began to insert these negatives – essentially sheets of paper sensitised with silver salts – into the backs of small wooden boxes fitted with a lens and started pointing them at immobile objects, like buildings. It was, in effect, a miniature version of the original room-sized camera obscura. It is a superb irony that a photographic process which depended wholly on the action of the sun was invented in England.

Great inventions are rarely made in isolation. In the 1820s in Southern France, a place with far higher daily levels of sunshine than Lacock Abbey in Wiltshire where Talbot carried out his experiments, Joseph Nicéphore Niépce (1765–1833) had also been successful in registering a sun-etched image on a pewter plate, using a very different chemistry. In 1829 he teamed up with Louis-Jacques-Mandé Daguerre (1787–1851) who, after

Niépce's death in 1833, reworked the process, using silver-coated copper as a base. In 1839, he showed his daguerreotypes to a stunned French public. The daguerreotype was, initially, a far more attractive proposition than Talbot's calotype process as the image registered on its silvered metal base was one of astonishing clarity and definition, and daguerreomania spread through France and the US like a hectic disease.

Photography reached a vast international audience when, in 1851, both calotypes and daguerreotypes were featured in the Great Exhibition of Works of Industry of All Nations at Crystal Palace in Hyde Park in London. Although photography was classified under 'Philosophical Instruments' in the 'Machine' section, rather than in the fine arts section where exhibiting photographers wanted it, there was much interest in items on show, particularly daguerreotypes of the moon. Just before the Crystal Palace exhibition was due to close, a few of Frederick Scott Archer's newly invented wet collodion negatives on glass were displayed to great acclaim. The interest in photography, which had ticked over slowly in the 1840s, exploded, particularly in Britain where stable social conditions provided the ideal environment for photography to take root. Few can have been as enthusiastic about the new medium as Roger Fenton (1819–1869). Fenton had trained for a career in the law, but photography rapidly became an all-consuming passion. He advertised in *The Chemist* in March, 1852 for like-minded gentlemen to contact him about the formation of a photographic society.

Eventually, after a successful exhibition of 779 photographs organised by Fenton at the Society of Arts in London in December, 1852, The Photographic Society of London came into existence on 20 January 1853 with Fenton as Honorary Secretary and Sir Charles Eastlake, President of The Royal Academy, as first President after Talbot refused the position. Queen Victoria and Prince Albert agreed to act as patrons. Fenton's ideals were high. In his introductory remarks to the Society of Arts catalogue in 1852 he wrote about the foundation of a Photographic Society: 'Such a society will be the reservoir to which will flow, and from which will be beneficially distributed, all the springs of knowledge at present wasting unproductively'. Thus the Society

OPPOSITE | William Henry Fox Talbot sat for daguerreotype portraits by both Richard Beard and Antoine Claudet, the latter took this one around 1844. Talbot also photographed Claudet on several occasions. Talbot's efforts to have his own calotype negative process used as a medium for commercial studio portraiture were largely unsuccessful but less than 15 years after this portrait was taken, the daguerreotype in Britain, the one-off studio portrait, had been wholly replaced by the descendants of Talbot's negative/positive process on which premise all succeeding photography has since been based.

was established for 'the promotion of the Art and Science of Photography, by the interchange of thought and experience between Photographers'. The Photographic Society of London became The Royal Photographic Society in 1894 and continues as such to this day.

Fenton had been inspired by two earlier, more informal photographic organisations. In Britain, the Calotype Society, a loose social grouping of a dozen or so interested members, had met and corresponded since 1847. In Paris, the Société Héliographique, founded in 1851, was an equally informal association of aristocratic and upper middle-class gentlemen who dined together and discusssed photography once a month. (In 1854, core members set up the Société Française de Photographie.) Photographic societies were subsequently set up in Austria in 1861 and in Philadelphia in 1862 (although the honours for the longest continuously running regional, rather than national, organisation go to Leeds Photographic Society, founded in 1852).

The Collection of the Royal Photographic Society comprises around 270,000 images, from 1826 to the present day, in every format and every process imaginable, on metal, glass and paper, along with related collections of 8,000 items of photographic equipment, 25,000 books and journals, and also research notes, letters, ephemera and other related documents. The Collection is made up, to a large extent, of a series of several hundred overlapping and inter-connecting archives rather than a few thousand stand-alone 'treasures'. This reflects the fact that 70 percent of the work in the Society's Collection is the work of the Society's members. These people knew each other, and met regularly at Society meetings, where, apart from listening to lectures on aspects of photography and new inventions in the field, they looked at each others' work and discussed this and their current photographic problems – a kind of photographic self-help group.

Imagine, in early 1855, Roger Fenton and Dr. Hugh Welch Diamond discussing recent advances in the sensitivity of the wet collodion glass negative with its inventor Frederick Scott Archer. Or, nearly 60 years later, in 1912, imagine Helen Messenger Murdoch, a photographer from Boston using The Royal Photographic

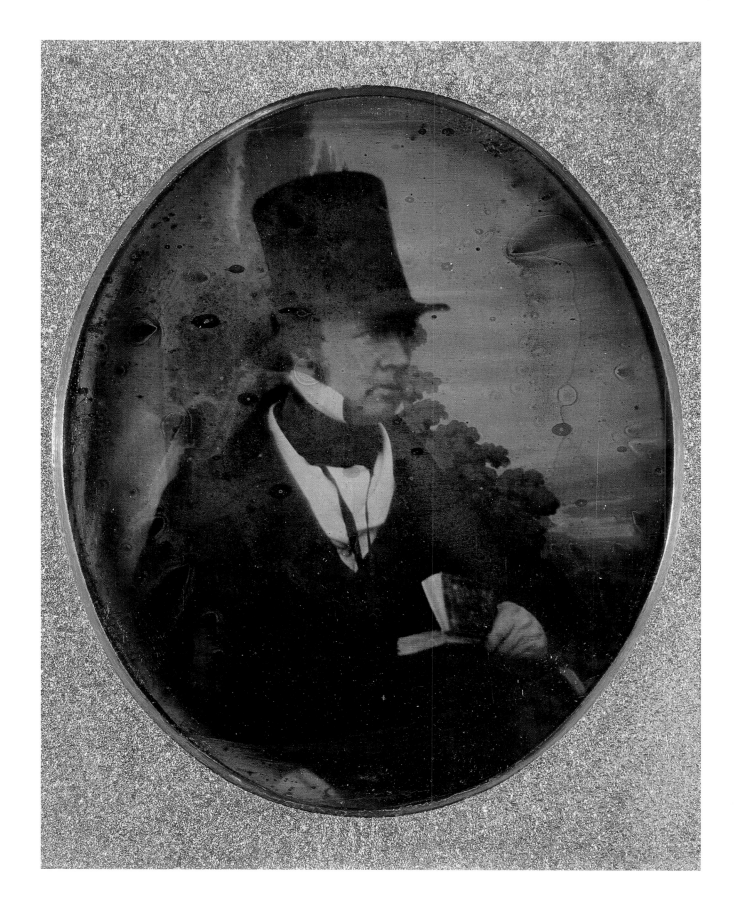

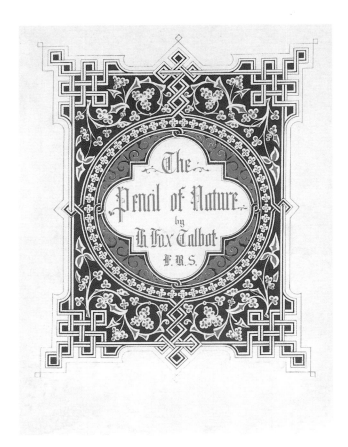
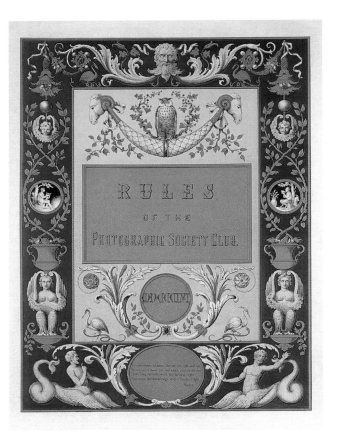

Society as her London base, discussing her planned round-the-world photography trip, using the colour Autochrome plate, with Agnes Warburg and Violet Blaiklock, both excellent colour printers on paper and proficient with a variety of colour processes.

Murdoch's archives of over 600 glass Autochrome plates documenting her two-year trip from London through Egypt, China and Japan are in the RPS Collection, as are Warburg's and Blaiklock's archives. From Fenton there are 780 prints; from Scott Archer a wet collodion plate camera of 1852, an album of early albumen prints and some early experimental collodion positives printed on cloth, glass and leather; and from Diamond a series of prints of mental patients taken at Surrey County Asylum in Twickenham from 1855.

There are many such personal archives of one photographer's work: prints, negatives, cameras, as well as letters, books, journal articles to put all this in context. Because the Society's Collection is largely the work of its members, over 80 percent of it is by British photographers. The other 20 percent is made up of work from American and European photographers, although there are small bodies of work by Indian, Chinese, South American, Australasian and African photographers as expected in a Society with an international membership.

The Society seriously and methodically began to acquire works from its current members or from descendants of its nineteenth-century members when, in 1923, John Dudley Johnston (President of the

OPPOSITE | Two treasured publications held in the RPS Collection: William Henry Fox Talbot's seminal work on photography, *The Pencil of Nature* (left), published in 6 parts with 24 plates from 1844–46 by Longman, Brown, Green and Longmans; and the 1856 edition of *Rules of The Photographic Society Club* (right). The club, a group of friends and photographic acquaintances within the Photographic Society itself (now the RPS), produced an album of portraits of Society Club members and published rules about the Society Club's guidelines in 1856 in a lavish album format.

Society in 1923–25 and 1929–31, Hon Curator from 1927–55), preparing his first presidential address on Pictorial Photography, decided to use projected lantern slides copied from original nineteenth-century photographs in the Society's Collection. He was only able to find 100 or so framed photographs 'in the lumber room on the top floor'. Many others had been damaged while on loan. Many more had gone missing. Johnston became a man with a mission, and from 1923 until his death in 1955, he tracked down the descendants of WHF Talbot, Roger Fenton, Julia Margaret Cameron and Oscar Gustav Rejlander, amongst many others, and acquired the milestones of the previous 90 years of photographic achievement.

John Dudley Johnston did not purely concern himself with the past but approached his contemporaries and secured major donations of work in the 1920s and 30s from Frederick H Evans, Alvin Langdon Coburn, Robert Demachy, Harold Holcroft, Edward Steichen and Alfred Stieglitz. Since Johnston's death in 1955, the acquisition of material has continued, and the Collection has grown from the 3,000 items he had collected by 1955 to its current total of 270,000. Having acquired this wonderful Collection over the last century, the Society must ensure that it is seen by many generations to come.

The photographs in this book represent only a tiny percentage of the Society's Collection and have been divided thematically rather than chronologically. The oldest photograph is from 1826 while the most recent is from 1997 although the majority are clustered between 1850 and 1930. Photographers represented are from different cultures and backgrounds – stretching across the art/science divide – but they all speak the universal language of photography. Every image on every page is important, whether it is a perfect lush and opulent Roger Fenton still life, an anonymous seaside snap or an instance of technical wizardry. Each image captures the eye and squeezes the heart. It stops you in your tracks; enables you to see the world differently, through other's eyes, snatching glimpses of something, someone long gone, a nuance of what the photographer felt and saw at that perfect moment when the exposure was made.

I.

PORTRAITURE

I.

LIKENESSES OF THE HUMAN FIGURE AND FACE ARE USUALLY THE FIRST SUBJECTS depicted in any nascent art form. Witness the stick figures scratched on the walls of the Lascaux Caves in France, or the carved limestone heads dating back to 3000 BC found in Egyptian tombs. These images speak of the importance and power of achieving a human likeness, be it for reasons of control, of magic, of worship, of religion or for an external and eternal representation of the human soul.

Perversely, photography's earliest extant camera images concern windows. Joseph Nicéphore Niépce's image of 1827, generally accepted as one of the first to be photographically produced, is the view from an upper window of his house in Saint-Loup-de-Varennes, and Talbot's first postage-stamp-sized negative is a view of the Oriel Window at Lacock Abbey in 1835. Early exposure times were initially so long that immovable objects were far better subjects on which to practise one's embryonic craft than fractious, blurring humans.

Nonetheless, Louis-Jacques-Mandé Daguerre was aware that the ability to capture a human likeness speedily by photographic means, rather than in an expensive and time-consuming painted miniature, was akin to a licence to print money and intimated as much in a letter to his photographic partner Isidore Niépce (son of Joseph Nicéphore Niépce) in 1835:

'Vous voyez que cette différence est énorme et que celà nous donne, surtout si je parviens à avoir assez de promptitude pour le portrait, l'éspoir de tirer un plus grand-parti de la découverte.' [You see that this difference is enormous and will give us, especially if I get sufficient speed for the portrait, the hope of turning the discovery to good account.]

Daguerre was so right. Within five years of this letter, the ability to capture the human likeness using photography was beginning to become the lucrative commercial business that it remains today. Accordingly, the RPS Collection contains over 30,000 portraits, from 1840 to the present, including a magnificent archive of 3,000 portraits of photographers, RPS worthies, medal-winners and Fellows. There are substantial portrait

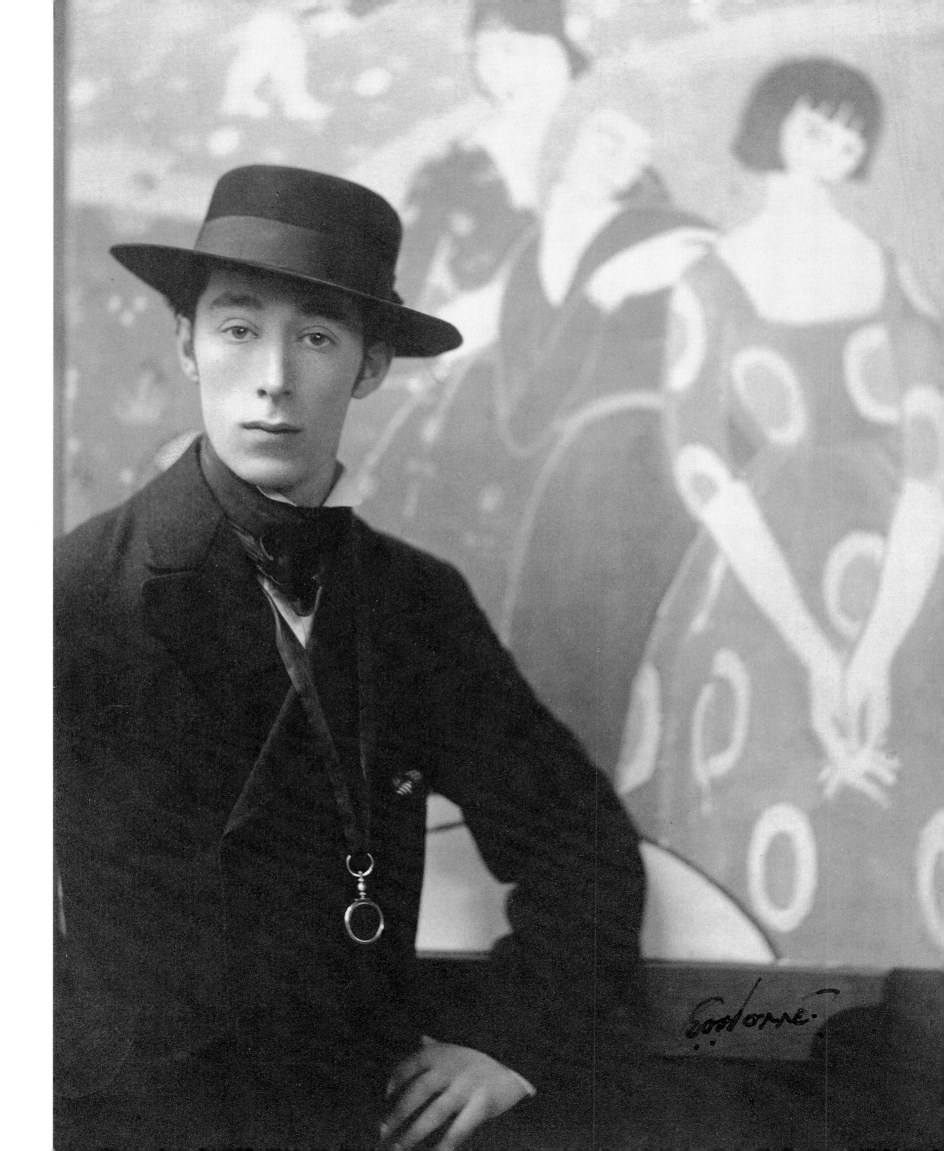

OPPOSITE | The first portraits that Talbot took were, fittingly for such a uxorious man, of his wife Constance, also his occasional printer. Three earlier portraits, taken a few days before, probably had an exposure time of over five minutes and show it in the consequent strain on Constance's face. This one, taken in bright sunlight, had an exposure time of as little as 30 seconds. It shows both Constance, the wife and sitter, and Henry, the husband and photographer, in a mutually complicit and warmly conjugal light.

collections by photographers from across Europe and the US – Hill & Adamson, Julia Margaret Cameron, Emil Otto Hoppé, Rudolf Dührkoop and Minya Diez-Dührkoop, Robert Demachy, Alvin Langdon Coburn, Fred Holland Day and Edward Steichen are just a few of the famous names found in this archive. The best of British studio portraiture from the mid-1850s onwards is also represented, from thousands of cartes-de-visite and cabinet cards, ambrotypes and tintypes, to celebrated twentieth-century work by Dorothy Wilding, Madame Yevonde, Walter Bird, James Jarché and Angus McBean.

The first portraits using the daguerreotype process were being made in Paris and the US by late 1839, a few months after Daguerre's official announcement of his invention in August 1839. Exposure times rapidly plummeted from 25 minutes to 50 seconds and below, so that it was no longer necessary to sit 'with your head compressed in a vice, and your limbs as stiff as biscuits', as writer Cuthbert Bede put it in 1855.

It has been estimated that over 90 percent of the millions of daguerreotypes produced over the next 20 years were portraits. The daguerreotype's success may have had much to do with its uncanny familiarity. As a silvery mirror-like image on a metal base it depicted the sitter's face as its owner was accustomed to seeing it in the mirror every day. Fortunes were made by daguerreotypists as sitters rushed to their studios – and then lost as photography found quicker, cheaper alternatives to capture the much-desired human likeness in the 1850s.

Daguerre had sold the rights to his invention to the French government in return for an annuity but applied patent restrictions on its use outside France. Despite this, there was a lively trade in portraiture in the 1840s and 50s in Britain, led by Richard Beard, Antoine Claudet and Thomas Richard Williams. The RPS daguerreotype collection includes portraits by all three, including both single and stereoscopic portraits by Claudet. A Frenchman who had moved to London in 1829, he had quickly taken out a licence on Daguerre's patent in 1840 and set up a studio in London in June 1841, just a few months after Beard's studio opened. Around 1844, Claudet even persuaded William Henry Fox Talbot to sit for a daguerreotype portrait.

Talbot's own photographic concerns were not primarily centred on portraiture. There is, however, one very pertinent portrait that he took of his wife Constance, dated 10 October 1840, just a few days after he had perfected the calotype negative, cutting exposure times from minutes to seconds in strong sunlight (and almost 7 years to the day after that fateful honeymoon experience on 7 October 1833). It would be fair to say that Constance looks rhapsodic. She is portrayed, forever, in an open and moving portrait of great emotional depth as she hovers in the misty mauve and brown tones of the image. It is deeply satisfying that one of the first portraits on paper is one of such a personal nature, and of such beauty.

If Talbot was not particularly interested in portraiture on paper beyond his immediate personal circle, then David Octavius Hill and Robert Adamson, were. As photographers practising in Scotland, where Talbot had not patented the calotype process, they were able to work freely using his process, as were amateurs within the rest of Britain, and scientists.

Hill and Adamson's ability to take a new concept, a totally new way of observing people, and to make it their own, almost instantaneously, refuted previous beliefs that portraits taken on paper were doomed to failure because of the paper grain showing through and ruining flesh tones. Hill's attitude, as a painter, was to treat the paper base in the same way that Rembrandt had treated his canvas base, using it to his advantage.

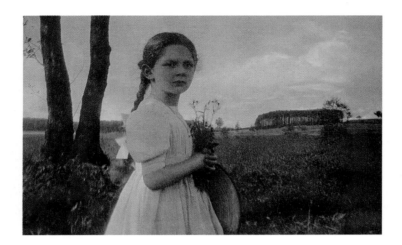

Rather than try to emulate the precision and minute detail possible with the daguerreotype – in which the posing, lighting and backdrops could often be uninspired and purposely derivative of miniature painting – Hill and Adamson jumped back a couple of centuries and went straight to Rembrandt's full-frame compositions and chiaroscuro lighting for inspiration, filling the paper with solid blocks of light and shadow. Unlike daguerreotypes, which were presented sealed in a small gilt frame, these portraits on paper were meant to be hung on walls or compiled in albums. They were meant to be looked at by a group audience whereas the daguerreotype remained a more personal, hand-held experience, needing to be tilted into the light for maximum visibility.

The craggy strength of the portraits produced during Hill and Adamson's four-year partnership made many British daguerreotypes produced at the same time look anaemic by comparison (although in Europe and America, daguerreotypes of astonishing confidence, composition and beauty were being produced). Adamson's early death in 1848, at the height of the partnership's expertise, and Hill's failure to find the same successful working relationship with other photographers, meant that their fame was largely limited to Britain until they were 'rediscovered' by James Craig Annan and then by Alfred Stieglitz in the early twentieth century.

William Collie (1810–1896), a Scottish semi-professional photographer practising in Jersey between 1845 and 1860, must have seen Hill & Adamson's work at some stage, as his own posing, composition and use of pattern, light and shadow owe much to that same confident use of the new medium, even though Collie felt his greater fame and fortune were much hampered by Talbot's patent restrictions. After Talbot relaxed all his existing patents in 1855, both amateurs and professionals – and those who had just kept quiet about exactly how commercial they were and worked on regardless – had free access to his inventions.

The 1850s brought with it the widespread adoption of the wet collodion glass negative. Invented by the British sculptor Frederick Scott Archer in 1850–51 and given freely for public use, it led to a rapid change in commercial portraiture. The wet collodion negative combined the best aspects of the calotype and the

OPPOSITE | This forceful portrait of his daughter Annemarie shows
the graphic strength of Hugo Erfurth's work as she holds us in her seemingly
critical stare. Erfurth was one of the most significant and successful German
portrait photographers of the 1920s and 30s, with a studio in Dresden
and then Cologne from 1934–43. He was a founder and president of the
Gesellschaft Deutscher Lichtbilder (German Photographic Society) from 1919.

daguerreotype. It registered as much detail as the dageurreotype, but, being a negative, like the calotype, was infinitely reproducible and thus unit costs were cheaper.

The daguerreotype itself was swiftly replaced by the wet collodion positive (known as the ambrotype in the US), an underexposed collodion negative which, after bleaching, was backed with black velvet – or more often, and more cheaply, painted with black lacquer – against which it then appeared as a positive image. The poor-man's daguerreotype, on a glass rather than a metal base, it was housed in a similar frame, of gilt, compressed card or thermoplastic. Unlike the daguerreotype, the image remained positive all the time and did not rely on reflected light for maximum visibility, and its relative cheapness appealed to a much wider market. It did not have the detailed beauty or the exquisite magic of the best daguerreotypes but then the best daguerreotypes were beyond the pocket of most.

Many serious 'artistic' photographers, like HP Robinson, refused to use the process, but it was a massive success with the general public, many of whom could now afford to have their likeness taken. HP Robinson and his fellow members of The Photographic Society were generally appalled by the commercial direction that photography was taking, and, to be fair, much shoddy work was produced by photographers who had barely mastered the rudiments of their trade. This may smack of elitism, but then The Photographic Society was an elite club, founded by the wealthy middle class and aristocratic leisured class and dedicated to using the science and technology of photography to create works of art.

Similar sentiments were held by other established European photographic societies, most especially the Société Française de Photographie in Paris, founded in 1854. In its early years it followed the same pattern of coming to terms with the commercialism of photography. Portraits by Photographic Society members – like Fenton's stunning series of informal studies of Victoria and Albert's many children in 1854–6, as well as his Crimean portrait work, and Hugh Welch Diamond's portraits of female mental patients under his care from

OPPOSITE | One of the rarest of photographic images, this heliograph on pewter is one of three made by Frenchman Joseph Nicéphore Niépce in 1826–7. He succeeded in exposing an engraving of the Cardinal d'Amboise on to a pewter plate which was coated with bitumen of Judea. The bitumen hardened on the action of the light and the unhardened areas were dissolved with lavender oil to leave a raised image. Because of the lack of interest in his invention, he left this and his two other heliographs at Kew in London when he visited in 1827. From there they made their way to the RPS Collection.

1852–55 – were not made for mass circulation but for a more noble purpose. In the latter case, they served as an experimental and groundbreaking aid to patients' self-analysis and rehabilitation.

The worst was yet to come. In France in 1854, André Adolphe-Eugène Disdéri (1819–1889) patented the carte-de-visite, a process whereby multiple small negatives, usually eight, could be produced on one large negative. Thus multiple copies of multiple negatives could be printed quickly and cheaply. The prints could then be cut up and pasted onto fractionally larger card mounts, which could bear the photographer's name and address and any other details deemed necessary. Photographic mass production and photographic advertising had finally arrived. Photographic mass purchase could not be far behind. Talbot's invention of the negative, from which could be produced an infinite number of positives, had finally reached its apotheosis.

Like all brilliant ideas, the carte-de-visite was incredibly simple. Despite this, it took six years to make an impact in Britain. When it did, however, it took off like an express train and the craze for cartomania was a national addiction from 1860–64 with thousands of millions of cartes sold. Fortunes were rapidly made and equally rapidly lost (Disdéri filed for bankruptcy in 1868). The growth in photographic studios, like mushrooms after rain, was phenomenal, in London, Paris, Brussels, Munich, St. Petersburg, Florence and New York.

The celebrity photograph came into its own, with four million cartes of Queen Victoria selling between 1860–62. Any member of the Royal Family was guaranteed a best seller, especially Princess Alexandra, the much-admired Princess of Wales. Several hundred thousand cartes of Abraham Lincoln, photographed by Matthew Brady, were used in the President's re-election campaign in the US in 1860. In Mexico, the dead body of Emperor Maximilian was photographed lying in its coffin, riddled with bullets.

Despite rapidly accelerating exposure times, very few portraits from this period show any of the sitters smiling or relaxed. Certain formal poses, largely culled from art history, required an immobile body and a fixed expression, the former aided by the ubiquitous neck and body clamps and the proud awareness of wearing

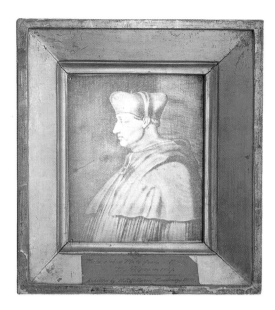

'best' clothes. Those few surviving portraits where a smile lifts and lightens the contours of the face or slight bodily movement suggests spontaneity and immediacy appeal far more to our twentieth-century sensibilities, conditioned as we now are to expect speed and instantaneity in all things.

Whenever the portrait habit looked like it was on the wane and sales slackened, a new marketing ploy was introduced – using different formats or different props – but the most successful sales technique was the portrait album. It became the acceptable way to store photographs, as it had long been the acceptable way to store prints and drawings. The enthusiasm for the family photographic album is one that endures to this day but has its strongest roots in the 1860s. The family album, along with the stereo-viewer and sets of stereographs, became a secular alternative to the family Bible as something the nineteenth-century family could gather around in the evening, a portable family museum of memories.

Perhaps the greatest album compiler and certainly the most inventive and imaginative British portrait photographer of the 1860s was Julia Margaret Cameron (1815–1879). Cameron gave albums of her own photographs, some of the most startling portraits ever taken, to friends and family alike. Despite photography lessons from David Wilkie Wynfield and Oscar Gustav Rejlander, her personal photographic style (seemingly uninfluenced by either of her tutors) sprang fully formed onto an unsuspecting world in 1864 when she took up the camera, aged 48. Whilst attracting the delighted praise of art critics, Cameron's lavish and heroic style was lambasted by the photographic press. Aided by her maid Mary Hillier, who acted as her chief model as well as one of the most long-suffering (and beautiful) photographic technicians in the business, Cameron produced over 2000 large-format glass negatives in an intense 11 years. The RPS owns 770 prints by her, an astonishing body of work. Her deliberately out of focus and seemingly breathless technique, larger-than-life-size presentation, total concentration on the personality and inner soul of her sitters and the abolition of any fussy and unnecessary props were the antithesis of the tiny contemporaneous cartes-de-visite.

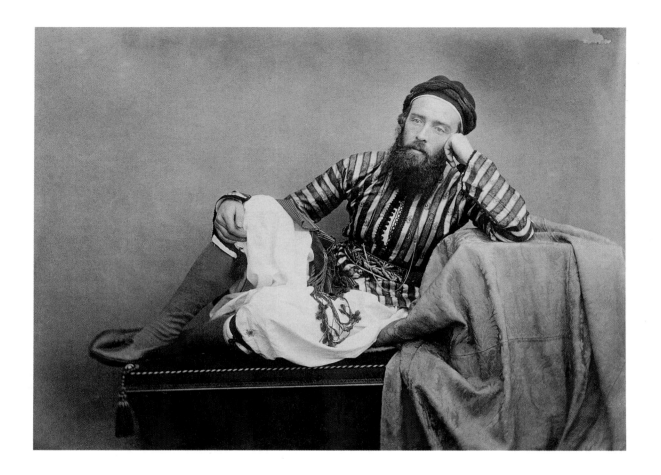

Cameron's work embraced both the cult of the male celebrity portrait as well as the cult of woman as an embodiment of religious, mythical and moral virtue. She photographed the male glitterati of her day, many of them close and influential personal friends, among them Alfred, Lord Tennyson, Henry Taylor, Robert Browning, Charles Darwin and Thomas Carlyle. Women had other roles to play as visual representations of high Victorian ideals. Cameron's most successful female portraits are those in which the nobility of her purpose is subverted by the sheer physical beauty and allure of her models.

After Cameron, portraiture seemed rather flat and passionless. She was an impossible act to follow and her work has rarely been out of the public arena since. Her influence is obvious in the portraiture of Alvin Langdon Coburn (he collected over 120 of her photographs), and her photographs were shown to the American viewing public by Alfred Stieglitz at *291* gallery in New York and illustrated in his publication *Camera Work*.

As the twentieth century progressed, the introduction and proliferation of ever simpler-to-use and cheaper-to-buy hand-held cameras (spearheaded by Eastman Kodak in the US) pushed photography in several different directions, but most especially out of the studio and into the domestic environment. Camera manufacturers in Britain, France and Germany were quick to try to capture an expanding market.

OPPOSITE | The 'Orientalist' craze in England in the 1850s was such that even the normally sedate Quaker, Francis Frith, felt emboldened to dress up in Turkish costume – not once, but several times, as there are variations of this self-portrait. This 1858 print appeared on the title page of his album of photographs from his travels in the Middle East. Back in England, at around the same date, Roger Fenton took a series of about 30 'Orientalist' studies using paid models and exotic props, reminiscent of the paintings of Delacroix.

The growth in home camera ownership meant that everyone could document their own lives, producing informal portrait studies. Snapshots of important family events could be captured quickly and cheaply without the expensive necessity of a trip to the photographer's studio, and smiling was allowed. The introduction in 1907 of the Autochrome, the first commercial colour process, and soon after the ability to reproduce photographs in newspapers, books and magazines, in black and white and full colour, made photography increasingly available to the general public.

In contrast, American Secessionist photographers like Alfred Stieglitz, Edward J. Steichen, Fred Holland Day, Clarence H. White, Gertrude Käsebier, Alvin Langdon Coburn and their British and European counterparts – Baron Adolph de Meyer, Frederick H. Evans, Robert Demachy, Heinrich Kühn–formed allegiances dedicated to the furtherance and acceptance of photography as a fine art in its own right. Influenced by Symbolism, Japonisme, Whistler and Impressionism, and working with complex and painstaking manipulative photographic 'fine art' processes, they introduced a style of pictorial photography which, in the hands of experts like themselves, produced images of a quality and a beauty not seen so consistently since photography's other 'golden age' in the 1850s. Their portraiture and frequent, almost obsessive, self-portraiture, is especially revealing of their pictorial aims, the chief of which was the awareness of the photographer as artist. Julia Margaret Cameron was 'rediscovered' and directly influenced Alvin Langdon Coburn (1882–1966) who, like her, photographed the writers, artists, musicians and thinkers of his day.

Women were favourite subjects, from the mystical and ethereal domesticity of portraits by George Seeley and Clarence H. White to the more commercially minded celebrity photography of Baron de Meyer and Edward Steichen, who eventually abandoned the artistic brotherhood for the more lucrative employment of Condé Nast. In time, the pictorialist vision they embraced was subsumed by the straight, modernist photography of Strand and Weston and of Stieglitz himself.

OPPOSITE | Edward Steichen accompanied Isadora Duncan (1878–1927) and her Isadorables (German girls adopted by Duncan and given dance and school lessons) to Athens in 1921, on the promise of being allowed to make a motion picture of Duncan dancing at the Parthenon. Duncan changed her mind about the film so instead Steichen borrowed a Kodak camera from the head waiter of his hotel and managed to photograph the diva of dance at the Portal of the Parthenon – a setting well suited to her talents and inspiration.

Meanwhile, back in the commercial world, women like Alice Hughes, Lallie Charles and Rita Martin opened portrait studios in London in the early twentieth century, specialising in glamorous and heavily retouched celebrity portraits of Edwardian beauties. During the 1920s and 30s, Herbert Lambert (1881–1936), Howard Coster (1885–1959), Dorothy Wilding (1893–1976), Madame Yevonde (1893–1975), Walter Bird (1903–1969), Nickolas Muray (1892–1965) and Yousuf Karsh (1908–) were just a few of the many busy and successful portrait photographers working in Britain and North America, providing exotic fodder for magazines. The introduction of professional colour processing in the early 1930s enabled Yevonde, Bird and Muray to indulge their surrealist and glamorous fantasies, creating Hollywood-style portraits in screaming primary colours that Hollywood could, as yet, only dream of.

Our urge for celebrity portraits is still, it seems, insatiable. Witness the modern-day manifestation of this in the success of celebrity magazines such as *Hello* – in effect, the cartes-de-visite albums of our times. But our fascination with portraiture is far stronger and more personal than that. The portrait is about the need to memorialise, be it a loved one, a desired one, an unattainable one, a dead one. It is about loving and knowing, or hoping, that we are loved; about existing and knowing that we did so, that we mattered. Two practising, living photographers, Don McCullin and David Bailey, have said that portraits are mostly about dead people. In McCullin's case this is certainly true. In Bailey's case, it is an interesting and provocative comment. Portraits capture moments of our own mortality but in doing so, render us immortal. That is their ineffable power.

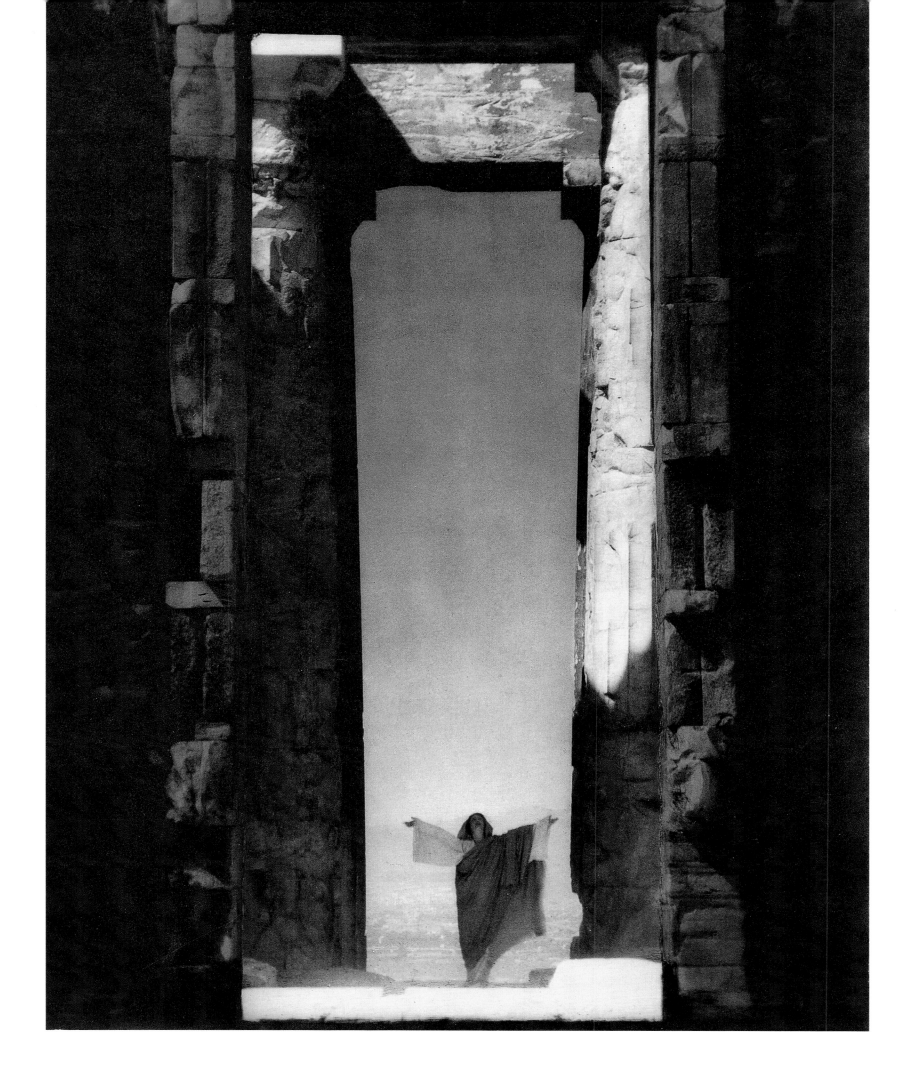

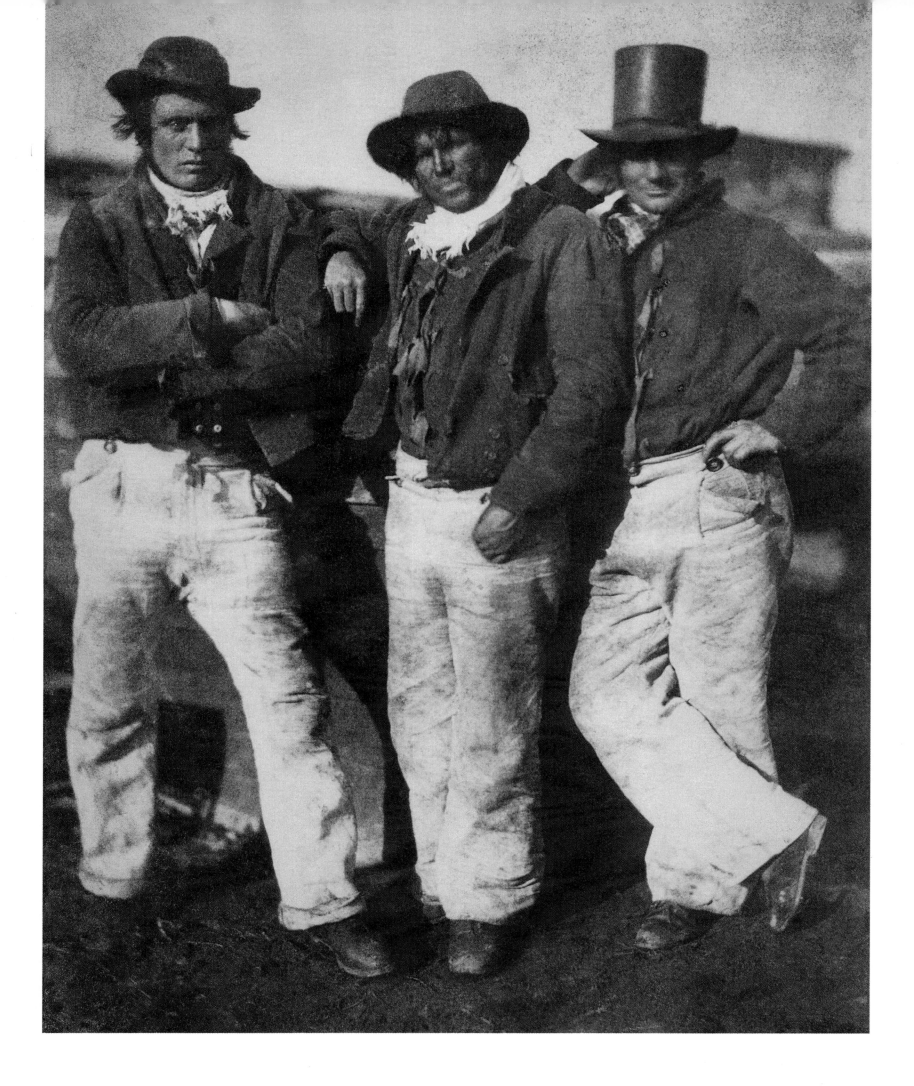

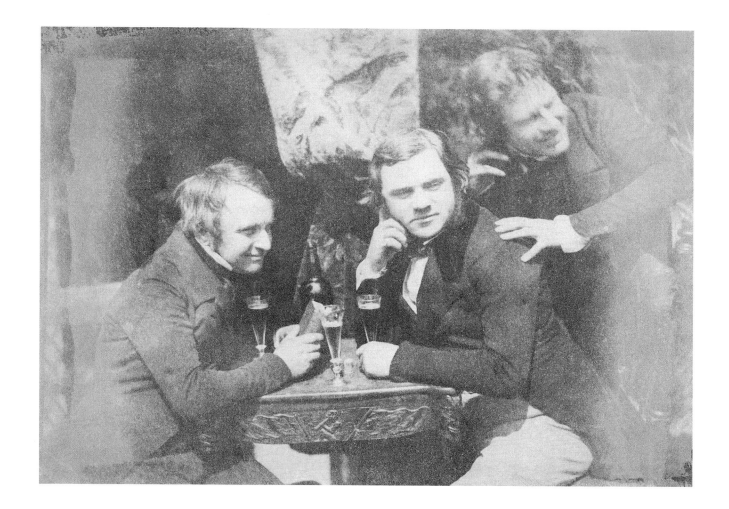

OPPOSITE | David Octavius Hill and his partner Robert Adamson planned
to document community life around Scotland, but the Newhaven project
was the only one completed before Adamson's untimely death in 1848.
Photographed in 1845, the fishermen of Newhaven, a village on the Firth of
Forth, were highly photogenic subjects, strong-minded individuals who were
far from camera shy.

ABOVE | There are more extant self-portraits of Hill than any other
nineteenth-century photographer. He used himself as an experimental model,
trying out different poses and backgrounds, the effects of drapery and costume,
and, most importantly, the effect of light on the sitter's face. In this print from
1845 Hill (at right) poses with friends James Ballantyne (left), an author,
painter and stained-glass artist who designed the windows in the House of
Lords, and Dr George William Bell (centre), one of the founders of the
'Ragged Schools' for destitute children.

OPPOSITE | Portrait of Sir Edward Coley Burne-Jones by Frederick Hollyer from 1873. Burne-Jones, one of the second wave of Pre-Raphaelite painters and initially much influenced by William Morris and Dante Gabriel Rossetti, gave up his plans to enter the priesthood to become a painter in the late 1850s. Frederick Hollyer, a successful portrait photographer, also sold photographic reproductions of Pre-Raphaelite works of art, especially those by Burne-Jones.

RIGHT | Edward Steichen, as much a painter as a photographer before World War I, moved to Paris in 1900 and made a series of photographs of Rodin, then regarded as the greatest living artist and sculptor in the world, in his studio at Meudon. Getting Rodin to pose as 'Le Penseur' (The Thinker), his most famous sculpture, some years later in 1907, only serves to emphasise the sculptural qualities of Rodin's craggy head and long tapering fingers.

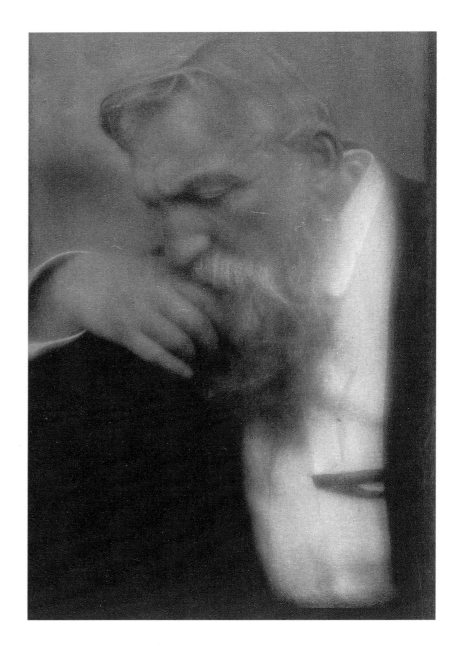

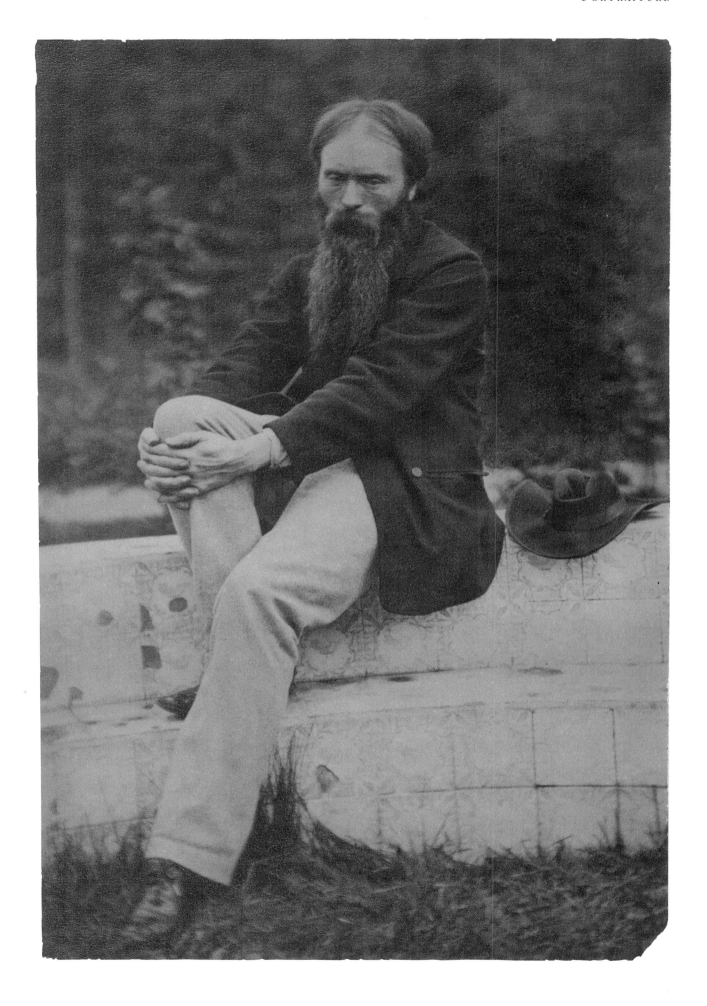

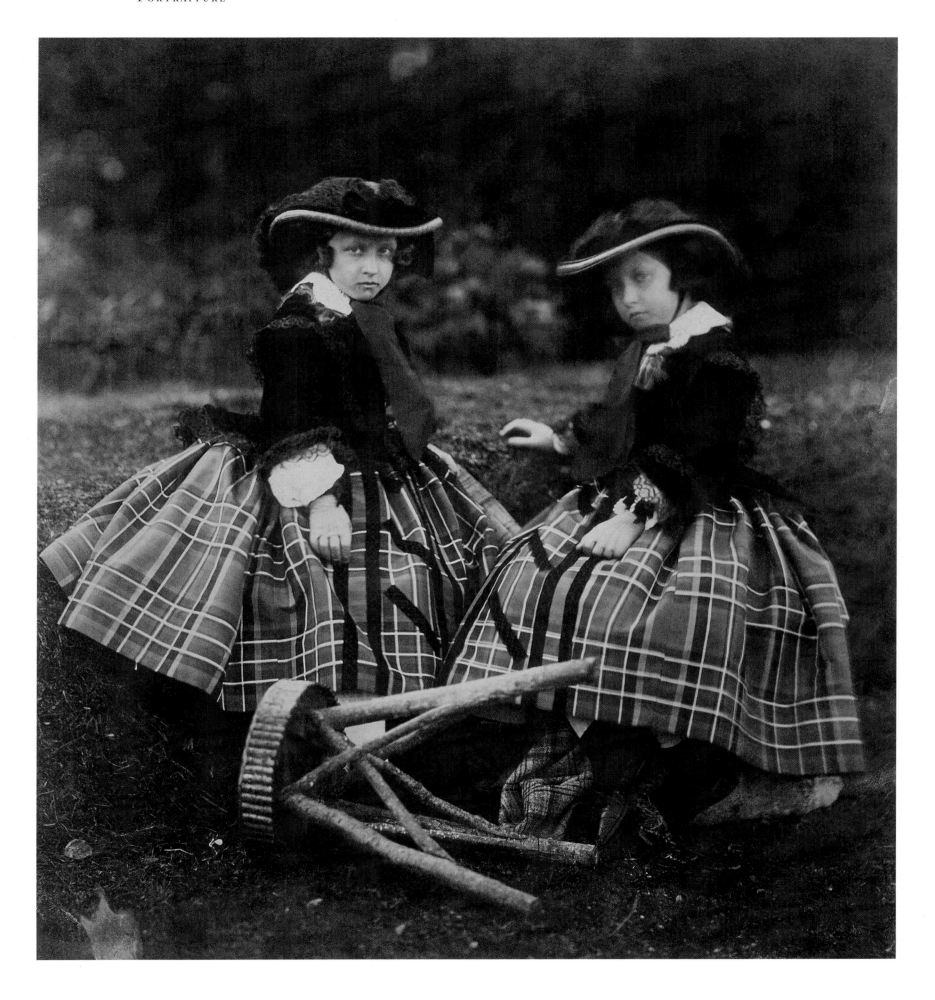

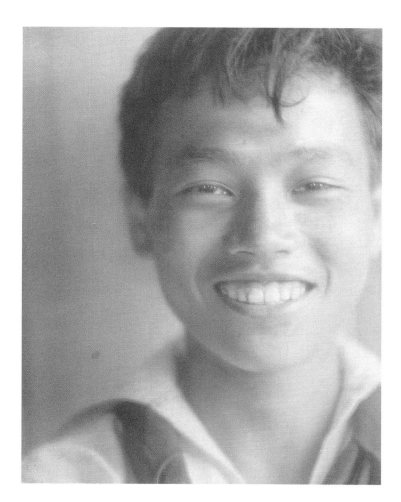 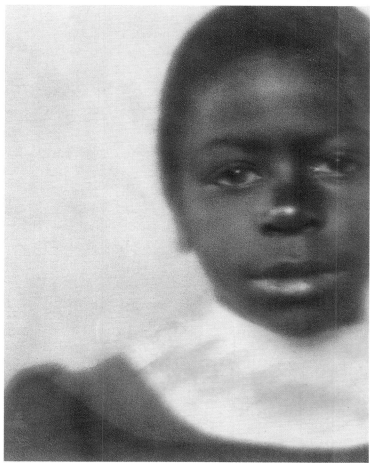

OPPOSITE | Roger Fenton was commissioned by Queen Victoria and Prince Albert to take a series of family photographs at Balmoral, among them this 1856 portrait of the Princesses Helena and Louise in their tartan skirts.

ABOVE LEFT | By 1900, the population of Boston topped half a million, one third foreign born, three quarters of foreign parentage, and Fred Holland Day often photographed the inhabitants of this racial melting-pot, stunningly so in this radically composed portrait of a second-generation Chinese boy.

ABOVE RIGHT | Four months after his Boston studio burnt down in November 1904, Day spent some time photographing at Hampton Normal and Agricultural Institute in Virginia , a training college for African and Native Americans. The emotional power and avant-garde composition of this series of photographs show Day determined to rise phoenix-like from his studio's ashes.

OPPOSITE | This portrait by Julia Margaret Cameron of Lady Florence Beatrice Anson (1860-1946) and the Hon Claude Anson (1864-1947), two of the 13 children of the Second Earl of Lichfield, was taken in August 1870, when Florence was ten, Claude six and Cameron at the height of her powers.

BELOW LEFT | Lord Tennyson became Poet Laureate in 1850 on the death of Wordsworth and was the most lauded literary figure of his day. He also happened to be Julia Margaret Cameron's nearest neighbour in Freshwater on the Isle of Wight, and she photographed him often. The title of this portrait, 'The Dirty Monk', is Tennyson's own, aghast at her depiction.

BELOW CENTRE | Cameron met the astronomer John Herschel at the Cape of Good Hope in 1835 and he became her photographic mentor as well as her lifelong friend. On seeing the resulting portraits from this sitting in 1867, Herschel said, 'You are too bountiful! How shall we all ever thank you enough for these superb things?' He appears adrift in infinite blackness, rushing towards the camera like a meteor, a living embodiment of his profession.

BELOW RIGHT | A portrait from 1864 of Annie Wilhelmina Philpot, a local orphan, has gone down in history as the first photograph with which Cameron was satisfied. She inscribed its title, 'Annie – my first success', on every print.

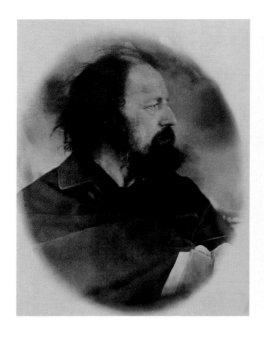
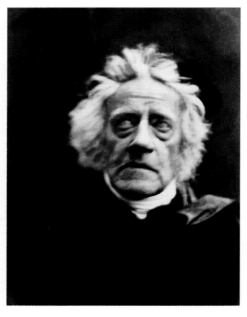
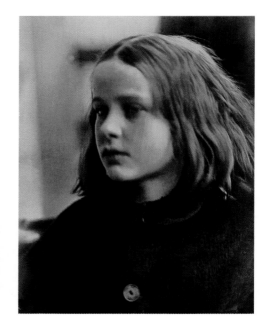

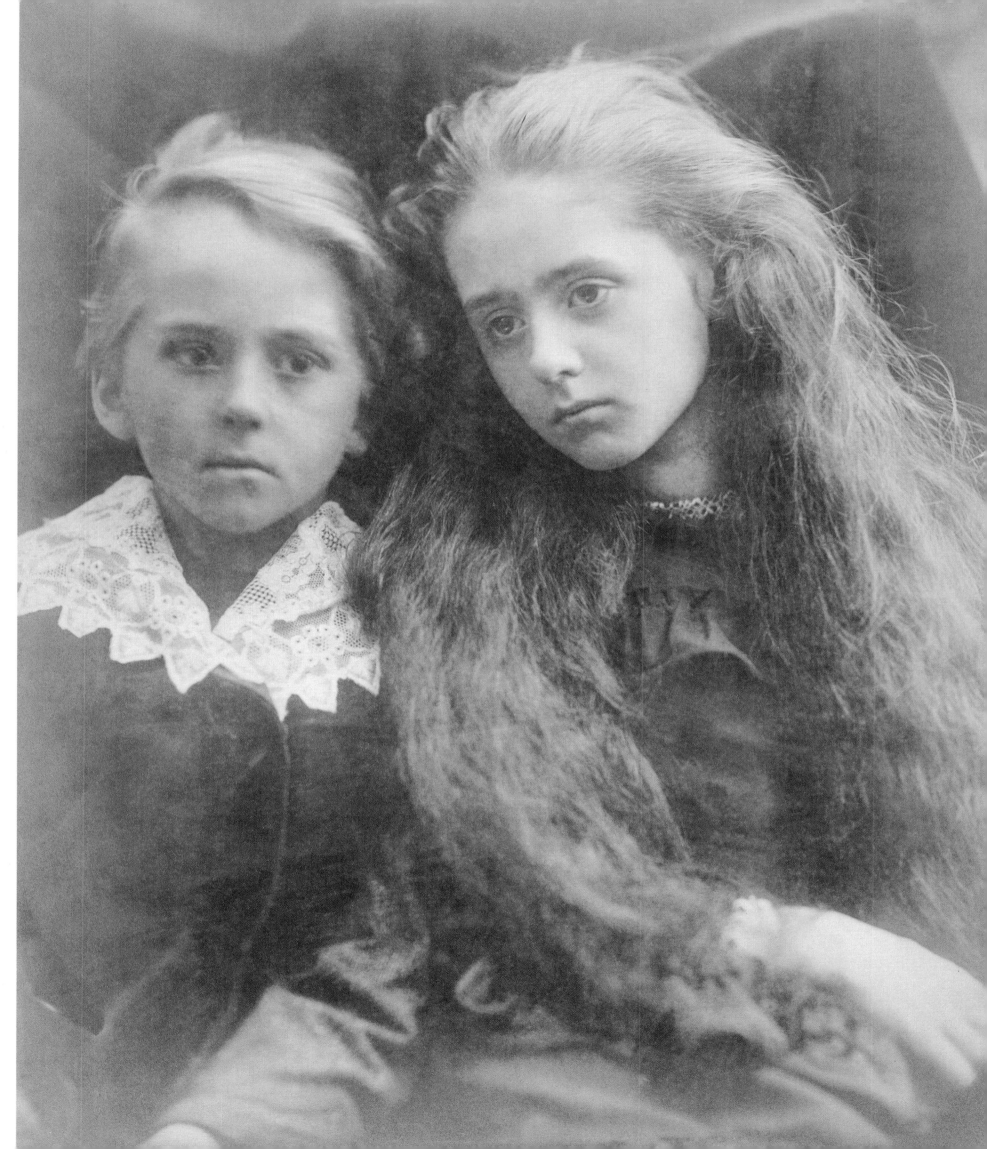

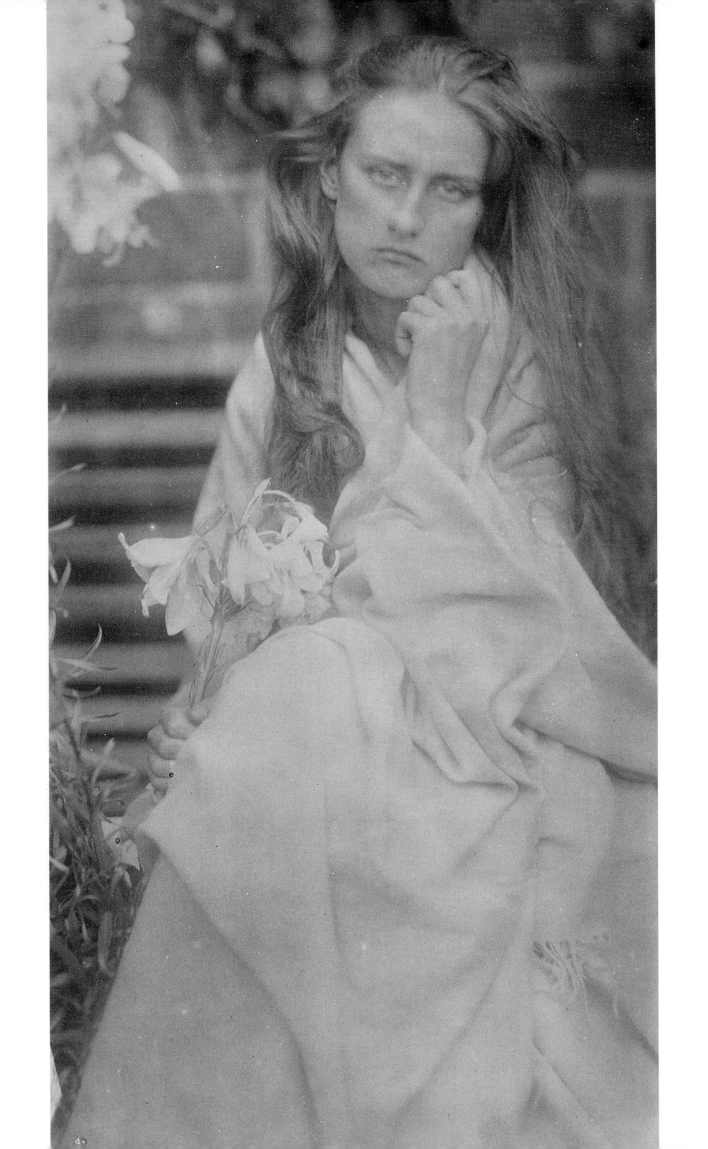

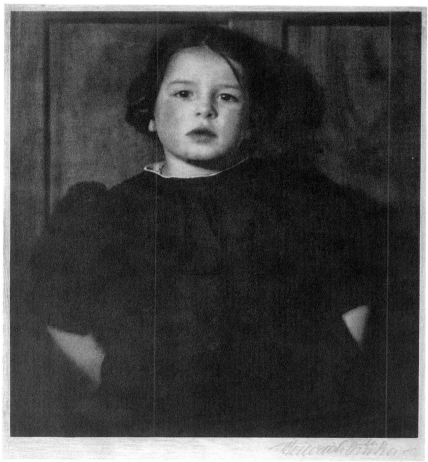

OPPOSITE | The expression on the face of this unknown sitter eloquently testifies to the fact that posing for Julia Margaret Cameron, and matching her exacting standards, could be a long and weary business. Whether Cameron had 'Despair' in mind as the expression she wanted to capture when she took this portrait around 1870, or titled the photograph after seeing the results, is unknown. (An apocryphal story has Cameron locking her model into a cupboard for several hours to acquire the requisite expression.)

ABOVE LEFT | Charlotte Dodgson was the second daughter of Hassard Hume and Caroline Dodgson and a cousin of the Reverend Charles Lutwidge Dodgson (Lewis Carroll). Carroll was a frequent visitor to the family's home in Putney, London where he took this photograph in 1862.

ABOVE RIGHT | The German Heinrich Kühn often used his daughters and their friends as models. This photogravure of *circa* 1908 is probably of his eldest daughter Lotte, most often depicted in Kühn's sunny Autochromes.

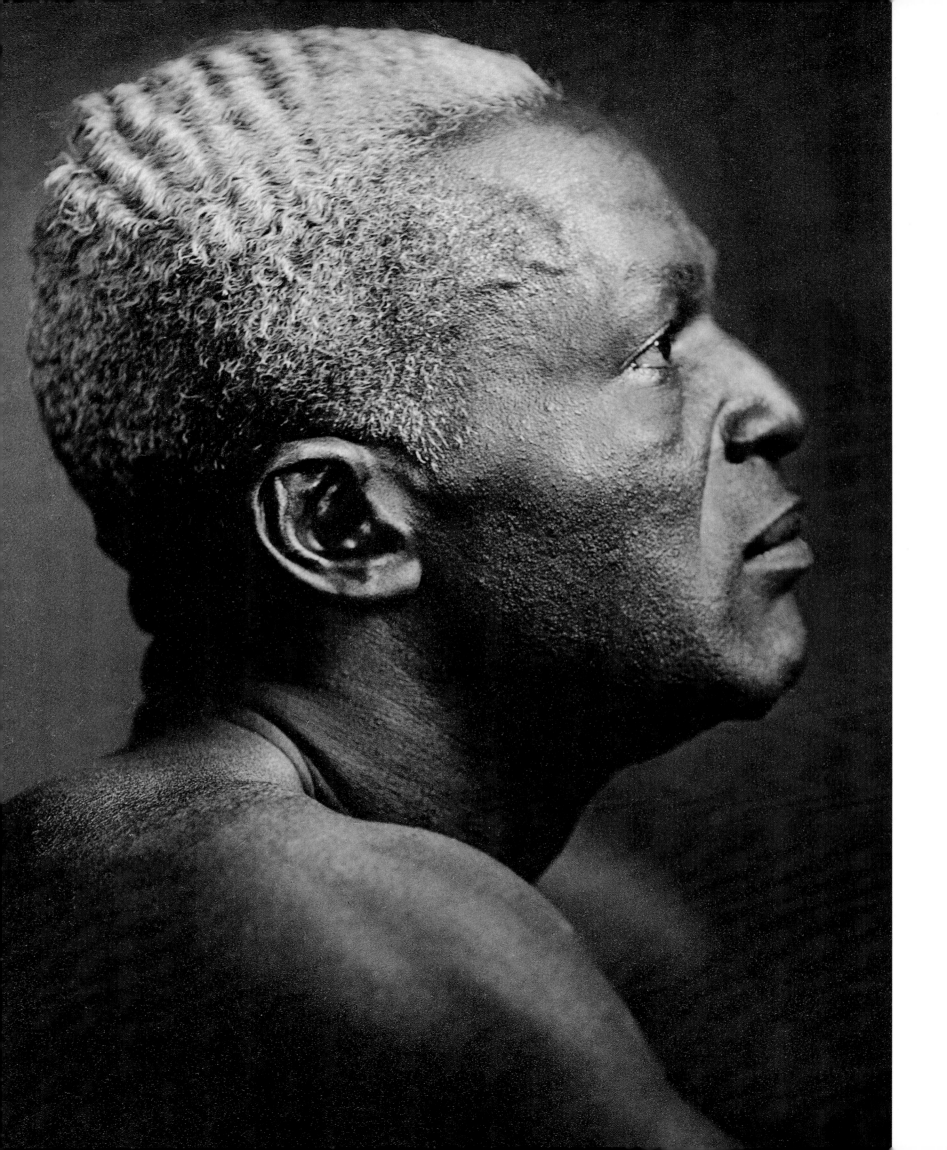

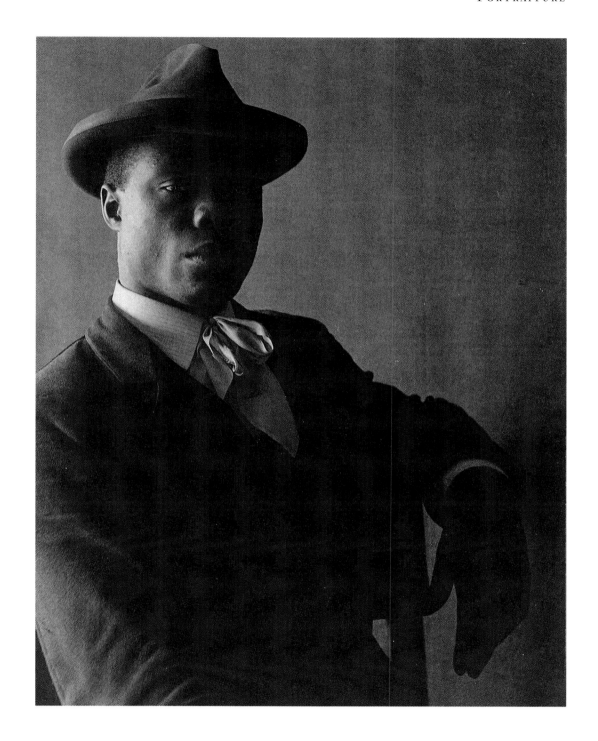

OPPOSITE | Dr Theron Wendell Kilmer was a practising paediatrician in New York from 1895. A Fellow of the Royal Photographic Society and a member of the Oval Table Society in New York, his most famous photographs were his portraits of men, including this one of an unknown sitter from around 1943.

ABOVE | Fred Holland Day used the striking looks and body of this African American model in a series of photographs taken in 1897, often presenting him as a Nubian chieftain. Here, with his model in everyday clothes, strong light on the right hand side of his face, shadow on the left, enhanced by the tonal qualities of the platinum print, Day achieves a portrait of compelling assurance.

OPPOSITE | Professor Edmund Kesting was at the forefront of German
avant-garde photography in the 1920s and early 30s and took portraits overlaid
with graphic patterns of light and shadow. This portrait of Professor Fetscher
was taken in 1936. Influenced by the Bauhaus and New Objectivity, Kesting
used high- and low-angle camera shots and photographed his human subjects
as artistic creators rather than as mere portraits.

BELOW | Anna May Wong (born Wong Liu Tsong, Los Angeles, 1907-1961)
became an international star after her performance in the film *The Thief of
Baghdad* (1924). This portrait by Edward Steichen for *Vanity Fair* was probably
taken in 1932 to coincide with Wong's new movie *Shanghai Express*.

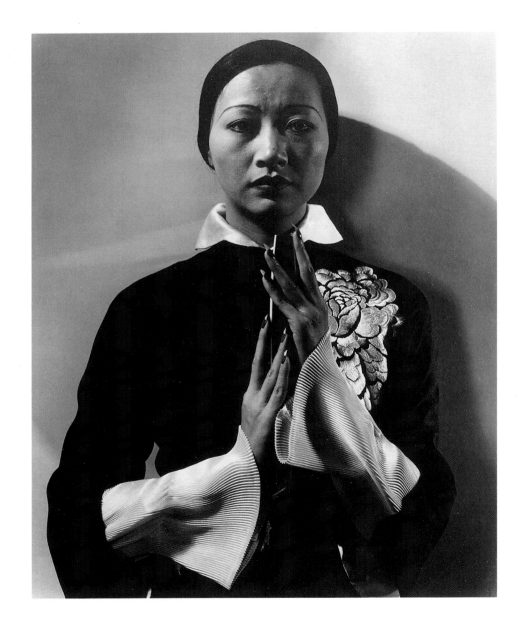

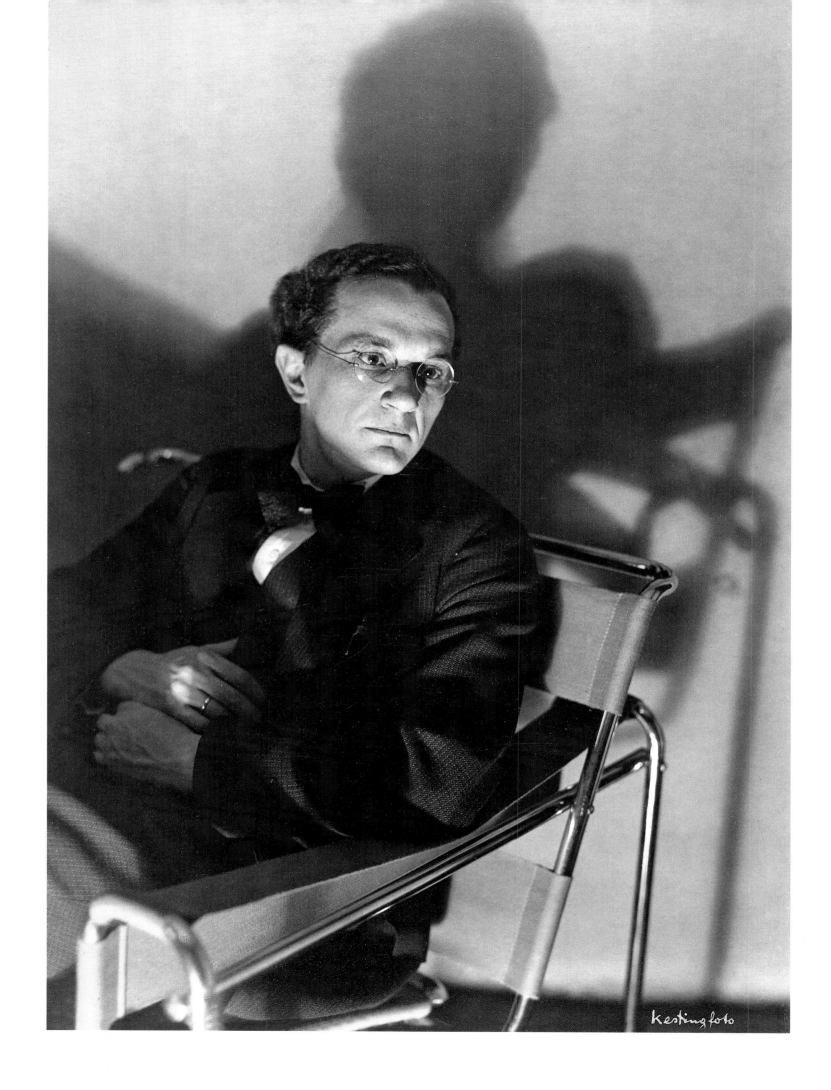

Kestingfoto

RIGHT | Portrait of the painter Edmund Victor Jamois, taken in 1911 by
Pierre Dubreuil. In the space of 10 years, Dubreuil's work rapidly progressed
from Naturalism through Symbolism to Modernism and he considered his
work as artistic as that of any painter, writing in 1930: 'Why should the
inspiration that exudes from an artist's manipulation of the hairs of a brush
be any different from that of the artist who bends at will the rays of light?'
He anticipated, by several years, the close-up, bird's-eye and worm's-eye view
of the 1920s Modernists. He became President of the Belgian Association of
Photography and Cinematography in 1932 and was honoured with a one-man
retrospective exhibition by the RPS in 1935.

OPPOSITE LEFT | Playwright, actor, producer, composer, Noel Coward was first photographed by Dorothy Wilding in her chic Bond Street studio in 1925, using one of her famous profile shots. The regrettable emphasis on his woolly sweater, like an illustration for a knitting pattern, was corrected in later sittings in 1930, when a beautifully besuited Coward posed with cigarette in holder.

OPPOSITE RIGHT | Baron Adolph de Meyer was the subject of *Camera Work* no. 40 in 1912 when 14 of his photographs were published as photogravures to represent all aspects of his work through still lifes, character studies, travel and portraits, including this enigmatic study of a young man.

BELOW | Darrel Coble was the smallest boy in Arthur Rothstein's 1936 photograph of the Oklahoma dust storm (page 97). Rothstein tracked him down 25 years later in Boise City, Oklahoma, and took this portrait.

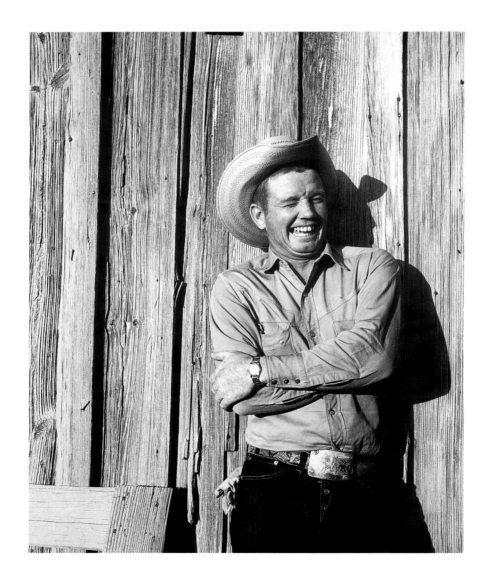

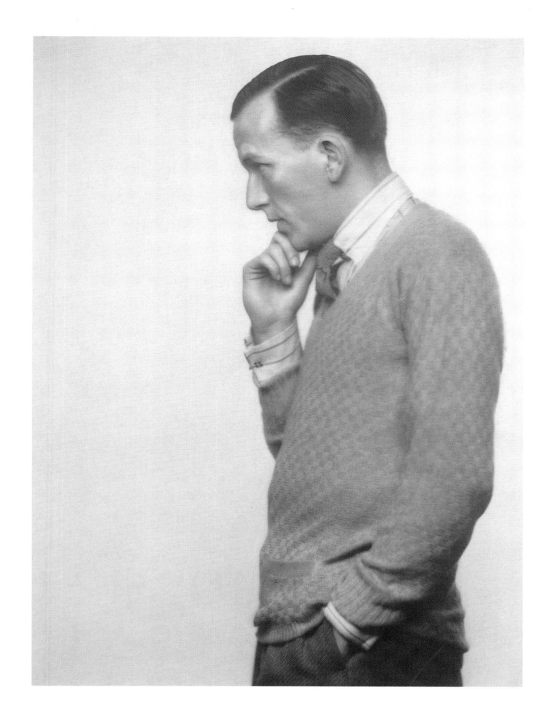

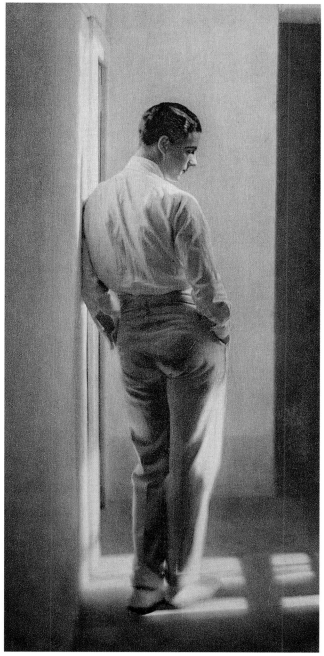

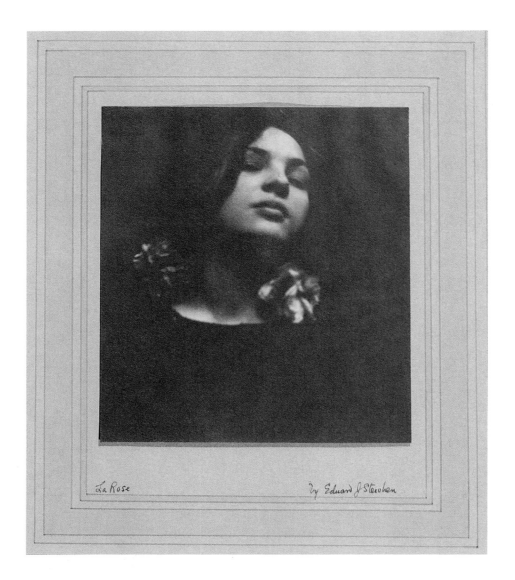

La Rose by Eduard J Steichen

OPPOSITE | Evelyn Nesbit, a showgirl and actress, was 16 when Gertrude Kasebier took this portrait in 1902 at the behest of Stanford White, the lauded New York architect who designed Madison Square Garden. Nesbit was White's mistress at the time. She later married Harry K. Thaw, a railroad and coal heir and a cocaine addict who shot Stanford White dead in 1906 in a fit of jealousy.

ABOVE | This portrait, taken in 1901 during Steichen's first year living in Paris, is of a woman called 'Rosa'. She seemed to feature prominently in his life at the time, as both lover and muse, and was the model for several of his nude studies. The title 'La Rose' was inscribed on the print by Frederick H. Evans, to whom Steichen gave this particular copy. Roses, indeed all flowers, were a recurring theme in Steichen's work and he was to photograph them again and again, most especially in his garden in Voulangis, France.

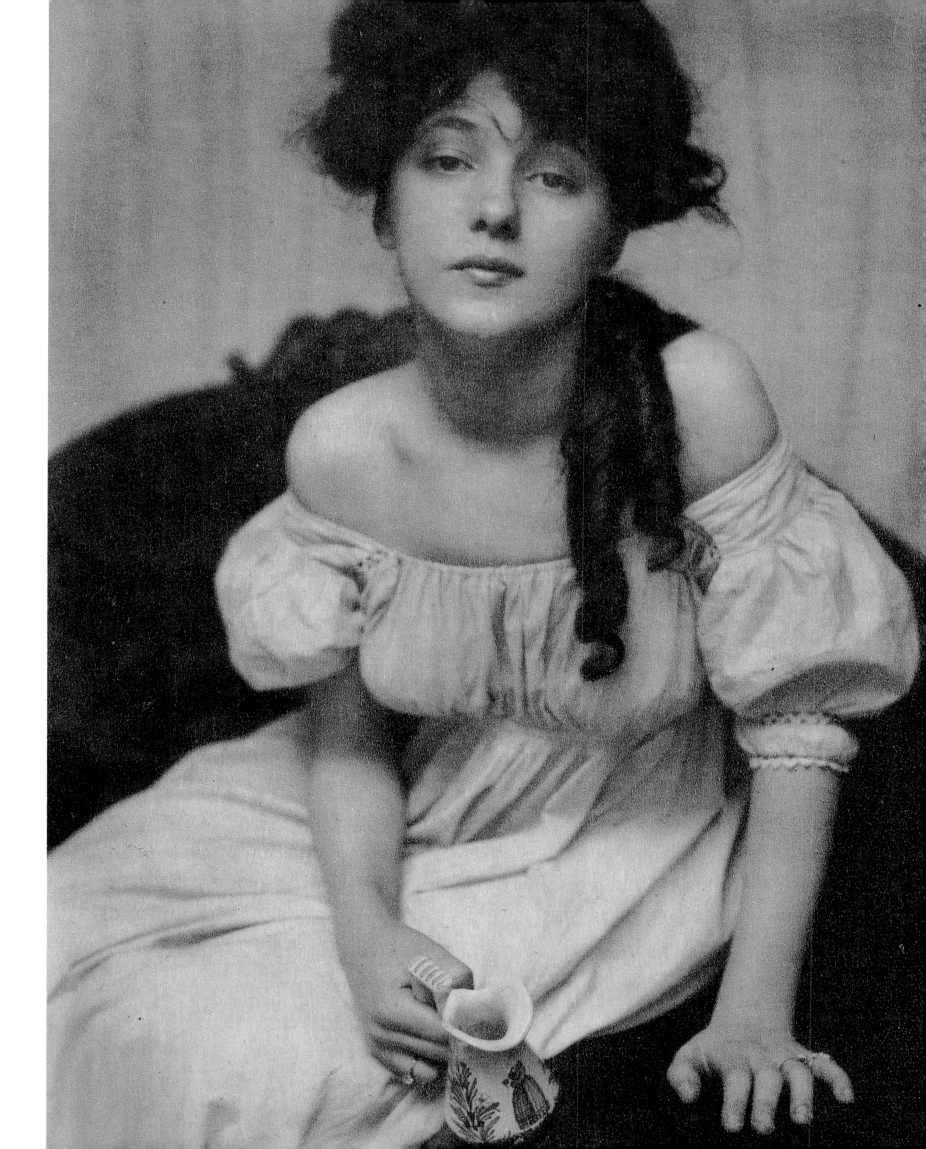

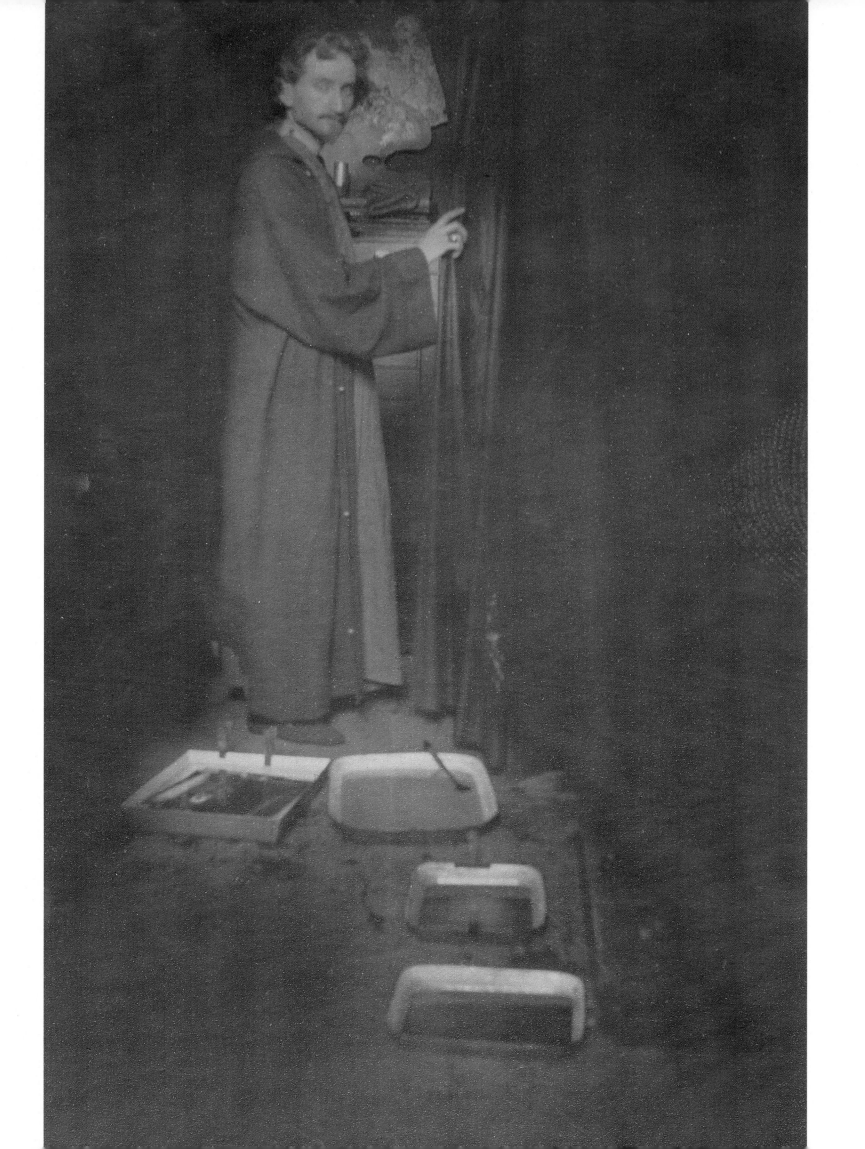

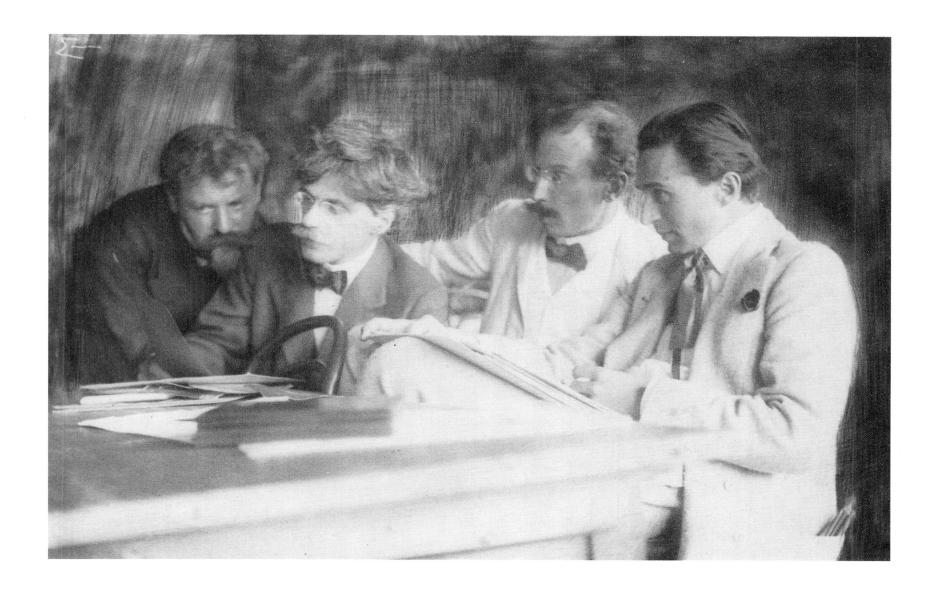

OPPOSITE | Fred Holland Day and Alvin Langdon Coburn, distant relatives from Boston, lived in London from April to December 1900 whilst Day was organising the exhibition 'The New School of American Photography' at the RPS, generating both rapturous critical acclaim and vitriolic criticism. The same year Coburn took this portrait of Day. His eccentric attire, the artist's palette and the conspicuous photographic developing dishes in the foreground emphasise Day's deserved credentials of 'artist-photographer'.

ABOVE | Frank Eugene was an early experimenter with the Autochrome process, invented by the Lumierè Brothers in Lyons in 1904. He took this 1907 photograph of himself (at far left) with three of the other major movers and shakers in European and American Secession photography: Alfred Stieglitz, Heinrich Kühn and Edward Steichen.

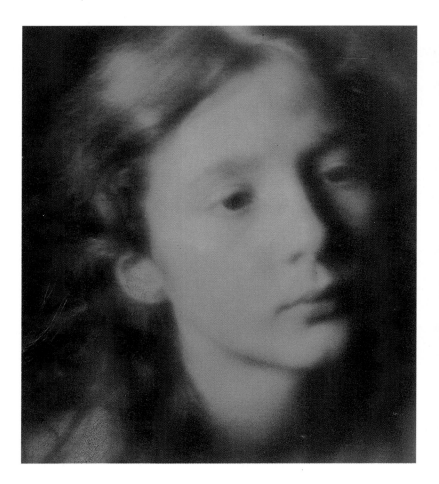 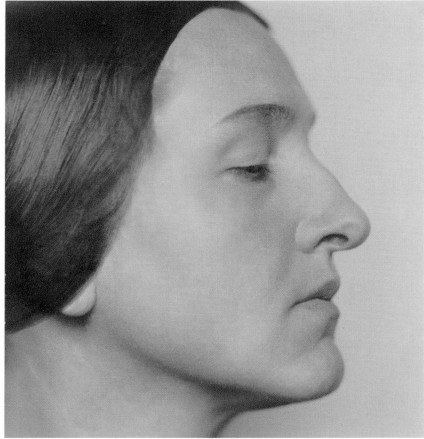

OPPOSITE | This 1844 portrait of two sisters contains many of the hallmarks of David Octavius Hill and Robert Adamson. Submission is suggested by downcast eyes but strength by the back turned to the camera. The composition makes the girls look, initially, like mirror image reflections of each other, but they are given individuality by the difference in their clothing and its patterns.

ABOVE LEFT | This 1903 portrait by Clarence Hudson White shows all the characteristics of his later work – soft focus, diffused lighting and, according to his fellow Photo-Secessionist, Joseph Keiley, writing in *Camera Work* in 1911: 'the music of line, and soft singing whisper of tone with only the ghost of a shadow of the personality behind their making'.

ABOVE RIGHT | Anna Arbeitlang (1895-1989), the wife and photographic model of Professor Rudolf Koppitz, studied photography at the Graphics Institute in Vienna where he taught. This striking profile was shot by Pamela Booth in 1933-4, using daylight in accordance with Koppitz's studio work.

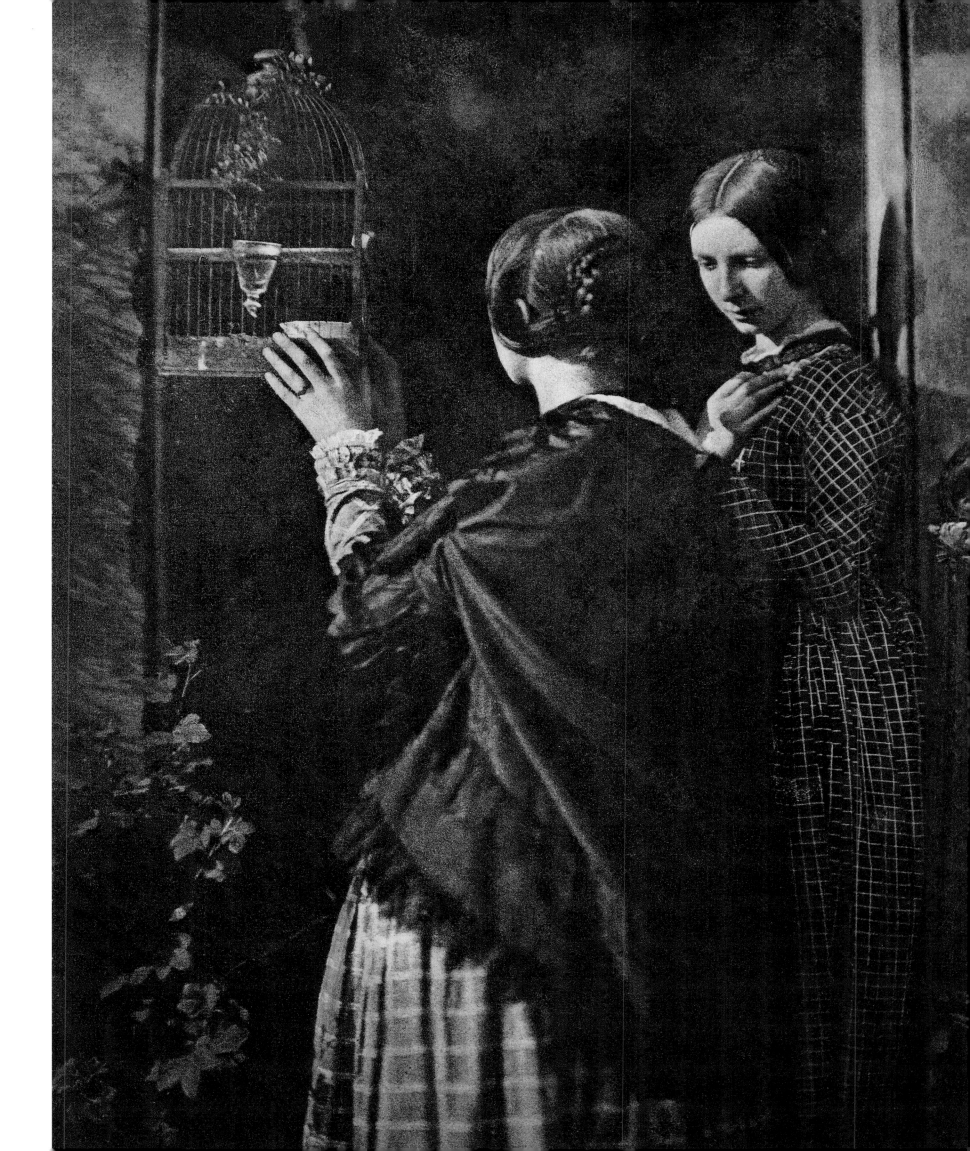

ABOVE | From an early age, Edward Steichen was acutely aware that self-presentation was of importance to the aspiring artist. This radically cropped and very modern looking self-portrait was taken in 1898 and shown in Fred Holland Day's exhibition 'The New School of American Photography' in London in 1900. The photograph elicited disdain from some members of the press who seemed to think that the cropping showed accidental ineptitude rather than intentional drama. One reviewer suggested the self-portrait be retitled 'Wanted, a Pair of Braces', 'for his trousers are tied up with string'.

RIGHT | This portrait of Fred Holland Day in reflective mood was taken by Steichen in Paris in 1901, prior to its reproduction in *Camera Work* some years later. Day had toured his exhibition of new American photography to Paris where it met with a far warmer reception than in London.

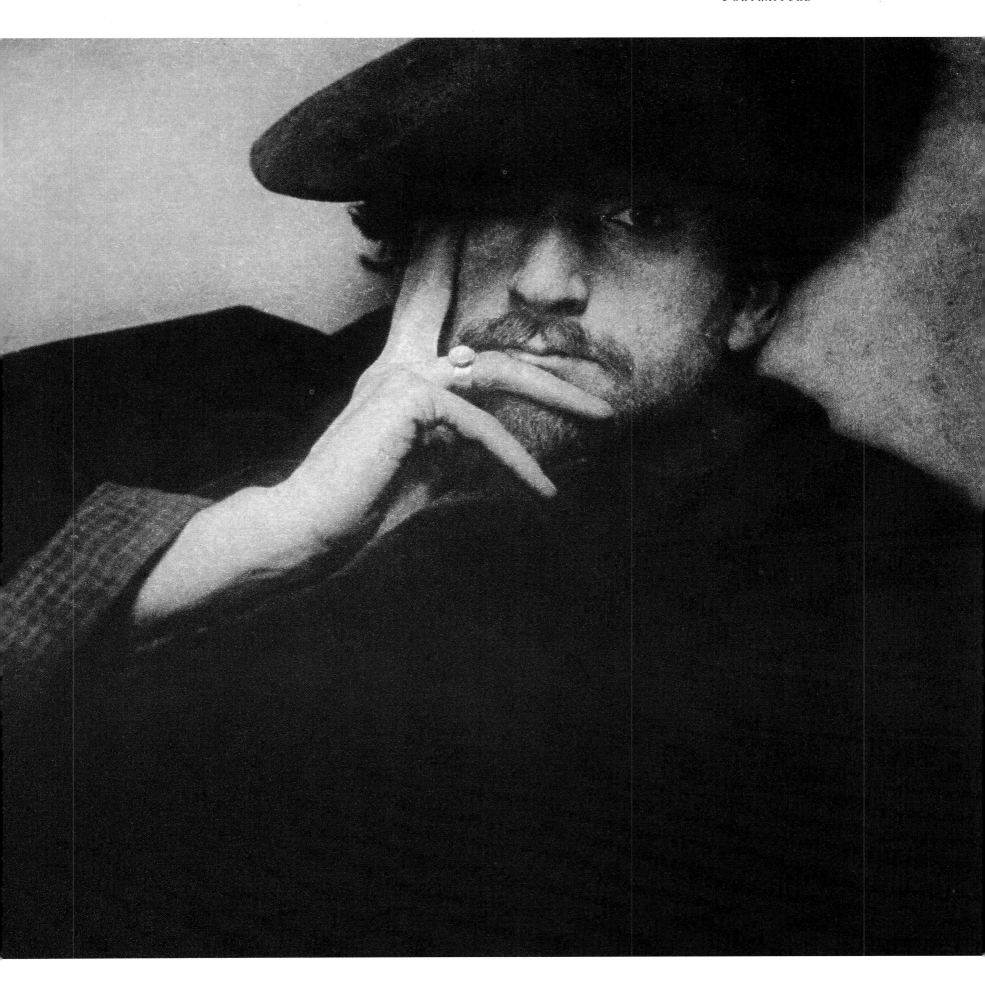

OPPOSITE | Isabella Caroline Somers-Cocks (1851-1921) was the eldest daughter of Julia Margaret Cameron's youngest sister, Virginia. She married Lord Henry Somerset MP in 1872 but divorced him when his homosexual affairs became a public scandal. This photograph dates from 1861 and has been attributed to both Julia Margaret Cameron and Lewis Carroll, but seems more likely to be the work of Oscar Gustav Rejlander.

BELOW LEFT | Mary McCandlish and her elder sister Margaret sat several times for David Octavius Hill and Robert Adamson in poses of sisterly harmony. Here, Mary has the look of a demon child as she glances up at the camera.

BELOW RIGHT | 'Xie' (Alexandra Rhoda) Kitchin (1864-1925) was one of Lewis Carroll's favourite models, whom he called 'my dear Multiplication sign'. This portrait was taken in 1873 in Carroll's rooftop studio at Oxford.

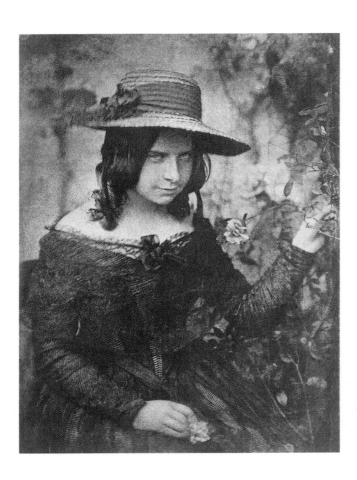
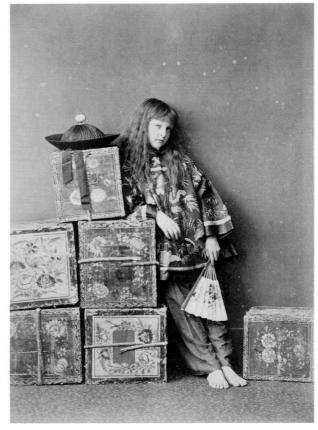

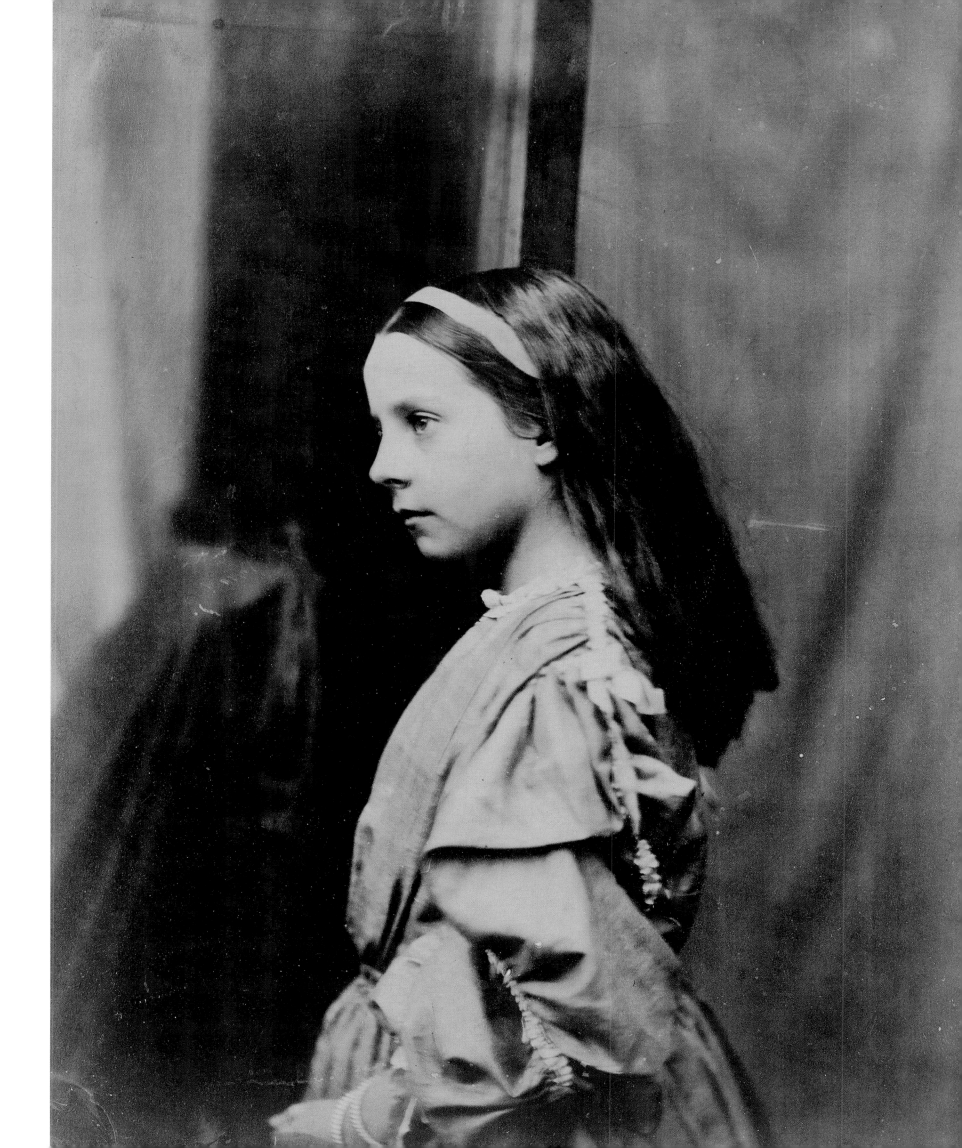

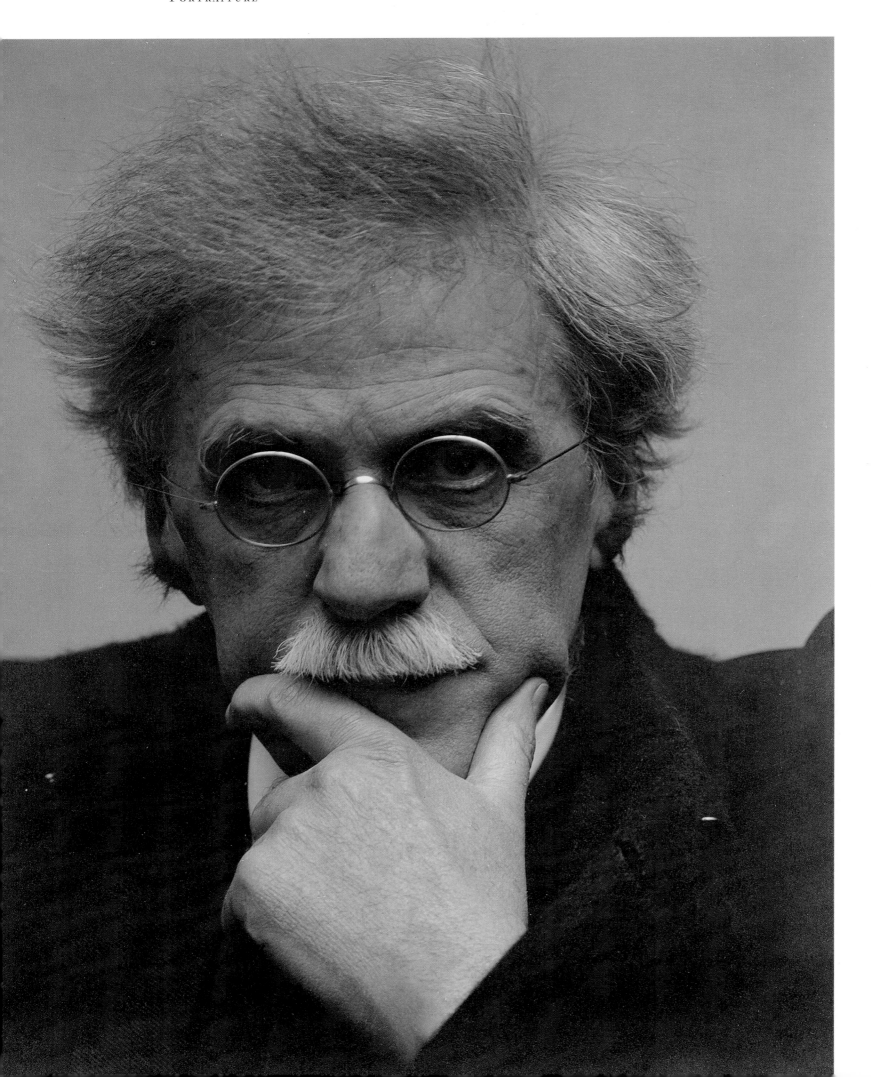

OPPOSITE | Alfred Stieglitz was 60 when this thoughtful and direct portrait was taken in 1924 by fellow American Paul Strand, the photographer whose 'straight' photography Stieglitz had actively encouraged since 1915. It was sent to the RPS when Stieglitz was awarded the Society's Progress Medal.

ABOVE | This striking photograph by Erna Lendvai-Dircksen was published in *Unsere Deutschen Kinder* (Our German Children) in 1932. Lendvai-Dircksen devoted herself to photographing close-up portraits under a harsh light which etched the face. The same year she published another series of anonymous portraits under the title *Das Deutsche Volksgesicht* (Faces of the German People).

OPPOSITE | John Cimon Warburg's love of the Autochrome plate was only tempered by its cost, double the price in England as France. His portrait of his daughter Peggy in the garden, is an Autochrome from 1909.

ABOVE | Alvin Langdon Coburn changed his appearance many times from 1900-14 and, like many other Secessionist photographers, was an obsessive self-portraitist. He had gone through romantic, stylish, foppish, extrovert and dandy phases, and the advent of the Autochrome and other colour processes allowed him to experiment with an Impressionist colour palette. This Autochrome self-portrait was taken around 1910.

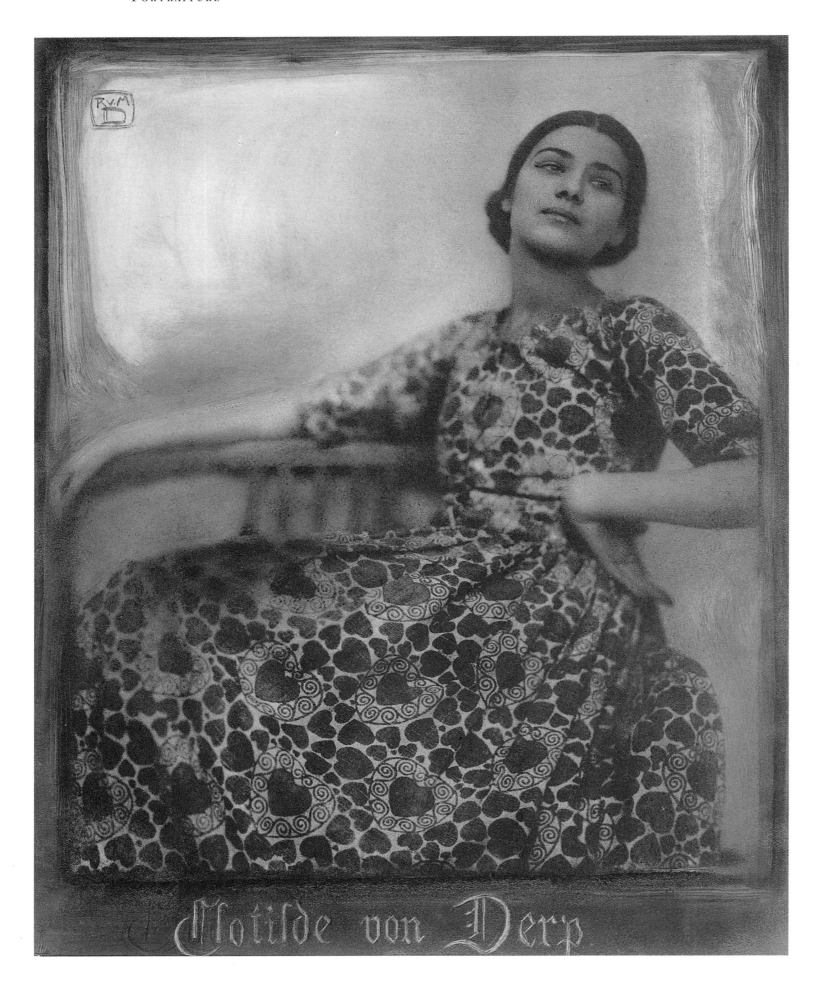

OPPOSITE | The father and daughter team of Rudolf and Minya Diez-Dührkoop were amongst the leading German portrait photographers of their day, based in Hamburg. Dührkoop published a series of 120 photogravure portraits entitled *Hamburg Men and Women at the Beginning of the Twentieth Century* in 1905. This portrait of Clotilde von Derp-Sakharoff, a famous German modern dancer in the style of Isadora Duncan, was taken in 1912.

BELOW | Lieutenant-Colonel Mervyn O'Gorman had a distinguished career in the aeronautics and automotive industries. In *Who's Who* he listed his pastimes as engraving and making lacquer although he also had time to master photography. This portrait, entitled 'Christina', is probably of his daughter.

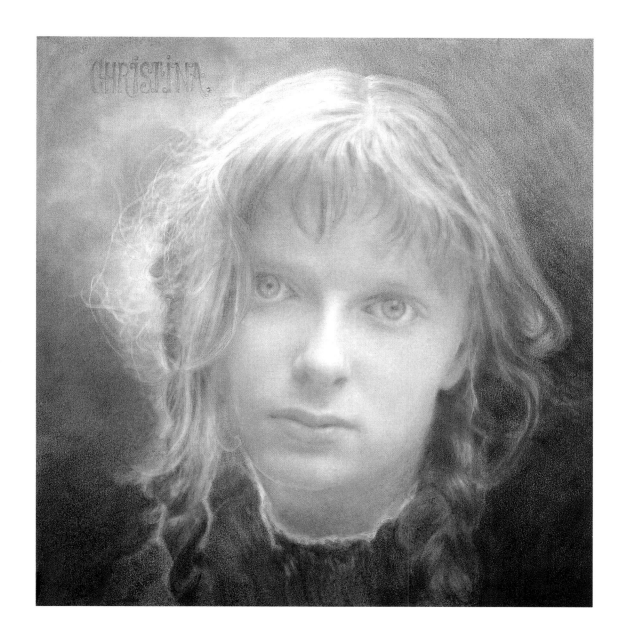

OPPOSITE | The American Helen Wills Moody was many times the
national tennis champion of the USA and won the Wimbledon ladies' tennis
tournament eight times. This was one of the prints that photographer Dorothy
Wilding presented to the RPS after a one-woman exhibition in 1930 when
she was also made a Fellow of the Society. It was taken in 1928.

BELOW LEFT | This photograph of Florence Lambert by Madame Yevonde
was captioned 'The Exotic Wife of a Composer' and appeared on the cover
of *The Sketch* in March 1933. It was taken when Florence was 18 and had been
married for two years to the musician and composer Constant Lambert.

BELOW RIGHT | British actress Margaret Bannerman was photographed
by Dorothy Wilding in 1925, in costume for the play 'The Grand Duchess'.
Wilding focuses the portrait on the actress's elegant profile and swan-like neck.

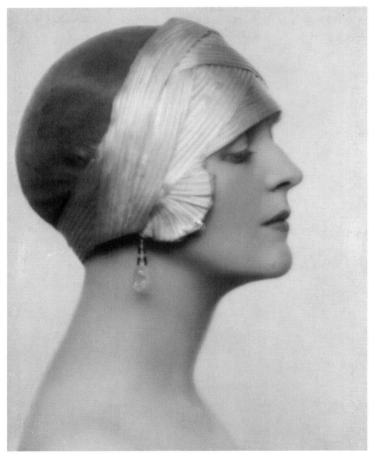

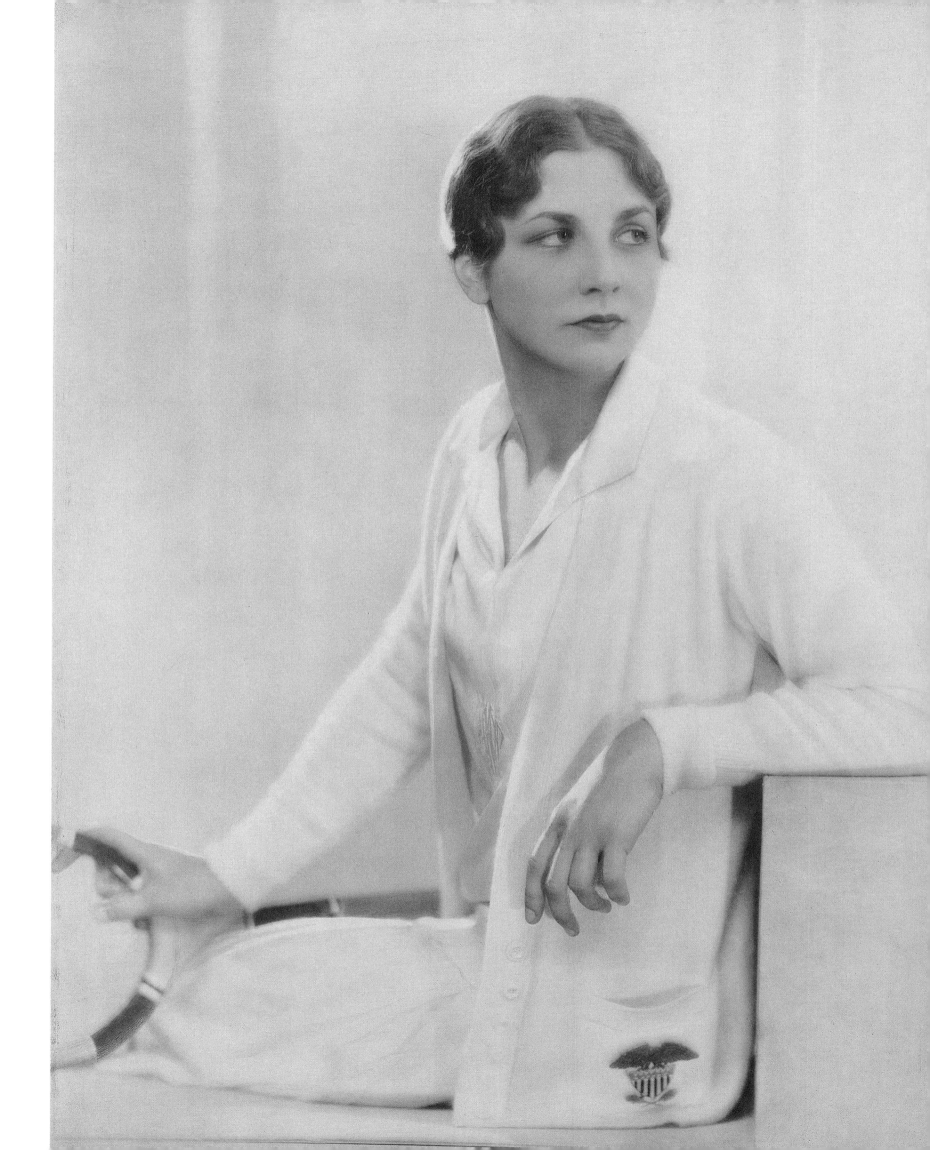

OPPOSITE | Gordon Crocker worked for Studio Sun, 'photographers to the printed page', in London. It seems likely that this is an advertising or publicity shot, and it was displayed at the First International Photographic Exposition in New York in 1938. The vivid colour and model's pose look incredibly modern.

ABOVE | Nickolas Muray left Hungary for the US in 1913 and after a successful career as a portrait photographer working for *Harper's Bazaar* and *Vanity Fair*, he switched to fashion, advertising and commercial photography in 1928. For the next 20 years he was a pioneer of colour photography, perfecting the carbro technique. This Shirley Temple lookalike was shot around 1940 for the cover of *The Parents' Magazine* run by The Parents' Institute in New York from 1929-53. The handsome and dashing Muray had many other interests apart from his photography. For several years, he was the lover of the Mexican painter Frida Kahlo and a member of the US Olympic fencing team.

II.

Social Documentary

II.

OPPOSITE | Civil war in East Pakistan created over a million refugees, their plight made worse by the onset of the monsoon which rapidly turned a cholera outbreak into an epidemic. Don McCullin took this eloquent and tragic photograph of a refugee woman and her child on the Indian border in 1971.

DOCUMENTARY PHOTOGRAPHY PRESENTS US WITH VISUAL PROOF that things happened at a specific time – be they wars, social conditions, political events, moments of acute historical significance or just moments in everyday life. They capture a moment in time and have a resonance to a multitude of people way beyond the photographer. They are often viewed as impersonal but truthful images for mass consumption, and give us what we may consider to be an honest, real and objective view of the past. Of course, the photographer responsible for the image is as subjective as the rest of us, so a degree of personal interpretation is taking place the second the exposure is made, another one when we view it.

Documentary photographs often take on more pertinence once they are put into context. Thus a photograph of an open-topped limousine cruising down a street, with a man and a woman sitting in the back, is of little visual interest until the accompanying text tells us that a few seconds later, one of the passengers, President John F. Kennedy, became the target of an assassin's bullets. The photograph then takes on a huge emotional relevance and a deep significance which it lacked before. After that it becomes impossible to separate the photograph from the event, as we invest it with our own knowledge and emotions.

Of course, the majority of twentieth-century documentary photographs need no words to convey their meaning. There is no need for explanatory text to talk us through the despair apparent in the Farm and Security Administration (FSA) photographs taken in the US in the 1930s. Nor do we need words to understand the brutality of warfare, nor the miseries of famine, disease and destitution. Since the introduction of the 35mm camera in the early 1930s, most especially the Leica, photographers have had rapid technological and visual, if not always easy physical, access to the depths and the heights of human existence.

In 1947, the co-operative photography agency Magnum Photos was founded in Paris and New York by an international group of photographers: Henri Cartier-Bresson (French), David 'Chim' Seymour (Polish), Robert Capa (Hungarian), George Rodger (British) and William Vandivert (American). Their aim was to

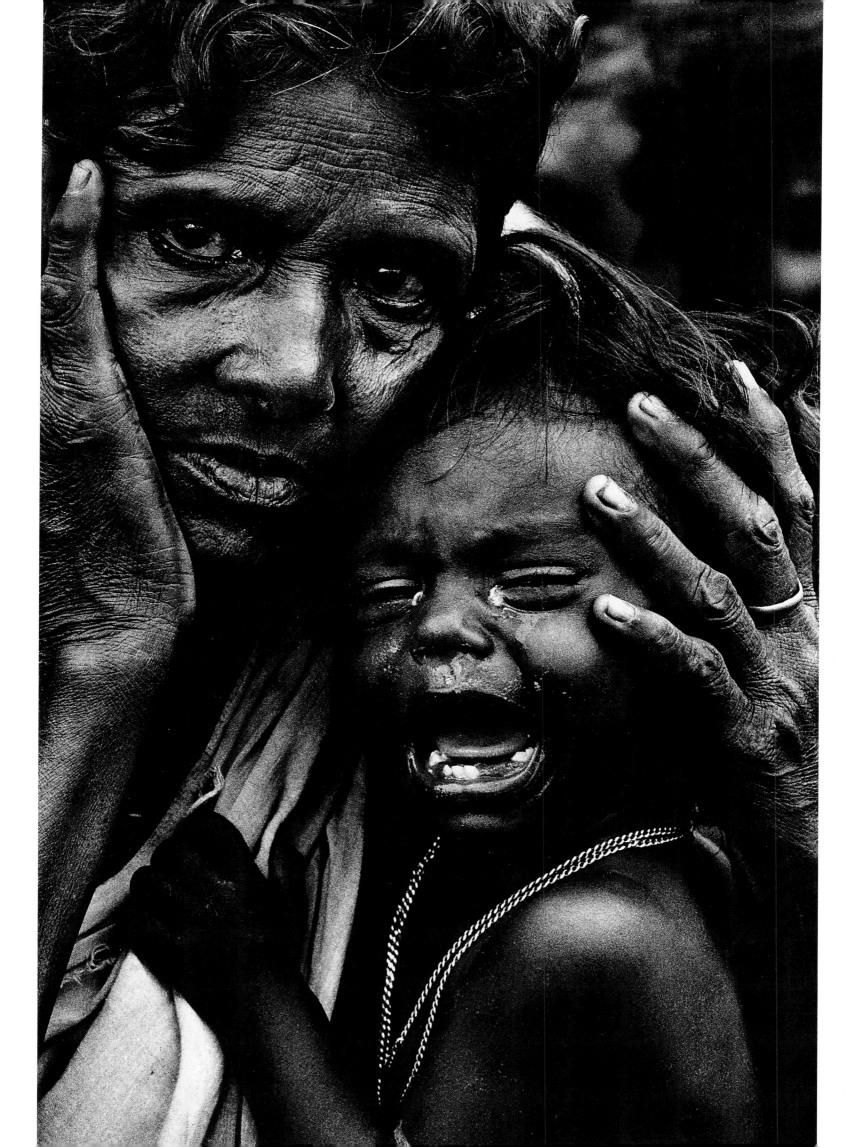

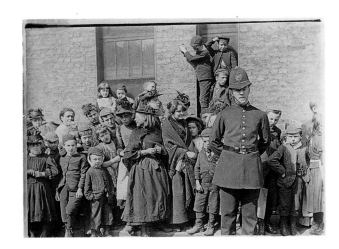

address subjects which needed attention worldwide, not just war and conflict but social, cultural and environmental issues. There is a particularly strong tradition of documentary photography in the US, which established itself with photographs of the American Civil War in the 1860s and continued through the work of Jacob August Riis (1849–1914) and Lewis Wickes Hine (1874–1940) and ever onwards into the twentieth-century work of Walker Evans (1903–1975), Robert Frank (1924–), Lee Friedlander (1934–) and Garry Winogrand (1928–1984). The investigative documentary tradition is not so strongly apparent in European photography in the nineteenth century although elements are undoubtedly there.

One of the reasons for this strong documentary tradition in the US is undoubtedly the huge numbers of immigrants flooding into the country in the late nineteenth and early twentieth centuries, causing rapid urban growth, and in turn the creation of slum housing with appalling conditions. A bewildering variety of racial and ethnic groups, usually at the very bottom of the economic scale, were thrown into a vast melting pot, producing social ills and hectic changes in society. These problems were thoroughly explored by reforming journalists, who, by the 1880s, were accompanying their words with photographs.

The first newspaper to print a photograph as an inclusive half-tone illustration, printed in conjunction with, rather than separately from, the text, was the *New York Daily Graphic* on 4 March 1880. Similar reproductions, using varying methods, were being printed in Europe simultaneously but the half-tone reproduction became the norm by the end of the century, proving to be quicker and cheaper than other processes.

Photographic images had been illustrated in newspapers before this date, interpreted via woodcuts, engravings and a variety of photo-mechanical reproductive media, but the advent of the half-tone opened the way for mass reproduction of photographs, something envisaged by William Henry Fox Talbot in 1842. The new-found technology for cheaply printing good-quality illustrations led to a growth in the numbers of photographers willing to supply them. It also spawned a new breed of reporter-photographer or

OPPOSITE | A small crowd has gathered in Lambeth, south London, to witness the funeral procession of a policeman in 1892. (In the excitement of making an arrest, Constable Daniels had swallowed his own false teeth and choked to death.) French-born Paul Martin photographed the crowd, largely children and young people who seem to be treating the event as something of a day out.

photojournalist, either a journalist who took up the camera to illustrate a story or a photographer who supplied annotated images. Because of the time it took to get photographs from the point of exposure to the editor's desk, weekly magazines were the largest users of half-tone illustrations rather than daily newspapers.

Horace W. Nicholls (1867–1941) was the first British documentary photographer to make a decent living from his photographs, and his negatives show his dogged determination to get the right shot, or failing this, to create the right shot in the darkroom. He had returned from documenting the Boer War to London in 1902 and threw himself into a career as a photojournalist. He photographed the hedonistic Edwardian social world at play, as well as the itinerants on the fringes of this social scene: gypsies, horse dealers, touts, thieves, pickpockets and beggars. He sold his photographs to any publication that would take them. Some years later, James Jarché (1891–1965) worked for practically every major photo agency and British newspaper including *The Daily Sketch*, *The Daily Herald* and *Weekly Illustrated* before finally retiring from *The Daily Mail* in 1959. The RPS acquired an archive of 530 of his black-and-white prints and lantern slides, bequested by him, in 1971.

The predecessors of Nicholls and Jarché, among them John Thomson (1837–1921) and Paul Martin (1864–1944), had a more altruistic approach to recording social mores and conditions. In 1876–7, Thomson produced a 12-part illustrated publication, *Street Life in London*, with text by the journalist Adolphe Smith. Thomson's photographs are posed, mostly outside given available technology, but begin to address society's underbelly and to capture a class of people, in their natural locale, previously invisible to the camera.

In 1890, Jacob Riis published *How the Other Half Lives; Studies among the Tenements of New York*, a 304-page book, with 43 illustrations by Riis and collaborators, showing the squalor and poverty of immigrant tenement life on the Lower East Side, in New York. The introduction of flash photography, using magnesium powder, in 1887, enabled Riis to take spontaneous photographs inside the tenements, and he had the satisfaction of seeing his photographs and writings have a direct impetus on the reform of social conditions for this underclass.

OPPOSITE | One of James Jarché's better known images, taken on a hot and muggy summer's day in London in 1924. Jarché had the enviable knack, essential in a photojournalist, of turning up at the right time. The smile on the face of the third boy from the right would suggest that the police constable, whilst doing his duty, had more than a sneaking sympathy for the skinny dipping lad, encumbered himself by woollen uniform, boots and helmet.

Earlier nineteenth-century documentary photography was, of course, limited by the abilities of the technology. Long exposures meant that photographs had to be staged. Oscar Gustav Rejlander's series of ragged street urchins, whether a real street child taken to the studio or a child model dressed as an urchin, rarely look convincing. Thomas Annan (1829–1887) photographed Glasgow slums as they were being demolished between 1868 and 1877 but the streets are largely empty, apart from occasional posed groups of slum-dwellers.

Victorian Britain was a relatively well-ordered society, superficially at least, compared to many of its European neighbours. It had an economically productive industrial revolution under its belt, a burgeoning wealthy middle class, a growing empire, and a confidence born of colonial supremacy and economic stability. Any wars in which Britain was involved took place outside its own boundaries, unlike the internal power struggles going on elsewhere in Europe. In France, the Revolution of 1848, the Franco-Prussian war of 1870–1 and the Paris Commune uprising of 1871 produced events of domestic social significance for photographers to record. Germany and Italy were in the process of unification and there is a wealth of documentary photography in German and Italian archives which attests to this and which is beyond the scope of this book.

Into this well-ordered British world had come photography in 1839. Initially the wealthy pursuit of leisured gentlemen and gentlewomen, photography, in its first three decades, depicted what it knew best and what it would like to know better, and there was little urge to point the camera at the less photogenic aspects of life. Roger Fenton went to the Crimea in 1855 (although not the first photographer there his work is certainly the best known and has survived largely intact). There he photographed officers in jaunty uniforms, distant views of camps, military stores and ships unloading at dock. He could do little else with the heavy and cumbersome equipment at hand. 'Action' shots, war photography as we now expect it, were still 80 years in the future.

As the practice of photography became cheaper, more portable and less dauntingly complex, other photographers also began to move out of the studio, and increasingly began to focus on the life that was being lived

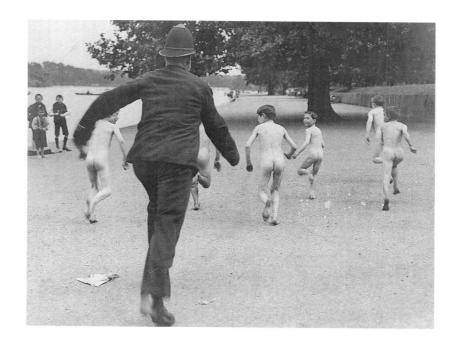

around them, exploring the rich photogenic possibilities of their immediate locale rather than the traditional, painterly themes of photography's first generation.

In the 1880s and 90s, the advent of speedier dry plate negatives, magnesium flash and then the introduction of increasingly simplistic Kodak cameras, enabled photographers to snatch a photograph unawares and abandon the studied artificialities of posing. Fixed cameras on tripods began to disappear as the portable camera, an increasingly fluid extension of the eye and hand, froze the moment instantaneously. Paul Martin captured the Victorian public at work and play, on the beach, in the streets, at the zoo, showing previously unrecorded inter-relationships between lovers, families, friends and crowds. He shot unobtrusively from the hip with a Fallowfield Facile detective camera, disguised as a brown paper parcel tucked nonchalantly under his arm. The people he photographed – happy, sad, blessedly real, living their lives in public, emotions chasing across their faces – are us more than a century ago.

The opening of the twentieth century brought dramatic change. The First World War of 1914–18 and the Russian Revolution of 1917 obliterated the old order in Europe, leading to the shifting of political, class, religious and economic barriers. This momentous shift also brought into question the abstract concepts of truth and beauty in art, previously accepted as inherent and endemic. Photography, the new, more realistic art of the twentieth century, became universal and was accepted as the modern art form.

In the 1930s, the revolution in picture-taking created by the compact, pocket-sized 35mm camera, and later colour photography, coincided with the movement of camera-carrying refugees from war-torn Europe to France, Britain and America and led to an explosion in social documentary photography. This work was

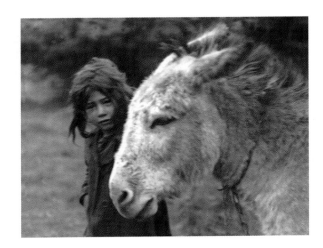

published in the new, heavily illustrated current affairs photographic weeklies, which had grown steadily in numbers and influence since the 1920s: *Arbeiter Illustrierte Zeitung* (1925), *Berliner Illustrierte Zeitung* (1928), *VU* (1928), *Life* (1936), *Match* (1937), *Picture Post* (1938). Photographers like Margaret Bourke-White, Felix Man, Kurt Hutton and Alfred Eisenstaedt were sent out on the road to capture a story in pictures, which would then be linked by editors and journalists, often using only expanded captions, to direct the emphasis at the images rather then the words.

The highly photogenic and dramatic conflicts of the next 30 years – the Spanish Civil War, the Second World War, Korea and Vietnam – saw a corresponding growth in war coverage, and eager audiences ensured that circulation of the photographic weeklies soared into the millions. This was the first time that photographs of war had reached a mass public, as progress in printing and photographic technology coincided with world-wide events of historic magnitude to enable the wide dissemination of images.

In 1938, *Picture Post* magazine unequivocally named Robert Capa 'the Greatest War-Photographer in the World'. It was a position he was to maintain until his death from an exploding landmine in Indo-China in 1954. Like Capa, photographers now had portable cameras and more rapid films, which enabled them to be at the heart of the action on the battlefield, risking their lives alongside the troops. Robert Capa, who maintained that 'if your pictures aren't good enough, you aren't close enough', placed a new emphasis on the photographer as action man, hero and mortality statistic.

War photography in colour has a visceral kick. Colour photographs by John Hinde and other anonymous photographers, taken during the London Blitz in 1943 (usually thought of as being photographed only in black and white), have an almost surreal quality of brightness and an unexpectedly jarring beauty. The very reality of colour, when photography's previous rendition of the world had been black and white, brown or grey, of sunny blue skies arching over scenes of devastation, becomes absurdly, uncomfortably unreal.

OPPOSITE | British photographer Mark Oliver Dell's favourite off-duty destination was the Pyrenees, where he returned year after year for photographic inspiration and where this image may well have been taken in the early 1930s. The massive and imperturbable head of the donkey is in sharp contrast to the slightness and apprehensiveness of the child.

By the 1970s the Vietnam War had become the most photographed and reported war in history, in both black and white and colour. Journalists, photographers and TV cameramen poured into the country in droves, initially encouraged by an American government as positive propaganda. In the RPS archive there is a harrowing and strangely beautiful collection of colour photographs taken on the battlefront by Larry Burrows (1926–1971). They are made all the more poignant by the fact that Burrows was killed when his helicopter was shot down, whilst the exhibition of his war images was on show. The tragedy served as a pertinent reminder that photography, by this time the leisure pursuit of many, could also carry a death sentence for those intent on using its power to expose the truth – as Burrows, Don McCullin (1935–), Philip Jones Griffiths (1936–) and many others angrily, eloquently and bravely insisted on doing. Burrows' colour photographs have a shocking immediacy and explicit detail. The photographer is no longer a detached observer but a participant, crawling in the same mud and exposed to the same dangers as the dying soldiers. His photographs capture the murky browns and greens of the mud and jungle but are shot through with the vivid red of bloodstains.

In complete contrast, the RPS Collection also boasts a strong tradition of British social documentary photographs, but they do not record the powerfully emotional and gritty life or death themes of war, urban deprivation or social struggle, all subjects which we now consider to be the mark of the social documentary photograph. Instead, one of the strongest bodies of work in the documentary genre focuses on an altogether quieter, calmer subject matter – the documentation of existence in rural communities, a way of life that today we increasingly regard with affection, nostalgia and regret at its passing. Whilst the Society's pictorial and art photography collections are international in content, the documentary collections have stuck doggedly to a British bias and are stronger for it, consisting in the main of large archives of a single photographer's work.

The strongest collections of work in this category are taken by locals with a camera, inner rather than outer observers. Frank Meadow Sutcliffe (1853–1941) earned a living from his portrait studio in Whitby, North

OPPOSITE | Swedish-born Oscar Gustav Rejlander was working in
Wolverhampton, England from 1846–62, during which time he took this
studio shot, one of his moral allegories, of a model dressed as a ragged, home-
less child. Such genre studies were amongst his most successful photographs
in the late 1850s and throughout the 1860s. For low-life scenes like this he
looked for inspiration to Dutch genre painting, Hogarth and Murillo, going
to inordinate lengths to find the right model and original clothing.

Yorkshire, but at the same time was also photographing the fishing community that gave the town its character
and its vibrant economy. Sutcliffe's exhibition prints were posed and carefully composed, his models often paid
to do as they were told. But the contact prints in his scrap albums show a genuine documentary concern to
commit a less pictorially pleasing real life to paper, to capture what was there before economic and industrial
progress and the growing tourist industry changed it irrevocably. Emile Fréchon (1848–1921) documenting a
similar fishing and rural community in the Pas-de-Calais area in Northern France at the same time, and pro-
ducing idealised studies for sale to tourists, also captured less salubrious aspects of life in his contact sheets.

John Hinde (1908–1998), photographing in the same vibrant colour he had used to document the London
Blitz, made intensive photographic studies of an Exmoor village in Devon in the 1950s for publication in
photographic books and magazines. The strength of the colour used (Hinde was working with the tri-colour
carbro process) transforms the ordinary everyday pursuits of village life, investing them with a Hollywood
unreality, as if Exmoor was in fact a reconstruction on a back lot at MGM.

This 'photographic humanism', a concern with the quiet truth of the ordinary, the common ground, the
mutual objective, the shared humanity, was the absolute antithesis of the newsworthy, the isolated event,
the spectacle, the disaster, and was a natural consequence of two generations of war – although its roots go back
to the nineteenth century. It was about finding satisfaction in continuation and sameness rather than in
moments of high drama and difference. It was about capturing extraordinary moments in ordinary lives.

In France, photographers like Henri Cartier-Bresson (1908–), Robert Doisneau (1912–1994), Edouard
Boubat (1923–1999), Willy Ronis (1910–), and Eugene Atget (1857–1927) before them, concentrated with
respect and understanding, with tenderness and optimism, with love and compassion on their fellow humans,
walking the same streets, living the same lives, making each moment count. Each of these photographers
brought a strong humanity to their subject matter. As inner observers, documenting the societies and the

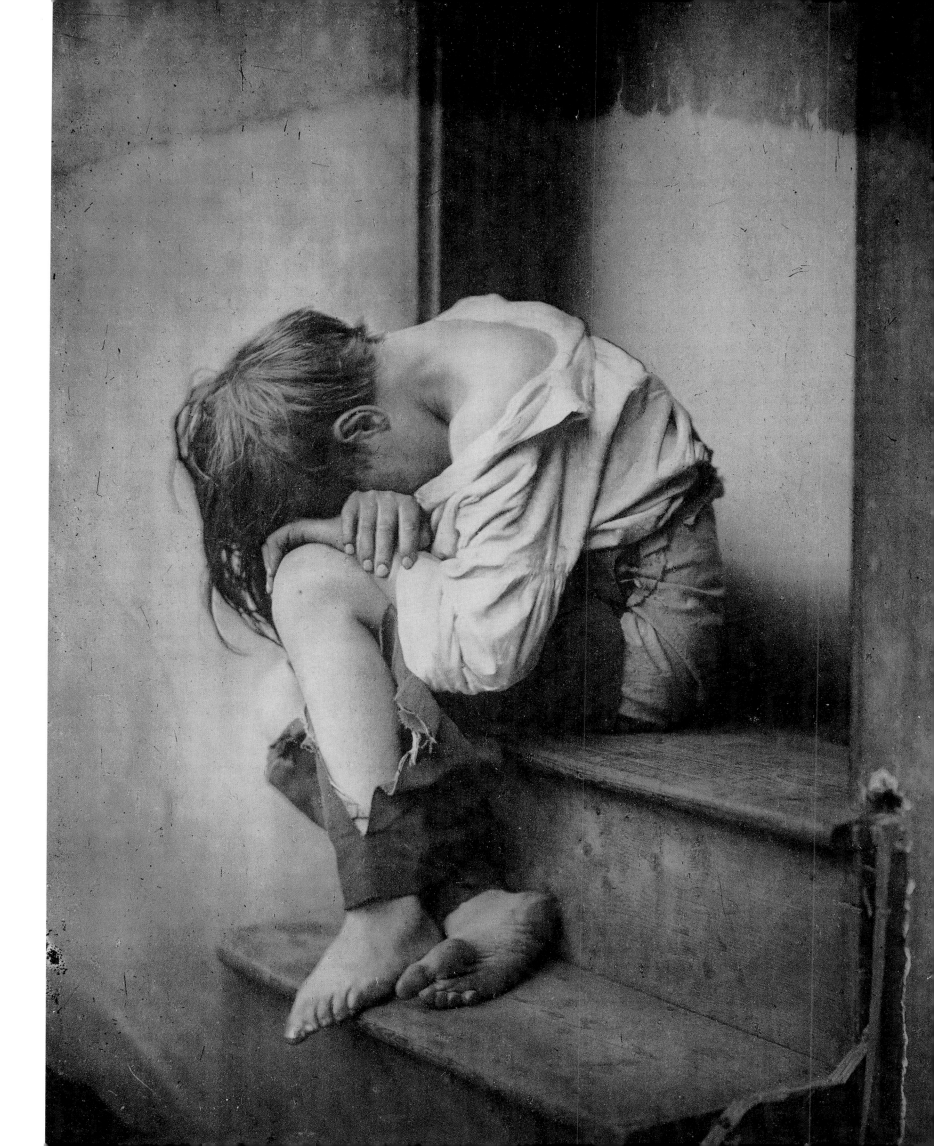

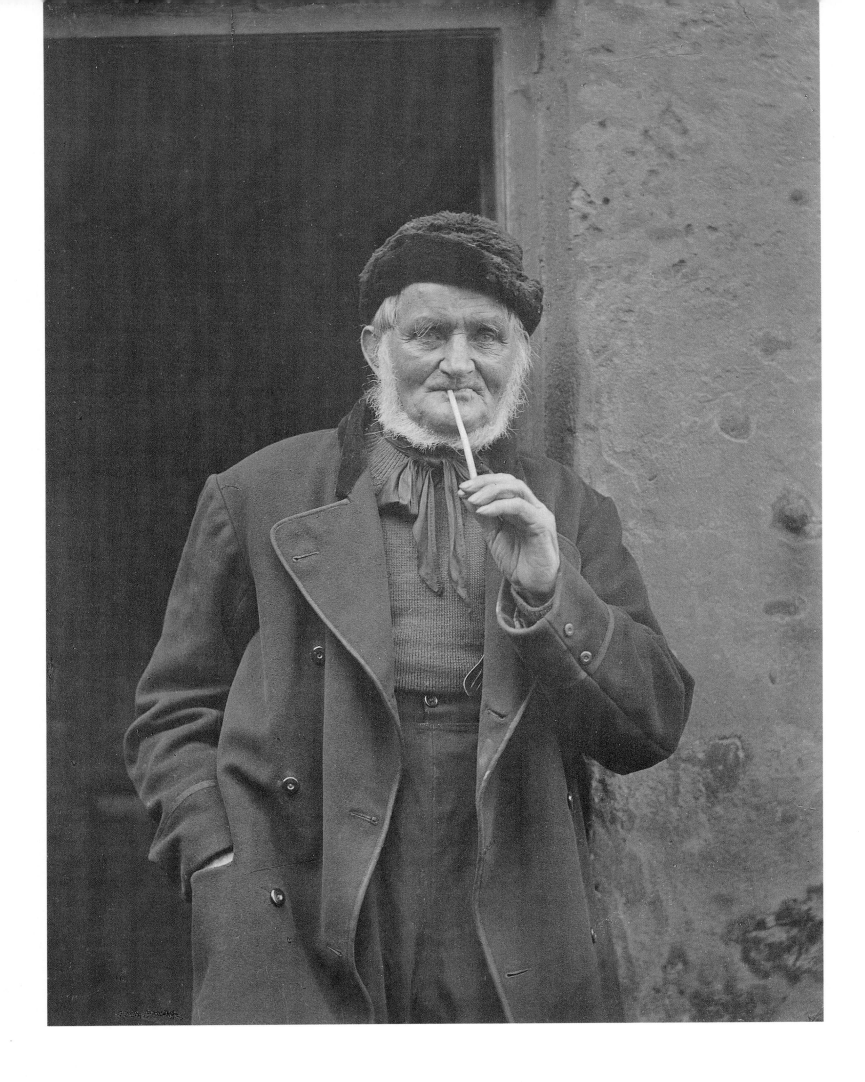

OPPOSITE | It is easy to tell what sort of man Frank Meadow Sutcliffe was from his photographs. A patient, friendly and appreciative man, part of the community in the coastal village of Whitby, England, he would always have time to stop and listen to the yarns of locals like this old man of the sea, whom he photographed in 1890. Although born in Leeds, Sutcliffe made Whitby his home from 1875 until his death, eventually becoming the curator of Whitby Art Gallery and Museum in 1923 at the age of 70.

traditions in which they worked and lived, these views are sympathetic, shot through with love and yet hugely informative. It was this spirit of shared humanity that led to the foundation of Magnum Photos in 1947, and continues to inspire its member photographers.

A natural inheritor of this photographic tradition in Britain is Martin Parr (1952–). Although he casts an altogether more cynical, ironic and beady magpie eye on the culture he sees around him, he is also a sympathetic observer. Focusing on the absurdities, the ugliness, the throwaway ephemerality of culture at the turn of the twentieth century, he can extract a social commentary from a shocking pink petunia. His use of strong and garish colour throws tacky reality in our faces, making it infinitely more horrible, but fascinatingly real. Over the last twenty years, he has influenced British social documentary photography profoundly through both his own work and his teaching and now, as a member of Magnum since 1994, has entered into the fellowship of an international humanist tradition.

At the end of the twentieth century opinion amongst those concerned with photography was that Henri Cartier-Bresson, the only surviving founder member of Magnum, was the most influential photographer in the medium's history. At the beginning of the twenty-first century, there seem to be few, if any, subjects concerning the human condition that photography is not interested in documenting. The iconoclastic shatttering of previously held taboos is deafening. All forms of the media saturate us daily with images. High-rating TV programmes show continuous footage of people filmed in their own homes, sleeping, eating, watching TV, going about their everyday lives, as ordinary, as potentially extraordinary, as the rest of us.

OPPOSITE | This anonymous gelatin silver print was taken in Britain during World War I. Are the soldiers home on leave or just about to go off to the Front? The strain on everyone's faces, especially the women and children, would suggest the former. The men seem more laconic, but the chance to grab a few last beers and crowd into the back yard of this terraced house for a group photograph must have seemed like a brief return to blessed normality.

ABOVE | An anonymous snapshot taken in December 1943 of an American Curtiss Kittyhawk fighter aircraft and RAF airmen from 112 Squadron stationed at Bari, S. Italy. By September 1943, Italy had surrendered unconditionally to allied troops and German troops were slowly being driven out of the rest of Italy but in early December 1943, German troops made a surprise attack on Bari. It was eventually repulsed by the likes of these airmen, with their cheerfully painted plane (the shark's mouth was a 112 Squadron motif) and their air of general confident insouciance.

RIGHT | The London Blitz began in 1940 and the city was bombed throughout the war. The lights of London were switched on again on 15 July 1945, after more than 2,000 nights of blackout. During the Blitz, the City of London and the docks were badly damaged, and the House of Commons, Saint Paul's Cathedral, Westminster Abbey and the British Museum were all badly hit. This anonymous photograph of a bombed street was taken in 1943.

BELOW | John Hinde's photographs during World War II show the war as we are unaccustomed to seeing it, in glowing colour. His photographs showing the Civil Defence services at work, here firemen training in a Welsh village around 1943, were published in *Citizens in War and After* with text by Stephen Spender and a foreword by Herbert Morrison, then Home Secretary and Minister of Home Security (published by George Harrap, London, 1945).

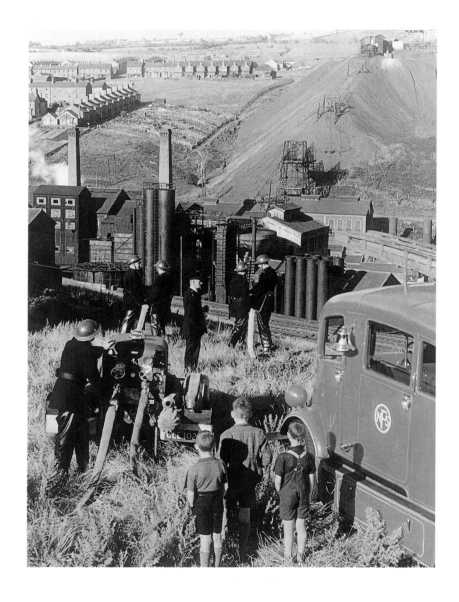

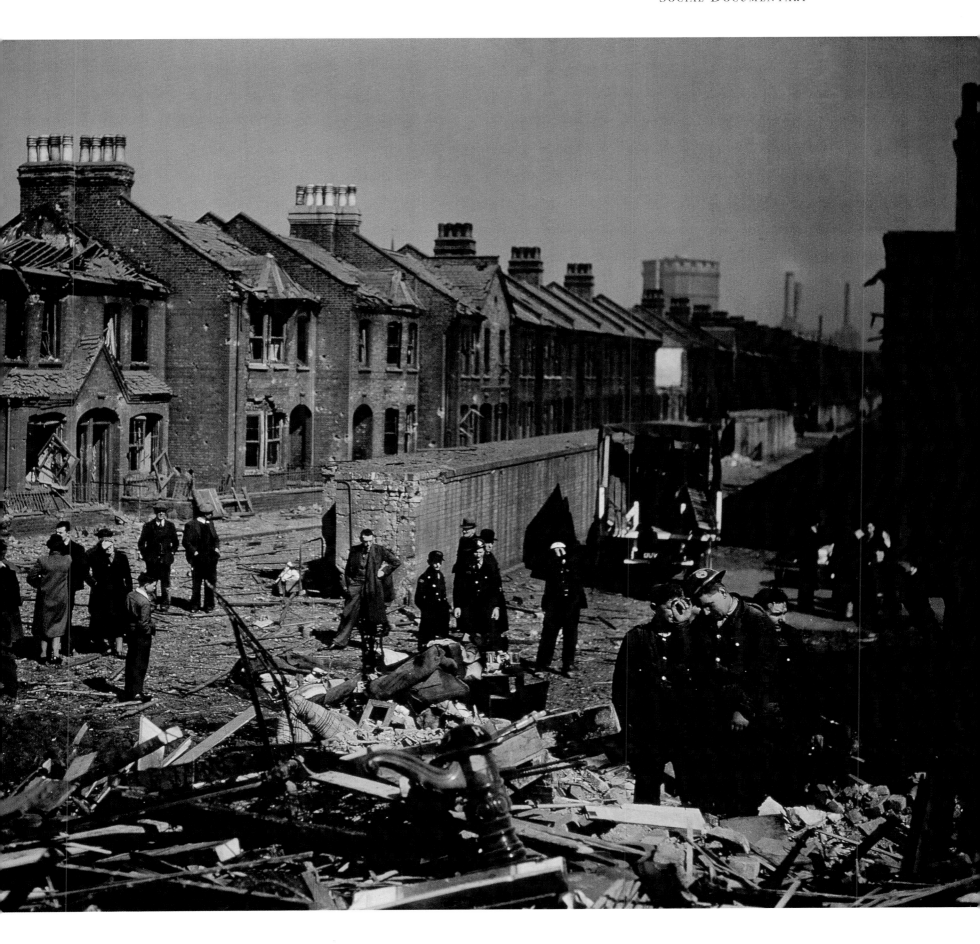

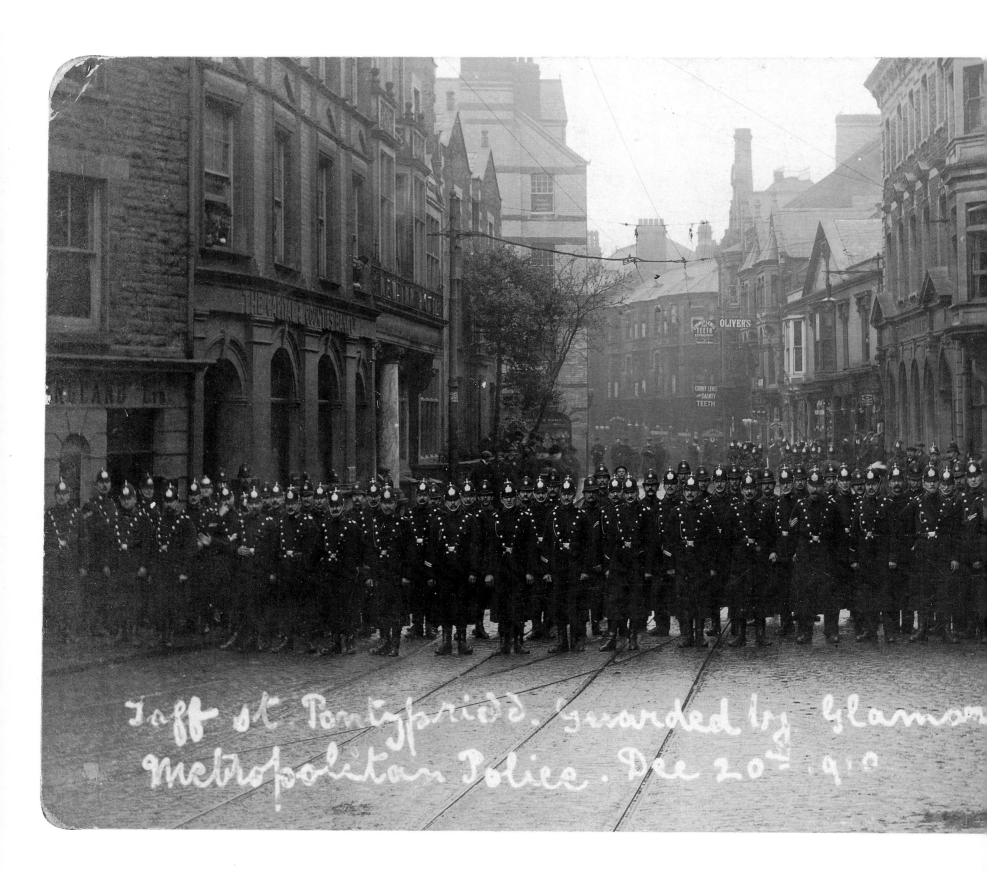

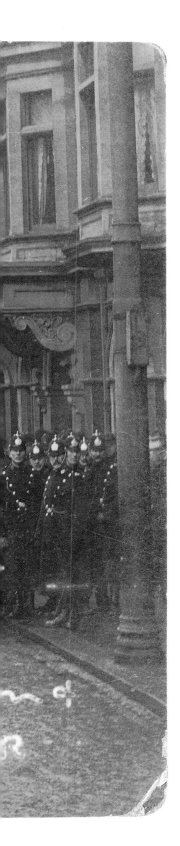

OPPOSITE | On 2 September 1910, 10,000 Welsh miners came out on strike in sympathy with the dockers over pay. On 20 December the same year, this street march took place in the coal-mining strong hold of Pontypridd. The miners' strikes paralysed Britain on and off until March 1912, when the Coal Miners' Bill established the principle of a minimum wage.

BELOW | The Boer army siege of Ladysmith, a British garrison town and railway junction in South Africa, lasted for 118 days from November 1899 until 28 February 1900 when British reinforcements arrived. The siege's end prompted this scene of jubilation in a London street, photographed by C. Churchill. Although the skirmish was deemed to be over this, the Second Boer War became even bloodier and did not end until May 1902.

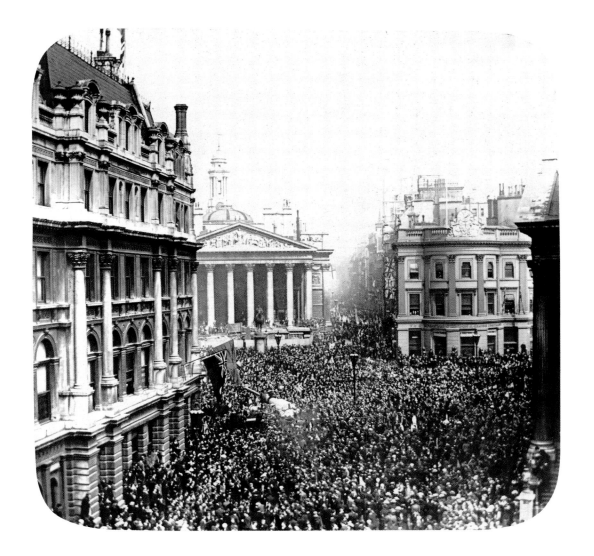

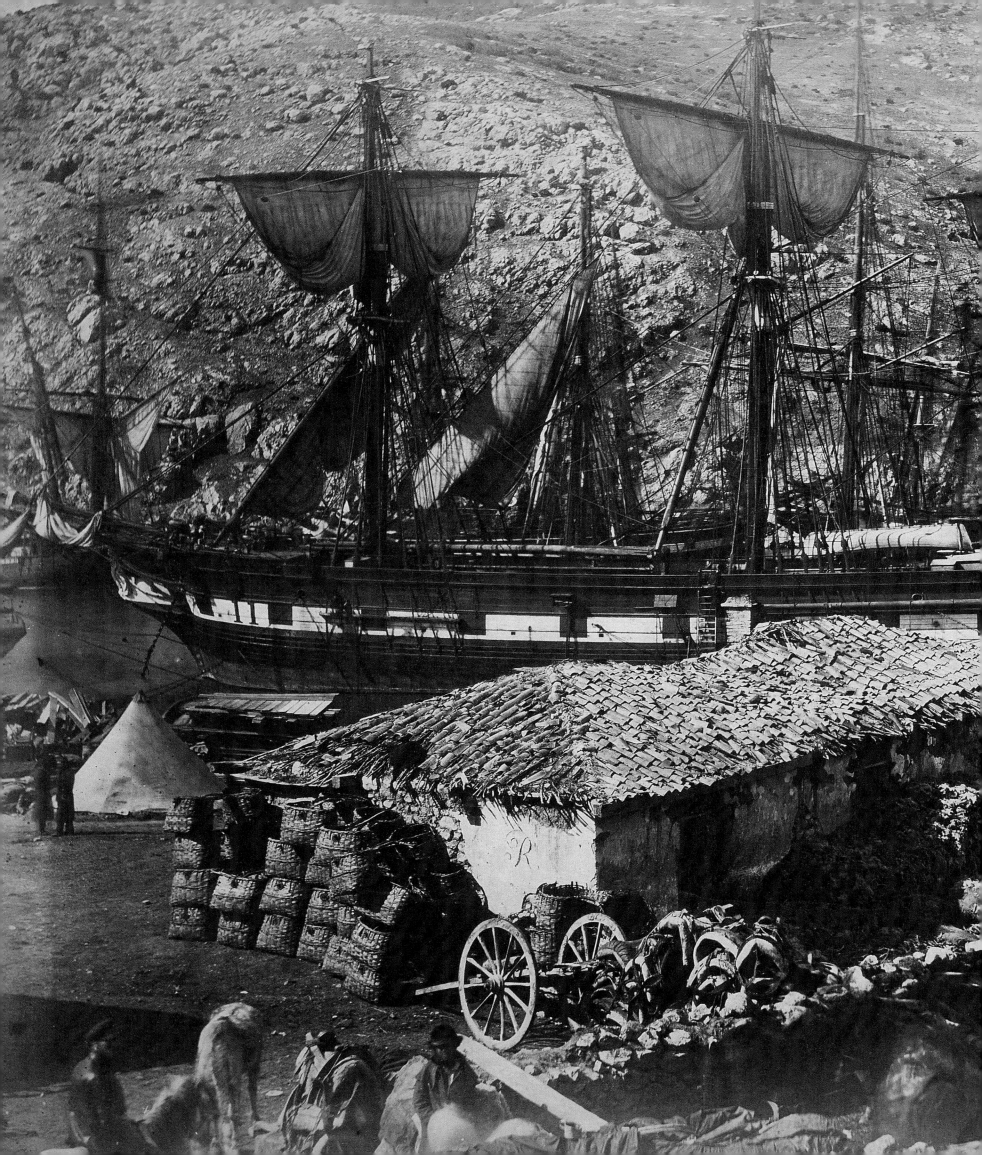

LEFT | Roger Fenton photographed in the Crimea for four months from March to June 1855 before he returned home, much weakened with cholera. The intense heat melted his gutta percha developing trays and heated the collodion for coating his negatives to boiling point. His photographic van was shot at and intense light levels caused many exposure problems. Despite this, he brought back 360 exposed negatives (from the 700 glass plates he had taken with him). Many were portraits of officers, but there were also scenes like this which show the elegant grandeur and squalid mess of war.

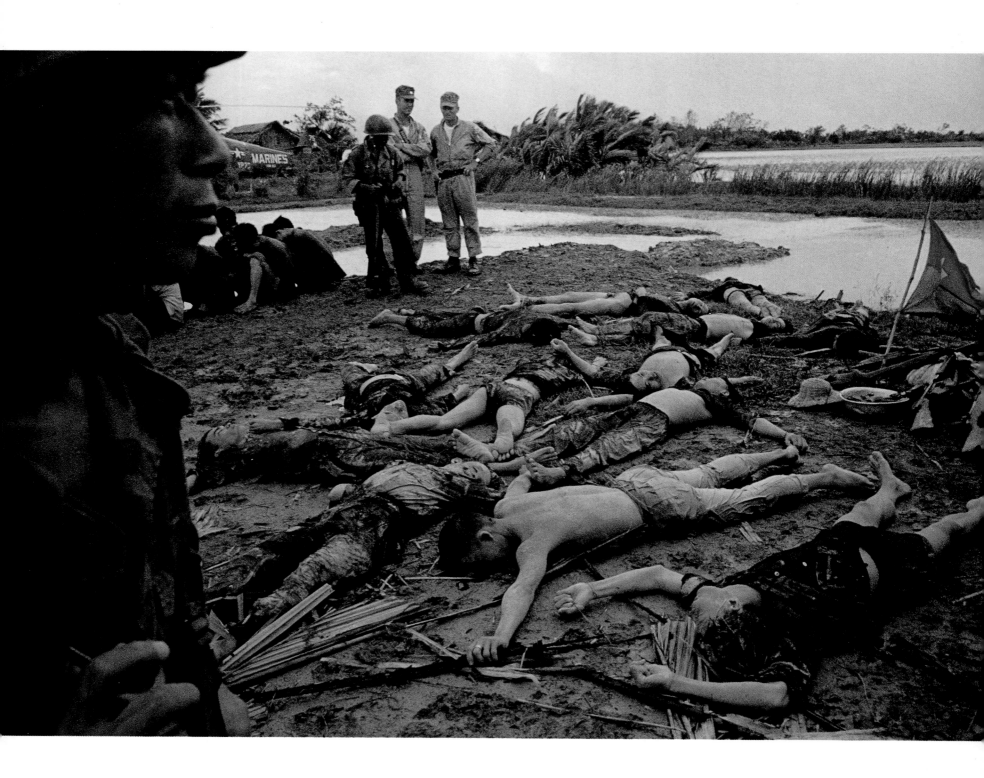

LEFT & BELOW | British photographer Larry Burrows was employed
at age 16 by *Life* magazine as a darkroom assistant, before going on to become
one of the publication's star photographers. His work appeared in *Life*, *Time*,
Paris Match, *Stern* and *The Daily Express* amongst many others. From 1961–71,
he was based in Hong Kong as *Life*'s staff photographer. From there he
covered the Vietnam War, capturing its grim futility in glaring colour. Burrows
supplied not only photographs but the text which went with them, and stopped
at nothing to get the story in both pictures and words. However, he risked his
life once too often when he was killed in a helicopter crash in 1971.

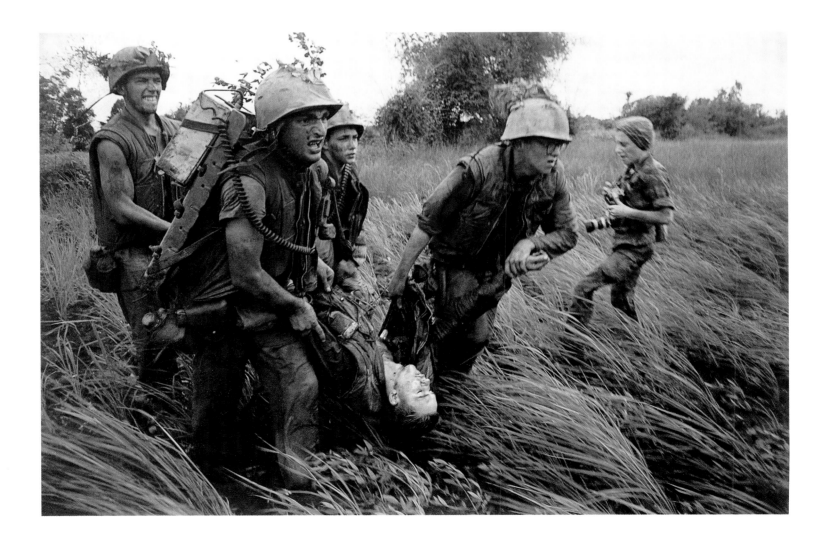

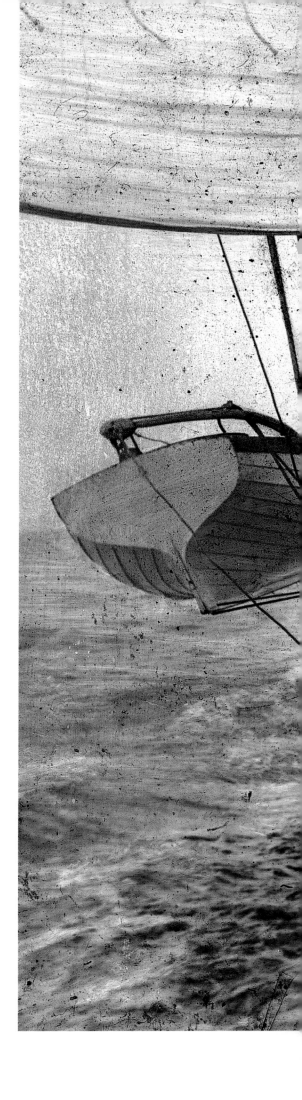

RIGHT | British photographer Howard Farmer was interested in colour processes and probably did the hand-colouring on this lantern slide himself. Whilst it is crudely done with what seems like oil crayon, and some colour has flaked off over the years, the colouring adds a certain surreal air to an already terrific image. Farmer was an inveterate traveller and ranched for many years in Patagonia so may be on his way there in this image, taken around 1905.

ABOVE | Some rather basic hand-colouring only adds to the charm of this lantern slide of a moustachioed trio with the rather dashing Adolphe Pégoud at the controls of his monoplane, a Blériot-built Type XI aircraft. Pégoud was an aviation genius, making the first parachute jump from a plane from the height of 250 metres on 13 August 1913, and following this up with a loop-the-loop on 21 September 1913. Regrettably, his skill and luck ran out during World War I on 31 August 1915 when he was killed in aerial combat over Montreux-Chateau in Alsace and was buried at Montparnasse cemetery in Paris.

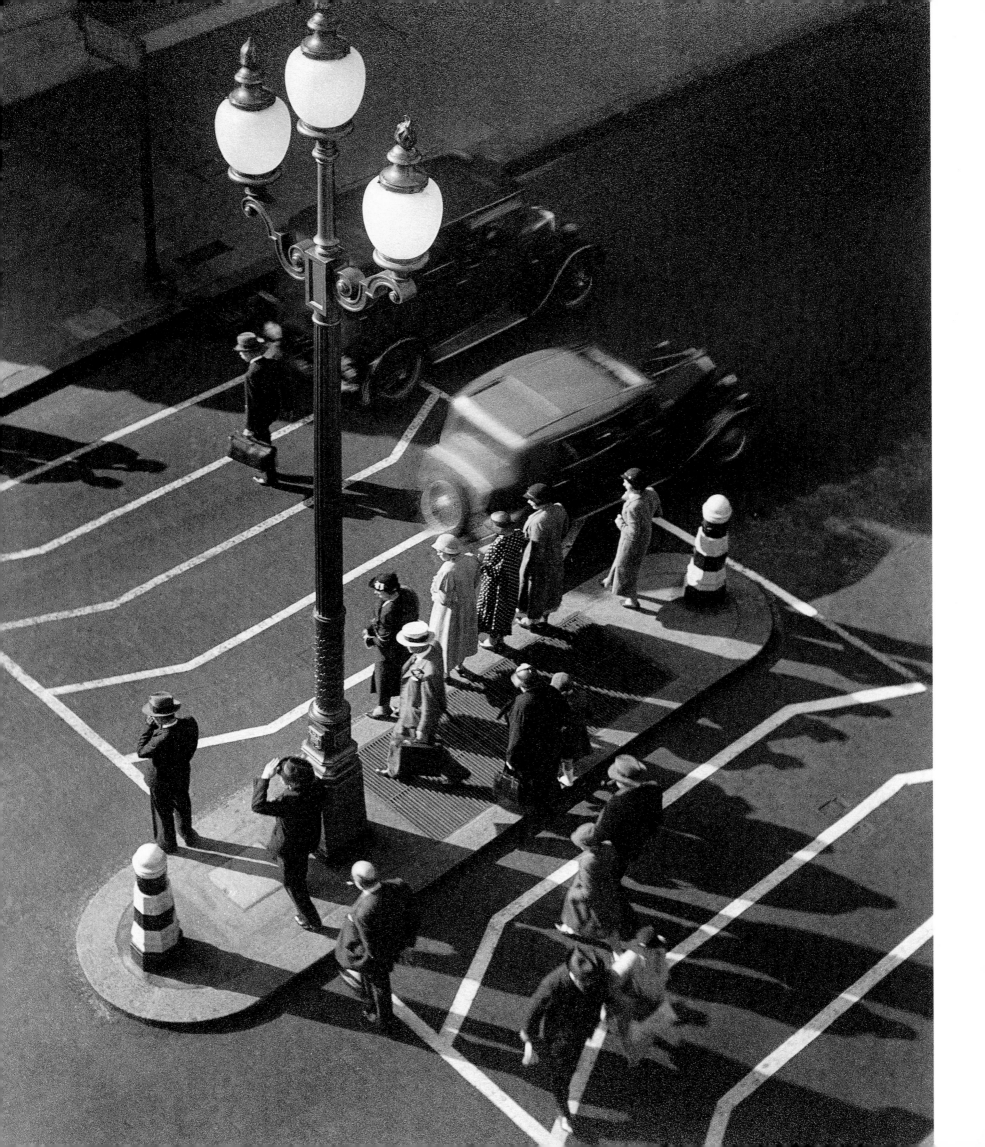

OPPOSITE | John Ahern was a British architectural photographer and cinematographer of some experimental note, and shot this street crossing in 1935. He was also well-known in railway modelling circles, being one of the pioneers in landscape modelling. His creation 'The Madder Valley Line', now considered a masterpiece of railway modelling, is preserved at Pendon Museum near Abingdon, Oxfordshire. He published many books and numerous articles in *Model Railway News* illustrated by his own photographs. He also frequently exhibited in RPS annual exhibitions throughout the 1930s and 40s. He and his wife held a joint exhibition of their work at the RPS in 1942.

LEFT | London was a favourite subject with John H. Anderson, who was able to extract a benign mystery from the city's streets and waterways. He exhibited his prints regularly from 1900 until the late 1930s. This charming stroll down Piccadilly suggests a summery Sunday afternoon and evokes a nostalgic calm difficult to associate with grid-locked Piccadilly these days.

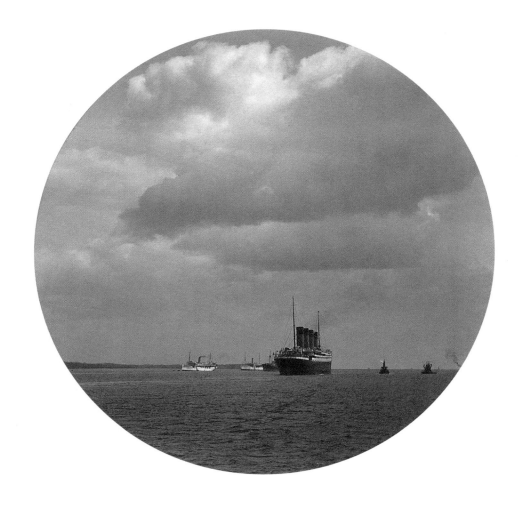

OPPOSITE LEFT & RIGHT | Francis James Mortimer's career in photography took in editorships of *The British Journal of Photography*, *Amateur Photographer*, *The Dictionary of Photography* and *Photograms of the Year*. He was President of the Royal Photographic Society (1940–42), the Camera Club and the London Salon of which he was a founder member. He was an avid photographer and exhibitor, and a prolific inventor and broadcaster. A member of the RPS since 1904, he was awarded its Progress Medal in 1944.

ABOVE | On her maiden voyage to New York, the *Titanic* was hoping to win the Blue Riband for the fastest Atlantic crossing. Less than five days later, she smashed into an iceberg when sailing at top speed. On 10 April 1912 William J. Day photographed her leaving England. On the reverse of the print he wrote: 'The White Star liner *Titanic* on her maiden – and only – voyage. A very striking illustration of the appearance of black and white on a summer's day in Southampton water. Note how prominently the ships are seen.'

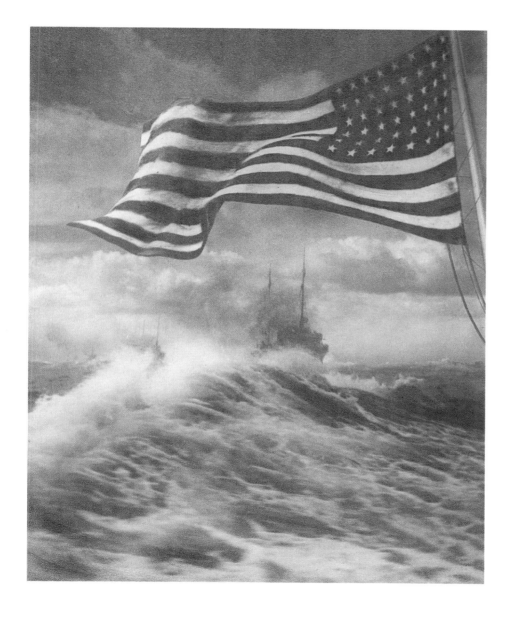

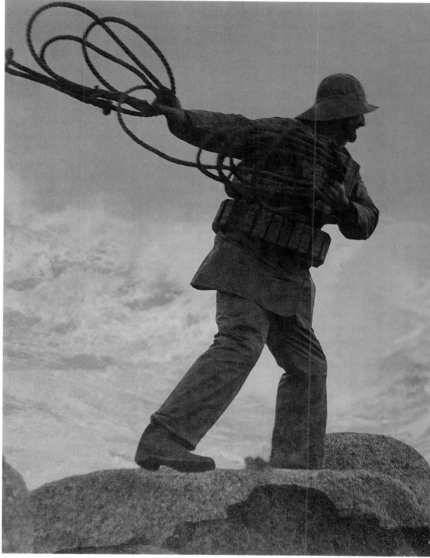

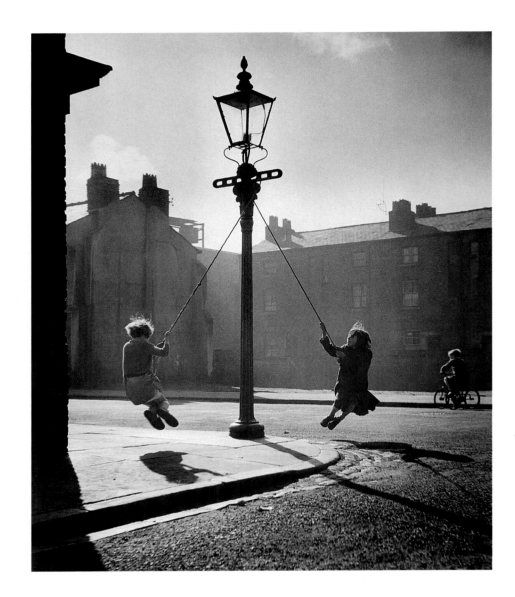

OPPOSITE | The dust storm of April 1936 swept across the US 'breadbasket' states – Kansas, Colorado, Wyoming, Oklahoma, Texas and New Mexico – leaving a trail of devastation and destruction behind. Millions of dollars' worth of crops were wiped out, animals died and humans contracted dust pneumonia. Bereaved families were unable to bury their dead until the storms subsided. In Texas, even the birds were afraid to fly, but nothing could keep FSA (Farm and Security Administration) photographer Arthur Rothstein away from the scene.

ABOVE | This photograph by Karl Hughes is from the RPS Tyng Collection and was exhibited at the RPS Annual Exhibition of 1959. Entitled 'la Ronde', it shows children of the day swinging from lamp-posts. a favourite occupation in Northern England. Hughes was from Cheshire.

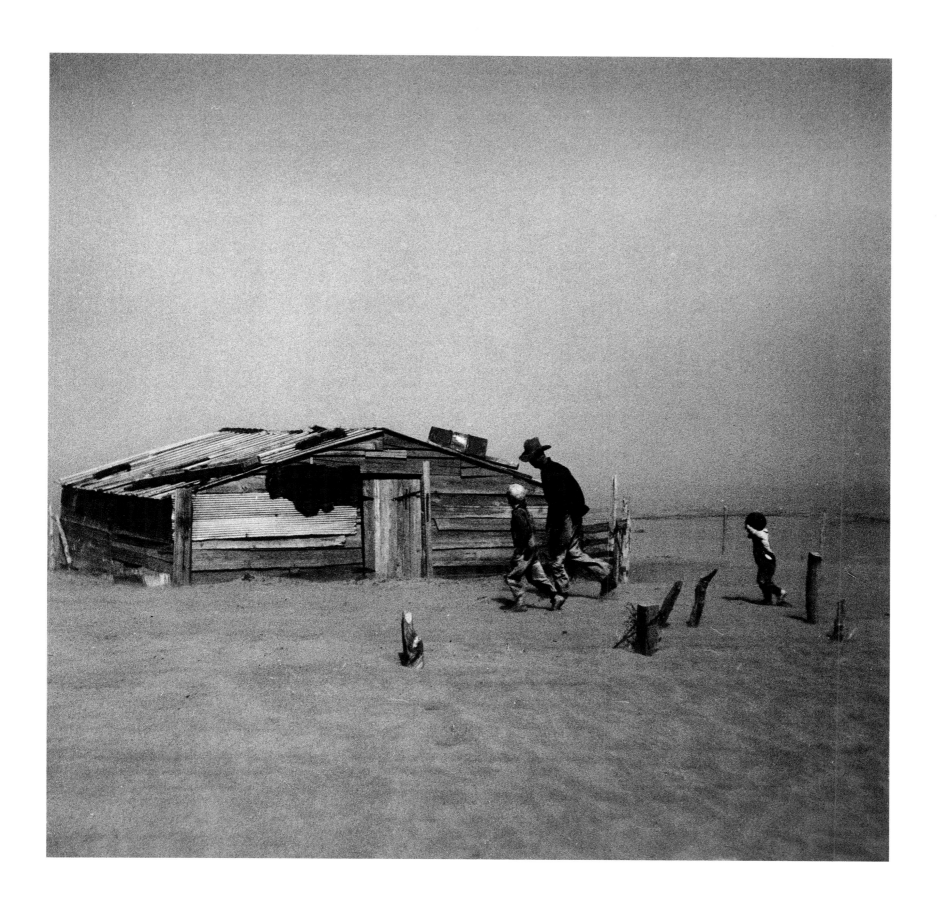

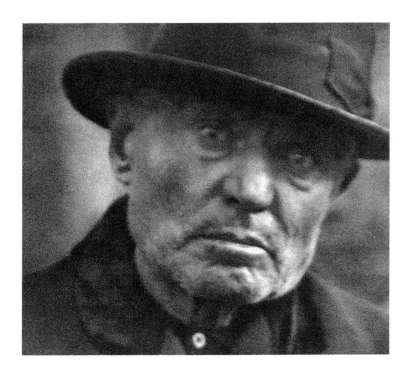

OPPOSITE | In 1917, Horace Nicholls began working as the Official Photographer to the Department of Information (which became the Imperial War Museum in 1918) at a generous salary of £350 per annum. The 'Women at War' series of photographs document women taking over men's jobs, both heavily physical (as here) and administrative work, whilst the men went off to be slaughtered at the front in World War I. (Nicholls' eldest son George was killed in 1917). They are among the best of the 100,000 photographs he took for the Imperial War Museum, where he worked until his retirement in 1932.

ABOVE LEFT & RIGHT | Paul Strand shot these New York street portraits in 1917 using an Ensign reflex camera. He enlarged the negatives onto 11 x 14-inch glass plates and made contact prints from these to get the striking quality seen here. The camera was fitted with a prism which made it possible for him to point it in one direction but to take photographs at a 90-degree angle, thus his subjects were unaware that they were being photographed and unknowingly presented their closed 'street' faces rather than their open posed ones. They are the antithesis of contemporary studio portraiture of the time.

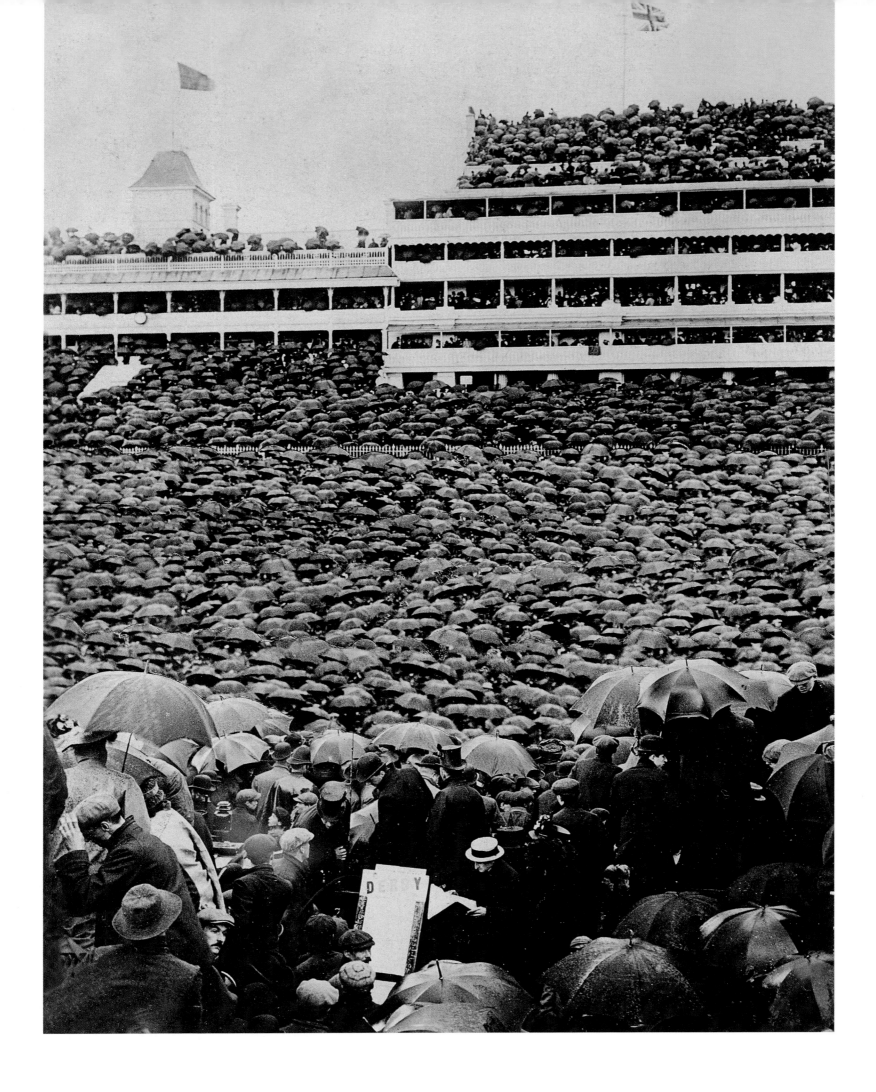

OPPOSITE & ABOVE | Horace Nicholls' main aim, after he had taken a good photograph, was to sell it. If it was not quite what a publication required, he would quickly adapt it to suit. This photograph of a rainy Derby Day in 1909 is a photo-montage from at least five negatives, printed, cut and pasted and then rephotographed as a composite, seamless whole. Nicholls has even filled in the race track, between the stand and the foreground spectators, with umbrellas. Writing in *Kodak Magazine* in June 1934 he explained: 'Sometimes when you have made a series of negatives of one subject there will be found among them views which have little interest when seen separately, but which, if carefully assembled, by using a portion of one and a portion of another, can be made to produce a striking result ... Here, five different negatives have been used to make the striking picture of Derby Day as I saw it 25 years ago.'

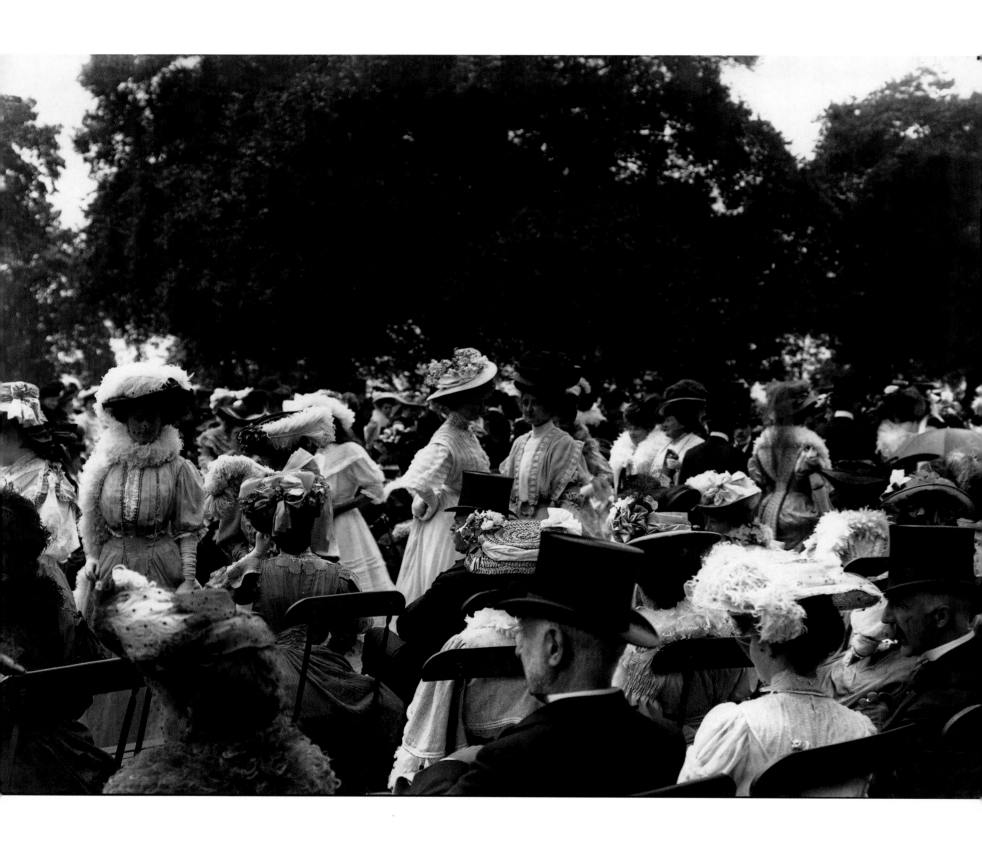

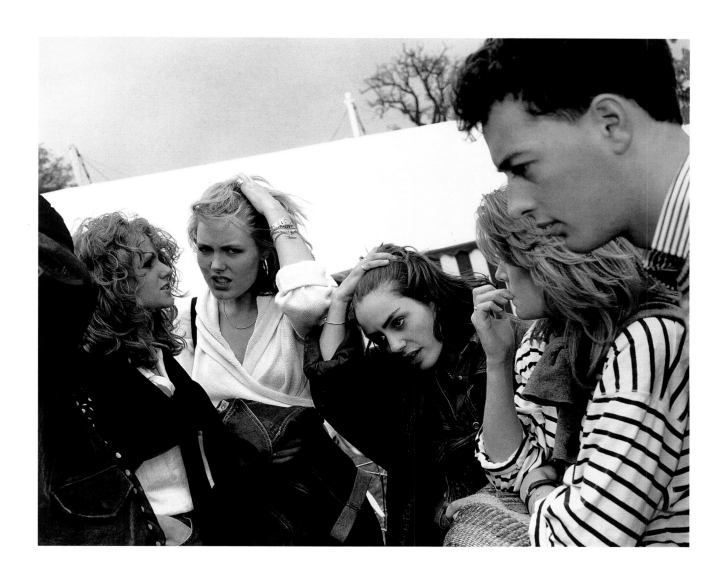

OPPOSITE | In the heady summer days of Edwardian London, liberalised
by a new king, Edward VII, and a new century, Hyde Park would experience
a British version of the Italian *passagiata*. Strollers would put on their best
clothes to mingle, gossip and flirt under the shady trees, or ostentatiously pile
into their barouches and carriages, the better to display themselves. Horace
Nicholls' photographs of Edwardian society at play, including this one from
1907, seem always to be dappled with summer sun.

ABOVE | In Martin Parr's photographic series of 1986–9, entitled 'The Cost
of Living', he captures the 'comfortable' classes as they spend their money and
pursue their recreations after ten years of Thatcherism, putting an ambiguous
spin on the phrase 'the cost of living'. This particular image was taken at
the Badminton Horse Trials, started by the Duke of Beaufort after Britain's
disastrous showing in the 1948 Olympics and now very much a social event.

III.

DOMESTIC

III.

OPPOSITE | One of Roger Fenton's first royal commissions was to take a series of photographs of Victoria and Albert's children in a variety of costumes at Buckingham Palace in 1854. Prince Arthur, who showed an early predilection for all things military and had a long career in the Army, is here perched on a covered box for this charming portrait. His nurse, the ghostly figure on the right, is ready to grab him with her outstretched hand should he wobble.

OF ALL THE MANY BILLIONS OF PHOTOGRAPHS TAKEN EVERY YEAR, the largest percentage by far are those taken by you and I, as memories, to capture and freeze the present, a present which instantly becomes the past, for the future. The family album, family snapshots, are as near to time travel as we will ever come. Since the early years of photography, some subjects have never changed: family celebrations, friends, weddings, babies, holidays, travel, pets, houses, gardens, Christmas, long sunny weekends, unexpected snow, personal participation in national events. The clothes may be different, the poses may be different, the photographic processes and technologies are certainly different, but people are much the same. Over the 150 years centuries, photography has created a whole new visual way of remembering and relating to our past, and it has only become widespread for the majority of people over the last half century.

How did we remember before photography? The occasional painting, if we could afford it. Most of us could not. Perhaps we had a keener oral memory when we were not constantly bombarded by images, and kept more written diaries. Has photography then stunted, enhanced or actually changed our visual imagination, our memory? How would someone who had never seen a photograph remember the past and how different would this be from the way we remember the past now, and how the past will be remembered in the future? It may be that the increasingly easy abilities of photography – these days, almost an inbuilt third eye – will eventually alter our memories in some way, perhaps genetically, an example of nurture over nature.

Take, for example, a photograph from 1947. A wary, worried and preternaturally serious one-year-old boy, his lower lip wobbling slightly with apprehension and trepidation, sits uneasily on the obligatory bearskin rug of studio portraits of the period, dressed for his first ever ordeal by camera in his best romper suit and new soft leather shoes. His mother's hand comfortingly props his back. The photograph is skilfully hand coloured. Photography, despite being around for over 100 years, is still quite a serious, studio-oriented event in this family, only used to mark special moments.

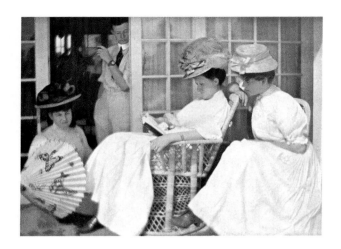

Over half a century later, this same little boy, now 53, is photographed tossing his year-old grandchild in the air, in vivid colour. Both of them are happy and laughing, oblivious of the camera. The pose is very different from that in 1947. The technology is also very different. Colour photographs of this particular moment, only one amongst hundreds that will be taken that day of a family event, are captured on film by the 53-year-old's wife, as well as his mother, his sister, his brother-in-law, his younger daughter and her partner. Everyone wants their own visual diary of this moment on their own camera.

In this scenario, the only person without a camera is the grandchild, but it can only be a matter of time before he gets his own 'baby camera', which satisfyingly clicks and flashes without film but introduces him to the supposed mechanisms and importance in his future life of image capture. He was photographed being born and practically every day since and is used to having a camera pointed at him. Already, he has his own visual past and present diary, assembled on his behalf until he is old enough to start to want to do it for himself. This urge is not just a modern phenomenon, intended to give us some senses of permanence in a rapidly changing world, but dates back to the very beginnings of photography.

It could be argued that much nineteenth-century photography is essentially domestic in origin. William Henry Fox Talbot photographed his family and servants, his home and his surroundings at Lacock Abbey in Wiltshire in the 1830s and 40s, as did John Dillwyn Llewelyn at Penllergare in Wales in the 1850s. Julia Margaret Cameron photographed female members of her extended household and family, visiting friends and acquaintances in the 1860s and 70s. It just so happened that the women in her household and family were generally possessed of an inordinate photogenic beauty and that her friends and acquaintances, amongst them Lord Tennyson, Sir John Herschel, George Fredrick Watts and Charles Darwin, were intellectual luminaries. In France, Louis-Rémy Robert (1810–1882) and Henri-Victor Regnault (1810–1878) also photographed their family members and friends.

OPPOSITE | The Lumière Company's Autochrome Plate, the first colour process available commercially, went on sale in 1907 and Edward Steichen was an early experimenter. He showed the results to Stieglitz when the two met up in Paris. They met again in Germany later in the summer along with Frank Eugene and Heinrich Kühn who were all agog with excitement over the new process. In the interim, Steichen had been in London, photographing portraits of George Bernard Shaw and Lady Ian Hamilton as well as this scene aboard a houseboat on the Thames. The Autochromes were gloriously reproduced in *Camera Work* in 1908 as four-colour half-tone reproductions.

However, these are not true chronicles of everyday domestic family life such as began to be compiled in photographic albums of the 1860s, and which we can trace through to modern practice. By this time, photography had been taken up as a pastime by a larger circle of amateur practitioners, both men and women, albeit of the leisured and wealthy middle classes, as photography was still a relatively expensive, cumbersome, intricate and time-consuming pursuit.

Photography gave those whose drawing or painting skills might be severely restricted an alternative mode of expression, and subjects to photograph were always close at hand. By the 1860s, the heavy cameras of the previous decade were giving way to the smaller half-plate ($6\frac{1}{2}$ x $4\frac{3}{4}$-inch) folding bellows type camera. The flexible bellows were made of leather or cloth and could be collapsed down into a more portable package. However, if photographing away from home, the photographer still needed to carry a tripod, plate holders, chemicals, glass plates, water and dishes as well as a mobile darkroom (which fitted into a large suitcase-sized container), in which to coat the plates. Photography was a long way from being portable, and the average amount of equipment required cost in excess of £100.

A series of three remarkable albums by James Helme, living in Walthamstow in Engand, show the grip that photography had on the Helme household. We know a lot about Helme, his family and friends from these photographs. They were much given to domestic entertainments, to dressing up, to charades and to having an all-round good time. In a world without the external stimulants to which photography would later give birth – film and television – they used their imaginations. Wooden boxes of stereo negatives sit, in pride of place, on a table, as does a stereo viewer, a light entertainment medium in the Victorian household. There must also have been a stereo camera as well as the half-plate camera mentioned above, proving that Helme had made a size-able monetary investment in his photography. The three annotated albums came from Helme's descendants and were preserved by them for over 100 years.

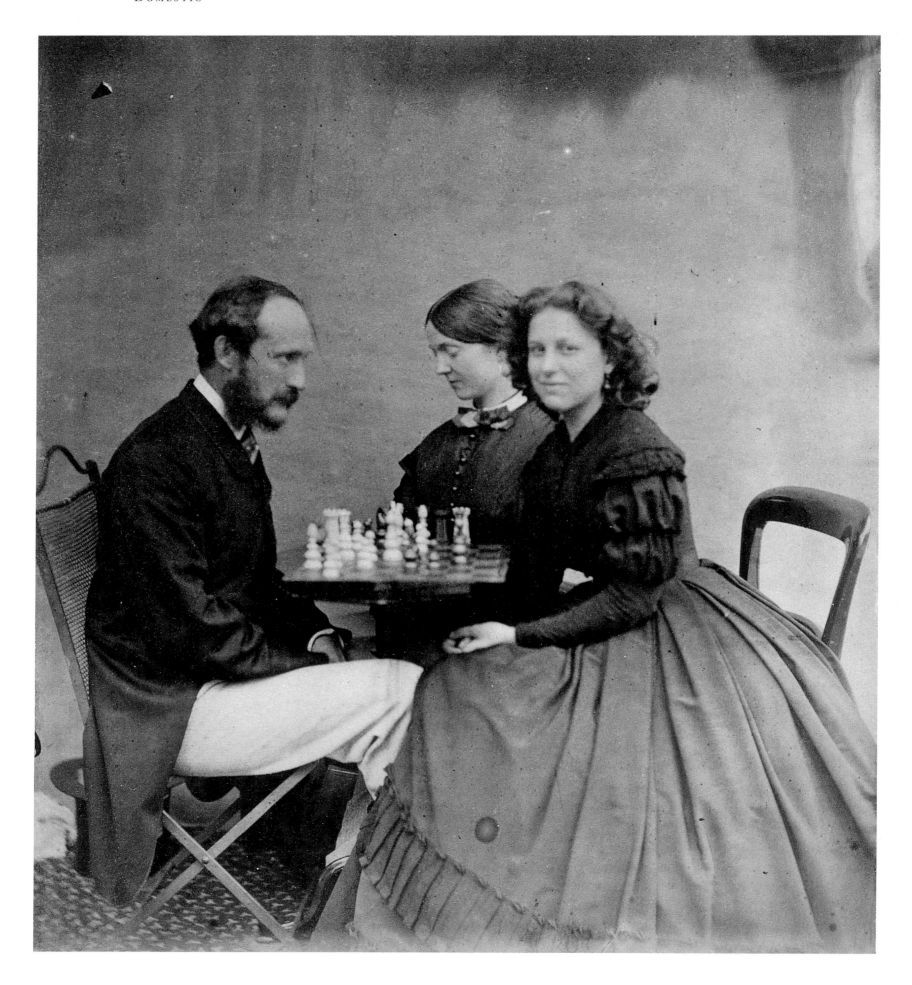

OPPOSITE | If every picture tells a story then this photograph, taken in the 1860s by British photographer James Helme, says it all: The smiling, knowing confidence of the woman on the right; the sheepish glance of adoration from her chess partner; the studied indifference of the woman in the background. This photograph is not just about chess ... but very much about the next move.

It is not surprising, therefore, that the urge to collate photographs on paper, to assemble them in albums, to construct a narrative and a visual flow, to tell a story, a personal history in pictures, is still as strong today as it was in the 1860s. But how many of our 'happy snaps', rapidly and cheaply processed and then stuck into albums with chlorine bleaches leaching out of their plasticised pages over the years, chemically reacting with and discolouring the images so lovingly assembled, will last for as long as Helme's photographs, 140 years' old and still going strong?

In the late 1870s, domestic photography began to be revolutionised. First came the widespread introduction of gelatin dry plates which could be bought ready-coated and were far more sensitive than the previous wet and dry collodion plates, with an exposure time of a fraction of a second. Then, in 1888, came the introduction of the Kodak camera, invented by George Eastman in the US. The camera was small (measuring around 4 x 3 x 6 inches) and light, but its most important innovation was that it used flexible paper roll-film long enough for 100, initially circular, exposures, rather than glass plates. After the exposures were made, the whole camera was sent back to the processing factory, the film removed and printed, a new film loaded and then both camera and prints were returned. This complete service took 10 days and cost two guineas.

Eastman's marketing aimed the Kodak camera at both men and women, and most especially at tourists who could now travel unencumbered. Further innovations over the next few years – celluloid roll-film, cartridge film, smaller cheaper cameras – eventually in 1900 led to the Brownie camera and opened the practice of photography up to millions worldwide. The launch of the first commercially available colour process, the Autochrome, in 1907, made the private, domestic environment an altogether more attractive subject matter. Perhaps the greatest domestic photographer was Jacques-Henri Lartigue (1894–1986). From the age of five he photographed the ordinary events of, admittedly, a rather exclusive domesticity in such a way as to render them quite extraordinarily modern and surreal.

OPPOSITE | Thomas Richard Williams had worked with Antoine Claudet before opening his own studio in London's Regent Street and excelled in stereo daguerreotypes and expert hand-colouring. He photographed the Great Exhibition at the Crystal Palace, carefully composed still lifes and genre studies, and in 1858 photographed Victoria and Albert's eldest daughter on the morning of her marriage to Prince Frederick William of Prussia. This hand-coloured stereo-daguerreotype of a soldier in red ceremonial jacket was photographed in 1855.

British, European and American photographers represented in the RPS Collection, if lacking the instantaneity and darting, daring straightforward vision of Lartigue, turned the domestic situation to their advantage in the same way, concentrating on their children, family events and holidays. They photographically embraced a world in which children were metaphorically heard as well as seen.

Many American and European Secessionist photographers in the first 15 years of the twentieth century purposely concentrated on their domestic environment as subject matter for creating their new, purely photographic reality. Clarence H. White (1871–1925) turned his eloquent camera almost wholly on his wife, Jane, her sisters and the couple's children, who were also much photographed by Fred Holland Day (1864–1933) during hot and hazy summer holidays on Day's and White's Maine estates.

Women photographers took up the camera with alacrity to document their families. In the US, Gertrude Käsebier (1852–1934) photographed her daughters and their friends whilst in the UK, Eveleen Myers (1856–1937) and Emma Barton (1872–1938), doubtless influenced by the work of Julia Margaret Cameron and Clementina, Viscountess Hawarden in the 1860s, photographed their daughters as fledgling madonnas and as Old Testament heroines, as well as charting the rites and passages of their children's own real lives, giving them their own pertinent identities.

These images embody an almost religious, certainly a spiritual mysticism, whereby the domestic becomes symbolic, a microcosmic world, hermetically sealed from the distant rumblings of war and a changing social order in Europe. John Cimon Warburg (1867–1931) and his sister Agnes Beatrice Warburg (1872–1953) used the painterly abilities of the Autochrome plate and the saturated colour possibilities of the tri-colour carbro process to depict the world from a child's eye view, where all was innocence, vibrancy and colour-awareness. The Warburg children were photographed drawing, reading, playing – being themselves, and not enacting parentally concocted mythologies – in a world dappled with summer colour, with rarely any adult intrusion,

other than that of the occasionally directorial all-seeing eye behind the lens. H. Essenhigh Corke, best known for his published nature photography, also took moving private colour portraits of his wife and baby.

Early colour photography, particularly responsive to the clarity of light available at the seaside, got the camera constantly onto the beach. Otto Pfenninger worked for an all-too-brief period around 1904–10 with variations of colour processes he had invented himself. He took a series of photographs of Edwardian children at play, some of which perfectly anticipate Thomas Mann's novella *Der Tod in Venedig* (Death in Venice) written in 1912. They could also be stills from the later film of the same name, despite being shot at the British seaside in Brighton, rather than the Venetian Lido.

Lieutenant-Colonel Mervyn O'Gorman (1871–1958) used the light of the Dorset coast to photograph his daughters in 1912, both in Autochrome colour and in moody black and white, in photographs so astonishingly modern because of the clothing and the posing they look like advertising shots taken 80 years later. Dr. E.G. Boon (c.1875–1959) used the radiant light of Venice to permeate his domestic interiors, allowing the everyday events of childhood – breakfast, a new kitten, a broken necklace, the proud wearing of a party dress – to dictate his subject matter. Dr. Friedrich Adolf Paneth (1887–1958), a chemist by training who left Germany and settled in England from 1933–53, took his Autochrome camera on his honeymoon to Egypt in 1913 and worked in a variety of colour processes throughout his life, leaving a legacy of over 3000 images, now in the RPS Collection. They were donated by his daughter Eva in the 1970s and late 1990s, the same Eva whom he photographed 70 years earlier, joyfully and unconcernedly doing handstands on the beach.

The Autochrome, a colour transparency on glass, invented in 1904 and made commercially available in 1907 by the brothers Auguste and Louis Lumière in Lyons, enjoyed a brief period of popularity over the next decade with both amateur and professional photographers alike, although diehard practitioners used it until 1930. It is perhaps the most beautiful of all the photographic processes, with its luminous Pointillist effect, but

had many drawbacks in that it was expensive, relatively slow, difficult to reproduce on paper and in books and could only be viewed over a light source, thus making it difficult to display.

Many photographers like Steichen, Coburn, De Meyer and Stieglitz toyed with the Autochrome briefly and then gave it up. Their fellow Secessionist, Heinrich Kühn (1866–1944), used it more intensively to photograph his children in some glorious Impressionist studies. However the Autochrome could not be included in family albums so it quickly fell out of favour with many amateur photographers who tended to stick with monochrome, taken increasingly after the 1930s on 35mm cameras. It was not until the later introduction of Kodacolor colour negative roll-film and Kodacolor paper prints in 1942, and the huge proliferation of increasingly cheaper colour processes ever since, that colour entered the family album.

Every month, the RPS Collection is offered at least one large archive of family photographs. These usually date back to the 1950s or earlier, most often shot on 35MM colour transparency, several thousand of them, individually labelled, dated and boxed – the carefully stored and much-loved memories of someone who wants them to survive beyond their own lifetime. Sometimes they are black and white prints in albums,

OPPOSITE | Lieutenant Colonel Mervyn O'Gorman photographed the enigmatic Christina many times, often at the beach at Durdle Door in Dorset but here in an English country garden setting in 1912–13. In O'Gorman's Autochromes of her, she is usually wearing red, probably not by accident, as red was a colour that the Autochrome process reproduced magnificently.

even boxes of quarter-plate glass negatives from around 1910 or 1920, or earlier Autochromes, tintypes, ambrotypes, even the occasional daguerreotype, showing the private and personal intimacies, interactions and events of family life and holidays – neatly packaged histories, sadly unwanted by the family. The descendants are probably accumulating their own photographic histories in increasing quantities, and so it goes on.

As many family archives as are relevant to particular collections are, of course, accepted, but most collections would need a space the size of an airport terminal to store everything they are offered, as well as a budget to match for conservation and preservation work. An album of cartes-de-visite from Lewis Carroll's immediate family is preserved in the RPS Collection and thought worthy of interest, although his relatives were doubtless as heterogeneous as yours and mine, no more and no less worthy of preservation. Relevant connections and condition are everything when so many billions of family photographs exist. More than 140 years after they were taken, Lewis Carroll's family photographs are still in fine shape; albumen prints attached to a good quality, rag-based paper with a simple starch paste.

Has family, domestic photography in its late twentieth-century proliferation and ease, now just become about the momentary thrill of capturing an image, and are we now unwilling to be saddled with memories of our past, in anticipation of future memories? Perhaps we now have so many visual memories, an overload, that we have to throw some away. Maybe we actually welcome the built-in self-destruct mechanism which will be the eventual fate of most modern cheaply processed prints. It seems that we, unlike our ancestors, are increasingly compelled to capture everything and preserve nothing.

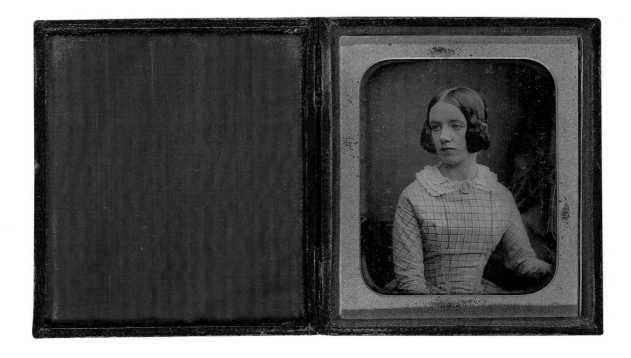

OPPOSITE | American Alice Boughton studied painting in Paris and
Rome before turning to photography full time. She worked as an assistant
in Gertrude Käsebier's New York portrait studio before setting up on her own,
photographing such literary personalities as Maxim Gorky and William Butler
Yeats. She also photographed outdoor nudes and children, frequently using
her two daughters as models. This photograph was taken in 1914 and is
entitled 'Prunella Group' (seemingly some sort of amateur dramatic group),
an example of her more allegorical and theatrical tableaux.

ABOVE | Antoine Claudet moved to London from his native Lyons in
1829, initially operating a glass business. He had lessons in daguerreotypy from
Daguerre in Paris in 1839, taking out a licence on Daguerre's patent in March
1840, and then ran one of the most successful photographic portrait studios
in London from 1841, eventually specialising in all forms of photography –
daguerreotypes, calotypes and wet-collodion negatives. A chemist and physicist
as well as an artist, Claudet improved on Daguerre's initial process and also
introduced stereo and hand-coloured daguerreotypes into his repertoire.
This portrait of a young girl is one of his daguerreotypes from around 1845.

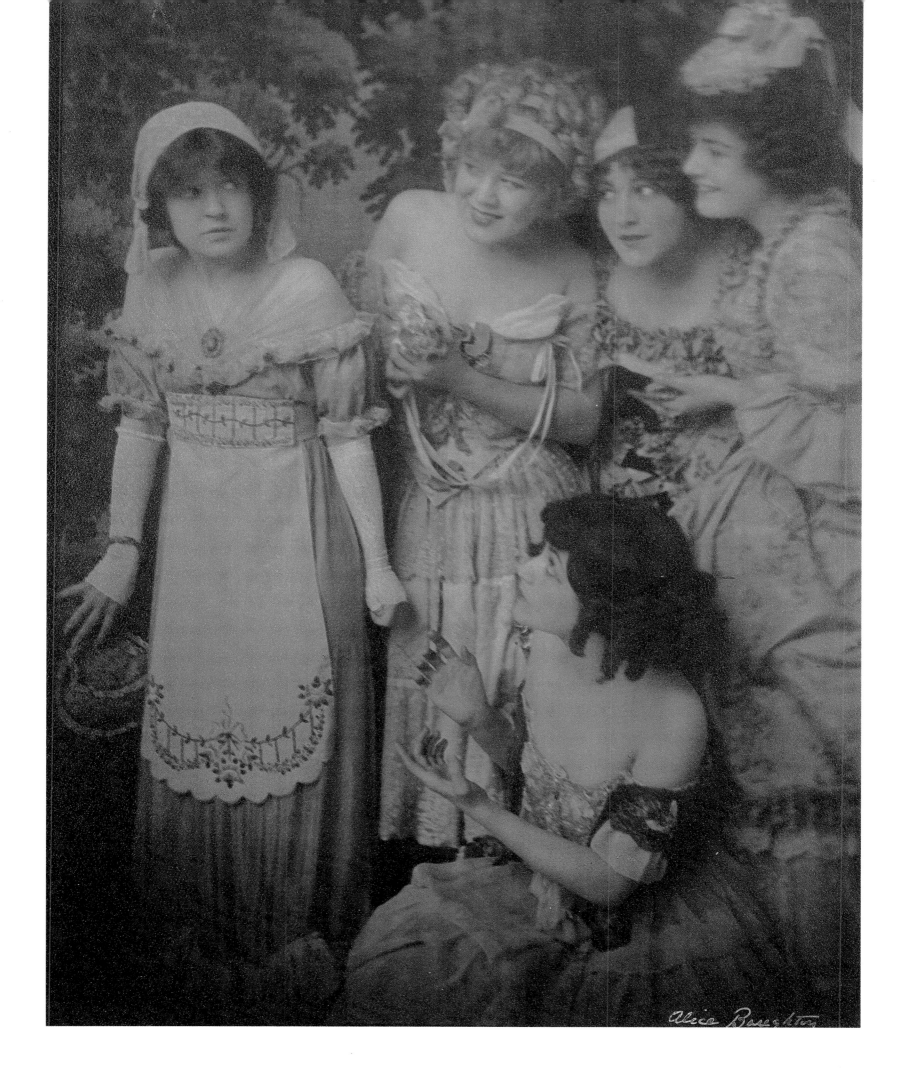

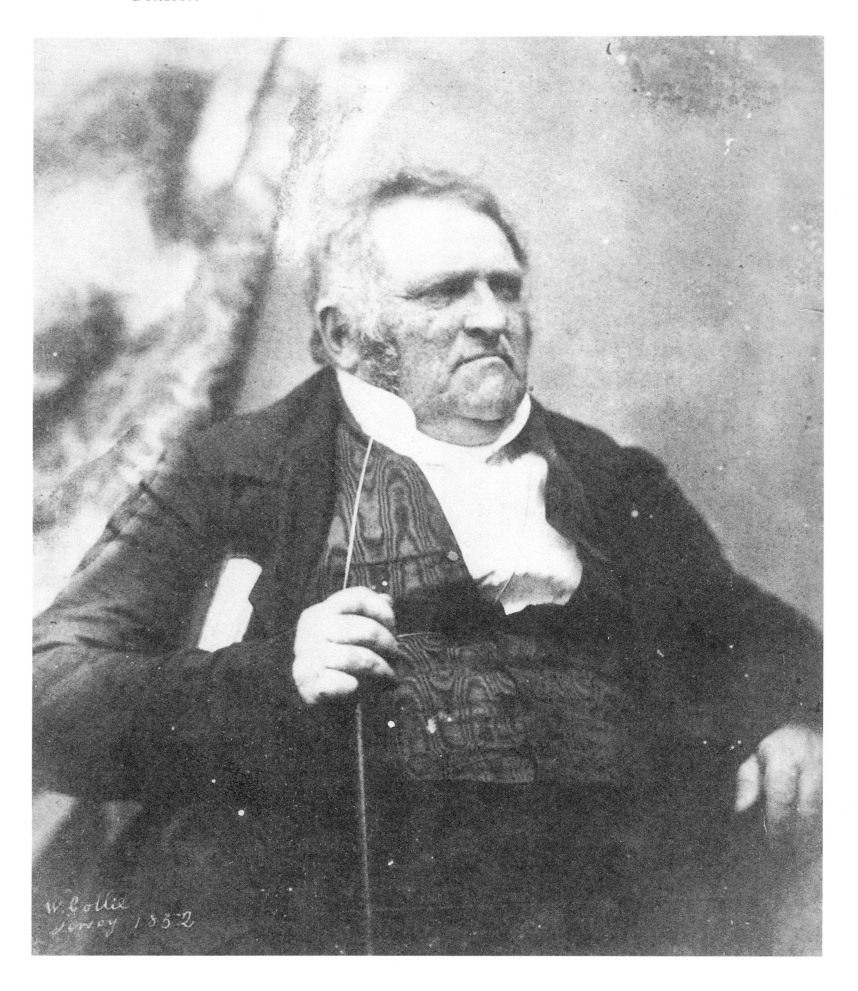

W. Collie
Jersey 1852

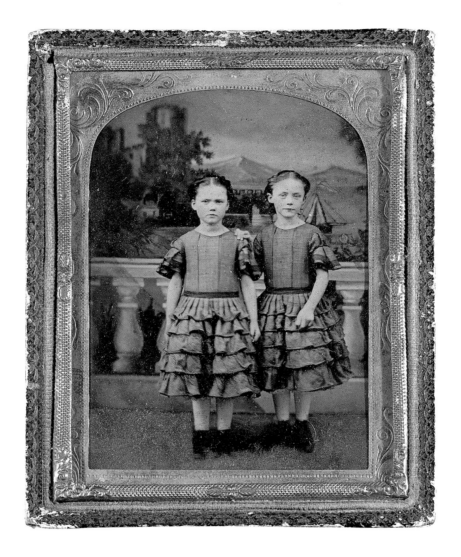

OPPOSITE | A salted paper print from British photographer William Collie, taken in 1852. His subject, Dr Wolfe, has a set expression on his face which suggests an acute dislike of being photographed, although he has been persuaded to wear his fine, watered-silk waistcoat for the occasion. From around this time onwards, the majority of photographic portraits were printed on albumen paper, which gave more detailed results and a glossy sheen to the end product, unlike the matt finish of the salted paper print.

ABOVE | These two sisters, photographed around 1860, look none too pleased at being dressed up in their finery, taken to the portrait studio and posed in front of an elaborate backdrop. However, the straightforwardness of the pose and the simple pinchbeck surround (pinchbeck was an alloy of zinc, copper and tin used as an imitation of gold) provide an image of great appeal.

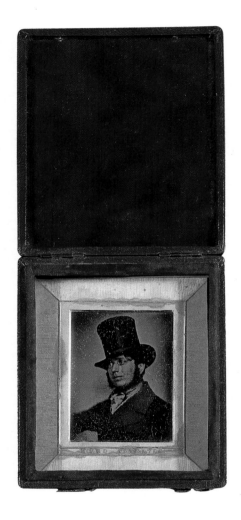

OPPOSITE | There was a hugely diverse selection of photographic formats available from 1840–70 and this page shows examples of just a few: daguerreotypes, stereo daguerreotypes (plain and hand-coloured), ambrotypes (collodion positives), relievotypes (a variation on collodion positive) and photographic jewellery for containing images of loved ones.

ABOVE | British photographer Richard Beard bought a patent to make daguerreotypes from Daguerre in 1841 for £800 and set up a studio on the roof of the Royal Polytechnic Institution in London. He was so successful that he opened a further eight studios under licence by the end of the year although he was bankrupt by 1849. The simplicity of presentation – the brass foil surround and the deep case, lined with velvet – would suggest that this was an early image. The identity of the very dapper sitter is, regrettably, unknown.

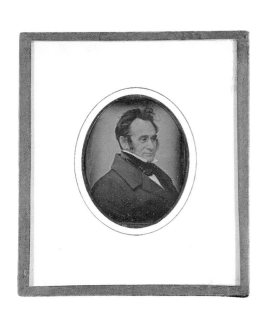

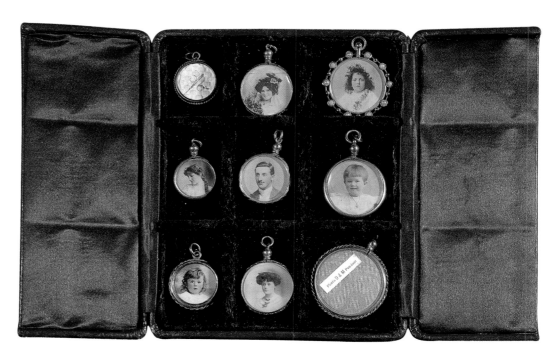

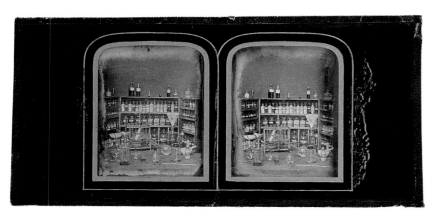

OPPOSITE | Austrian photographer Friedrich Adolf Paneth continued to photograph using the Autochrome long after many of his fellow photographers had given it up, only abandoning it for a Leica camera and 35mm colour slides in the mid-1930s. In 1925 he photographed his 11-year-old daughter Eva and his wife Else at the beach, probably the Lido di Jessola outside Venice, where the Paneth family spent their holiday.

BELOW | Otto Pfenninger, a German photographer who spent time working in Britain, captured this scene at Brighton beach on 16 June 1906. It is a tricolour carbon print, part of a series he took of Edwardian children at play. The rich, silvery-blue tones create a particularly haunting atmosphere.

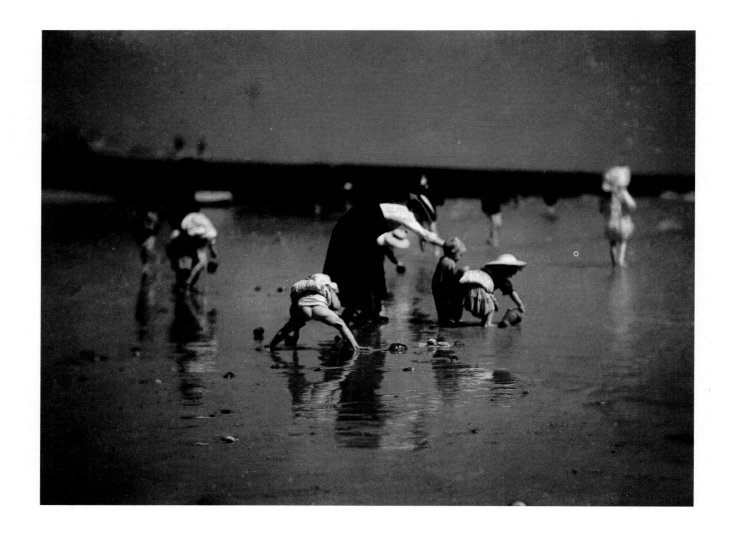

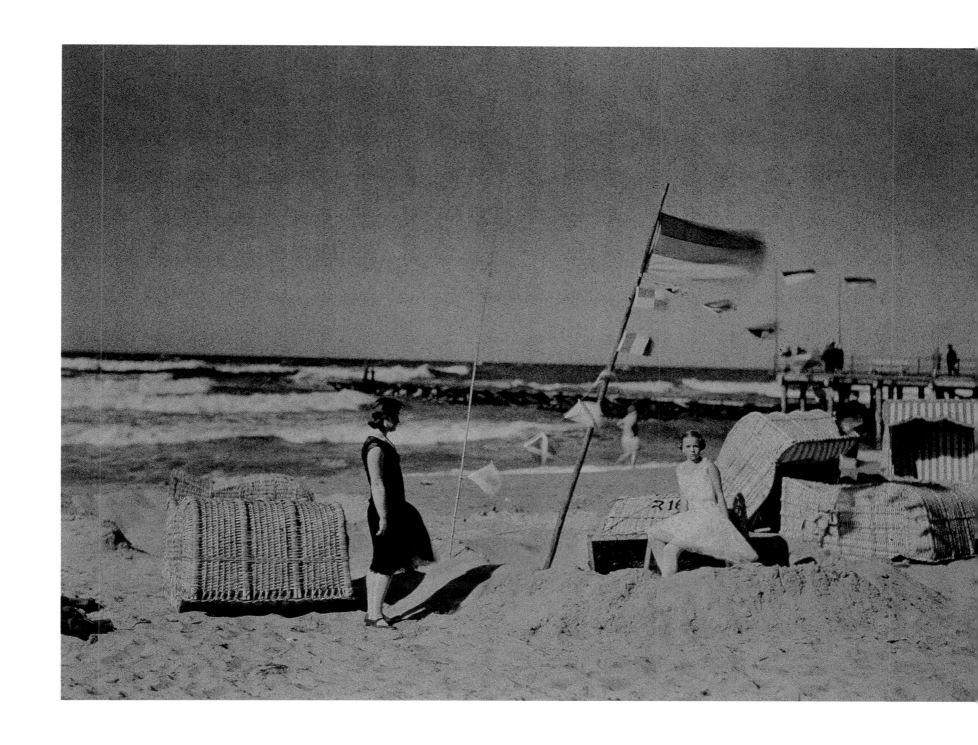

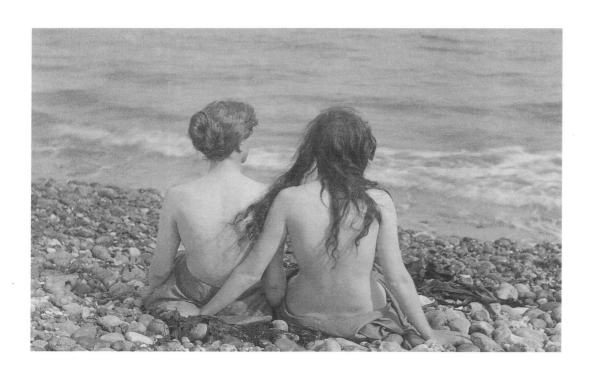

ABOVE | William J. Day (1854–1939), and his father Robert (1822–1873) before him, photographed around the Dorset/Hampshire area, taking topical photographs of their locale with much the same sort of spirit as Frank Meadow Sutcliffe in Whitby. These two topless girls seem rather risqué for 1910 but then had probably not expected a photographer to sneak up behind them.

RIGHT | Entitled 'The Lesson' but also known as 'The Picture Book' and 'The Instruction', this photograph taken by the American Getrude Käsebier in 1903 shows Beatrice Baxter Ruyl, an accomplished illustrator of children's books, and Charles O'Malley, Käsebier's grandson, summering in Newport, Rhode Island. As a loving portrait of an accomplished woman and of a young child, it addresses two of Käsebier's most typical subjects, the whole illuminated in a glorious summer light.

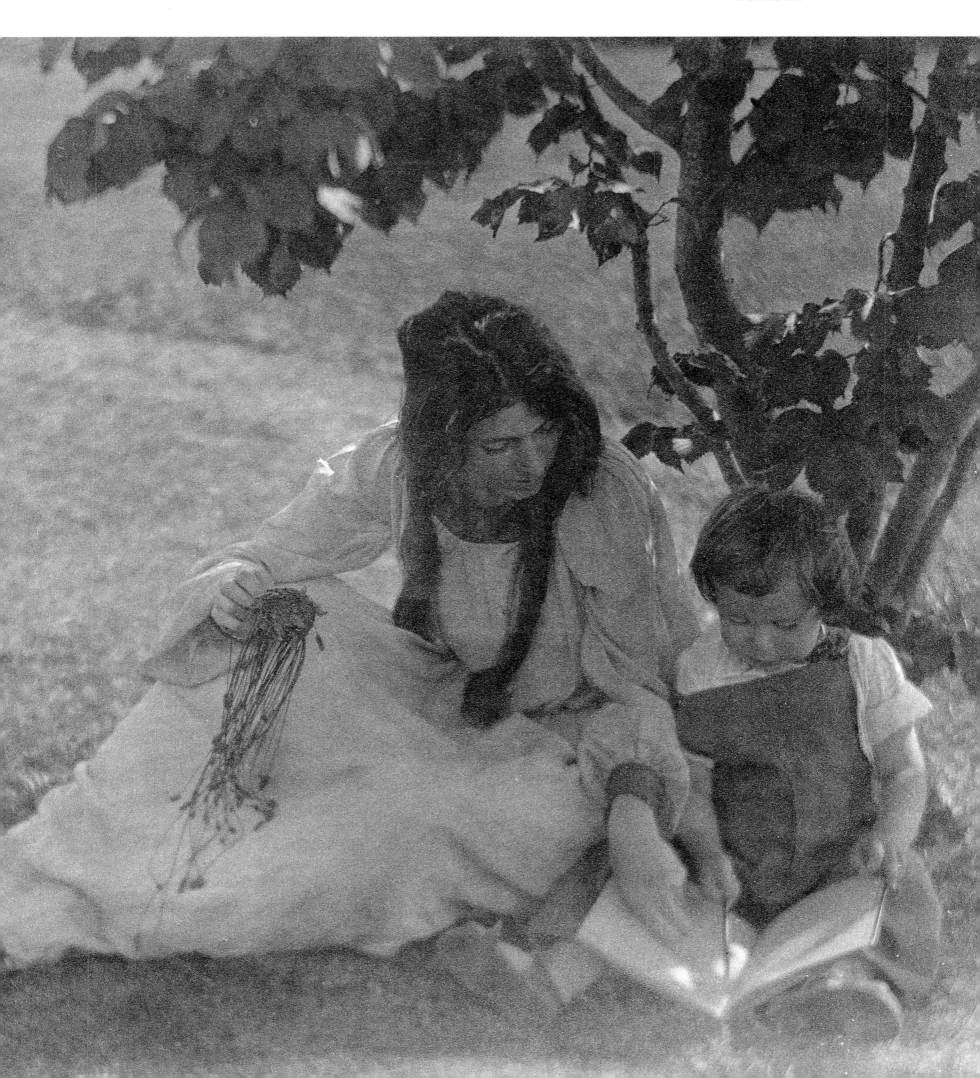

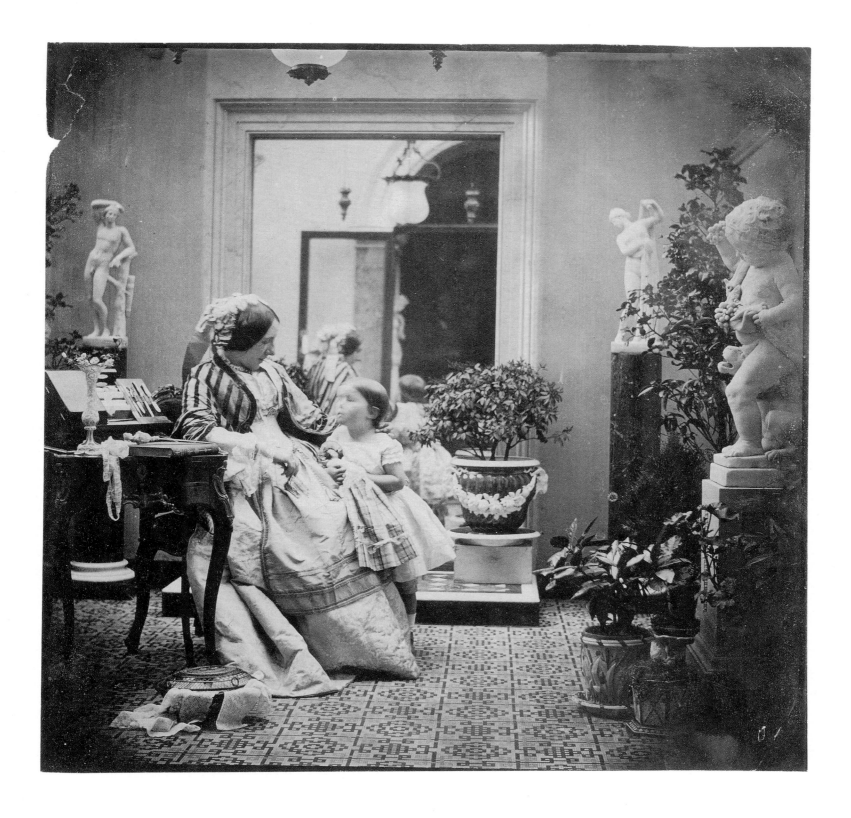

OPPOSITE | William Lake Price, an artist who became a photographer and wrote manuals and articles on early photography, specialized in genre studies such as this, taken in 1855. His photographs are full of miniaturist detail, packed with art references, allusion and allegory. They also clearly show Price's eye for architectural perspective, often lacking in his contemporaries.

BELOW | This window-lit family group was taken in 1908 by Emma Barton at her home in Sutton Coldfield, Birmingham and shows, left to right, her son Aubrey, Barton herself, daughters Marjorie and Hilda, son Cecil (shown five years earlier in 'The Awakening', p.205) and daughter Dorothy. Barton's delightfully photogenic family were frequently her models.

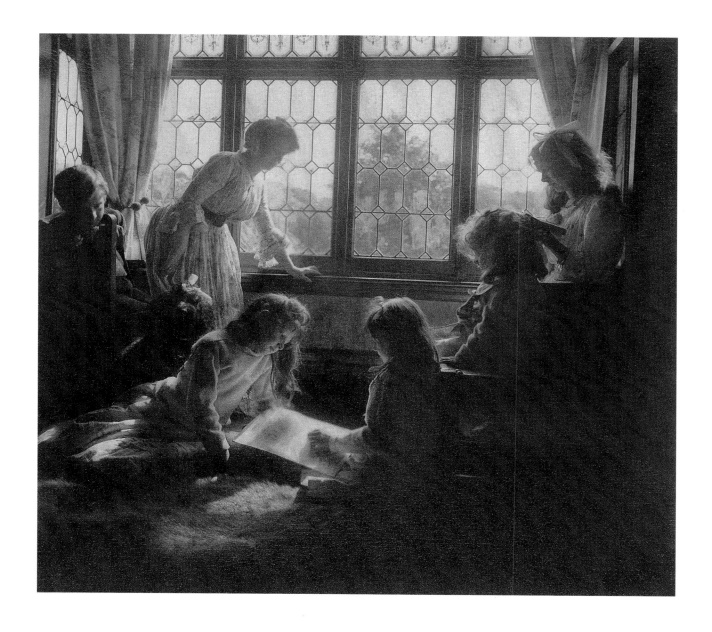

OPPOSITE | Malcolm Arbuthnot, Alvin Langdon Coburn and Pierre
Dubreuil, have often been hailed as the first European Modernist photo-
graphers, approaching spatial composition in a different way to their
predecessors. Their work abandons the tenets of European Pictorialism and
rejects the American Pictorialists' obsession of 'globes with everything', prefer-
ably carried by women in long white dresses. Arbuthnot's interest in Japonisme
enabled him to make minimal compositions like this one, taken in 1910.

ABOVE | John Cimon Warburg was devoted to his three children, as
is evident in the several hundred photographs he took of them, including these
two Autochromes taken around 1910. Frederick, Joan and Peggy (above left)
are here seen pretending to be drawing (with Joan sneaking a glimpse at
daddy with his camera). In another charming portrait (above right), Peggy
reads by the window. Warburg was one of the first British photographers
to master the Autochrome process in 1907 and used it to document his
family's everyday life for several years. He and his sister Agnes collected work
by their contemporaries and gave both these and their own work
to the RPS Collection.

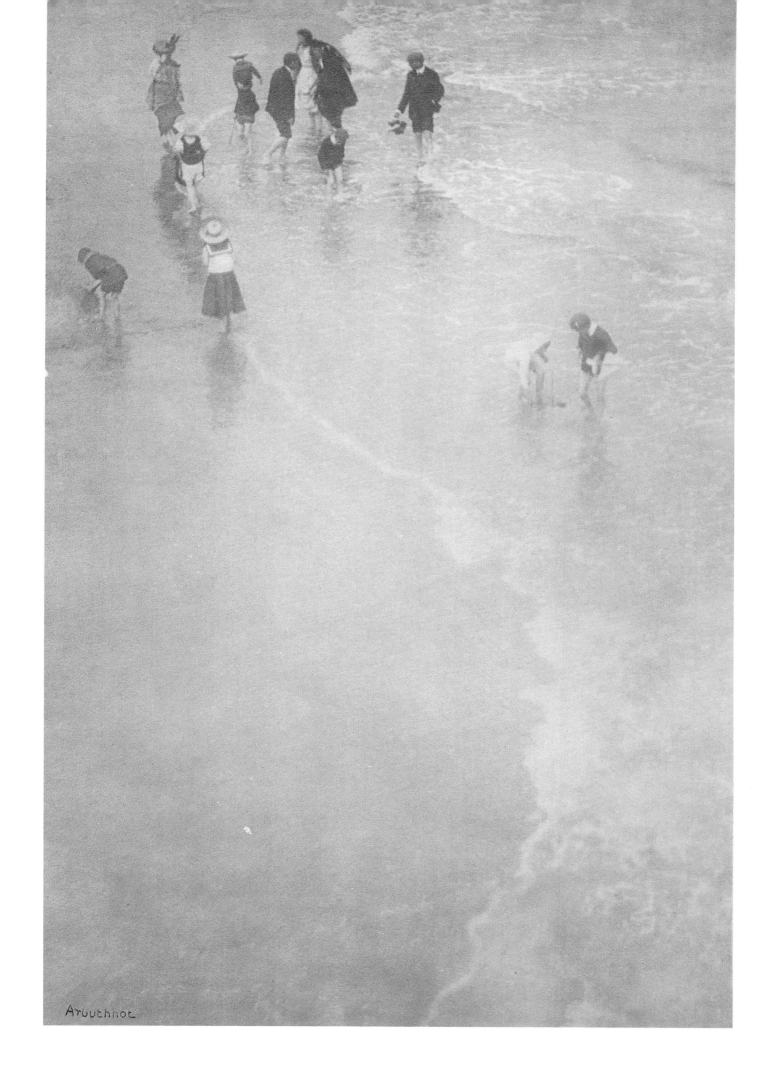

Arbuthnot

Hon. C. Ruthven.

Hon. Mrs. C. Ruthven.

OPPOSITE & BELOW | Catherine Mary Wood, the daughter of Colonel E.R. Wood, assembled and hand painted this British album of photographs of family friends and relatives in 1868. Her opinion of them is obvious from the less than charitable interpretations she paints around them on each page. Few come out well, apart from the family dog. Subjects include: Mina Llewellyn inside a spider's web, at the centre of all intrigue; The Hon Mr. and Mrs. C. Ruthven being pecked by giant birds; Harry Benson having his head squeezed between a crab's claws; Richard Crawshay and mushroom growth; and the family dog carrying a portrait of another dog from the same household.

OPPOSITE | In 1909, the Bassano Studio in London produced a book entitled *England's Beautiful Women*. With an introduction by Queen Alexandra, it reproduced photographs of some of the many titled ladies who had sat for portraits at Bassano, with captions extolling their virtues. Viscountess Helmsley (upper left) 'is devoted to most forms of Sport, particularly hunting, and is a keen rider to hounds'. Viscountess Massereene and Ferrard (lower left) is also 'an ardent follower of hounds'. Mrs. Paris Singer, with her daughter, Miss Winnaretta Singer (upper right) is 'an enthusiastic motorist', whilst Mrs. Leslie Melville (bottom right) has 'artistic taste in dress and is very musical'.

BELOW | From a family album come these prints taken in 1929–30 of the royal nanny with baby Princess Margaret Rose (left), Princess Elizabeth (now Queen Elizabeth II, centre) and the Duchess of York (now the Queen Mother) with the two princesses.

 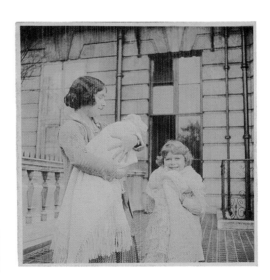

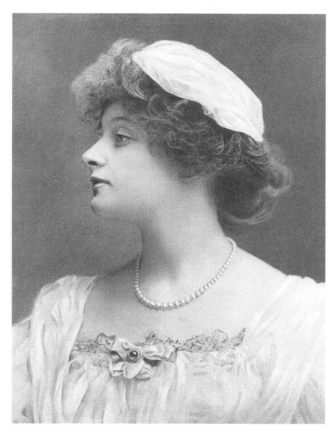

Mrs Paris Singer and her daughter Miss Winnaretta Singer.

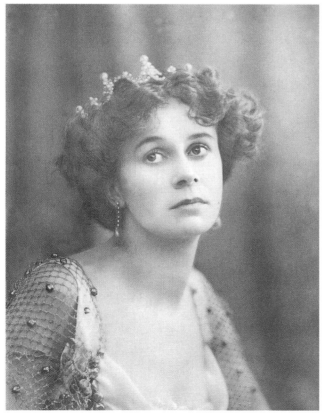

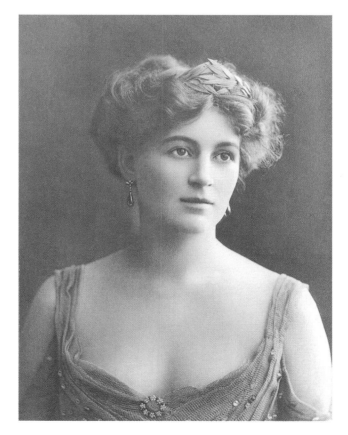

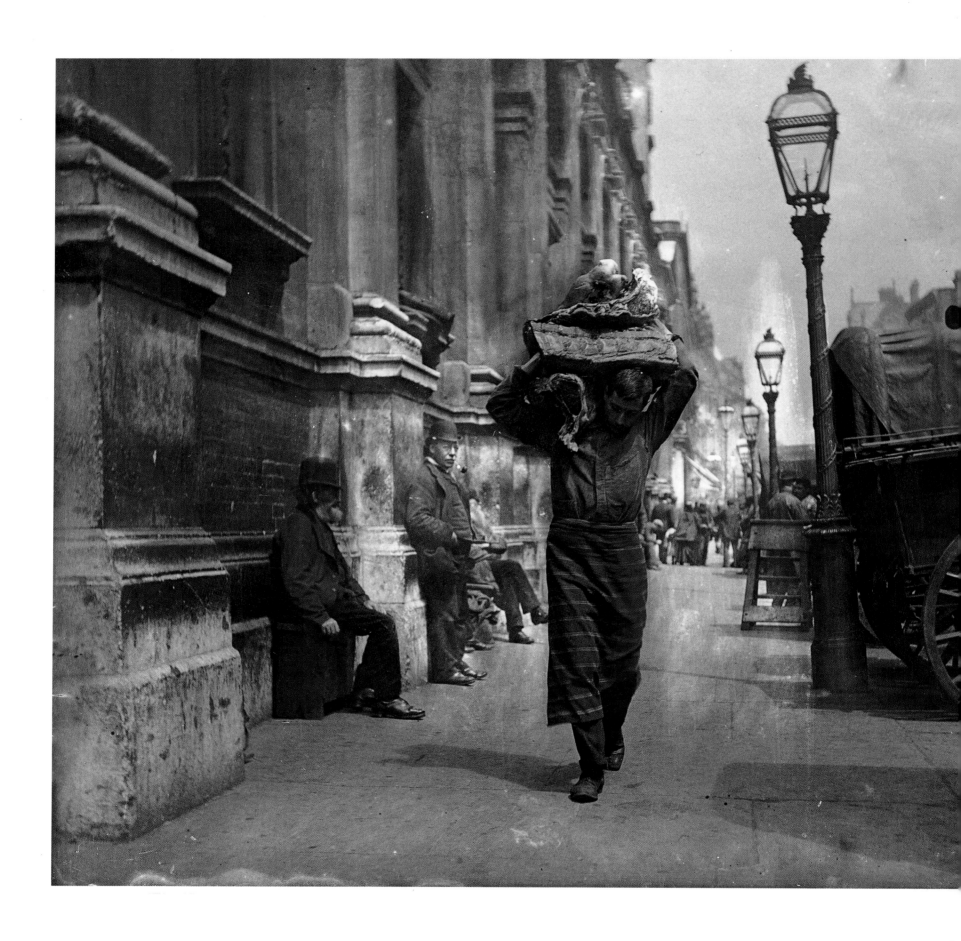

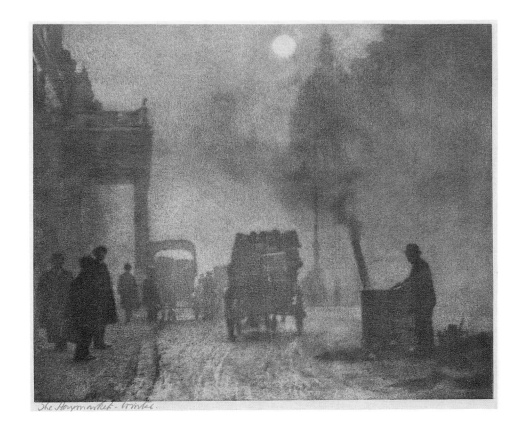

The Haymarket - Trinder.

ABOVE | James A. Sinclair set up his own photographic equipment business in Haymarket, London in 1903 and by 1910 had gone into partnership with A.S. Newman to increase the manufacturing side of the business. It was with an Una Sinclair hand camera that Helen Messenger Murdoch took her photograph of the Kilauea crater in Hawaii (page 304). Sinclair's own photographic work was elegant and unshowy, like the man, and exquisitely printed as either photogravure, gum, platinum or carbon.

LEFT | Paul Martin photographed London's wholesale markets – Billingsgate, Covent Garden and, here, the Smithfield meat market around 1893. The central figure is positioned in such a way that he could later print it separately (by making a copy negative from his original and carefully painting around the figure, thus obscuring the rest of the negative) to make a 'living statuette'. He would make this into a magic lantern slide for showing to an audience through a projector. For the modern viewer, the detail of the London streets in the background is probably more interesting than the foreground figure.

OPPOSITE & ABOVE | These five gelatin silver prints represent just a fraction of the 200 or so photographs in the family album of Baron Nicholas de Rakocij. Little is known about him other than that he left Vienna in 1938 to move to England, where he pursued a dual career as a portrait and equestrian photographer. His family albums, mostly snapshots taken with a Rolleiflex or a Leica camera, document daily life and political events in Vienna in the late 1930s, including the local camera shop as well as Nazi rallies and anti-Jewish street posters. Rakocij's fascinating and varied body of work was donated to the RPS Collection by his widow in 1985.

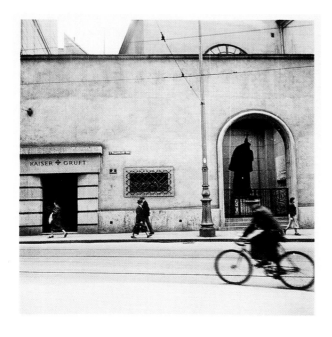

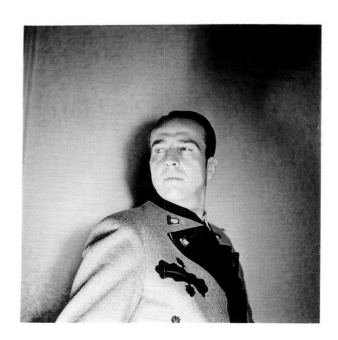

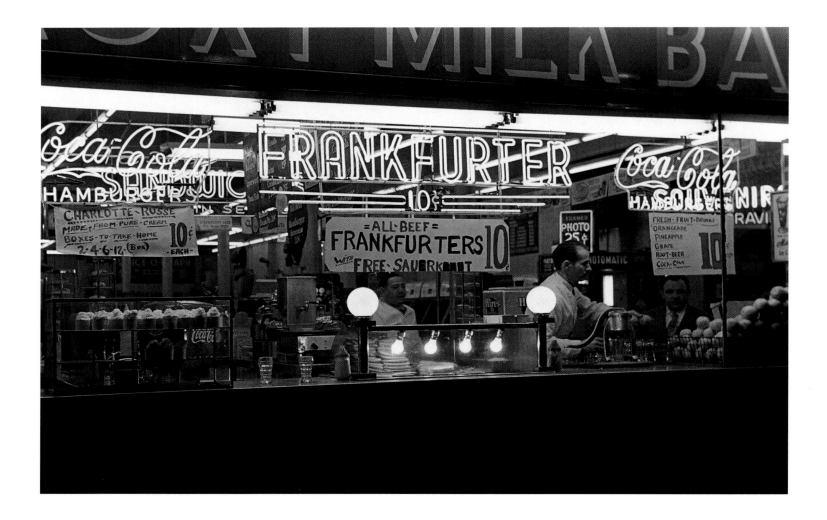

OPPOSITE | Dr. J. B. Pardoe was a member of the Oval Table Society in New York and a more than competent photographer who was active during the 1920s and 30s. Family photographs show him and his wife as the proud owners of several cameras. This quiet and reflectful photograph was probably taken at Grand Central Station, New York. It captures a time when railway stations were calm and well-ordered places, where there was nothing to do but wait.

ABOVE | When British photographer Walter Poucher travelled to New York in 1949 he took this snapshot of what appears to be the 'Roxy Milk Bar'. This, and the other photographs resulting from the trip, mainly of skyscrapers, reveal that, as well as the mountain views with which he is usually associated, he could also photograph New York's mean streets.

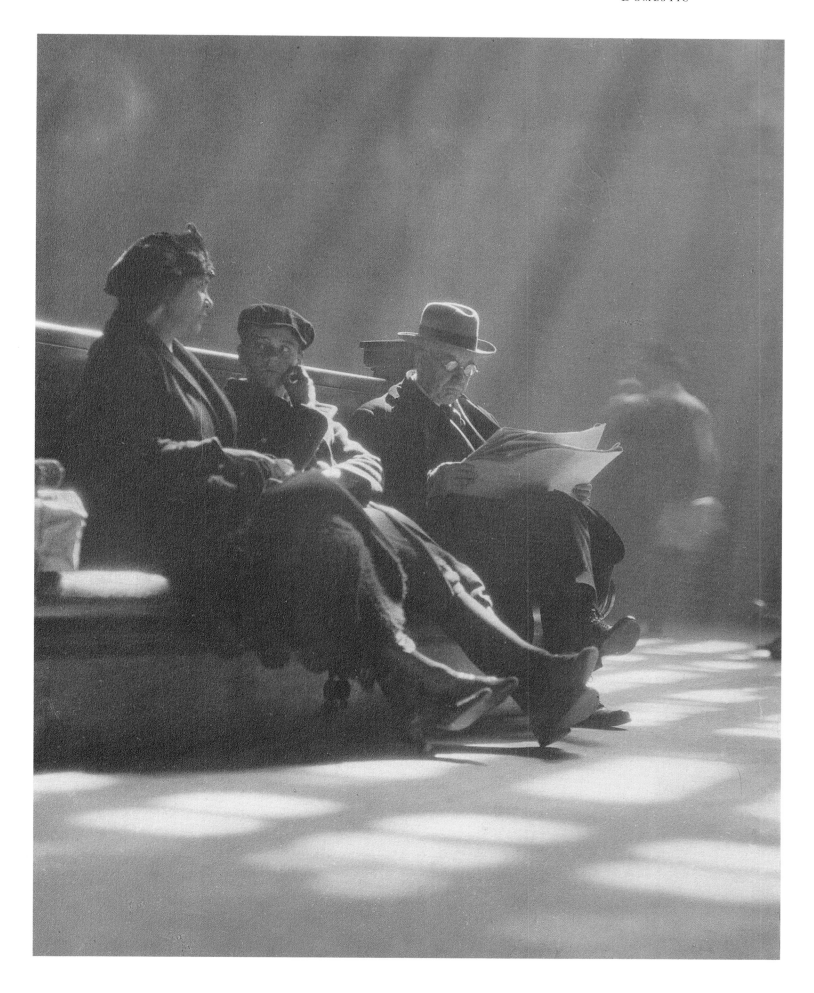

IV.

Nature & Science

IV.

OPPOSITE | Fox Talbot's earliest photographic experiments in photography during the 1830s involved laying leaves, flowers and lace onto light-sensitive paper. He called these photogenic drawings. The fine detail in this photogenic drawing negative of a leaf, made around 1843–5 and printed here at about 16 times the size of the original, shows the beauty of unadorned simplicity.

THE INVENTION OF PHOTOGRAPHY PRESENTED CREATIVE ARTISTS WITH another exciting medium of expression and definition. This technology – mixing chemistry, physics and optics – could produce an end product of sublime artistic merit every bit as worthy as work produced with paint, pastel, pencil or chisel. But photography, the art-science, the all-seeing eye, had many other roles to play. It was so critically important in accelerating progress in diverse areas of scientific research that its artistic credentials almost pale into insignificance compared with its immediate impact in the fields of photomicrography, natural science, biology, botany, medicine and astronomy. This impact was deepened by the new medium's later abilities, less than 30 years after its invention, to capture movement and colour. Photography redefined previous perceptions of space and time and created a new vision with which to see the world, a third eye.

It had something for everyone. Artists appreciated how the camera could record, subjectively, their own personal way of seeing. Scientists quickly realised the possibilities of photography's pure objectivity, its ability to capture everything before it, to faithfully reproduce that which is visible to us without the intrusion of personal interpretation. Both artists and scientists soon discovered that photography also had its own way of seeing; it had other ways of capturing the world far beyond the capabilities of the human eye. It was able to record movement, infinitesimal variations in size, light and colour as well as invisible radiant energies like ultra-violet, infra-red, gamma and X-rays. It is hardly surprising that the huge growth of interest in spirit and 'ghost' photography in the 1890s – photographs of supposed ectoplasmic emissions and of phantasms – happened at the same time as these discoveries. If photography could capture hitherto invisible energies, then the feeling was that it could also probably capture invisible life forces and auras. Photography could reveal the truths, and the untruths, behind scientific theories, uncovering an exhilarating and brave new world.

Yet at the same time, photography itself was in a state of constant invention and evolution, flux and change. There were so many ingredients in its mix, so many elements that could be tweaked and improved as its early

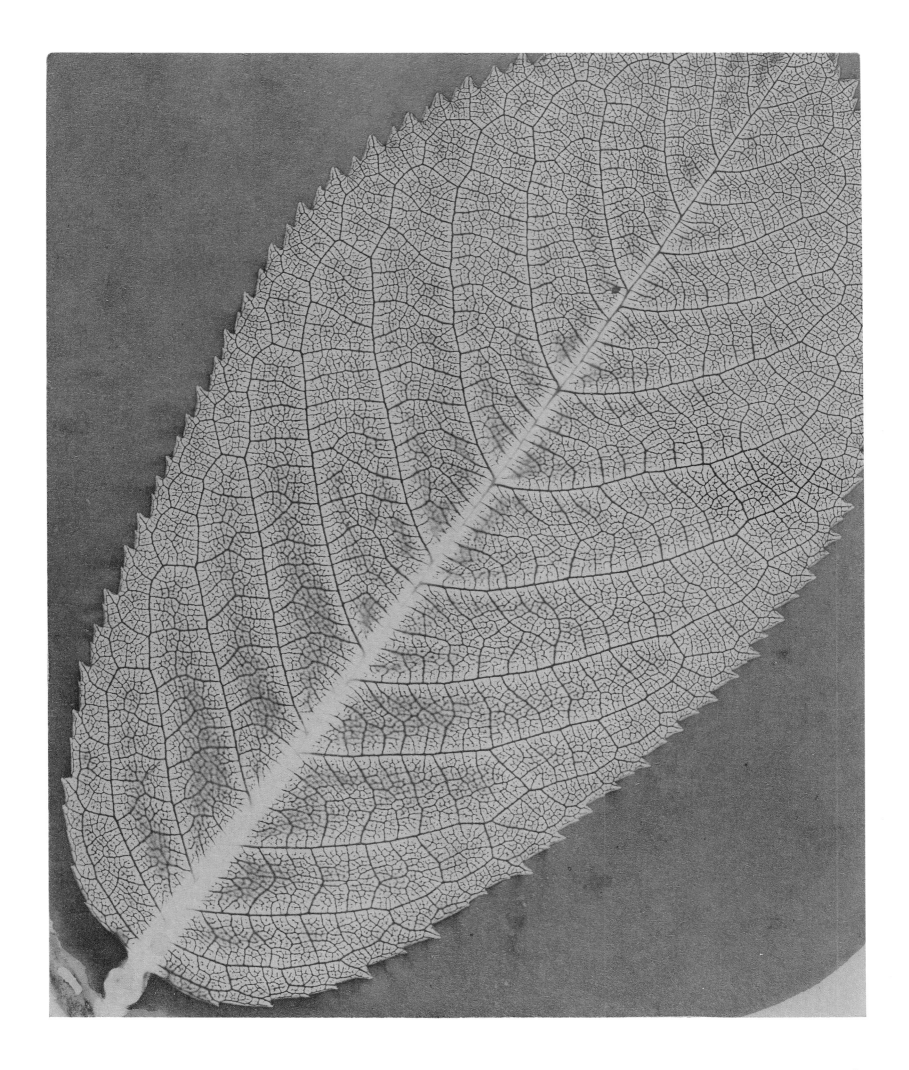

practitioners introduced modifications, that its capacities seemed limitless. So many scientists had tackled the precepts behind what would become photography that it seems it should have been invented at least forty years earlier. Thomas Wedgwood (1771–1805) and others had registered images on white leather and paper coated with light-sensitive silver compounds in the late eighteenth century but were unable to 'fix' the image, that is, control the darkening properties of the action of light. Sir Humphry Davy (1778–1829) had toyed with Wedgwood's research but had not progressed it.

It was not until the French scientist Joseph Nicéphore Niépce (1765–1833), working first alone and then in partnership with Louis-Jacques-Mandé Daguerre (1787–1851), Hippolyte Bayard (1801–1887) and the English polymath William Henry Fox Talbot (1800–1877) applied their different experiences and knowledge to the action of light on particular chemicals that photography produced permanent, if differing, results.

Over his years of experimentation, Talbot anticipated many of the different areas of scientific knowledge to which photography could be applied. A consummate botanist, Talbot's early photogenic drawings of leaves, ferns, seed heads and other plant forms, and his later photomicrographs of plant and insect forms using a solar microscope, produced images of great beauty which also had profound scientific connotations.

These images trigger an emotional response in the viewer but also convey important information about the integrity and complexity of the photographed object in equal measure. Through photography, the patterns and mathematical designs inherent in nature – the perfect geometrical order of plant forms, the unexpectedly graphic beauty of the hairs on the wing of a housefly, or the sucking tube on the tongue of a blowfly magnified by 300 times – could be reproduced in large numbers for wide dissemination. In this way the true forms of nature became accessible to many rather than the privileged few who had access to a microscope. Nature could now be seen to have been created according to a frighteningly competent order, method and logic. Nothing was random; everything was planned and conformed to an astounding complexity of pattern and design.

OPPOSITE | Writing in *Amateur Photographer* on 2 February 1909,
photographer Carine Cadby advised that cobweb-hunting was best done
'in spring and early summer ... for only then are the atmospheric conditions
amenable, the webs have caught the slight moisture that makes them visible to
our eyes, and there is not yet wind enough to destroy their gossamer fabric'.

Talbot was taking photomicrographs on paper using a solar microscope at almost 300 times magnification as early as 1839. In Vienna, Dr. Andreas Ritter von Ettingshausen (1796–1878), a professor of physics and mathematics at the University of Vienna, used the daguerreotype process, after personal tuition from Daguerre in Paris, to make photomicrographs of cross-sections of plant structures.

Whilst the daguerreotype process produced a more precise and detailed image than a print on paper, it was a unique positive image on metal and could not be replicated unless recopied, leading to a loss of definition. The original daguerreotype could also be engraved and prints made from this engraving but this increased the expense of reproduction. A process was needed which married the clarity of the daguerreotype with the reproducibility of the paper negative to enable the proliferation of images. The wet collodion negative, introduced in the early 1850s, solved many of these problems, combining the best of both earlier processes.

During the next three decades, much notable work on natural history and natural science was produced: in Paris by Louis Pierre Rousseau (1811–1874) and Achille-Jacques-Jean-Marie Deveria (1800–1857) in association with the photographers Louis-Auguste (1814–1876) and Auguste-Rosalie Bisson (1826–1900); in Massachusetts by Dr. James Deane (1801–1858), who photographed geological fossil specimens; and, as early as 1855, by James Glaisher, a President of the RPS, who produced photomicrographs of snowflakes.

The late nineteenth-century introductions of photogravure, photo-lithography and half-tone printing meant that the reproduction of original photographs became both cost-effective and widespread and photographic illustrations in books, periodicals, newspapers etc. became increasingly commonplace.

The same need to know and to understand that drove nineteenth-century photographers of the natural world is also apparent in the twentieth-century photographs of flower and plant forms by the American Edward Steichen (1879–1973) and the German Albert Renger-Patzsch (1897–1966). Steichen's intensive photographic studies of foxgloves, delphiniums and sunflowers at every stage of their life cycle and Renger-Patzsch's mantra

OPPOSITE | This scene of a girl and her father looking at palaeontological specimens was taken by Oscar Gustav Rejlander around 1858 and represents a subject of acute interests to the Victorians. One of Daguerre's earliest daguerreotypes was of fossil specimens, and geological and palaentological subjects appear frequently in the work of other photographers of the day.

that 'the hardest thing to see is what is in front of your eyes' led them both to concentrate on organic forms in very different ways. Steichen conveyed a profound and lush sensuality in his photographs, while the images of Renger-Patzsch reveal a sense of identification with, and faithful depiction of, the object in question.

As the cumbersome hardware of photography became infinitely smaller and more portable, and as increased film speeds enabled photographers to capture and freeze movement, it became possible to photograph nature on the move: running, flying, swimming, creeping and crawling. Earlier charming, and often unintentionally amusing, wildlife studies by John Dillwyn Llewelyn (1810–1887) show stationary stuffed otters, rabbits, deer and herons doggedly posed in sympathetic environments.

By 1900, ornithologists and naturalists had access to both enhanced and more portable photographic technology, with the rapid film speeds and sensitivity of the gelatin dry-plate negative, and then film negatives, rectilinear and telephoto lenses as well as vastly improved and cheaper means of colour reproduction. The brothers Richard (1862–1928) and Cherry Kearton (1873–1940) were at the forefront of this advance, working both together and separately. Between them they produced over 30 natural history books ranging from *British Birds' Nests* in 1905 to the more exotic *In the Land of the Lion* in 1929. Their work forms the solid core of over 1500 photographs covering the history of nature photography acquired by the RPS from the Nature Conservancy Council in the 1960s, and to which additions have been made on a frequent basis.

Other photographs, mainly black and white, in this fascinating collection encompass a variety of photographic styles, from an objective, detailed presentation and visual cataloguing of British birds and wildlife, some of them now extremely rare, through Pictorial whimsy and splendidly silly examples of anthropomorphism, to later high-speed photographs in colour. Detailed studies of plant forms growing in their natural habitat again point to photography's ability to conserve, if only on paper, what once existed, as twenty-first-century progress with all its attendant environmental dangers strangles these plant forms into oblivion.

Photographing the sky from the earth and the earth from the sky was another driving force in nineteenth-century photographic discovery. For an earthbound population, the former came first. Daguerre made an exposure of the moon in 1839, since lost. Long exposures, initially often of many hours, and the lack of rapid negatives needed to register accurate astronomical detail (not available until the late nineteenth century) meant that astronomical photography was often a frustrating business. Despite this, many astonishingly detailed images of the sun, moon and stars were made by John Adams Whipple (1822–1891) and George Phillips Bond (1825–1865), Warren De la Rue (1815–1889) and Lewis Morris Rutherfurd (1816–1892) amongst others.

Photographing the earth from the sky was an altogether easier matter, at least once aviation existed. Prior to this, Nadar (Gaspard Félix Tournachon) had photographed Paris from a balloon in 1858 and James Wallace Black (1825–1896) photographed Boston in 1860 from a tethered balloon which rose to a height of 1200 feet. Aerial reconnaissance shots taken during World War I of the battlefields, trenches and emplacements were initially taken from balloons but then from aircraft, producing images with geometric and graphic impact.

It seemed that aerial photography revealed the same sort of truths about the earth's broad sweep as photomicrography revealed about its minutiae. The culmination of photography's exploration of the heavens and earth was probably best expressed by the first lunar landing of 1969, when it was difficult to decide which

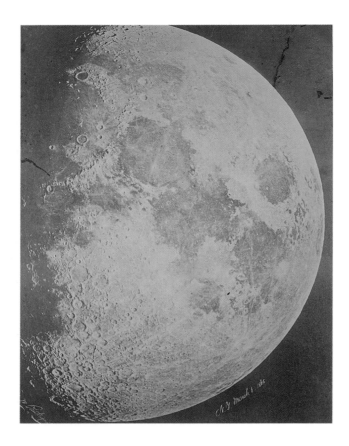

images were the more arresting – those of the first man to walk on the moon or those distant views of the earth on which he had walked only four days previously.

Because of nineteenth-century photography's apparent ability to see what the human eye could not, it is not surprising that the camera was soon turned on the human body in an attempt to reveal the workings of this most complex of machines. But it was not until the turn of the century, after the discovery of X-rays by Wilhelm Conrad Roentgen (1845–1923), the proliferation of higher film speeds and, later, the availability of colour, that photography of the body's interior began to make significant strides forward.

Nineteenth-century medical photography thus tends to concentrate on the body's exterior, on what can be learned of the patient's mental and physical state by close photographic observation and analysis. Such images were taken almost wholly within the definitions established by studio portraiture. It was thus often more of a subjective recording device of an identifiable person than an objective aid to diagnosis and, as such, raised questions about patient anonymity and confidentiality.

Dr. Hugh Welch Diamond (1808–1886), superintendent of the female wards of Surrey County Asylum from 1848–1858, an avid photographer and one of the founders of the RPS, was the first to introduce photography as an aid to psychiatric diagnosis from 1852. The photographs could be shown to colleagues in the field, sparing the patient herself the traumas of further examination, and were also used in self-help, self-awareness therapy. Photography was also employed for psychological case studies in Paris by Dr. Jean-Martin Charcot (1825–1893), head of nervous diseases at the Salpêtrière Hospital in the mid-1870s, and by Albert Londe (1858–1917), who became the head of the hospital's photographic services in 1884.

OPPOSITE | Lewis Morris Rutherfurd, a scientist of considerable independent means, took his magnificent photographs of the moon, planets and star clusters using a lens with an aperture of 13 inches, corrected specially for celestial photography and mounted into an equatorial refracting telescope which he had installed in his private astronomical observatory. The lens, calculated to his own formulae and the first of its kind, enabled him to take photographs of the solar spectrum up to 11 feet long. This photograph of the moon was taken in New York on 6 March 1865.

The archives of the RPS Medical Group, some 1000 or so photographs, show a broad sweep of the progress and specific applications of medical photography over the last 100 years. An important album of photographs taken in the Orthopaedic Unit of St Bartholomew's Hospital in London between 1892 and 1894 by Frederick Glendening concentrates on many before-and-after photographs, showing disfiguring facial cancers and then the patient's progress after radical and invasive surgery. Female patients are photographed draped and with faces turned away or heads partially cropped from the image to preserve their anonymity and modesty. The conventions of the portrait studio still apply in that men are wearing collars and ties, hair is neatly combed and styled despite the sad horror of a disfiguring illness, making these photographs all the more extraordinary and poignant. By this time, practically all major medical institutions worldwide had documentary photographic units working to make a visual record of condition, diagnosis and treatment carried out. Photography was also used to record a particular surgeon's skills in successful operations.

One of the most important evolutions in nineteenth-century photography, and one which had huge repercussions in all of photography's multiple applications, was that of high-speed photography. The ability to capture and freeze movement enabled photography to gain control of time and space. The work of the British photographer Eadweard Muybridge, born Edward Muggeridge (1830–1904), the French photographer, Etienne-Jules Marey (1830–1904) and the Prussian Ottomar Anschütz (1846–1907) is especially important in these areas although many others were experimenting along the same lines at the same time.

Muybridge, who emigrated to the US from Britain in 1851, had been based in San Francisco since the early 1860s, working as a very successful landscape photographer in the American West, especially Yosemite, and Central America. He was commissioned in 1872 by the gold prospector and railroad baron Leland Stanford to photograph the horses in his racing stables in Palo Alto, particularly his prime trotter Occident. Stanford hoped to demonstrate that, at the gallop, all four hooves were in the air simultaneously. Muybridge finally established

photographic proof of this in 1878. The artistic convention of painting galloping horses with at least one hoof always in contact with the ground was shattered.

Muybridge continued his experiments and also went on a hugely successful world lecture tour using his zoopraxiscope, a device for animating and projecting his photographs of motion to show them as moving images. Facilitated by the advances in the speed of dry plate negatives in the 1880s, and using an improved multiple-camera system comprising three batteries of twelve cameras and new electro-magnetic shutter devices, Muybridge set up a massive study of animal and human locomotion from 1884–7 with funding from the University of Pennsylvania in Philadelphia.

The resulting eleven volumes, entitled *Animal Locomotion: An Electro-Photographic Investigation of Consecutive Phases of Animal Movements, 1872–1885* contained 781 plates. They featured movement studies on paper of athletes, male and female models, zoo and domestic animals, as well as amputees and subjects with spinal disorders and paralysis. They went on sale by subscription at 110 guineas in 1887. Because of their high cost, the volumes achieved a relatively small distribution amongst the general public, but were greeted with huge enthusiasm and excitement by artists and scientists alike. Notable subscribers included scientists – Edison, Mach, Vogel and Helmholtz – and artists – Tiffany, Rodin, Puvis de Chavannes, Millais, Watts and Lenbach.

Smaller, cheaper editions were published under the titles *Animals in Motion* and *The Human Figure in Motion*. These became popular publications, influencing generations of artists as well as Isadora Duncan and Gertrude Stein. The camera had finally captured detailed animal and human movement, showing the interplay of muscle and bone in motion. This revelation was greeted with enthusiasm by members of the medical profession, artists and, doubtless because of the number of naked women and men shown, by those whose appreciation was recreational rather than professional. Eight years later, on 28 December 1895, the first commercial moving picture on projected film was screened in Paris. Taken by the Lumière Brothers on their

OPPOSITE | One of the first commercially available subtractive colour processes was the bichromated gelatin glue process which was patented by the Lumière Brothers in 1895. They exhibited examples on paper at the Paris Exhibition of 1900. The process was capable of deeply rich and luminous colour. This stereoscopic transparency of laboratory equipment utilised the same technology and, sandwiched between glass, was translucent and could be projected for a three-dimensional colour sensation.

Cinématographe camera and lasting only a minute, it was not expected to have much of a future. The screening received a rapturous reception from the paying audience at the Grand Café, 14 boulevard des Capucines, and photography took off into the most lucrative direction in its existence.

But the photography of sequential movement, chronophotography, for non-cinematographic purposes, did not stop. If cinematography strung separate movements together and showed them as a seamless whole, comfortingly like real life, then chronophotography showed each movement as an arrested entity, invisible motion such as the human eye could never see. In the photographs of Arthur C. Banfield, drops of milk splashing and dogs and cats jumping are frozen in motion using the bright light of electrical sparks created from Leyden jars. Banfield's photographs, still preserved in their original frames with exhibition labels, toured the Western world in the first decade of the twentieth century and featured prominently in exhibition reviews of the time, but have since been undeservedly neglected.

The later experimentation of Harold Edgerton (1903–1990) in the 1930s whilst working at Massachusetts Institute of Technology led to his subsequent invention of an electronic flash unit, which he named the stroboscope. Initially designed to examine machinery in rapid motion, Edgerton allied his invention to photography and began to produce scientific photographs that crossed the boundaries into art. His use of the brilliant colour saturation of the dye transfer printing process meant that his frozen glimpses of bullets splaying through bright red apples, acid yellow lemons and all manner of other objects, the creamy coronet of splashing milk on a blood red background, the ovoid shape assumed by a spherical golf ball when hit by a club, have given his scientific observations worldwide cachet, possibly the perfect symbiosis of the Art and Science of photography.

OPPOSITE & BELOW | The first commercial photographic printing works was set up in early 1844 in Reading, Berkshire by Nicolaas Henneman with Fox Talbot's financial support, with the aim of mass producing salted paper prints for sale. By June of that year, the first part of *The Pencil of Nature*, illustrated with five photographs tipped in by hand, was published. Five more parts followed, illustrated with photographs printed at Reading from Talbot's negatives. Each print was accompanied by an extended caption concerning the technical, aesthetic and future possibilities of photography. However the publications did not sell well enough to make the Reading Establishment profitable and it was closed after three years.

These two panoramic negatives (opposite) and the prints from them (below) show Talbot (lower negative, far left) taking a portrait with the largest camera, while other photographers copy statuary and paintings. Sun-printing is also taking place on the racks.

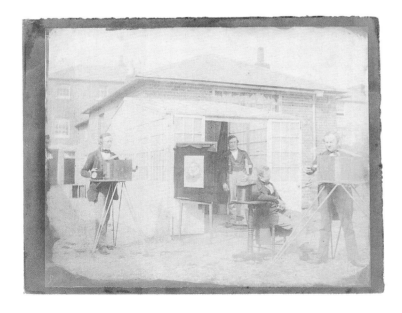
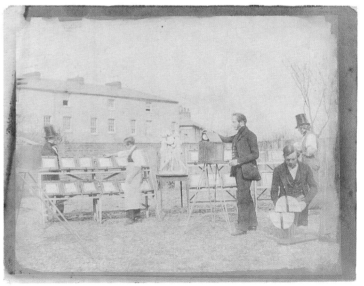

OPPOSITE | Dr Hugh Welch Diamond mastered Talbot's photogenic drawing process soon after it was announced in 1839 and was active in photography for around 20 years. He is well known for his portraits of female mental patients in his care, including this one dating from 1855.

BELOW | Frederick Glendening was a staff photographer at St. Bartholomew's Hospital, London, where he took these photographs in the Outpatients Department between 1892 and 1894. The female patient on the left suffered from lateral curvature of the spine and is identified as Ellen Boran. The male patient with the same affliction is unidentified.

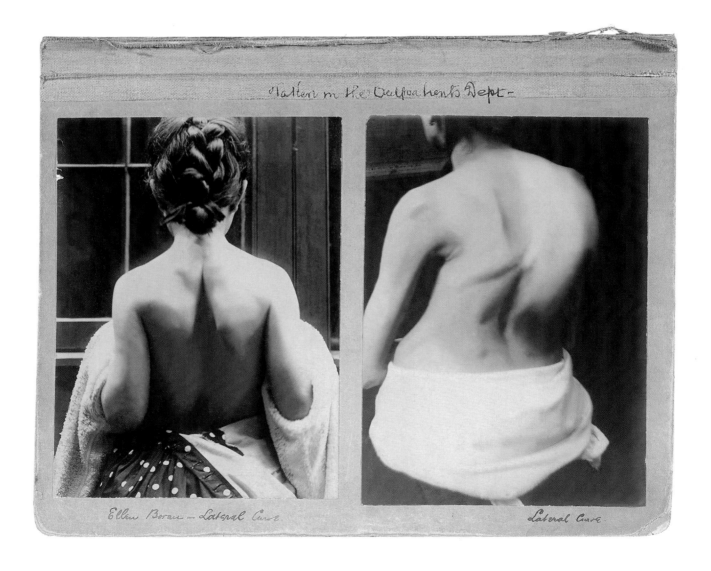

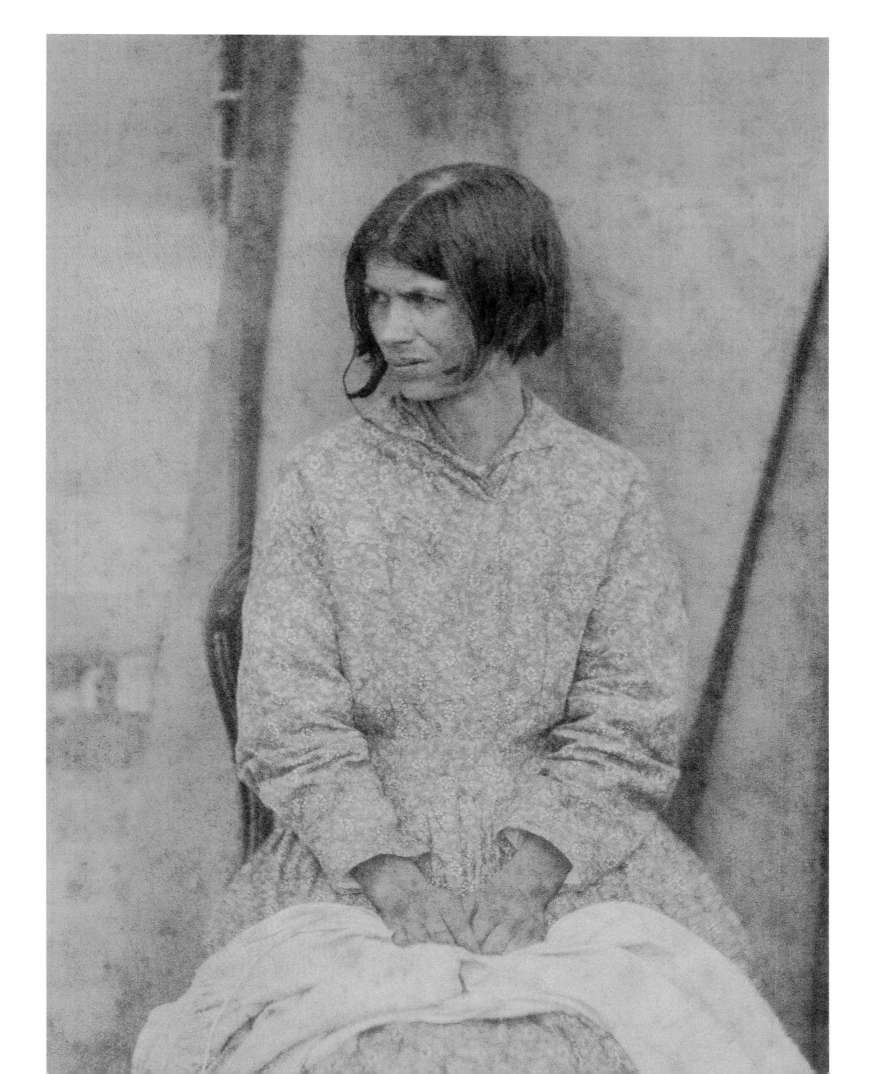

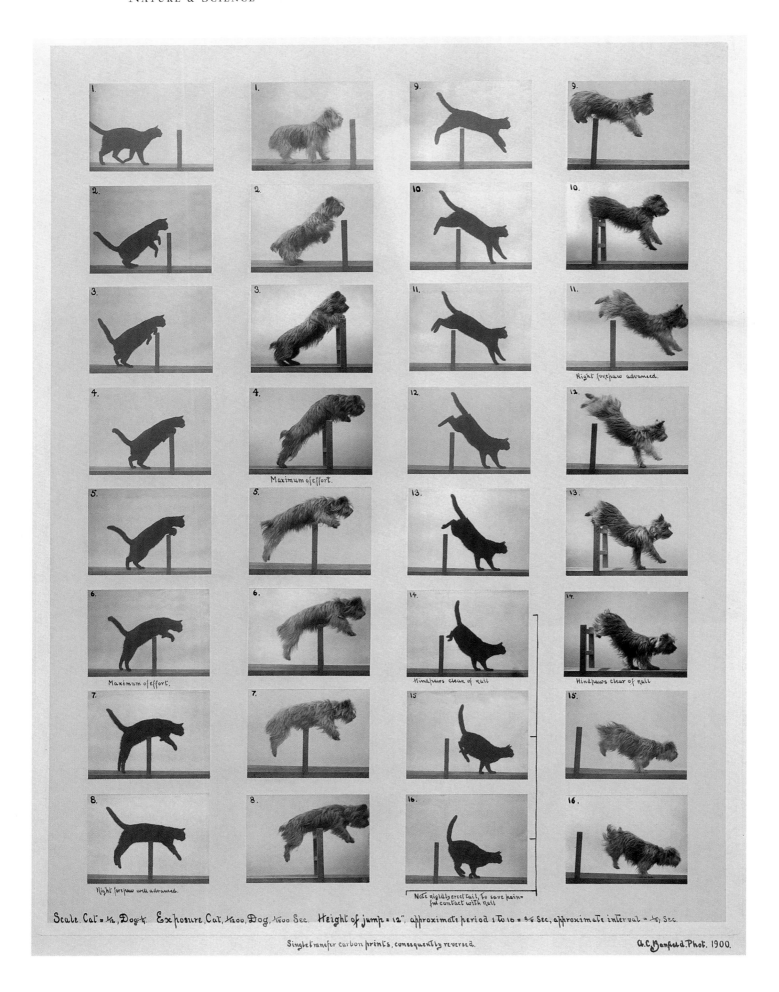

Scale Cat = ⅟₄, Dog ⅓. Exposure Cat, ⅟₂₀₀, Dog, ⅟₆₀₀ Sec. Height of jump = 12", approximate period 1 to 16 = ⅚ Sec, approximate interval = ⅟₁₆ Sec.

Single transfer carbon prints, consequently reversed.

A.C. Banfield. Phot. 1900.

OPPOSITE | Photographed by Arthur Banfield in 1900, these 32 images of a cat and dog jumping are scaled with the cat at one-twelfth and the dog at one-ninth actual size. Exposure times for the cat are one two-thousandth of a second, and for the dog one fifteen-hundredth of a second. The height of the jump is 12 inches and the approximate period of time between image 1 and image 16 is two-fifths of a second, with an approximate interval between each image of one-thirty-seventh of a second. Handwritten underneath print no. 16 of the cat is the following wry comment: 'note rigidly erect tail to save painful contact with rail'.

BELOW | Not all Muybridge's studies for *Animal Locomotion* are concerned with recording rapid movement, as it seems that the contortionist here, photographed in 1887, has held some of his poses for several seconds. Muybridge may have been more interested in the figurative imagery of the contortionist's body and the way it semaphors across the page.

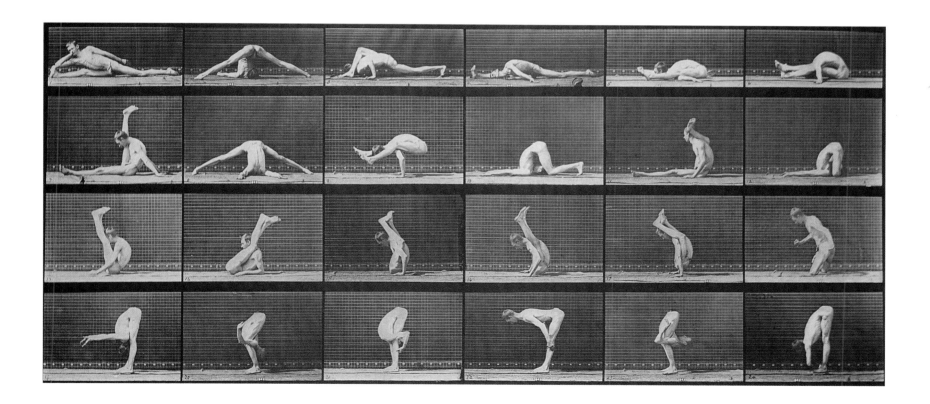

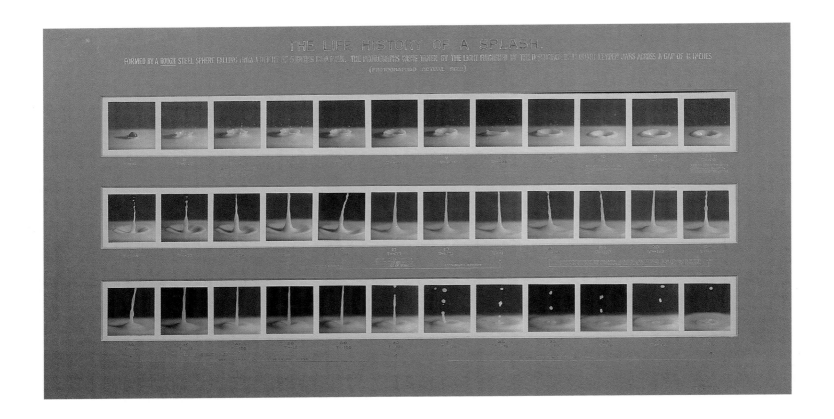

THE LIFE HISTORY OF A SPLASH.

FORMED BY A ROUGH STEEL SPHERE FALLING FROM A HEIGHT OF 5 INCHES INTO MILK. THE PHOTOGRAPHS WERE TAKEN BY THE LIGHT PRODUCED BY THE DISCHARGE OF 12 QUART LEYDEN JARS ACROSS A GAP OF 1⅛ INCHES
(PHOTOGRAPHED ACTUAL SIZE)

OPPOSITE | Dr Harold Edgerton lit his bullet photographs using speciality electronic flash units with a flash duration of one-millionth of a second. He said of his photographs that they enabled 'time itself to be chopped up into small bits and frozen so that it suits our needs and wishes.'

ABOVE | 'Life history of a splash' was taken by British photographer Arthur Banfield in 1900. The splash was formed by a rough steel sphere falling from a height of five inches into milk. The 36 photographs were taken by the light of the spark discharged by 12 quart Leyden jars across a gap of one and one-eighth inches. Banfield presented these images, set in a grey-blue mount with informative text added, within a polished wooden frame, and exhibited them in both the UK and the USA to great, and astounded, acclaim.

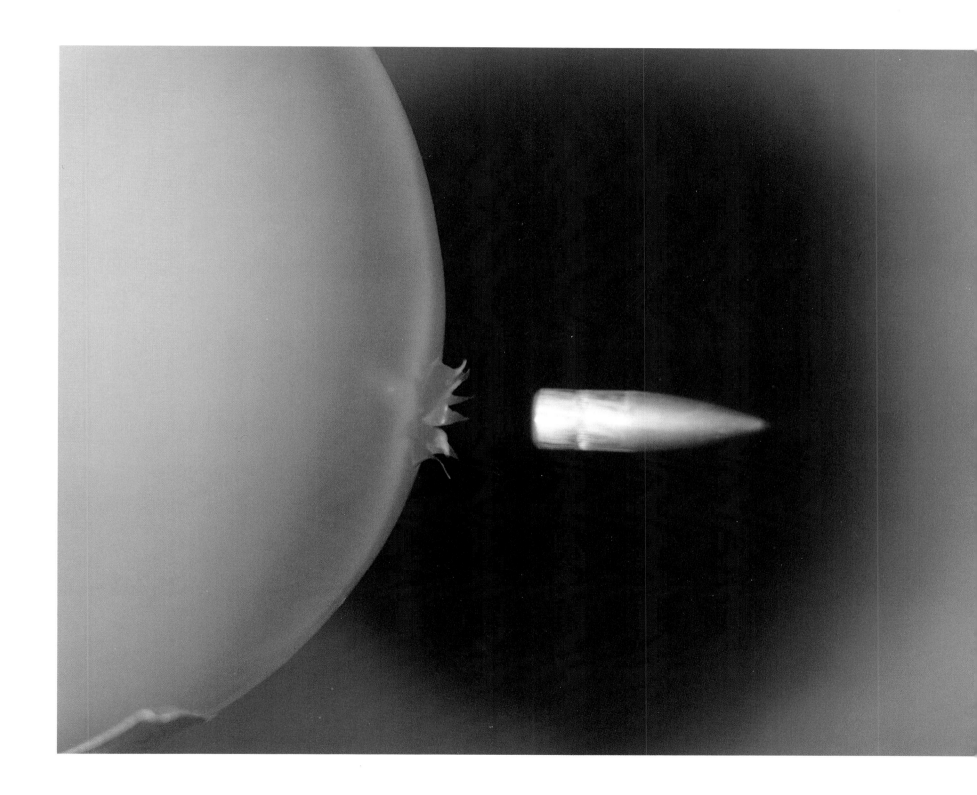

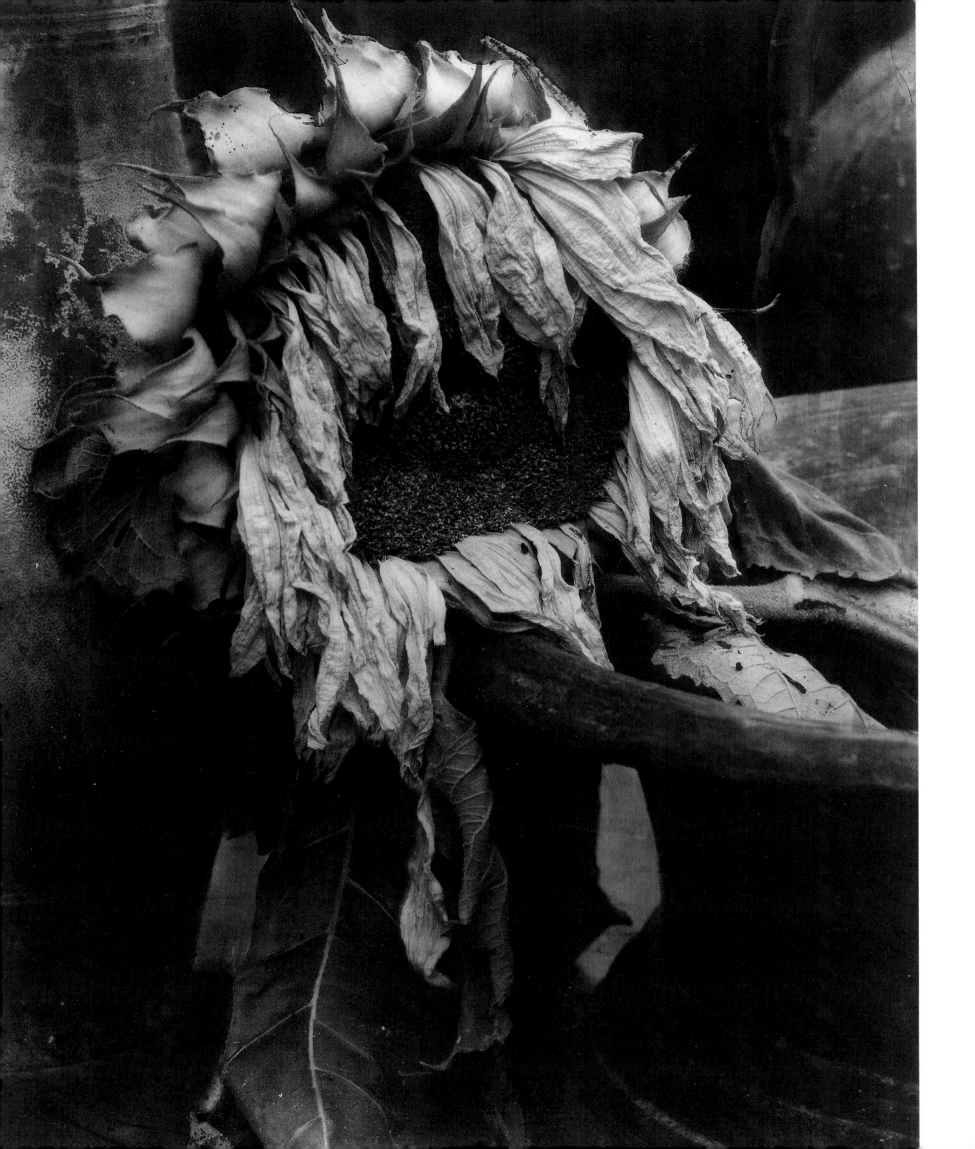

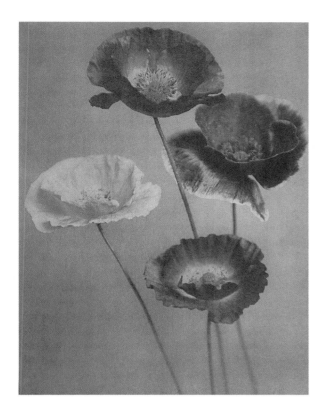 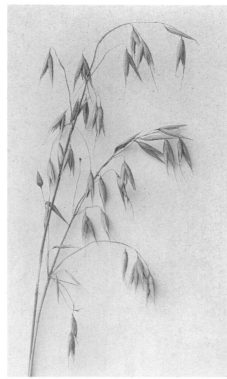 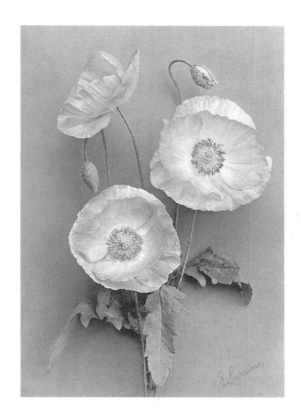

OPPOSITE | Edward Steichen's total obsession with photographing plant forms came as a cathartic period after his experiences as an aerial photographer in World War I and after the death of his friend, the sculptor, Rodin in 1917.

ABOVE LEFT | Carine Cadby found her subject matter in her garden, photographing grasses and weeds as well as flowers, such as these poppies taken in 1901. 'My aim in flower photography is to represent flowers in such a way that emphasis is given to their forms, and the loss of colour to a certain extent mitigated', she wrote in the May 1899 issue of *Photogram*.

ABOVE CENTRE & ABOVE RIGHT | Edward Seymour spent most of his photographic life capturing the evanescent beauty of flowers and fruit and experimented with every printing process at his disposal. He produced exquisite and delicately detailed work, and was at his most productive between 1904 and 1915, when he photographed these poppies and oat stems.

OPPOSITE | Asahachi Kono was a member of the Japanese Pictorialists of California and worked as a retoucher in the photography department at RKO Radio Pictures. He photographed in the US during the 1920s and 30s but returned to Japan before the outbreak of World War II. This photograph shows a Japanese delicacy of touch as do Kono's other more abstract works.

ABOVE | Albert Renger-Patzsch's book of a hundred photographs, *Die Welt ist Schön* (The World is Beautiful), was published in Munich in 1928 and included these two images. It was regarded as a revolution in photography because the images owed nothing to art, or manipulation, or fancy printing, but they owed everything to the 'consciousness' of the camera, to the hidden order of details.

OPPOSITE | Stanley Crook's bird photographs, many of them of owls, tend to anthropomorphise the birds. Through his lens they take on human characteristics whilst still retaining their avian credentials. Crook became a Member, Associate and Fellow of the RPS in the same year, 1931. His photographs are mainly taken around Clitheroe in Lancashire where he lived. These two young tawny owls were photographed by him *circa* 1930.

BELOW LEFT | The works of British photographer Harold Arthur Hems (1921–) are well represented in the Nature Conservancy Council Collection at the RPS. Taken in 1960, this photograph of spawned-out frogs lying exhausted in a mass of spawn has a sort of *louche* charm to it.

BELOW RIGHT | It is not known if Baron Adolph de Meyer was a keen fisherman or, if not, how he came upon these four fresh brown river trout, still bright-eyed and firm finned, photographed *in situ* on the river bank. This Autochrome was taken in 1908, a year after the process made its debut.

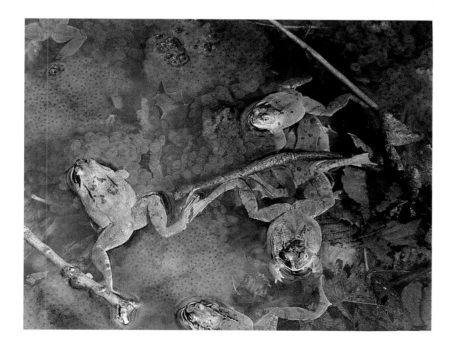

OPPOSITE | John Dillwyn Llewelyn married Emma Thomasina Talbot, a cousin of Fox Talbot, and their daughter, Thereza Mary, married Nevil Story-Maskelyne, another photographer, thus perpetuating their own photographic dynasty. Llewlyn invented his own oxymel process, of which this photograph is an example. Apart from his still life studies of stuffed animals in sylvan settings, he made extensive and loving photographic records of his family.

ABOVE | Richard, the elder of the two Kearton Brothers, introduced the 'hide' method of bird-watching and photographing. Noticing that birds ignored other animals, the brothers draped themselves in cow and sheep skins, often with hilarious results, as these two photographs from 1899 and 1900 attest. Cherry, who in 1905 made the first aerial photographic record of London from a balloon, seems to have been as inventive as his brother where nature and wildlife photography was concerned, and between them the brothers did much to popularise natural history in Britain.

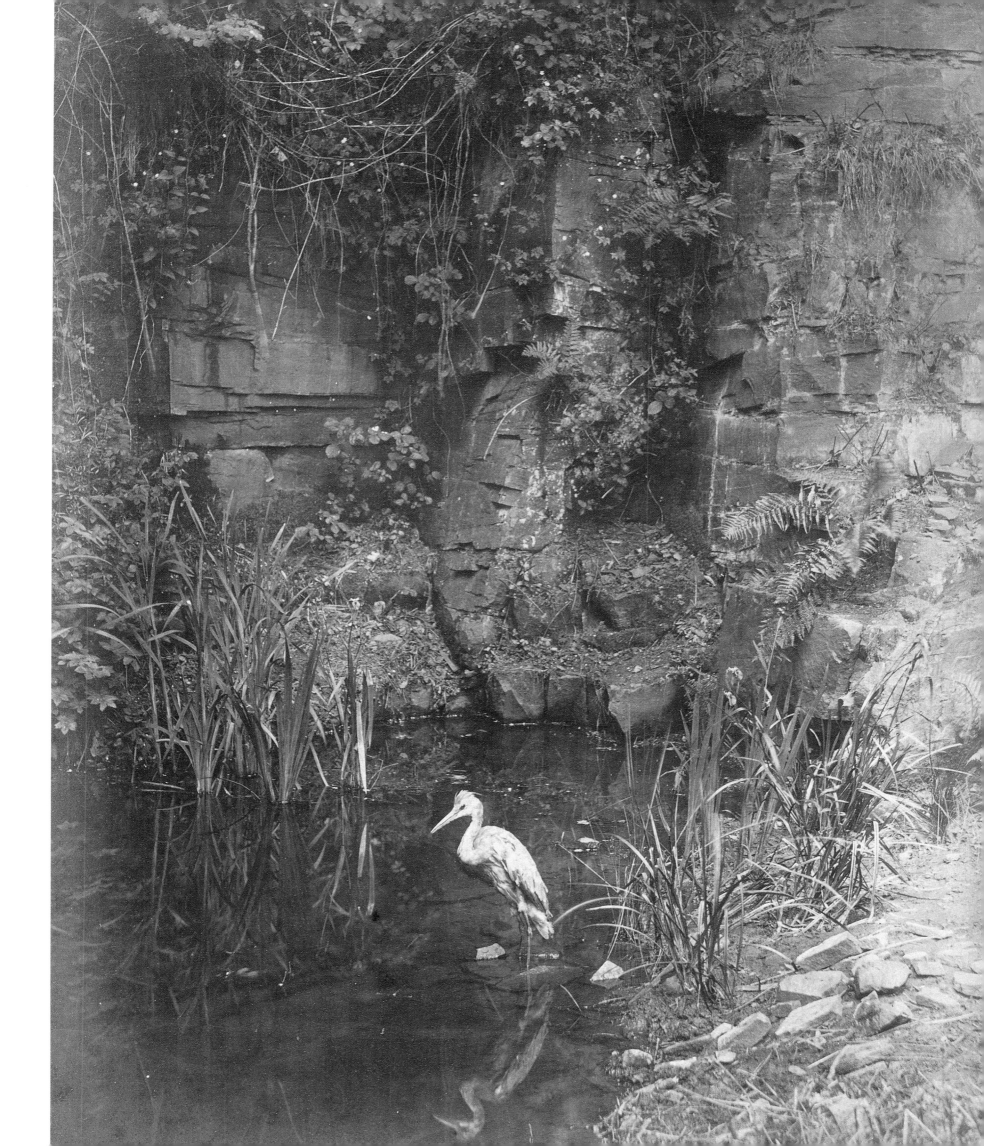

OPPOSITE | This anonymous photograph of the hairs on the wing of a
house fly was taken in 1900 at 450-times magnification, with a 30-inch camera
extension and a 12-second exposure. The photographer has rendered a poten-
tially unphotogenic, indeed repulsive, subject into a photograph of great beauty
which shows the economy and defined structure of nature's design.

BELOW | Another anonymous photograph of the same date, this time of
the sucking tubes on the tongue of a blowfly. This 300-times magnification
was taken with a 27-inch camera extension and a 5-minute exposure.

ART

V.

OPPOSITE | Wilhelm von Gloeden, an art historian, moved to Sicily from Germany for health reasons in 1877–8 and learned photography from a cousin in Naples. His photographs of naturalistic youthful male nudes, like this one, arranged in pseudo-classical poses, have an obvious homo-erotic content and sold well. In 1906 he was visited by Alvin Langdon Coburn, who wrote enthusiastically about the meeting to his relative in Boston, Fred Holland Day.

ON 31 JANUARY 1839, WHF TALBOT'S PAPER DESCRIBING his photographic discoveries, 'Some Account of the Art of Photogenic Drawing', was read to The Royal Society. In it Talbot listed some of the potential applications of the new medium of photography, modestly stating: 'to the traveller in distant lands, who is ignorant, as too many are, of the art of drawing, this little invention [photography] may prove of real service; and even to the artist himself, however skilful he may be'.

Talbot saw photography as a recording device, as a tool to aid artists, both unskilled artists like himself who had previously had no other satisfactory method of registering an image, as well as skilled artists, who could use a photograph as an *aide-mémoire* and time-saver. But even at this very early stage in its existence, he saw photography as an art form in its own right.

The close links between art and photography were rapidly realised over the next few years. Fourteen years after Talbot's paper, The Photographic Society (later The Royal Photographic Society) was founded by Roger Fenton and others for the 'promotion of the Art and Science of Photography, by the interchange of thought and experience amongst Photographers'. The history of the Society's Collection, like the history of the Society itself, reflects the struggles, the wars and truces that this spirited 'interchange of thought and experience' between artists and scientists brought about. From 1925–55, RPS Curator John Dudley Johnston swung the acquisitions policy and the emphasis of the RPS Collection from its previous largely scientific and technical bent wholly behind art and Pictorial photography and this remains its solid core today.

The Société Française de Photographie, established in Paris in 1854, had a similar mission statement, declaring itself 'an artistic and scientific association of men studying photography'. Its membership, like that of the Photographic Society of London, encouraged a mix of professions: painters turned photographers like Gustave le Gray (1820–1882), Eugène Durieu (1800–1874), a lawyer, Henri-Victor Regnault (1810–1878), a physicist and director of the Sèvres porcelain factory, Viscount Onesipe-Gonsalve Aguado de las Marismas

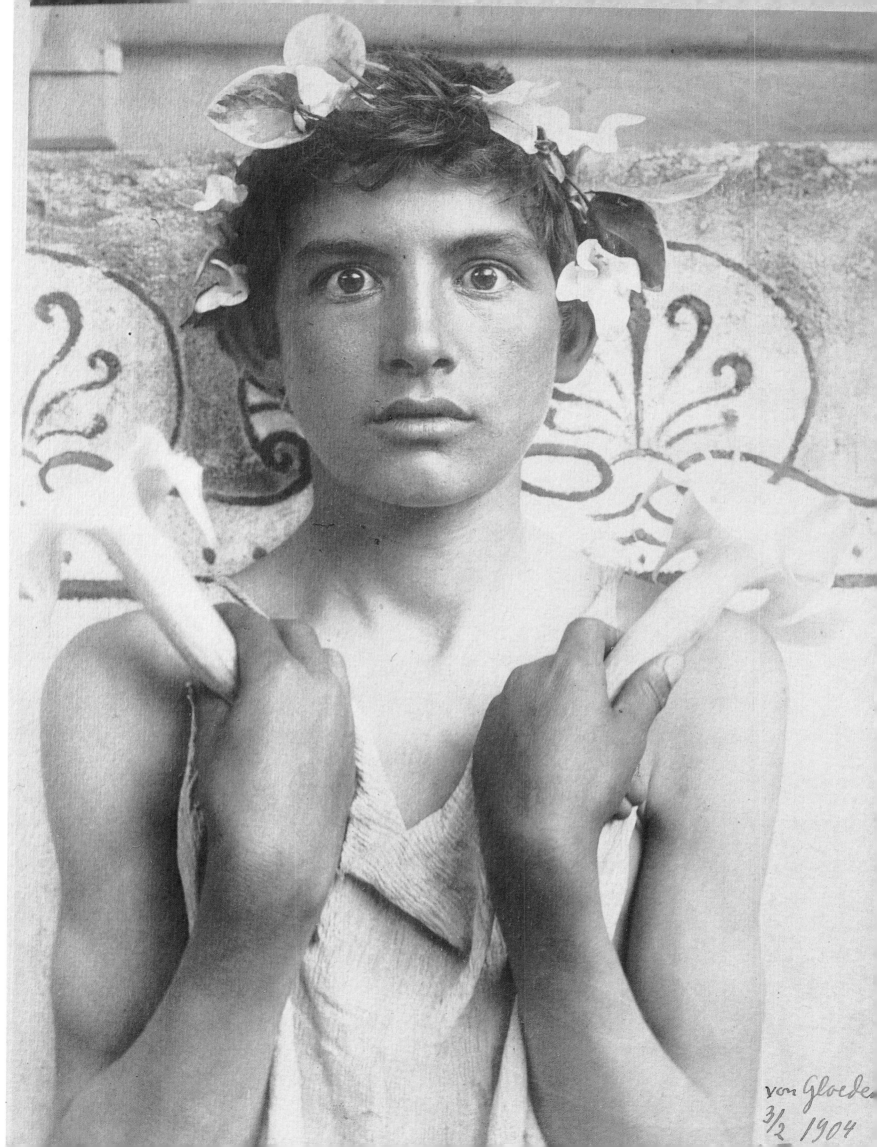

von Gloede
3/2 1904

OPPOSITE | A stunning gothic photograph from Henry Peach Robinson dated 1866. Two lines of a poem are written on the photograph's mount: 'They sleep in sheltered rest/Like helpless birds in the warm nest'. These foreboding lines from Malcolm Arnold's *Tristan and Iseult* are enacted by Robinson's own children Edith and Ralph Winwood. This, Robinson's best photograph, whilst still retaining his usual sentimental trademarks, overrides these with elements of fear and dread, evoking an uneasy emotional charge.

(1831–1893) and his brother Olympe (1827–1894), wealthy aristocrats. Unlike its British counterpart, it does not seem to have welcomed women into its ranks.

Practically, as in Talbot's paper, photography was an aid to the actual act of creating art, and a whole industry of supplying photographic studies for artists use mushroomed in the nineteenth century. Oscar Gustav Rejlander believed that photography would make painters better artists and more careful draughtsmen. Whilst photographs of models, especially nude female models, may sometimes have served a double purpose, as both art and soft pornography, they were undoubtedly cheaper and more practical for the artist to use than paying a model to pose for several days. Many were taken specifically for use by artists, such as Rejlander's series of artists' models and genre photographs, but are nonetheless impressive in their own right.

Nineteenth-century photographers also sold study photographs, both general and detailed, of landscape, architecture, rural scenes, seascapes, cloudscapes, children and animals – in fact, whatever was required by the artist to create his or her painting. Initially, many artists refused to acknowledge any debt to photography although some, like Lawrence Alma Tadema, accumulated large private collections from which they painted. Working from the product of another man's vision, a photograph pinned up next to the canvas, may have seemed like painting by numbers, but eventually many nineteenth-century artists took up the camera themselves, most successfully Degas.

If the new-found portability of of the Society itself, reflects the struggles, the wars and truces that this spirited 'interchange of thought and experience' between artists and scientists brought about. From 1925–55, RPS Curator John Dudley Johnston swung the acquisitions policy and ththe twentieth century, Thomas Eakins, Edward J. Steichen, Alvin Langdon Coburn, Constantin Brancusi, Pablo Picasso, Henri Cartier-Bresson and David Hockney have worked easily in several mediums, fulfilling Stieglitz's belief that a true artist could produce art using any medium.

In its earliest years, photography was extensively used to reproduce existing art, whether paintings, drawings or sculpture. Albums of photographs of treasures held at the Uffizi, the Vatican, the Louvre, the National Gallery, the British Museum and other institutions were produced throughout the nineteenth century. Companies which specialised in art reproduction like Leonida Caldesi in London, Fratelli Alinari in Florence, Bisson Frères in Paris, Hanfstaengl in Munich and Gustav Schauer in Berlin were set up to cater to this growing market.

Loose prints were also sold, so that a reproduction of Botticelli's *Birth of Venus* or a favourite Victorian painting of the day could be pasted into the family album next to the cartes-de-visite of relatives. The only way to have seen great art works previously was to travel to where they were hung or see them reproduced as engravings and lithographs. Photography liberated and popularised art, albeit in shades of brown and cream, until the advent of colour photography in the twentieth century.

The teasing question about whether photography was an independent art in its own right seems not to have bothered Talbot at all. He knew it was, and often referred to it as a 'new' art. Today the arguments about photography's status as an art form seem irrelevant. The relationship between photography and art has seen periods of close rapprochement as well as angry estrangement, but a mutual respect for the differences as well as an increased awareness of the similarities seems to be the outcome. Witness also the increasing use of photography by 'serious' artists and the influence of the auction houses in emphasising the value of certain photographs by treating them as fine art. The irony is that photography, invented as an infinitely reproducible medium, is supposedly gaining legitimacy and esteem through its uniqueness and its monetary value. Photography undoubtedly produces art, as all the photographs in this book show. But then photography also produces social documents, snapshots, communication, medical records, X-rays, film, television and many other manifestations. Its diverse possibilities are photography's greatest strength.

The link between photography and art which is represented most strongly in the RPS Collection is in the making of photographs that mimic and are heavily influenced by fine art: in image composition, as in the case of Roger Fenton's still lifes; in content, as in the work of Julia Margaret Cameron, H.P. Robinson and Fred Holland Day; and in physical appearance, as in the work of Pictorial and Secessionist photographers. The latter was achieved by choosing a suitably 'artistic' subject matter, such as Richard Polak's 1914 photograph of the artist and his model set in a re-created Dutch interior, or by representing the subject matter in a visually and apparently non-photographic way. A variety of manipulative photographic processes – such as gum bichromate, bromoil transfer, platinum – could be used to achieve the appearance of charcoal drawings, oil paintings or Impressionist pointillism. Photographs by Robert Demachy and Frank Eugene are examples.

In the mid-nineteenth century, the British art photographer's subject matter was largely the same as that which influenced the Pre-Raphaelite painters. Biblical, literary, poetic, allegorical and mythical scenes with a strong narrative element were important, as there were few alternative photographic processes available until the 1880s to make the photograph look like anything other than a photograph – in this case, most often, a brown albumen photograph. The suggestion of fine art had therefore to come from the subject matter, the handling of lighting and composition and the presentation. The emphasis on constructed narratives and *tableaux vivants* seems, on the whole, to be a peculiarly British thing.

This is most evident in the work of Julia Margaret Cameron (1815–1879), who was inspired by the paintings of Perugino and Raphael, by the Pre-Raphaelite painters that she met at her sister's salon in London's Holland Park, by the literary works of Dante, Milton and Shakespeare, by the Bible and by British and European myths and legends. Cameron's stunning whole head portraits, cherubs and madonnas of the 1860s evoke the mood of Renaissance and Pre-Raphaelite art in their emotional content and inspired lighting. They rely on this powerful distillation of intensity rather than on her mastery of technique, often passionately,

OPPOSITE | Oscar Gustav Rejlander worked from two negatives to create this head of John the Baptist from the Biblical story of Salome. He used the first negative to 'behead' his model and reassemble him, after much detailed darkroom work, on the second of a serving plate. Queen Victoria bought a copy of this photograph from Rejlander in 1869, along with 21 other prints.

dashingly imperfect. As her photographic technique improved in her later genre studies of the 1870s, influenced more by literature than by art, so the emotional power of her photographs diminished.

Many early photographers were initially painters and used photography to aid their painting, as in the case of David Octavius Hill, working with Robert Adamson in the mid-1840s. He used his stunning photographic portraits as references for his not-so-stunning paintings, and was heavily influenced by the painterly composition and lighting of Rembrandt. Many discovered they were better photographers than painters and kept the latter as a private pursuit whilst concentrating on the former as a professional career. Roger Fenton, Oscar Gustav Rejlander, William Lake Price, Henry Peach Robinson and Samuel Bourne were all competent artists but made a better living from photography, spectacularly so in the cases of Robinson and Bourne.

Rejlander made one large composite photograph, 'The Two Ways of Life' in 1857, but he showed little enthusiasm for ever doing it again. Robinson, however, the so-called 'godfather of Pictorialism' was so enthused by the possibilities of combination printing from several glass negatives that he produced a new 'composite' picture every year and constructed these photographs into art, although the actual separate elements and process of construction are often of more interest and of a rarer beauty than the end product, which can seem mundane and overly sentimental by comparison.

Whilst the subject matter for such photographers was invariably figure or narrative based, another popular tradition of fine art photography in the 1850s was the still life, a subject largely ignored by the Pre-Raphaelites. The photographic still life was inspired by the eighteenth-century tradition of European, especially Dutch, painting, produced largely for wealthy patrons to show aristocratic wealth and possessions. For the photographer, still-life compositions had the advantage of immobility during long exposures and enabled a broad degree of experimentation. William Collie, John Dillwyn Llewlyn, William Sherlock, Dr. Hugh Welch Diamond and others produced charming still-life studies in the 1850s, usually of dead game,

OPPOSITE | Baron Adolph de Meyer was initially smitten with the artistic possibilities of the Autochrome and, like Steichen, learned the process from the Lumière Brothers themselves, but he soon stopped using it, probably as early as 1909. His Autochromes were exhibited in Paris in 1908, the same year he took this still life. Its jewel-like colours are still vibrant after almost 100 years.

flowers, or a mixture of class-establishing artefacts, but it was not until Roger Fenton turned his attention to this particular genre that its fullest possibilities were realised.

Fenton took a series of carefully planned and composed still-life photographs from 1858–60, using three different cameras in large, medium and stereo formats. Whilst many of the resulting images reflect 'painterly' Flemish and French inspiration from previous centuries, others are purely photographic and simplistic in their composition. They are early examples of the pure photography that Stieglitz was to encourage half a century later. The 50 or so Fenton still-life prints in the RPS Collection show a variety of styles within the genre. They range from dense and intricate 'contained' compositions – marrying the elemental forms of fruit and flowers with exquisite and expensive man-made *objets trouvés*, Chinese caskets, cut-glass decanters, silver goblets and carved alabaster putti, compositions very much of their time – to the stark and more abstract simplicity of bunches of grapes, photographed purely for their shape, form, pattern and texture, compositions very much of the future. Still lifes by Adolphe Braun (1812–1877) and Charles Aubry (1811–1877) taken around the same time in France tend to be more natural, less arranged than Fenton's compositions, concentrating on flowers, or, in Aubry's case, exquisitely lit plant forms, leaves and grasses.

The advent of alternative photographic processes in the early years of the twentieth century brought renewed interest in still-life photography. The infinite tonal possibilities of platinum printing and the advent of colour photography, most especially in the work of Baron Adolph de Meyer, Clarence H. White, and a plethora of avid Autochromists and tri-colour carbonists, produced classical, natural and, in the case of Madame Yevonde and John Hinde, quite surreal still lifes.

By the late-nineteenth and early-twentieth centuries, subject matter and compositional style had shifted away from the precise detail and constructed narratives of the Pre-Raphaelites and from the Gothic Pictorialism of the Romantic watercolour era to coalesce with the concerns of the art movements of the day. These were

most notably the Barbizon School, Impressionism, Symbolism and Japonisme. From 1900 onwards, the artistic impulse stemmed from a firm belief in the subjectivity of the inner soul, and from the photographer's confidence to trust in his or her own vision.

Generally, in its wish to be accepted as an independent art form, photography's emphasis at the turn of the twentieth century shifted to the mood created by manipulation of photographic process. This trend was spurred by an explosion of new processes on the market, encompassing platinum, photogravure, autochromes, gum bichromate and bromoil. Photography was finding its own language and creating new tools, a new vocabulary, with which to express it. With this development came a new vision.

The interplay between photography and art came to a head in the 30-year period from 1885–1915 with the initial momentum coming from P. H. Emerson in 1886. Emerson's 'naturalistic' photographs of people and landscapes of the Norfolk Broads – influenced by Constable, by the Barbizon School of painting of Corot and Millet, by Whistler, by Hermann von Helmholtz's theory of selective vision (cameras provide more definition than the human eye, thus softer, longer focal lengths should be used to replicate natural vision and obscure extraneous detail), and printed using the subtle tonal variations of platinotype – were hugely influential both in Britain and internationally. There was no doubt about the art inherent in Emerson's photography, which was to profoundly influence the Secessionists, especially Stieglitz.

By the 1890s, photographers concerned that photography should be regarded as an art form in its own right rather than as a purely mimetic medium began to form into 'Secession' groups, fragmenting away from

OPPOSITE | German Johann Carl Enslen began experimenting with photography in 1839, at the age of 80, after reading reports of W.H.F. Talbot's experiments in England. This photogenic drawing from the same year was sent to Talbot for his opinion and remained in his collection, being attributed to him until some few years ago. The line drawing of Christ's head used must have been from a photographic negative as it is a positive in this image. Enslen's collection of experimental photography, held by a museum in Lubeck, was largely destroyed by fire during World War II.

the more orthodox and established bodies of photographers, like the RPS in London, the Société Française de Photographie in Paris and the Camera Clubs of New York and Vienna. They wished to disassociate themselves from two other vogues of photography. One was the apparently random product of the Kodak amateur snapshotter. (Kodak cameras first went on sale in 1888 and Kodak Brownie cameras cost only five shillings or $1.00 by 1900). The second was the emphasis on perfect objectivity and sterile technique, with low artistic and subjective input, as promulgated by the establishment organisations.

In effect, Secession photographers represented the pictorial and subjective Art versus the technological and objective Science of photography. This melting pot of talent, ego and hyperbole produced an outpouring of photography using ever-more elaborate manipulative photographic techniques like platinum, gum bichromate and carbon, etching and scratching negatives. Photographers produced limited editions of prints and then destroyed the negatives. Of course, in reality, many Secessionist photographers produced achingly bad images whilst many of the supposed 'old guard' produced great ones. Some photographers, like Frederick H. Evans, Frank Meadow Sutcliffe, Alvin Langdon Coburn and Gertrude Käsebier worked happily in both camps.

At the same time, a small group of European photographers, like the Dutchman Richard Polak and the Italians Guido Rey and Arturo Tagliaferro, clung to a vision of photographic re-creation of other previous art worlds based on Dutch and Italian narrative interior paintings. With hindsight, their photographs now look strangely, eerily Post-Modern rather than Pictorial.

The Linked Ring Brotherhood was formed in London in 1892, the Photo-Club de Paris in 1894, Das Kleeblatt (The Clover Leaf) in Vienna in 1896 and the Photo-Secession in New York in 1902. The Secessionist photographers were not only younger, with more zealot mission than their peers, they could also write convincingly about their art and did so in articles, journals, and, eventually, from 1903–17, in their own periodical, *Camera Work*, the most beautiful and intelligent, but also the most self-indulgent, publication on

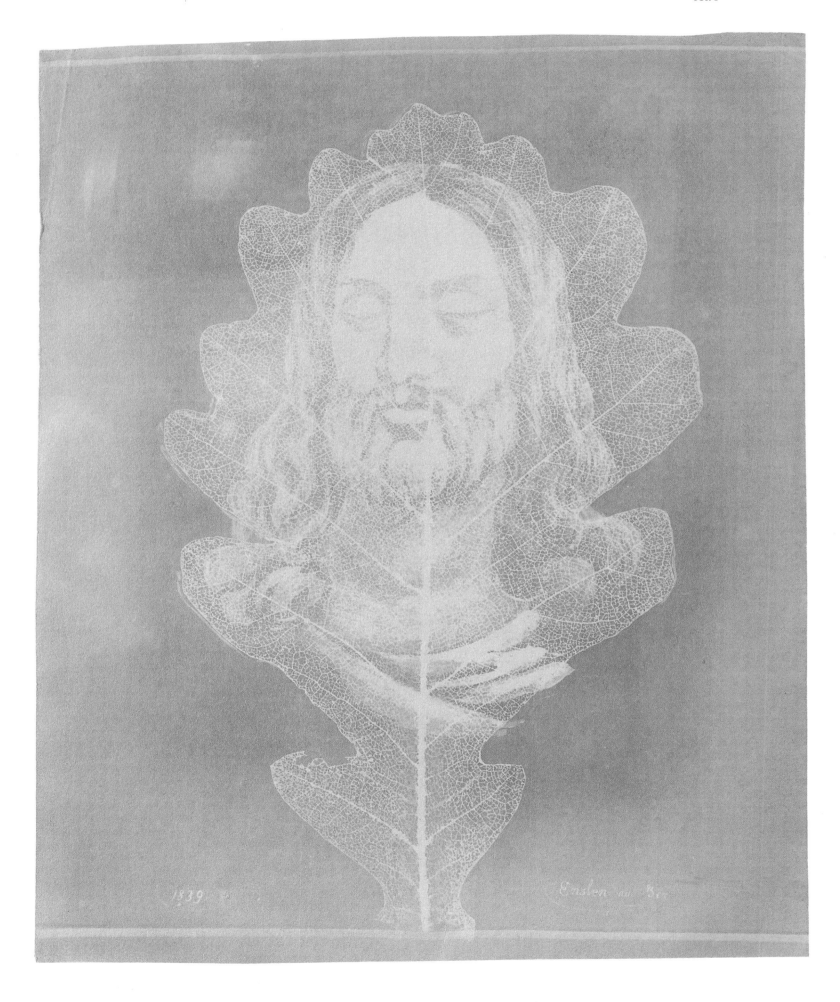

1839 Enslen aus Ber

photography ever produced. It was published, edited and financed by Alfred Stieglitz, who also opened a gallery, *291*, on Fifth Avenue in New York to give photography its own permanent venue. In the style of exhibitions established by The Linked Ring Brotherhood in London from 1893, photographs were simply framed and hung, well spaced, at eye level, setting standards of presentation which still endure. Whilst photographic exhibitions had been held regularly throughout Europe and the US during the nineteenth century, they tended to be large exhibitions of 500 or more works. Generally every inch of wall space was filled with photographs, often stacked six deep, with little attempt at spacing or selective grouping. Those submitting their photographs late had them hung either at ground or ceiling level. One-photographer shows were unusual unless held in the photographer's own studio. Julia Margaret Cameron rented private galleries in London (often just before Christmas in the hope of making extra sales) to show her photographs, all listed and priced in a catalogue. Through his exhibitions at *291*, Stieglitz helped to endow photography with a new intelligence.

In order to promulgate the cause of Pictorial photography as a contemporary art form, it was important that photographs were seen in a complementary setting. *Camera Work* often acted as an exhibition catalogue and also featured reviews of the exhibitions at *291* where Stieglitz hoped an informed public would buy photographs, thus bringing photography into the commercial mainstream. However, most of the photographs sold at *291* were bought by Stieglitz himself. Although Stieglitz began by practising and encouraging the labour-intensive form of manipulated Pictorial photographic production, he was able to assimilate and absorb

OPPOSITE | The simplicity of this drooping bloom with still-vibrant leaves makes it a strong and potent image. It dates from around 1848 and is a salted paper print from an album by William Collie, who photographed his native Jersey from 1847–52. Photographs of friends and colleagues are interspersed with landscapes and the occasional still life.

photography's other less tortuous and more immediate possibilities. He began to abandon Pictorialism. Instead he produced a purity and simplicity of vision and technique which eventually became known as 'straight photography'. This was the photography of the future, as exemplified by Paul Strand, whose photographs, printed brutally in strong black and white, were featured exclusively in the last issue of *Camera Work* in 1917 and in an exhibition at *291*.

Photography no longer had to prove itself as an art by copying painterly art. It was pure photography and that in itself was enough. In 1925, in one of a series of letters to John Dudley Johnston, Curator of the RPS, with whom Stieglitz had a good relationship (he was made an Honorary Fellow of the RPS in 1905 and was awarded the Society's Progress Medal, its highest distinction, in 1924), Stieglitz wrote: 'There is no such thing as progress or improvement in art. There is art or no art. There is nothing in between.'

The various Pictorialist and Secession groups eventually fragmented by 1910, owing to petty infighting and, for many, an over-stringent adherence to achieving painterly effects. But over an 18-year period, from 1892 to 1910, the photographic explosion produced work by talents as diverse as Fred Holland Day, Robert Demachy, Baron Adolph de Meyer, Gertrude Käsebier, Clarence H. White, Frank Eugene, Frederick H. Evans, Alfred Horsley Hinton, Heinrich Kühn, Theodor and Oskar Hofmeister, and its three shining stars, Alfred Stieglitz himself, Edward Steichen and Alvin Langdon Coburn. From this movement came the 'pure' photography of Paul Strand, Edward Weston and Ansel Adams.

Coburn spiralled off into Vorticism, producing the first totally abstract, non-subject photographs, whilst Steichen embraced the commercial world at Condé Nast. Clarence H. White set up a school of photography in 1910, producing students of the calibre of Laura Gilpin, Paul Outerbridge and Margaret Bourke-White. Stieglitz himself became the 'photographer's photographer'. Like Emerson 30 years earlier, his effect on photography was immense. After the shattering of the various Secession groups, his own photography

achieved the formalism and abstraction that he found in the work of his wife Georgia O'Keefe, in Rodin, Matisse and Picasso, all of whose work he showed in his gallery in New York, exhibiting painting, drawing, sculpture and photography side by side.

In the early years of the twentieth century, photography had found huge confidence and credibility, aided by a technical revolution. And, like other art forms, it soon began to diversify. Amateur photography exploded into a massive commercial market as first Kodak and then other manufacturers introduced cheaper and easier-to-use cameras. In the 1930s, Leica introduced the 35mm camera, and colour photography became more readily available to all after World War II.

The RPS, rather then attempt to collect examples from this rich diversity of photographic output, largely chose to follow the path of British and American Pictorial photography, thus ignoring what John Dudley Johnston termed the 'Modern Photography' of Man Ray, Moholy Nagy, Rodchenko and Kertész, which was being produced at the same time. Johnston was certainly well aware of the influence and importance of their work but chose instead to collect photographs by his contemporaries F.J. Mortimer, Fred Judge, Charles Job, Alexander Keighley, John and Agnes Warburg, amongst others, as well as important contemporary collections from Alvin Langdon Coburn, Frederick H. Evans, Fred Holland Day, Edward Steichen, Stieglitz himself and Linked Ring material. As decisions go, it can certainly be challenged in many respects but it follows though the strong Pictorial strand of photography that Johnston could trace back to Talbot. He had his own definitions of Art Photography, and of the history of photography, and consequently assembled a remarkable collection of photographs. At their best, they represent a flowering of an inventive British Pictorial domestic tradition, an interlinking and an integration of art and photography that is unique to the RPS Collection.

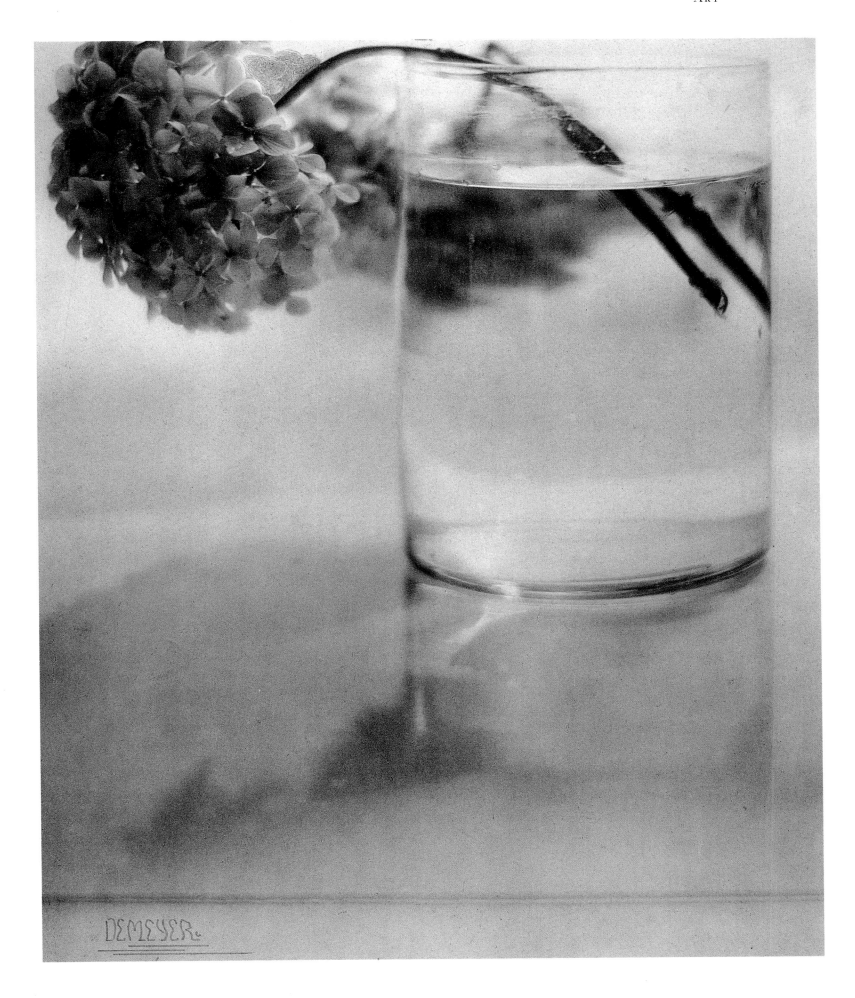

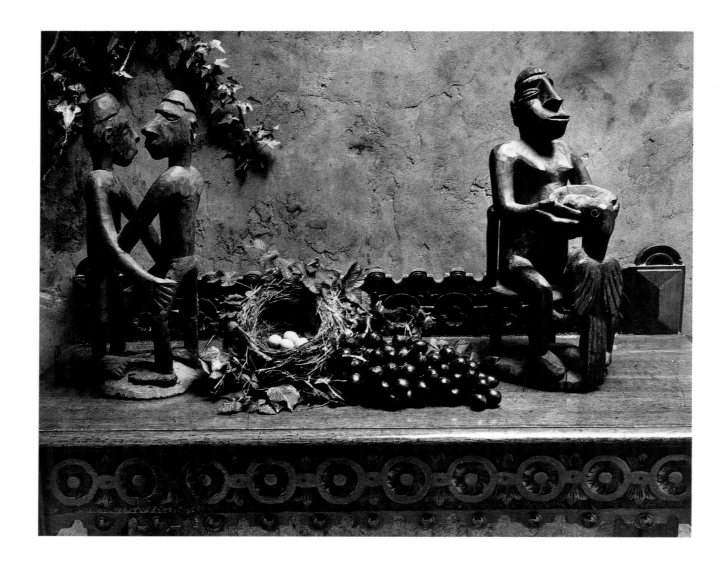

OPPOSITE | Roger Fenton abandoned photography in 1861, just after he had made an astounding series of still-life photographs, with which he reached technical and aesthetic perfection. Of the 60 or so of these rich gold-toned albumen prints in the RPS Collection, many are still in mint condition, such as this one entitled 'Flowers and Fruit'. The detail in each grain of pollen, each flower petal, in the bloom on each fruit skin, has never been bettered.

ABOVE | After two decades photographing war and its ensuing mayhem and misery in the trouble-spots of the world, the privacy and intimacy of Don McCullin's still-life work and landscapes have acted as a personal catharsis and have a stillness and calmness of purpose. Like Roger Fenton 130 years earlier, and whose still lifes he loves, McCullin's props come from near and far. In this 1991 still life, an abandoned bird's nest from his garden in Somerset is juxtaposed with statuettes collected from Irian Jaya in Indonesia.

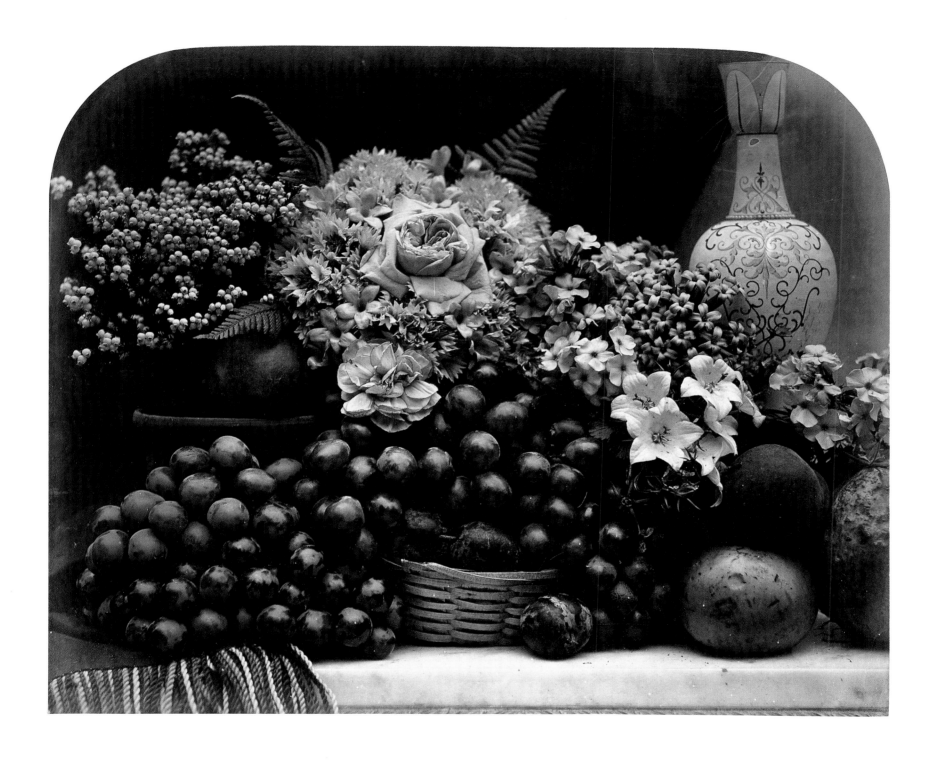

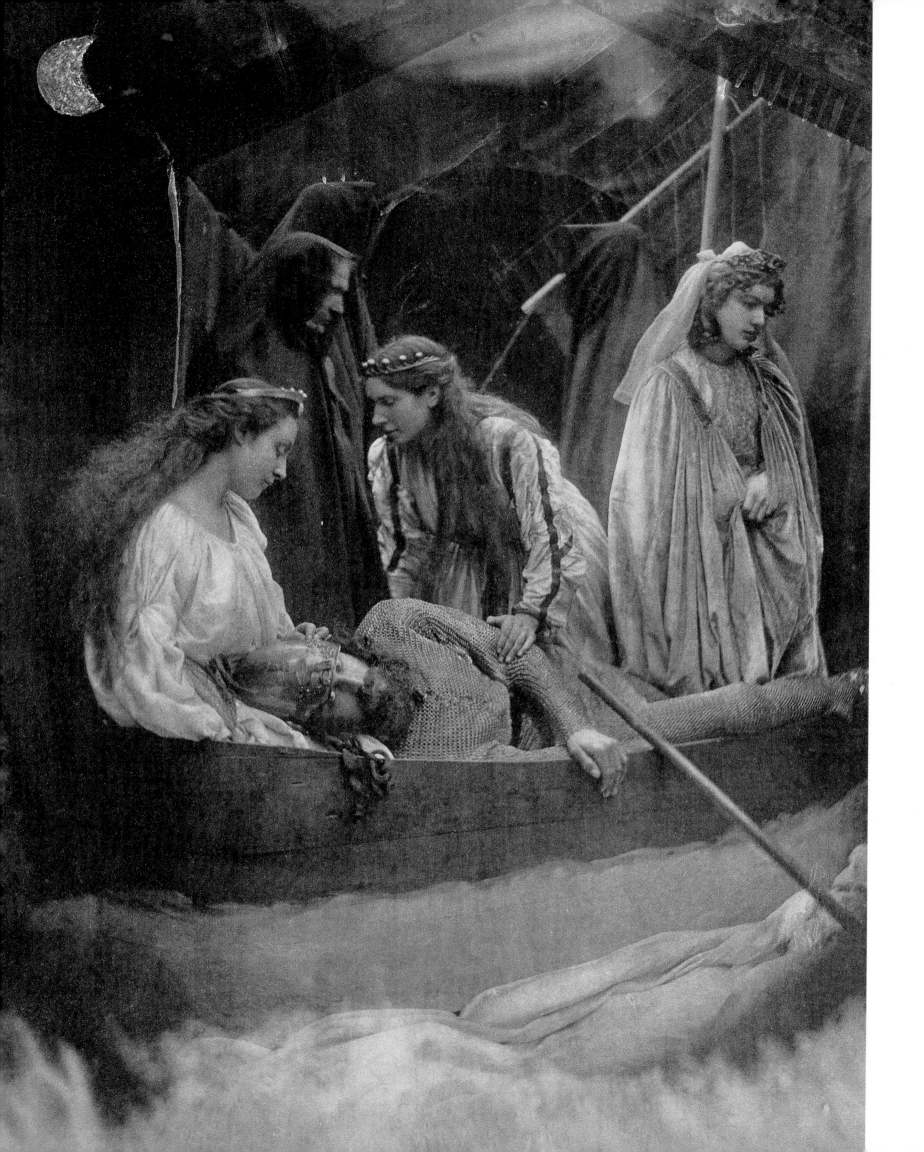

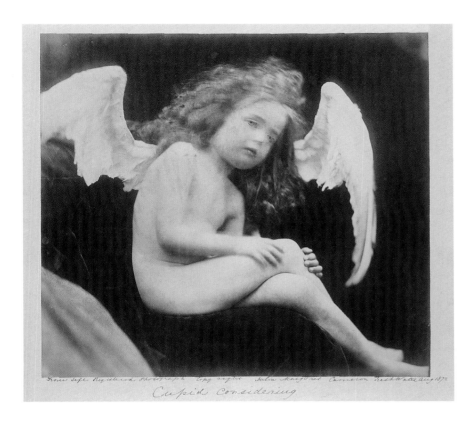

Cupid Considering

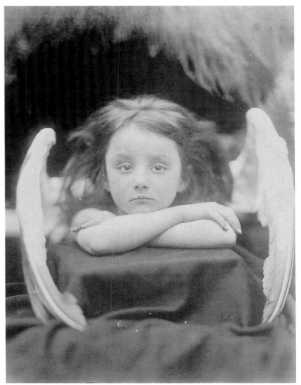

OPPOSITE | In 1874–5, Cameron produced two volumes of photographically illustrated versions of her neighbour Lord Tennyson's poems of Arthurian legends, *Idylls of the King*, selling for six guineas a set. This undertaking was not a financial success but enabled Cameron to pay homage to a much admired friend. This photograph, portraying the dying King Arthur, shows Cameron's hyperactive imagination running splendidly to riot.

ABOVE | The set of swan's wings that appear in both of these photographs by Julia Margaret Cameron were acquired from the local poulterer on the Isle of Wight. Photographed in 1872, the cupid on the left has been touchingly and amateurishly enhanced by a young Cameron descendant with smears of red and blue crayon on the lips and eyes respectively. The following year Cameron photographed her great-niece Laura Gurney (right) as an angel.

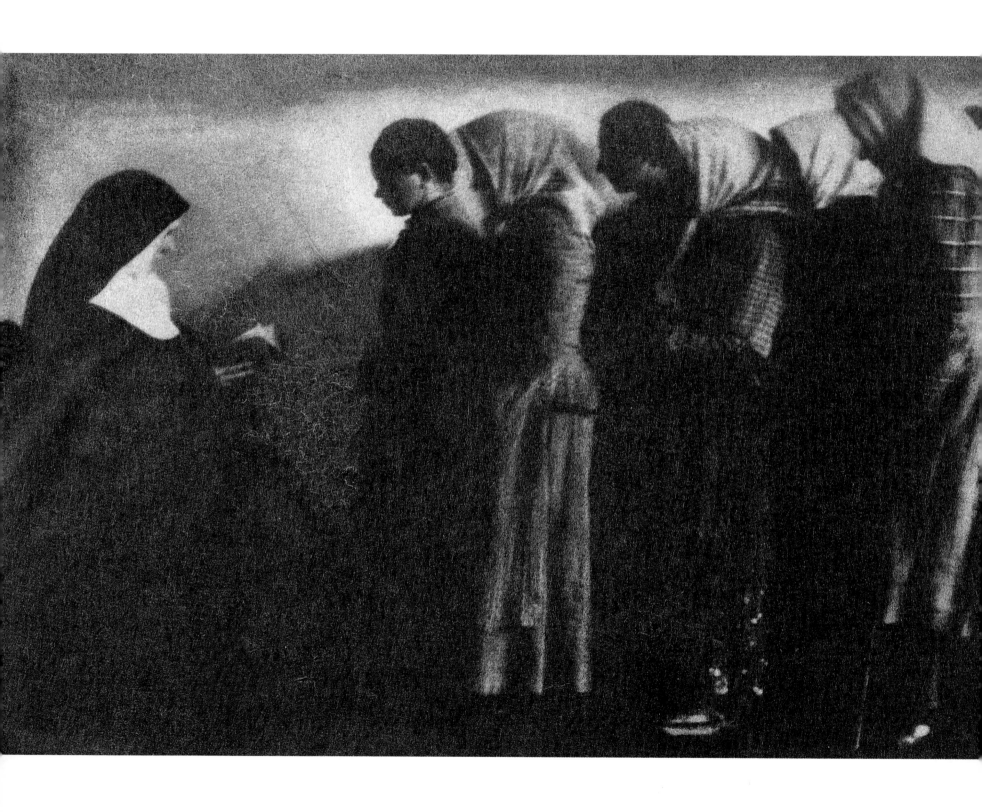

LEFT | Rudolf Koppitz's dreamy peasant studies conformed to 'Heimatphotographie', a genre exploring an image world of specifically Austrian character, expressing a love of the land and the people. Influenced by the paintings of Albin Egger-Lienz (1868–1926), Koppitz's work from this period in the 1920s fills the frame with darkly silhouetted and shadowy foreground figures against a bright and empty background.

BELOW | This (purposeful) double exposure of the Barry children was taken by Lewis Carroll in August 1863 in Whitby, Yorkshire, at the home of the Rev. William Keane (1818–1873). Of his visit Carroll wrote: 'We have had a very pleasant stay there. I took my camera to Mr. Keane's, and there photographed all his party, as well as Mrs. Barry's three, Johnnie, Loui, and Emily.'

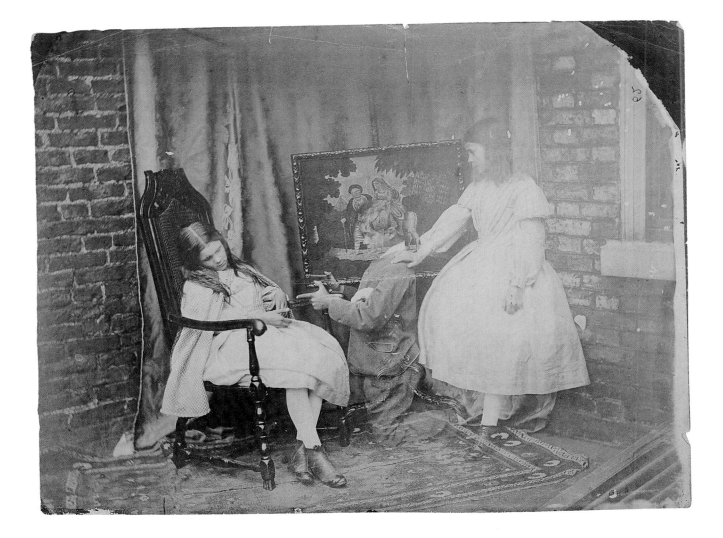

OPPOSITE | This atmospheric image was taken in the early 1920s by the
Austrian photographer Professor Rudolf Koppitz. The magical and mythical
properties of three women is a reccurring symbol in European art and
photography, also depicted by Gentej, Demachy, Kühn and White. Here the
theme is given a particularly Tyrolean slant by Koppitz.

BELOW | This enigmatic 1905 photogravure by German photographer
Heinrich Kühn – entitled 'In der Dune' – shows three women, their faces
never seen, labouring up a sand dune in the hot midday sun, casting shadows
before them. The image is imbued with a slow-moving, dreamlike quality
and the women exist in a plane of tones, of spaces and pauses.

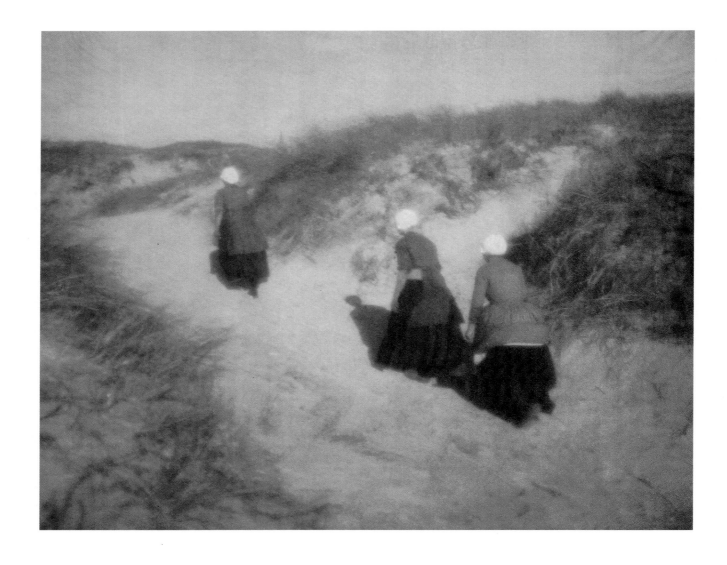

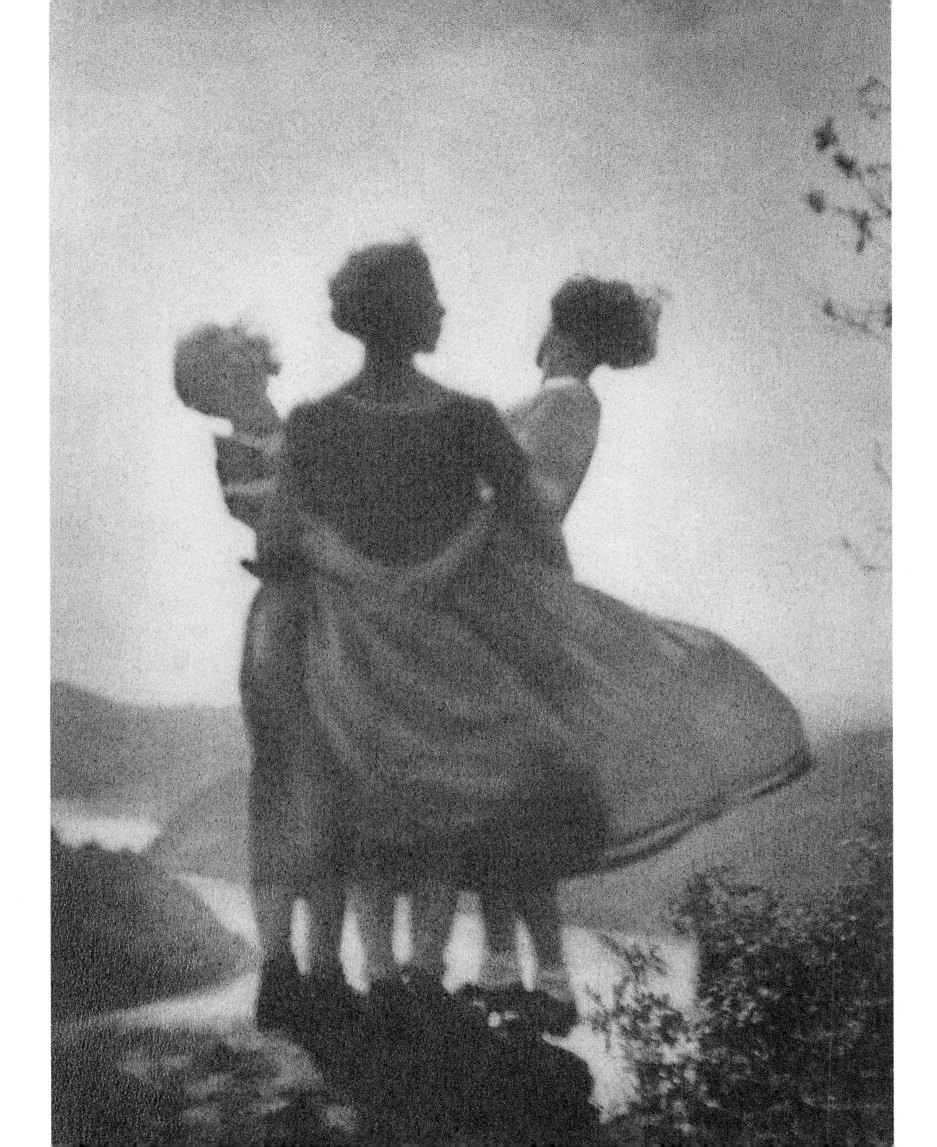

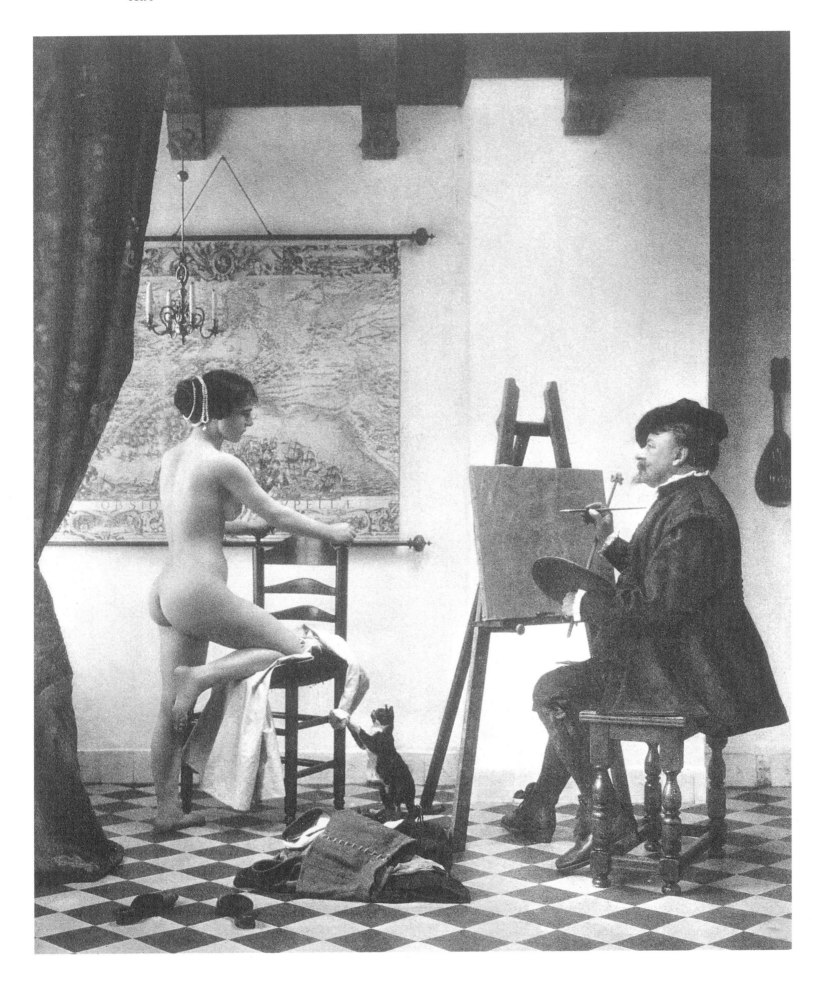

OPPOSITE | In 1914 Dutchman Richard Polak bought an old house
and filled it with 17th-century furniture and other props for photographing
re-creations of Dutch interior paintings, especially those of De Hooch and
Vermeer. He assembled a cast of models, dressed them in clothing copied from
paintings and posed them in scenes of 17th-century life. He published the
prints in a portfolio entitled *Photographs from Life in Old Dutch Costume*.

ABOVE | Roger Fenton's photograph shows art students industriously
drawing the figurative sculptures on display in the British Museum. From
1854–7 Fenton was commissioned by the museum to photograph sculptures,
paintings and other artefacts in the collection.

OPPOSITE | Inspired by Wyndham Lewis (founder of the avant-garde movement known as Vorticism) to make abstract photographs, Alvin Langdon Coburn devised the 'Vortoscope' late in 1916. The instrument was made from three mirrors, fastened together in the form of a triangle, which acted as a prism, splitting the image formed by the lens into segments.

BELOW | Robert Demachy's photograph entitled 'Vitesse' (Speed) was taken in 1903, the same year that six people were killed on May 24 at the opening day of the Paris-Madrid motor race. Whether Demachy's photograph is of a competitor in the race is not clear but the car quickly became a potent symbol of 20th-century modernism. Demachy himself was a fast-car enthusiast.

RIGHT | Inspired by the paintings of Wilhelm Von Diez, whose art classes he attended at the Königlich Bayerische Akademie der Bildenden Künste (Royal Bavarian Academy of Fine Arts) from 1886–94, Frank Eugene etched his negatives with a needle to enhance their graphic texture and also to scratch away areas of the background not required, thus throwing emphasis onto the subject. This technique has here rendered a working cart-horse into a gleaming and magnificent beast, light glinting on its polished flanks.

BELOW | Hungarian-born Lászlo Moholy-Nagy visited the RPS on 24 January 1935 when he was living in London for two years and showed his work to John Dudley Johnston, giving the RPS copies of published books and articles. Prints seem to have been offered but then the correspondence ceases. At some stage, Johnston seems to have made lantern slide copies of several of Moholy-Nagy's images, including this cat, and used them for lecture purposes.

OPPOSITE | The symbolism of the globe, the crystal ball and the sphere
is often invoked by Photo-Secession photographers – in this case by Gertrude
Käsebier *circa* 1904. The unknown sitter is perhaps trying to see her future
in the magic depths of the crystal ball. The intense manipulation and reworking
that Käsebier has done on the negative seems to surround the globe and the
peerer after truth in a vortex of swirling light and energy.

BELOW | Annie Brigman lived in Oakland, California and took all her
photographs outside, in a natural environment. She used her friends and family
as models, juxtaposing her sitter, usually a naked woman, against a rocky outcrop
or a tree. Here, in 1912, she uses the favourite prop of the American Secessionist
photographers, the symbolic globe, which also appeared frequently in work of
the same period by Clarence H. White and Gertrude Käsebier.

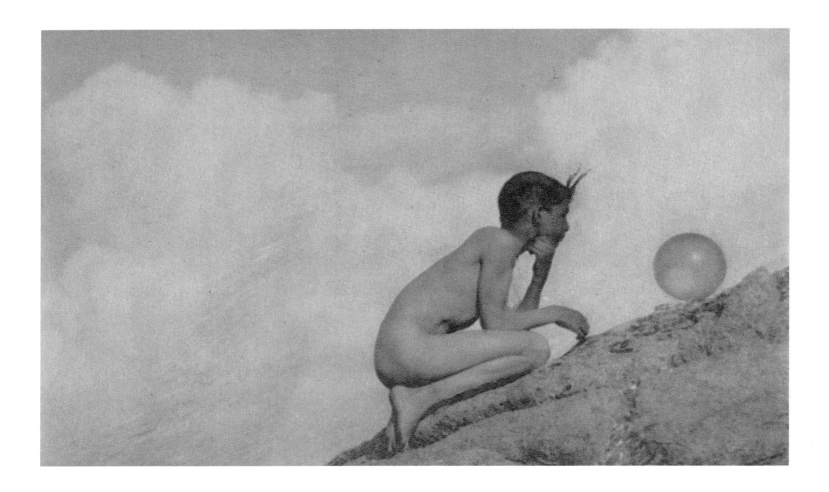

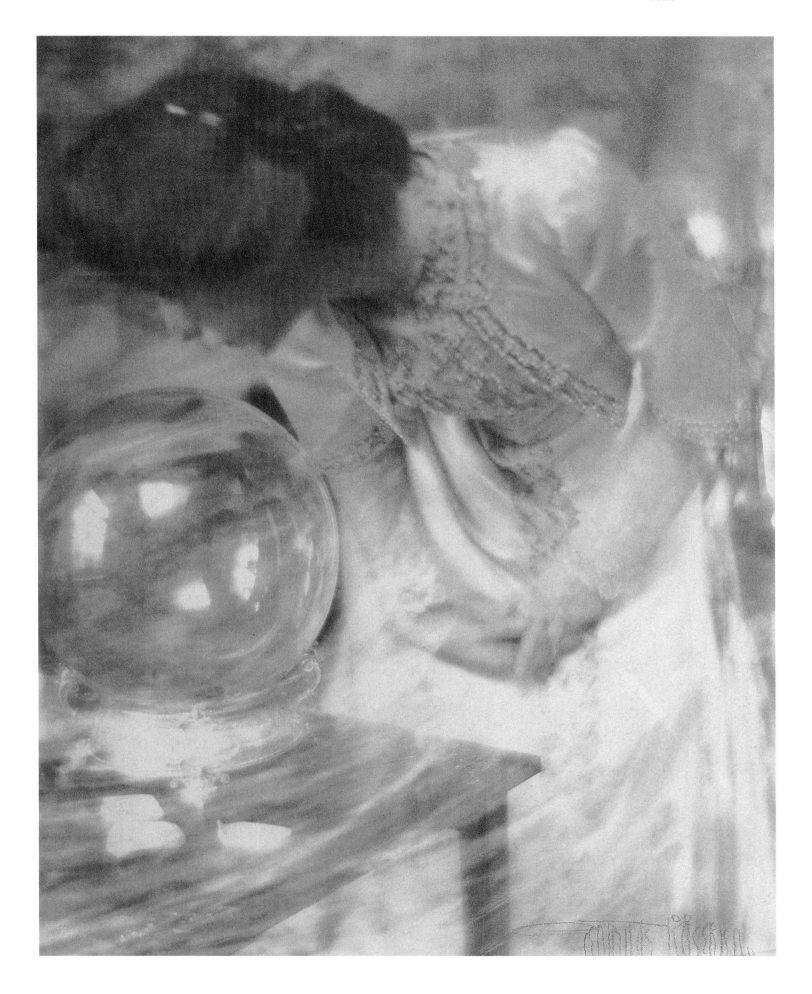

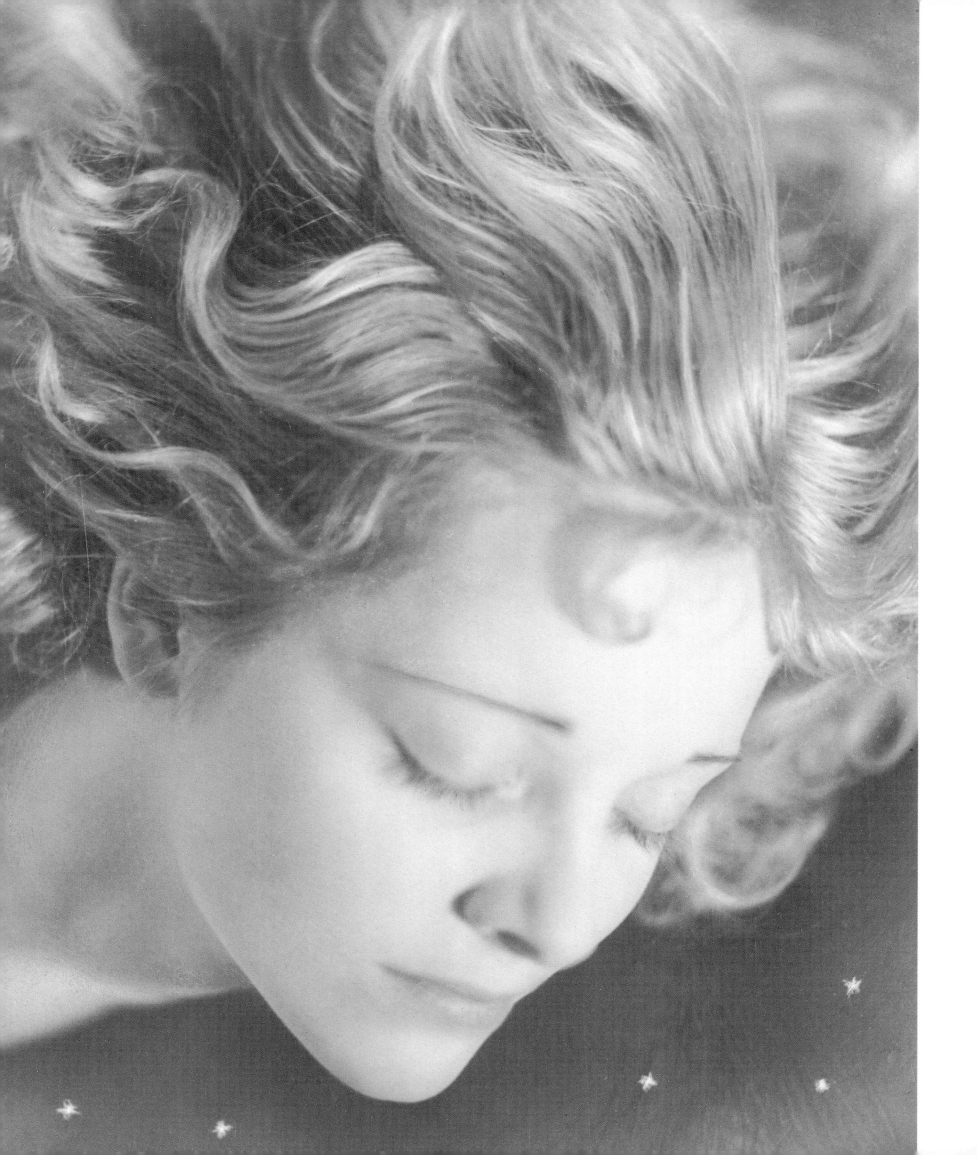

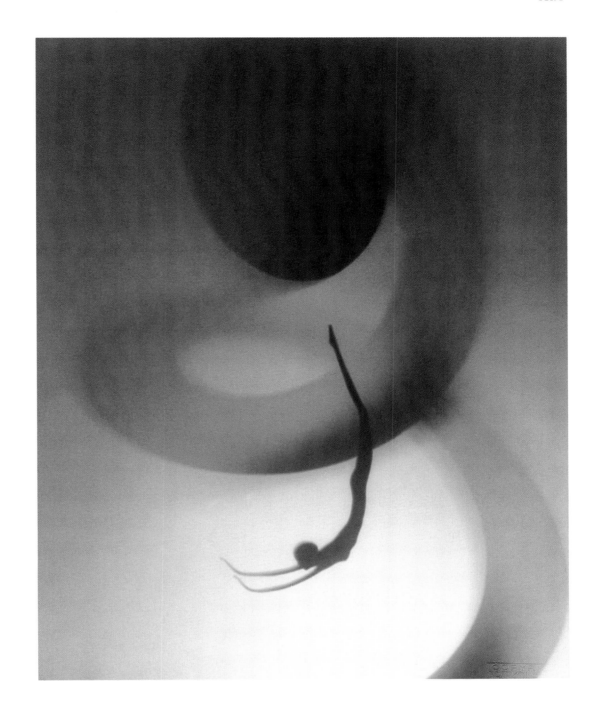

OPPOSITE | Howard Coster advertised himself as a 'Photographer of Men' and photographed most of the leading male figures in the British literary, theatrical, artistic and musical worlds from the 1920s to 40s. He occasionally relented and photographed women like Vita Sackville-West and Barbara Hepworth and, even more occasionally, allowed himself moments of surreal fantasy as in this lovely image of 1931 depicting a lost star.

ABOVE | František Drtikol, a painter and photographer, was involved in the Czech Modernist Movement of the 1920s and 30s. In his nudes, always women, he mixes the curved graphic style of Art Nouveau with the angular directness and brutal starkness of a more futurist style. He often used these paper cut-out figures to create his photo-collages.

OPPOSITE | Emma Barton considered this 1903 self-portrait with her son Cecil, as Renaissance Madonna and child, to be her best picture. So did others, and it was awarded an RPS exhibition medal the same year, with a solo exhibition of her work showing at the RPS the year after. She was the best-known British woman photographer of her day.

BELOW | In 1898, after some months of frugal eating, and wearing a crown of thorns, Fred Holland Day had himself tied to a cedar cross, commissioned from a Syrian carpenter and erected at Willet Pond near his home in Norwood, Boston in the US. He then took a series of stage-managed photographs of the Crucifixion with himself in the starring role as Jesus Christ.

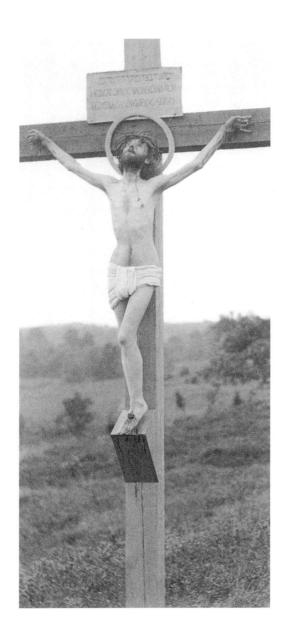

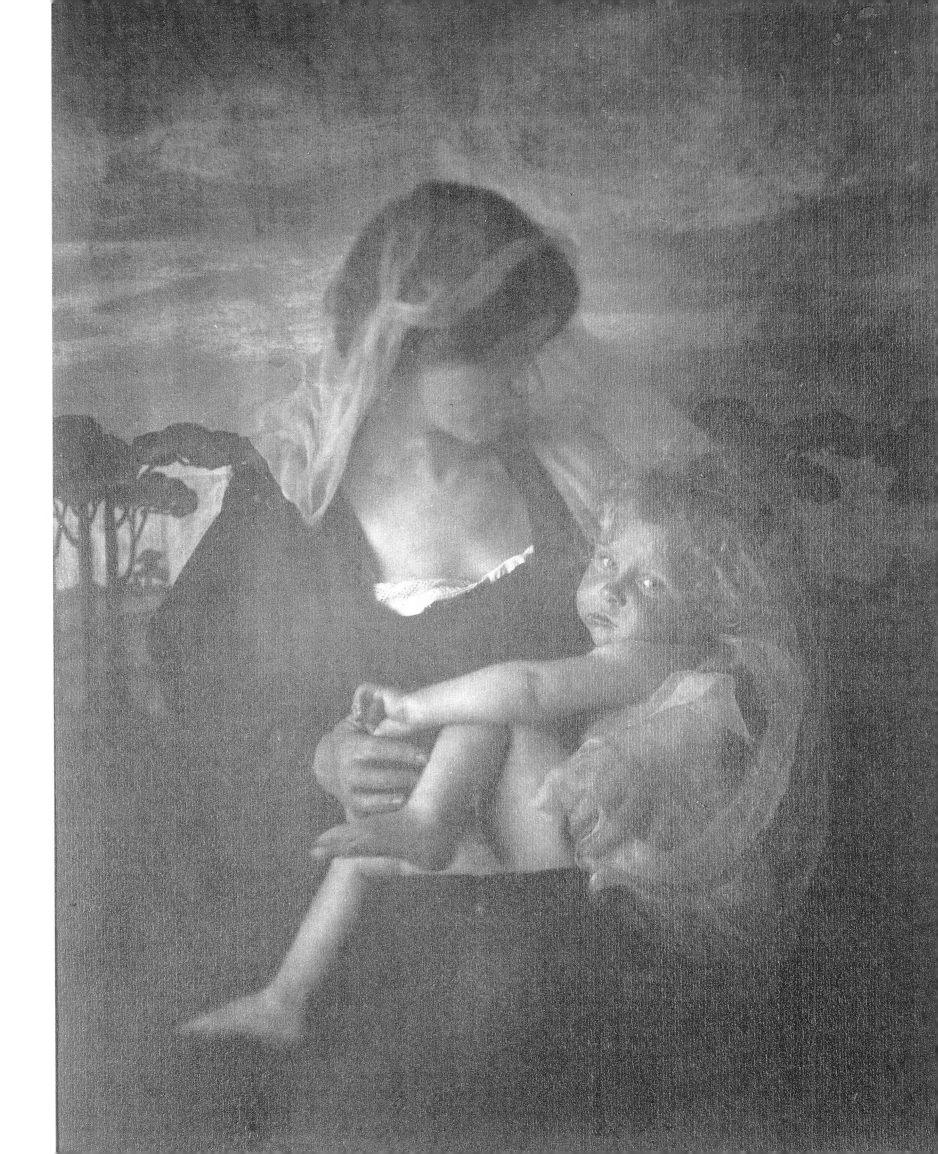

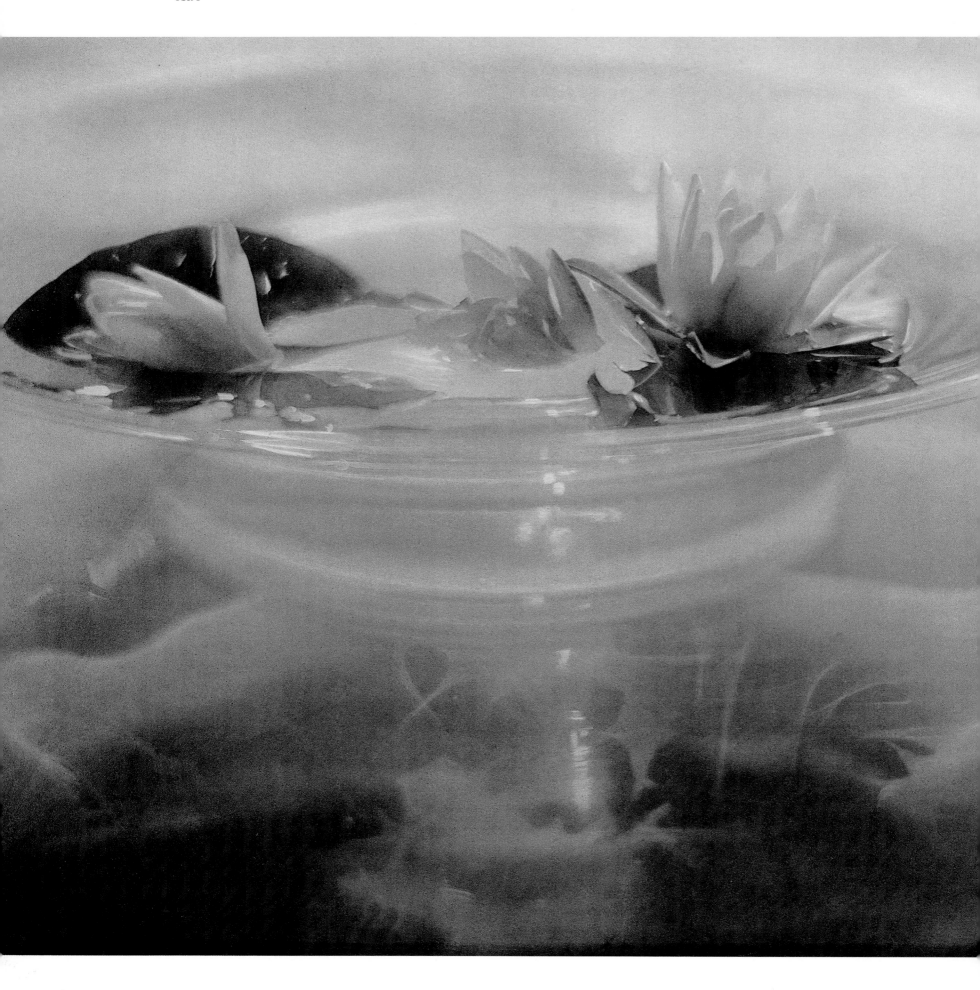

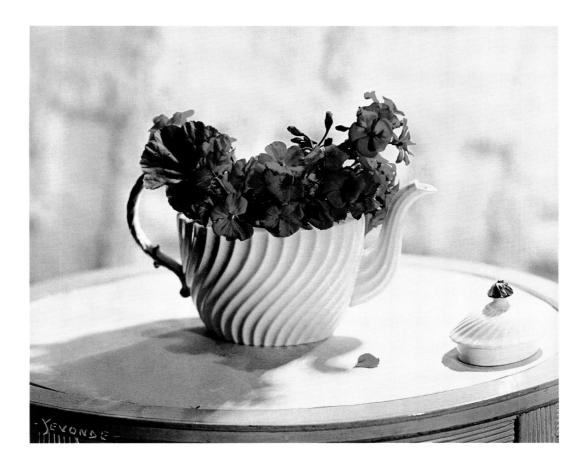

LEFT | Baron Adolph de Meyer was anxious to capture the sparkle of the waterlilies in this still life – 'the water and glass shining in the sun'. He did this largely through his printing technique, using platinum, a photographic process which gave light and luminosity to water, glass and delicate blooms, having the wide tonal range needed to capture every nuance of light.

ABOVE | Madame Yevonde took to the Vivex colour process (invented in 1932) like a duck to water, and especially experimented with photographing red: clothes, hair, lipstick and here, a vibrant crimson splash of geraniums, photographed in 1933. The shed petal appears as a drip of blood on the table.

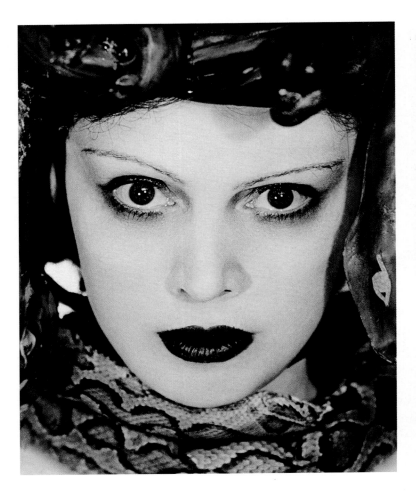 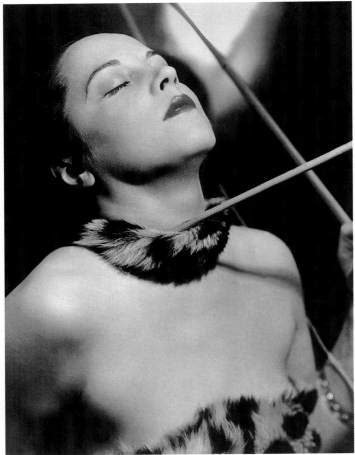

OPPOSITE | A self-portrait of Madame Yevonde taken in 1940, the year after her husband died and war broke out in Europe. As a result of the war, the colour printing laboratory she used closed down. After the demise of both her husband and colour photography, the joy went out of her work and her life. This sad-eyed self-portrait says it all eloquently.

ABOVE | Two photographs by Madame Yevonde from her 'Goddesses' series of 1935 – 'Medusa' (left) and 'The Dying Amazon' (right). Of 'Medusa', she wrote in her autobiography *In Camera*: 'I had chosen as a model … Mrs Edward Mayer … a beautiful woman with eyes of the strangest and most intense blue. I realised that warm tones must be avoided if I were to get an effective picture: Medusa was a cold voluptuary and sadist … We painted the lips … a dull purple and made her face chalk-white. The background was vaguely sinister and unevenly lit and over one light I put a green filter. The effect was excellent.'

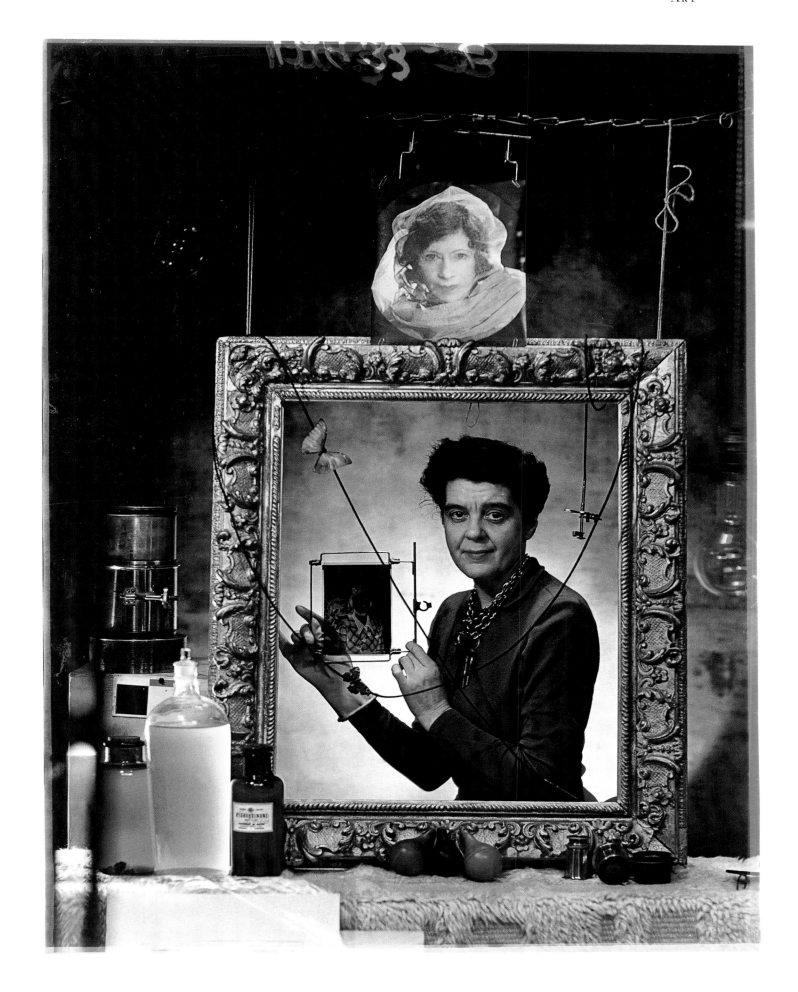

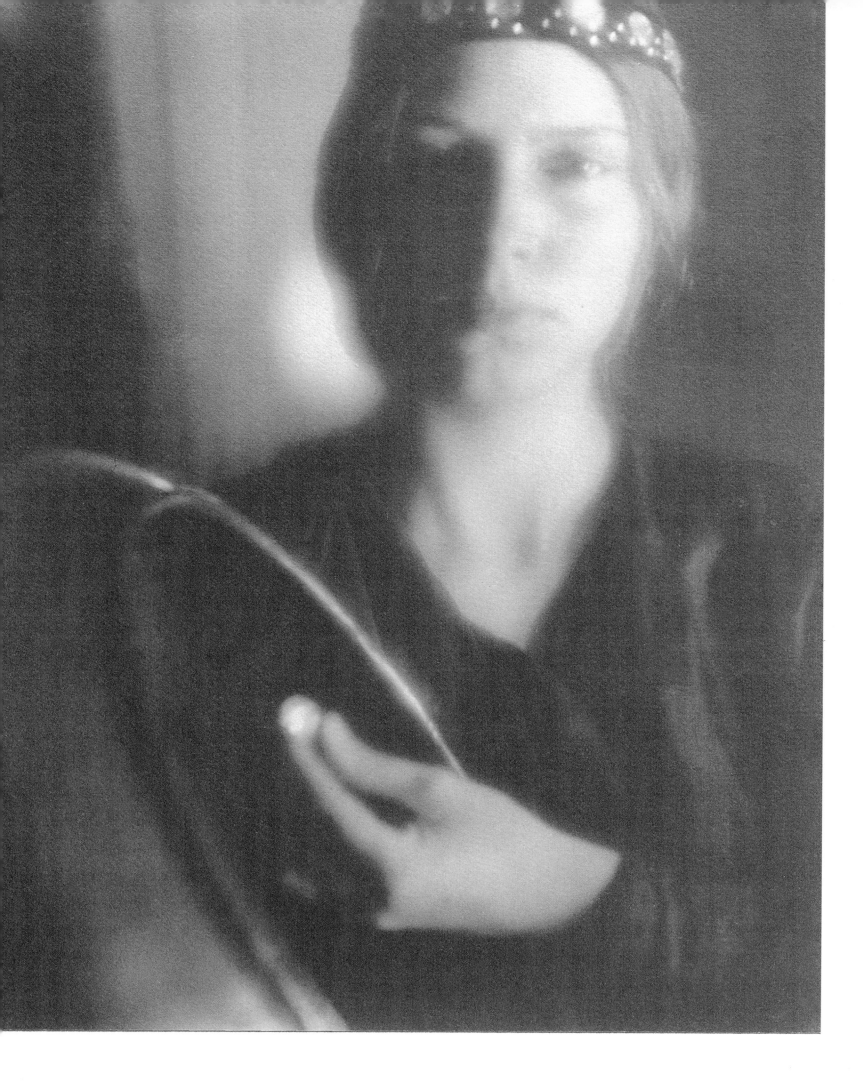

OPPOSITE | George Seeley was one of the globe-carrying fraternity of American Secession photographers (he became a member in 1904), and he photographed his sisters clutching globes, orbs and metal bowls back in his native Stockbridge, Massachusetts. Whilst some of these photographs have an undeniable appeal and are superbly printed, as in this example from 1907, Seeley's abstract landscapes of light and shade are his most powerful work.

BELOW | Clarence H. White's platinum still life of 1907 is taken through the symbolic crystal globe of the Secessionists. White was influenced by Arthur Wesley Dow's teaching on 'notan' (the harmonious balance of both form and tone) as well as his belief in the social usefulness of the arts.

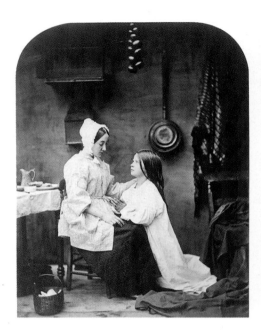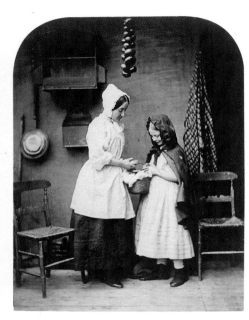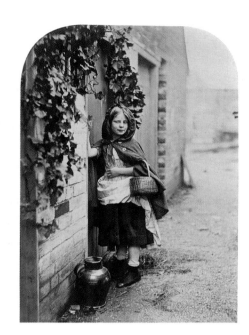

OPPOSITE & ABOVE | Henry Peach Robinson's pictorial depiction of the children's horror tale of 'Little Red Riding Hood' is his most charming and unexpectedly surreal work, especially so because of the mangy stuffed wolf he used in the penultimate photograph (detail opposite) in this, his first photo-essay, taken in 1858. He has taken the story further than Lewis Carroll's rendition, photographed a year earlier and exhibited at the Photographic Society's Fifth Annual Exhibition in London in 1858 (and which Robinson undoubtedly saw). In contrast to Robinson's engaging albumen prints, Carroll's version showed only a grumpy child, Agnes Grace Weld, skulking in the hedgerow, decked out in hooded cloak and glowering at the photographer.

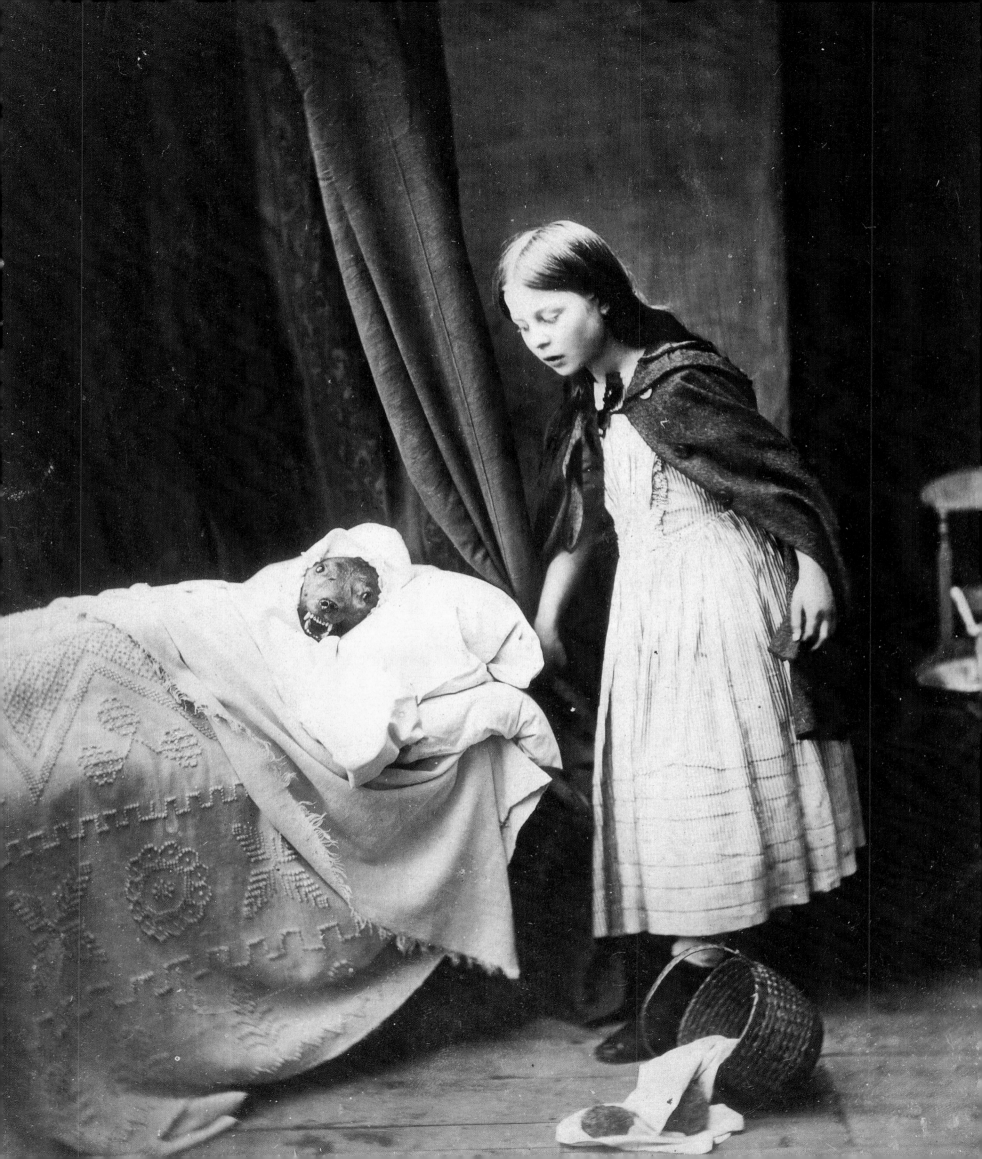

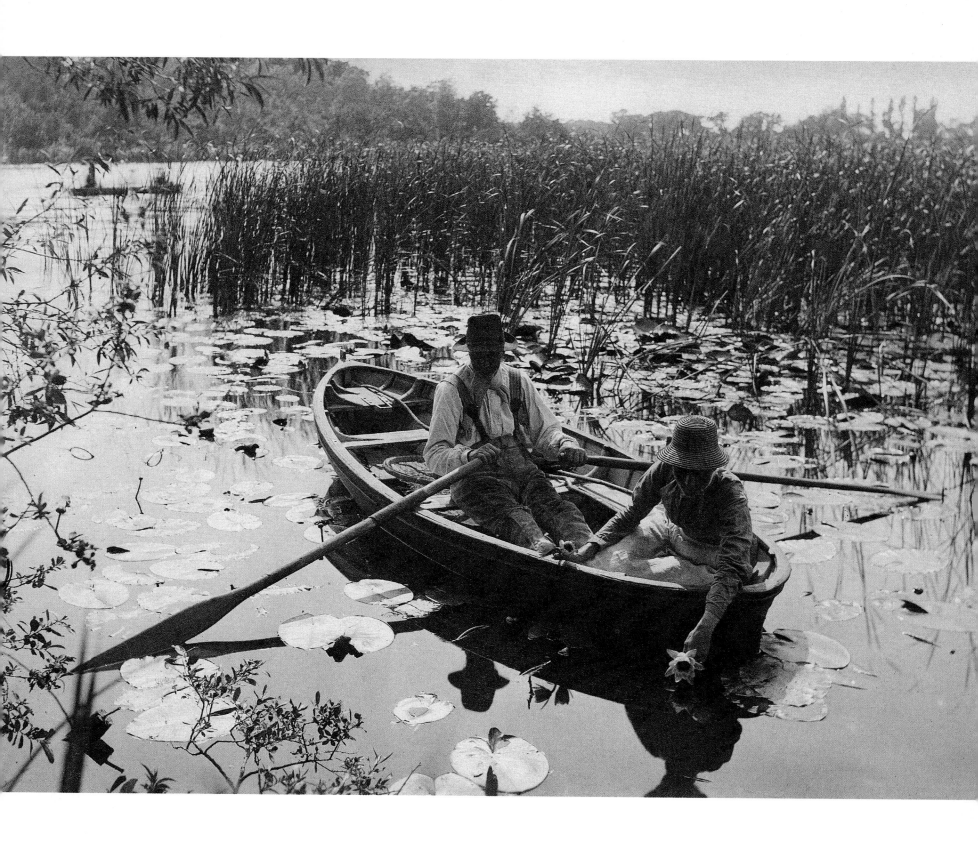

LEFT | By the 1880s, widespread use of the rapid dry plate negative and the proliferation of new printing papers, such as platinotype, enabled photographers to capture the effects of light and weather on the landscape in an altogether more natural way than before. One such photographer was Cuban-born Dr Peter Henry Emerson, who concentrated on the Norfolk Broads of England, looking for pictures that would replicate the personal visual experience of a place and mood. This is one of his best-known platinum prints.

BELOW | The photographs of the German brothers Theodor and Oskar Hofmeister are impressive for the sheer grandeur of their size and display a masterly use of the gum process, often in three colours, enabling the brothers to manipulate the tonalities for their aesthetic ends. This image from 1899, of the noble peasant girl in harmony with her natural environment, was a favourite European subject matter at the end of the nineteenth century.

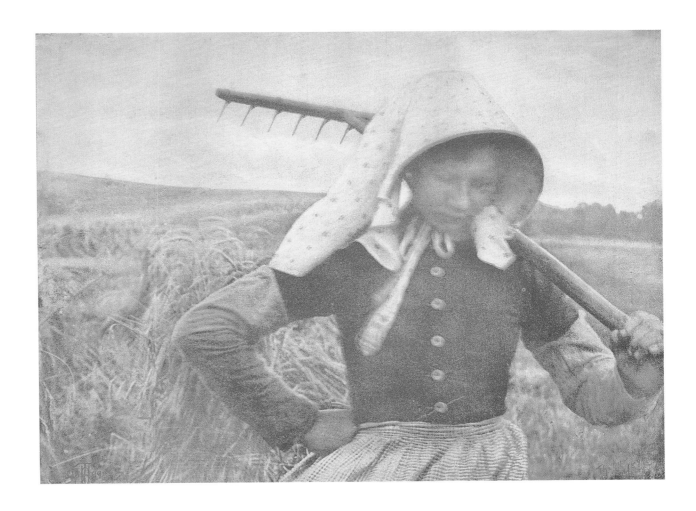

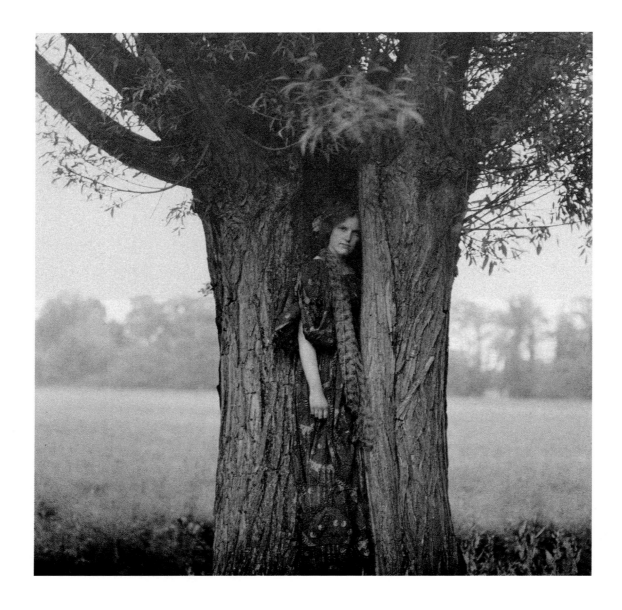

OPPOSITE | German-born Minna Keene apparently took up photography in the 1890s to take her mind off a particularly troublesome toothache. She and her family travelled extensively, living in South Africa for 10 years and then emigrating to Canada in 1913. This beautiful, lush image, taken in 1910, may be of her daughter Violet, also a photographer.

ABOVE | This Autochrome taken by John Cimon Warburg around 1910 is entitled 'The Dryad'. Dryads are tree nymphs who are thought to die when their host tree dies. Warburg's tree nymph, bedecked with a few leaves to establish her dryad credentials, seems to be rather more intent on showing off her peacock-tail patterned dress and her floating chiffon scarf.

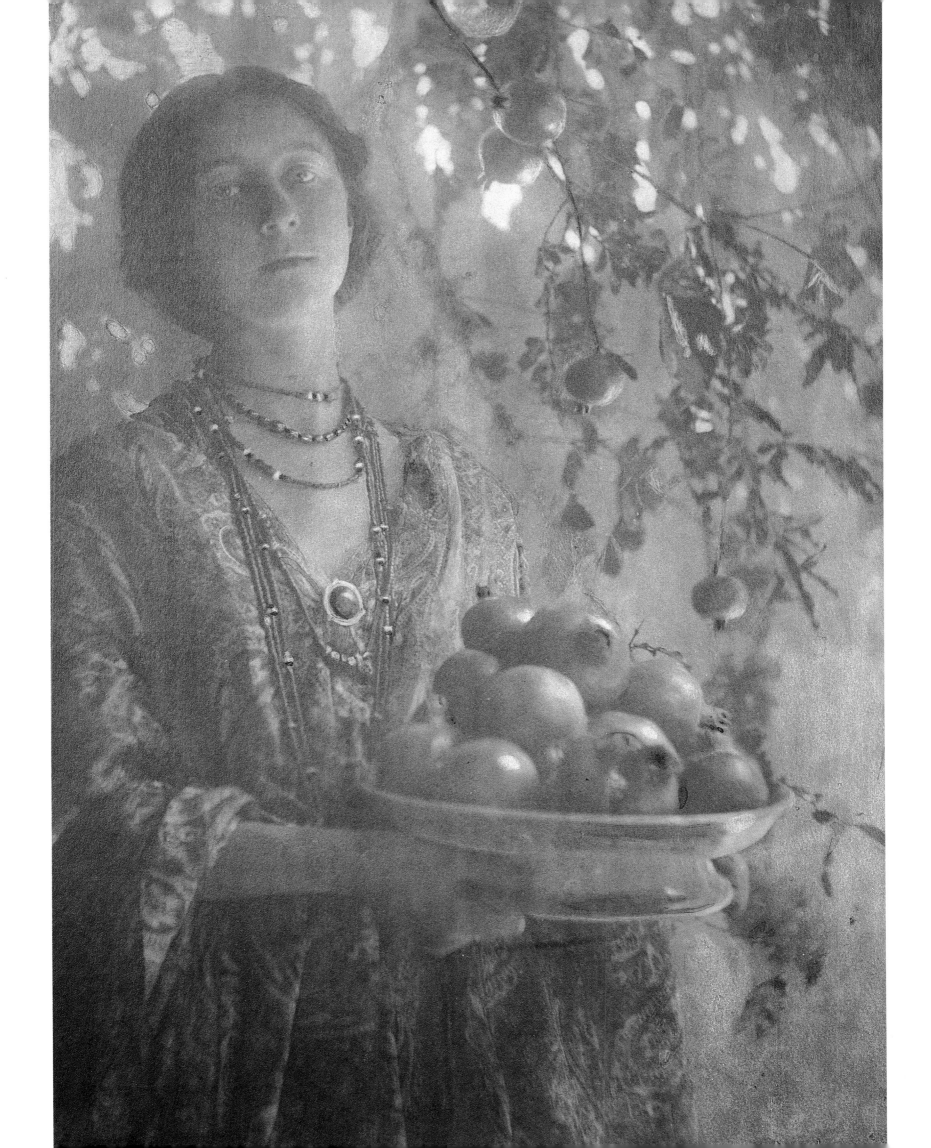

VI.

NUDES & FASHION

VI.

ALMOST IMMEDIATELY AFTER PHOTOGRAPHY'S INVENTION, it turned its gaze onto naked women, with many protestations and disclaimers issued about its intentions to capture the beauty of the female form. A large market in erotic and pornographic images rapidly sprang up, most especially in France, where the daguerreotype, with its great clarity of depiction, proved the perfect medium for capturing every detail of a woman's body, in a variety of sexually provocative poses. Paris was the epicentre of the new erotic photography and images were shipped from there to print sellers and photographic studios around Europe. Photography's ability to depict a real woman rather than a painted or pencilled interpretation of one, must have come as a startling revelation to the general public.

The market was largely focused on photographs of women taken by men for consumption by the heterosexual male voyeur, although homosexual and lesbian images were also available. These images highlight a critical social difference between the way that men and women experienced the world. Men were the observers, women were the observed. The male gaze was stimulated by elements of sexual fantasy and fetish, supplied by women, often very explicitly, but stage-managed by men.

Women have always posed for pornographic photographs. Is it the desire to be seen as physically and sexually attractive that compels them? Is it pride in their bodies? Or is it the power and control inherent in being able to arouse desire, but at a safe and remote distance? Other motivations are purely financial, of course. In the twentieth century, soft or hardcore pornography became a bus ticket on the journey to celebrity status, and often to a more desirable career in films or modelling. In the nineteenth century, posing for pornography stemmed from a basic and often desperate economic need to make money from an asset, in this case one of purely physical derivation. With few exceptions, the images from this period show women photographed only as bodies, as fleshy illustrations devoid of personality. Often their heads are not shown at all, are turned away, are in shadow, or are obscured by a raised arm.

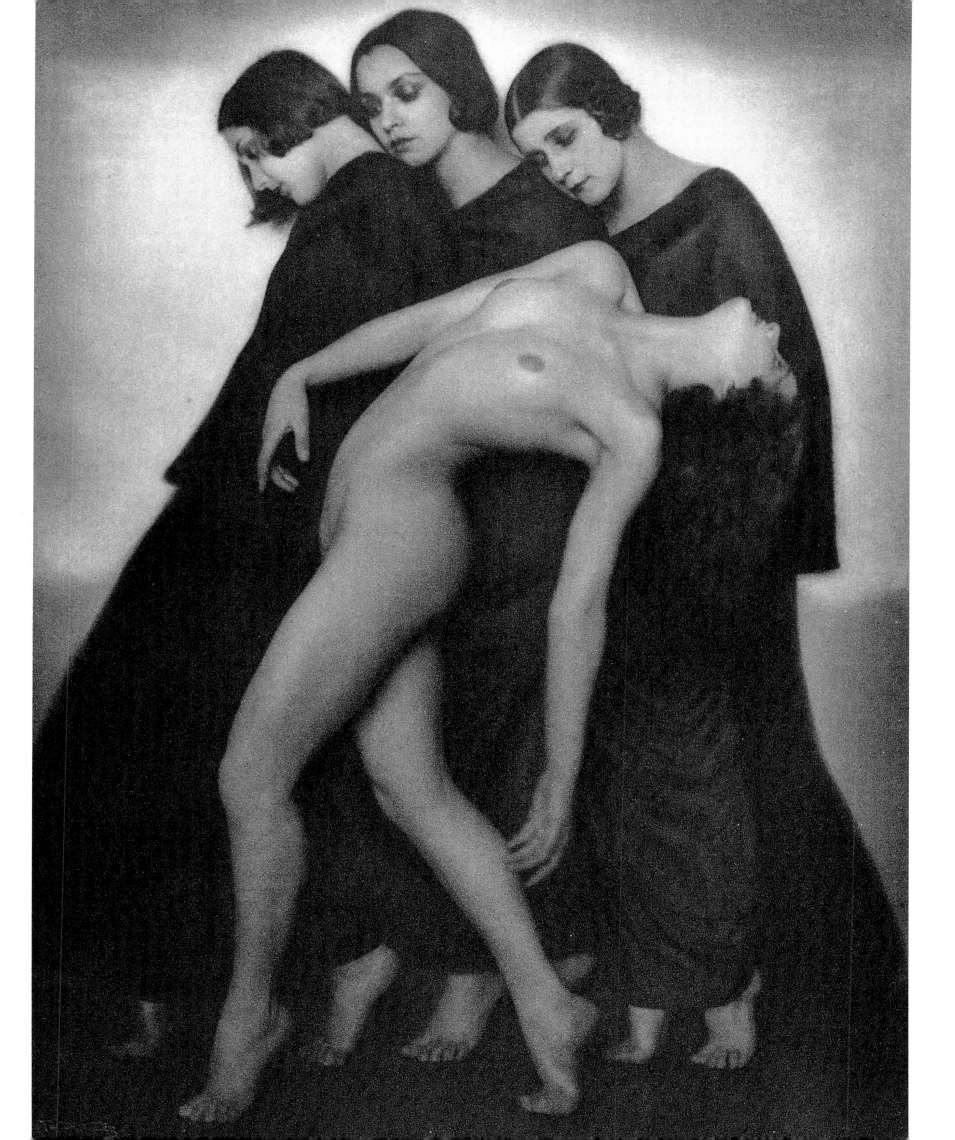

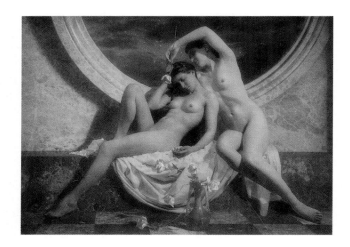

In the 1850s, as pornography spiralled and became the preferred medium for the satisfaction of voyeurs, so the trade in photographs known as 'artists' studies', or 'Academy studies', also grew. There was a blurry line between where the more revealing and erotically charged artists' studies ended and where soft-core pornography began. Artists could purchase such photographs reasonably cheaply and thus save themselves the daily expense of hiring a model. Professional artistic pride initially demanded a denial that they ever worked from photographs but many did so, often even cutting out the middle man and photographing their models themselves. Degas photographed models to use in his paintings, while Delacroix worked closely with the photographer Eugène Durieu, specifying the poses required of the models. The fine distinction between the sensual and the heroic and classical fine art tradition inspired a series of studies by Oscar Gustav Rejlander using male, female and child models in the late 1850s. His female models are often draped, always with their heads turned away and discreet in a rather touching and beautiful fashion.

Around the turn of the nineteenth century, the naked body, usually female, became a favourite subject for Secessionist and Pictorial photographers, but the emphasis of vision had changed from one of public provision to private consumption. Photographers were no longer interested in providing studies for artists to copy but in creating art for themselves and their colleagues. This art was intended for exhibition and sale to a discerning public, although more often than not it was to other photographers within their circle.

In France, Robert Demachy and Emile Joachim Constant Puyo (1857–1933) photographed girls and women, usually unidentified, using complex painterly printing processes such as gum bichromate, bromoil and hand-colouring with oil crayons. They abandoned the everyday reality of nineteenth-century studio work with its plethora of tacky props, models with dirty feet, less than perfect bodies and hair, and produced photographs of real women made to look like pastel sketches or watercolour paintings. In the US, Edward Steichen (initially influenced by Demachy) and Frank Eugene worked within the same tradition, often

OPPOSITE | Canadian Harold Frederick Kells was an artist turned
enthusiastic photographer, smitten with the results he achieved using a friend's
borrowed Kodak camera in the late 1920s. He worked in both photography
and painting for the next 10 years and then, in 1938, went to work for the
Public Relations branch of the Post Office where he remained until his retire-
ment in 1966, although still practising colour photography for another decade.
His exhibited prints of the early 1930s, like 'Grecian Nocturne' mostly have
classical/mythological themes. After his death, his negatives were destroyed.

etching negatives and manipulating prints to achieve a non-photographic result, as if a real person had
walked into an Impressionist painting or a cosmic swirl of abstraction.

Clarence H. White and Fred Holland Day used carefully graded lighting and the luminescent qualities of
platinum printing to achieve an overall emphasis on skin tones, turning the human body into a landscape
of shadows and shimmer. Day's photographs from the Nubian/Ethiopian series in 1897, his homoerotic
studies of boys in sylvan settings and White's photographs of Miss Thompson in 1906–7 acquire their
sensuous and erotic charge both from the very tactile nature of the skin, seemingly washed with light, the
complicity of the model and the interplay between model and photographer. White later worked in partnership
with Stieglitz on a further series of nude studies of the photogenic and radiantly pliant Miss Thompson.

The relationship between photographer and subject heavily informed the work of both Alfred Stieglitz
and Edward Weston. Stieglitz's obsessive photographing of Georgia O'Keeffe for more than 20 years
from 1917 onwards provides the most intimate photographic catalogue ever taken of a woman's body. The
personality of O'Keeffe – on her way to becoming one of the most famous artists of her time – heavily informs
the photographs with an eloquent and rhapsodic quality. There is not a trace of passivity in her attitude,
and her presence helped to take Stieglitz's work into new and abstract areas. Stieglitz's urge to know was
overwhelming. O'Keeffe's urge to reveal only what she chose was equally strong.

Weston employed a more organic approach, with the same purity, passion and precision of vision evident
in nude studies of his wife Charis Wilson, as in his studies of green peppers, shells and sand dunes. The images
of Wilson suggest a replete physical knowledge and appreciation of his subject, rather than an innate need
to explore her psyche or her soul. His work is infused with the gusto of sexual energy and satiation.

Creative artist-photographers of the 1920s and 30s used the naked female body as a design mechanism,
juxtaposing its soft curves and sinuous undulations as well as its physical and emotional power in symbolic,

OPPOSITE | William Whetten Renwick studied sculpture and painting in Rome and Paris and developed a method of 'fresco-relief' to combine the two. He become a member of the Camera Club of New York in 1898 when Stieglitz was vice president and editor of the Club's new quarterly journal, which may explain this one reproduction of his which appeared in *Camera Work* in 1907.

surreal, Art Nouveau or modernist poses. During a period when soft Pictorialism, first encouraged and then rapidly abandoned by Alfred Stieglitz in favour of straight photography, was the favoured style of the day, photographers like Rudolf Koppitz (1884–1936) and František Drtikol (1883–1961), working in Vienna and Prague respectively, produced images of astonishing compositional quality. They created their own illusory worlds in the confines of their studios, far removed from the turbulent events between the two World Wars.

Koppitz's body of work comes laced with mystery, boasting startling images of great resonance which transcend their obvious design and leave unanswered questions in the viewer's mind. Psychologically provocative and composed in an almost mythical and symbolic way, they seem to be photographic manifestations of Freudian and Jungian theory. Drtikol, meanwhile, used harsh lighting, Vorticist and modernist graphics and often the suggestion of arrested energetic physical movement. He employed the female body in his photographs as an illustration of his own personal visions.

The use of the naked body during this period by more Pictorially inclined, less imaginative photographers often results in something closely approaching kitsch. Such images can be easily dated to specific decades, from the 1930s to the 1950s. The advent of commercial colour processes in the 1930s, the willingness of celebrity sitters to be photographed naked, or fetchingly draped, the retouching of pubic hair, and compositions which deftly shielded the genitalia are the easily identifiable product of studio photographers of the time.

Walter Bird, a prolific and competent London portrait photographer, produced an astonishing series of photographs of nudes in the 1930s, both in colour and monochrome. His subjects had the permed blonde or brunette hair of the times, but were otherwise not hirsute, sprawled luxuriously across fur rugs or decadently stretching in ruched plastic sheeting. The saturated brightness of the colour Vivex process that Bird used and the tortured hairstyles render these images borderline kitsch, but many have a power and a strength that show a brave imagination and a canny commercial eye.

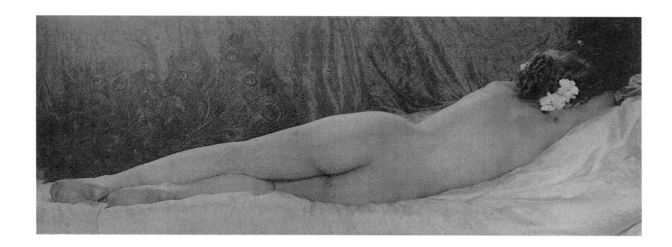

Women photographers too were turning to the nude, often as self-portraits. In the US during the early years of the twentieth century, Annie Brigman photographed herself or her sister clambering and crouching in natural settings, by rivers, by trees, positioning the naked body in natural surroundings, using the body for its metaphorical rather than its erotic content. Kate Smith in England photographed loosely draped or mistily nude female models in the woods near her home, giving her photographs titles such as 'The Dryad' or 'The Nymph' to take them into the realms of make-believe. In the UK in the 1930s, both Madame Yevonde and Dorothy Wilding photographed the female nude on a more commercial basis, often incorporating a heavy design element and often to satisfy the *risqué* predelictions of their aristocratic and society clientele who wanted to pose for such photographs. Wilding's adventurous approach made her one the of the most successful portrait photographers of the period. Commuting between her studios in London and New York via luxury liner, she popularised her particular brand of stylised, profile portrait on both sides of the Atlantic.

Also in London at the same time as Wilding, Australian-born Rosalind Maingot was a prolific photographer, not only of female nudes but of subjects as diverse as medical photography, costume studies, still lifes and flowers. Her body of work – over 2,000 negatives, prints and colour transparencies – is unique to the Royal Photographic Society. When it came to nudes, Maingot was interested enough in her subjects to photograph them both in and outside a studio setting, taking natural studies of her models in outdoor settings. Her exhibition prints tend to be the more formal and dramatic studio shots, taken with an artistry and directness as well as a subtlety of lighting that transforms the female body into an exquisite sculptural object.

Scopophilia, the pleasure of the act of looking, was deemed by Freud to be a particular male attribute, and this view seems to be supported by the very few examples of women photographers photographing men for the same ends – at least until relatively recently. Whilst photographs of naked women taken by women may have acknowledged or unacknowledged lesbian content, photographs of male nudes by women are more

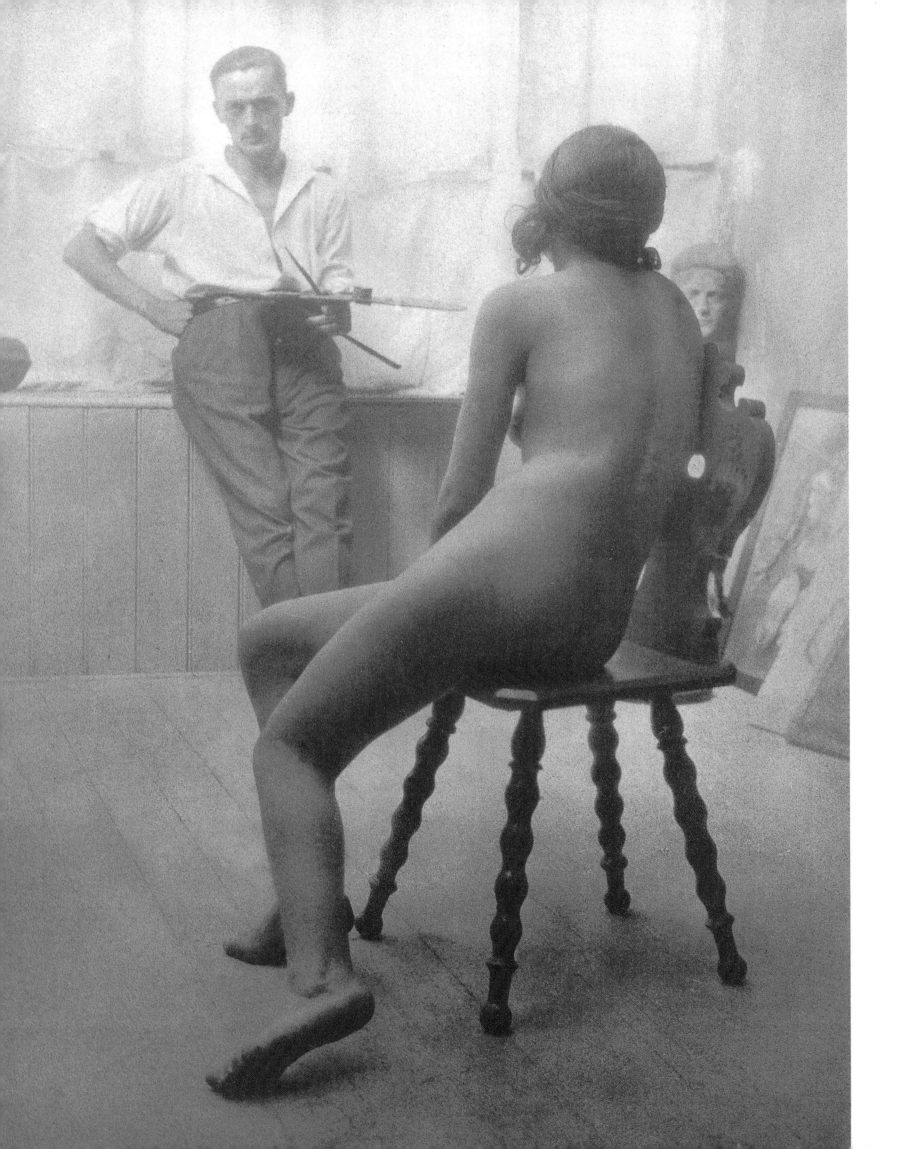

OPPOSITE | Franz Fiedler initially worked with Hugo Erfurth and also Rudolf Dührkoop in Germany and then ran his own portrait studio, also taking commissions for architectural and landscape work. He perfected the complex bromoil and carbon processes and used these for most of his work. This photograph of 1930 was printed using pink bromoil. Pink is a brave colour that few photographers used to print their work, apart from Julia Margaret Cameron and Frederick Hollyer in the nineteenth century and Georgia Procter-Gregg in the twentieth. Here, it gives great warmth to the image.

difficult to find. Such male nude studies as there are by men – the work of Wilhelm Von Gloeden, and Fred Holland Day at the turn of the twentieth century, and later twentieth-century work by Minor White and Robert Mapplethorpe – have a definite homoerotic intent. They are taken to appeal to other men, not to women.

Conversely, fashion photography, from its very beginning, was aimed at women, to appeal to a perceived aspirational sense and to sell a product. By buying the product, the viewer could buy into the same idealised world of fantasy, luxury and beauty as inhabited by the model. If photographs of unclothed women excluded the average female viewer, then photographs of clothed women were designed to include her.

Photographic illustrations, initially printed from wood-blocks and then from colour-enhanced half-tones, had been included in fashion magazines from the late 1880s, but these largely involved getting a well-known actress to pose in a designer gown in a portrait studio with all the standards of presentation that the portrait studio entailed. Thus the end-product was as much a portrait of the sitter as of the costume worn. Horace Nicholls photographed fashionably dressed ladies at events in the British social calendar, like the Derby, Goodwood and Ascot, but these were largely reproduced in society publications like *Tatler* and *The Bystander* rather than as commercial fashion plates or advertisements.

It was not until Condé Nast employed Baron Adolph de Meyer to photograph women's fashion for American *Vogue* magazine from 1914–25 that fashion photography gained its own imaginative space and became a genre in its own right. Over the next few decades, fashion photography cloned and evolved for its own use the modernist art movements of the day, initially Impressionism and Pictorialism rapidly followed by Symbolism, Surrealism, Cubism, Dadaism as well as referential nods back to Neo-classicism. Photographers like Edward Steichen, George Hoyningen-Huene, Man Ray and Horst P. Horst created an enclosed and self-referential world where the cult of beauty was worshipped at the shrine of commerce with spectacular results, both in photographic and monetary terms.

OPPOSITE | Paris was the centre for daguerreotype nudes in the 1850s, from serious artists' studies to hard core pornography. They were often anonymous to protect the identity of the photographer, who might well be raided by police. The stereo daguerreotype was especially popular as, when placed in a stereo viewer, the subject would spring into three-dimensional life.

Fashion photography is naturally responsive to social conditions, and has thus changed considerably over the decades. The privations of World War II, the arrival of photo-journalism and the postwar growth in photographically illustrated magazines and colour supplements, coupled with the emerging liberation of women and the feminist movement in the 'Swinging Sixties', led to a vast diversity in approach. If the 1960s reintroduced the close personal and physical relationship between photographer and model, most especially in the work of David Bailey and Irving Penn, then it also introduced a democratisation of fashion with the growth in mass-market fashion stores – copying, normalising and popularising elements gleaned from haute couture and aiming them squarely at a younger, less affluent, but increasingly avid consumer market.

Fashion is now for everyone and photographic styles constantly evolve to appeal to a particular targeted audience. Anyone can buy into the dream, the fantasy, the cult status of belonging, seemingly endowed by the purchase and display of the right label, whether it be on trainers aimed at 10-year-olds or this season's 'must-have' handbag, or whatever the vast array of fashion publications insist we rush out to buy, only to find that fashion moved on six months earlier and we are, yet again, too tardy.

Over the last 40 years, the emergence of women in the fashion world, as designers, as photographers, but perhaps most especially in the cult of the celebrity super-model, have changed the rules yet again. At the same time, male models and men's fashions increasingly are being featured in the world's fashion press. This deconstruction of the relative positions of the sexes may eventually bring us, in the twenty-first century, to a situation where women become the new scopophiliacs and the art of looking becomes the pleasure of both sexes.

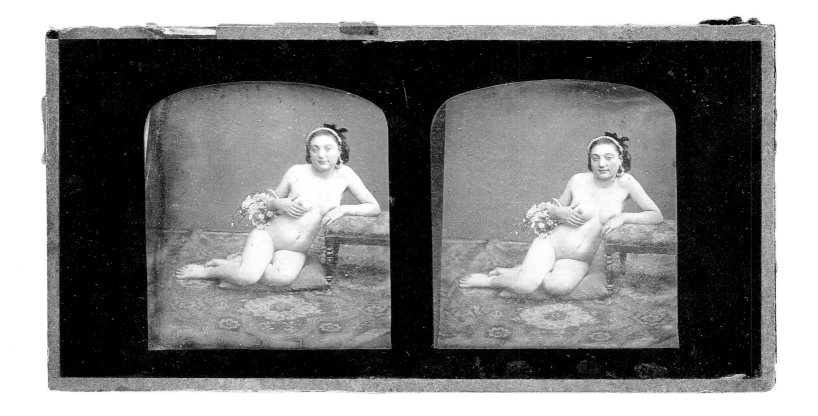

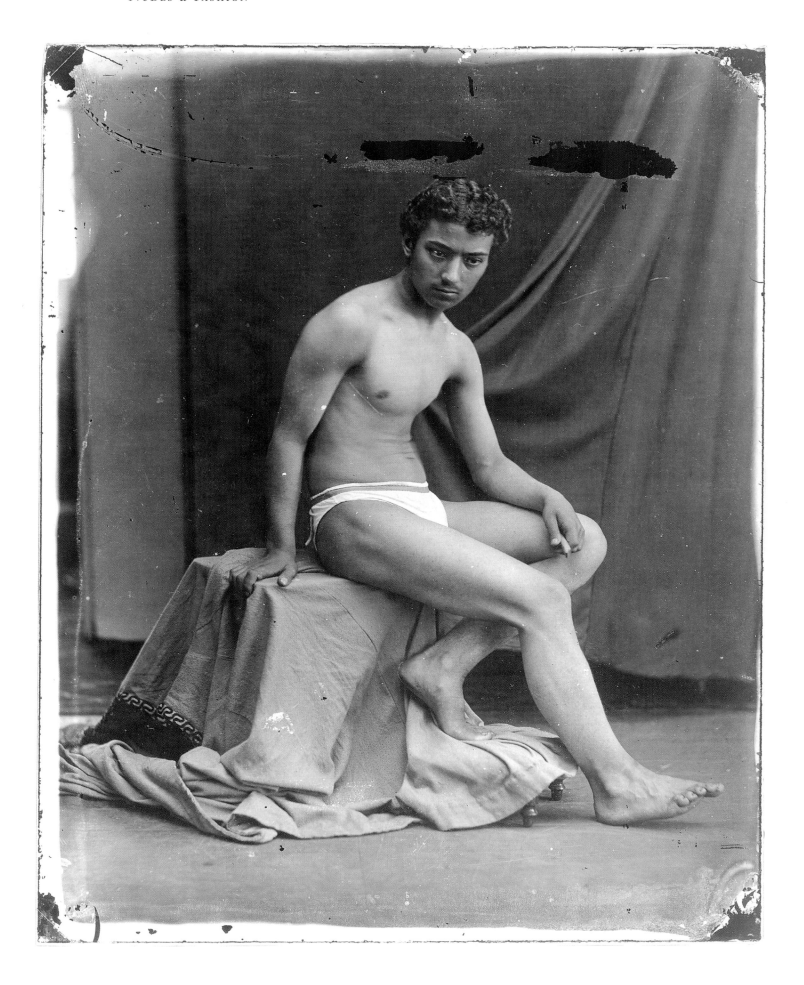

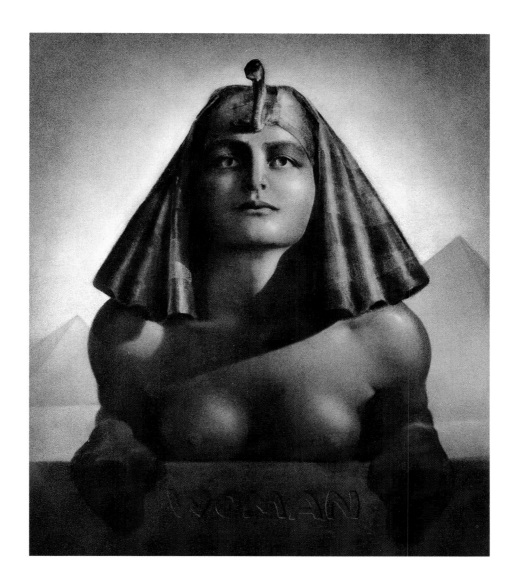

OPPOSITE | An artist's study by Oscar Gustav Rejlander dating from around 1857. Whilst Rejlander's artists' studies were invariably of women, there are four negatives in the RPS Collection of male nudes. This study is a modern gold-toned print from the original wet collodion negative.

ABOVE | G. N. Lude's photograph of 1939 is in the great 1930s Pictorial tradition and has a kitsch unsubtlety to it. Lude has done some restoration work and a sex change on the original man-made Sphinx of Ghizeh (which represents the Pharaoh Cheops as half man, half lion, constructed around 2600 BC) and added rounded and polished breasts, thus restoring the Sphinx to that personified in the Greek legend of a woman's upper torso on a lion's body.

OPPOSITE | Edward Weston saw with a passionate vision, photographed with perfectionist precision and printed with meticulous purity. His nudes, shells, vegetables and sand dunes of the mid-1930s are all shot with his trusty 10 x 8-inch camera. 'The camera should be for a recording of life,' Weston wrote, 'for rendering the very sustenance and quintessence of the thing itself, whether it be polished steel or palpitating flesh.'

BELOW | American Eleanor Parke Custis was a prolific exhibitor and showed more photographs in international salons than anyone else in the world from 1934-50. She achieved a distinctive silhouetted effect in her work, as in this photograph taken *circa* 1907, by using a 'Flou-Net' enlarging diffuser, invented by Léonard Misonne, which gave her images a soft romantic glow.

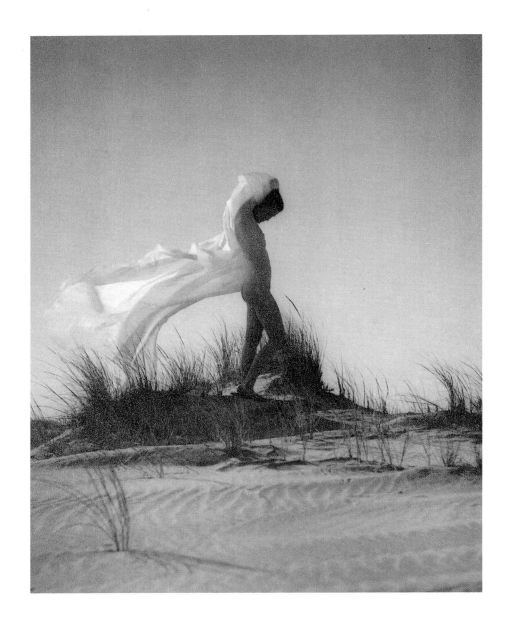

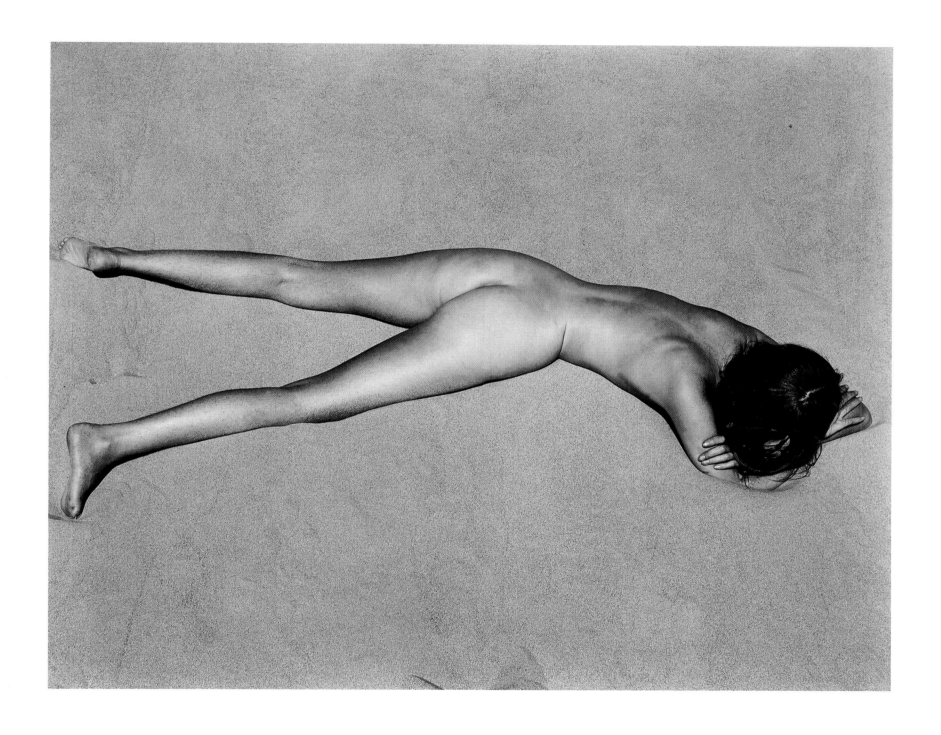

RIGHT | H. A. von Behr had a studio in New York at
20 West 8th Street and specialised in portraiture and
advertising work, but little else, as yet, is known about him.
The title of this nude study, 'Rebecca', appears to allude to
the Biblical story of Rebecca at the well, as the model here
is holding a ewer. The main attraction of this image is the
sculptural effect of the overhead lighting which emphasises
the curves of the model's face, arms and breasts, juxtaposing
them with the swell of the ewer.

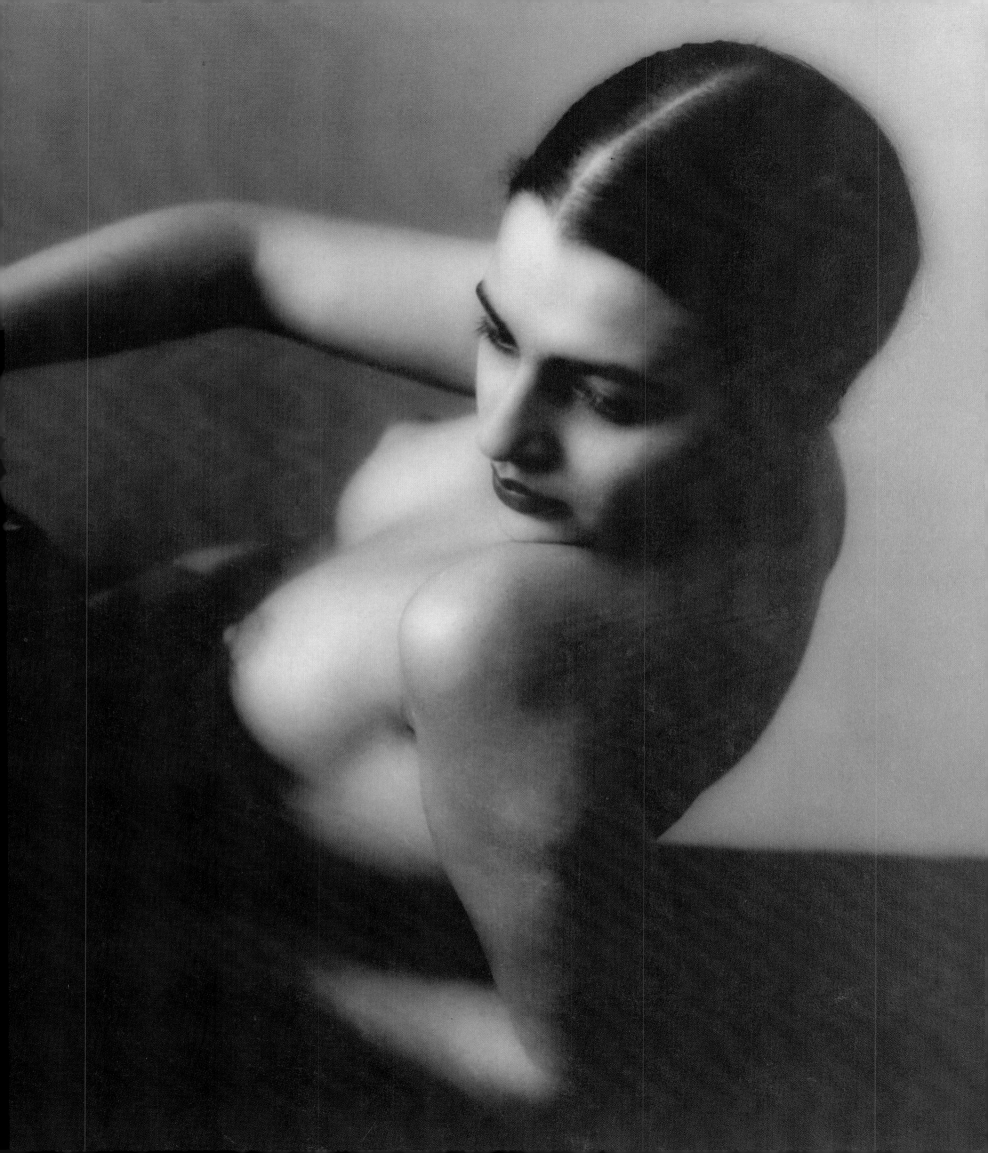

OPPOSITE | Frenchman Paul Haviland took a series of photographs of the dancer Rose Cohen in 1909-10 when he lived and worked in New York between 1901-15. He was a member of the Photo-Secession, became a close colleague of Stieglitz, and for several years financed the running of the *291* Gallery (where this photograph may have been taken). Haviland's photographs, including this one, were reproduced in *Camera Work* in 1909, 1912 and 1914.

BELOW | Robert Demachy's painterly interests and training are most obvious in his nude studies. He did intensive reworking on the negatives, etching and scratching at the emulsion to obliterate any background and throw the figure into relief. He then worked on the prints themselves where he often added pigment, here by using pastel oil crayons. There is a certain sulky sensuality about many of his nudes, which is lightened here by the use of colour.

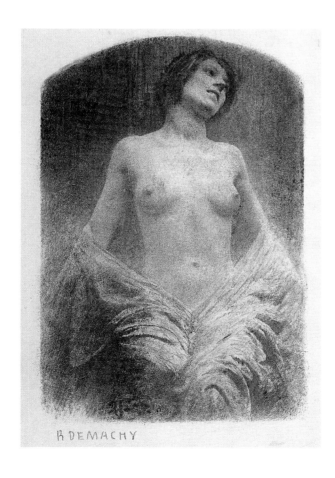

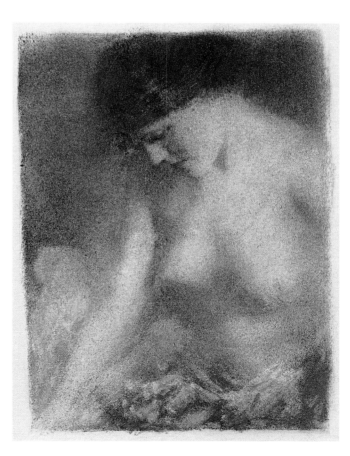

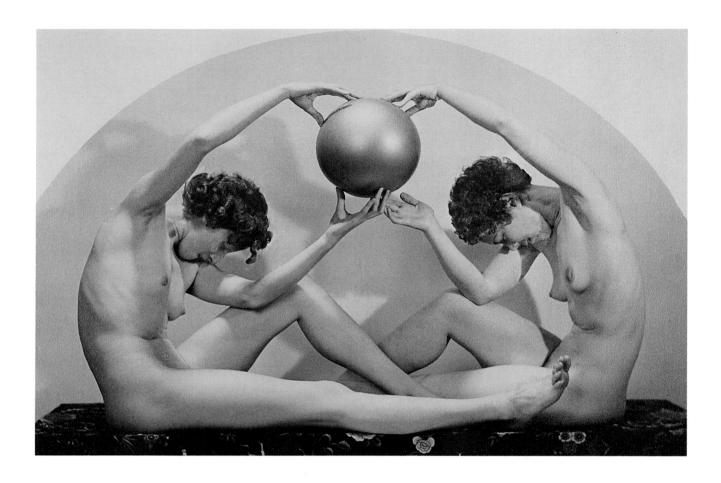

ABOVE & RIGHT | Arthur Palmer often used his second wife Judy (on the right of the above with her cousin Joy on the left, and alone on the opposite page) as a model in his nude studies. A civil engineer by trade, Palmer was based in Kuala Lumpur, where he worked on the building of the first Malaysian Railway before retiring back to London in 1931, preceded by thirteen crates of photographic equipment. He photographed his models in front of a taut white sheet, lit from behind by a battery of lights, using a Rolleiflex camera or, occasionally, an old 'Tropical Adoro' camera. The result was a high key, pencil-line drawing effect with little shadow detail.

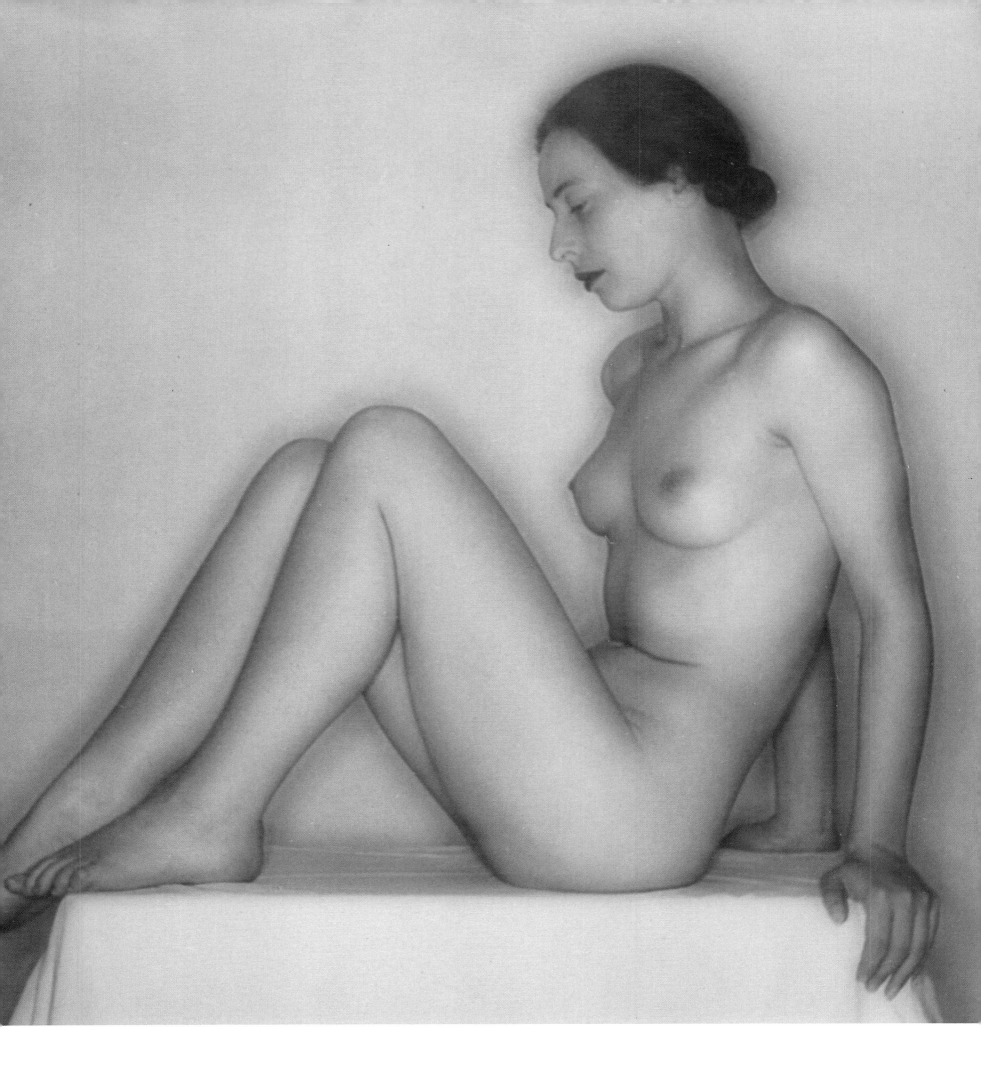

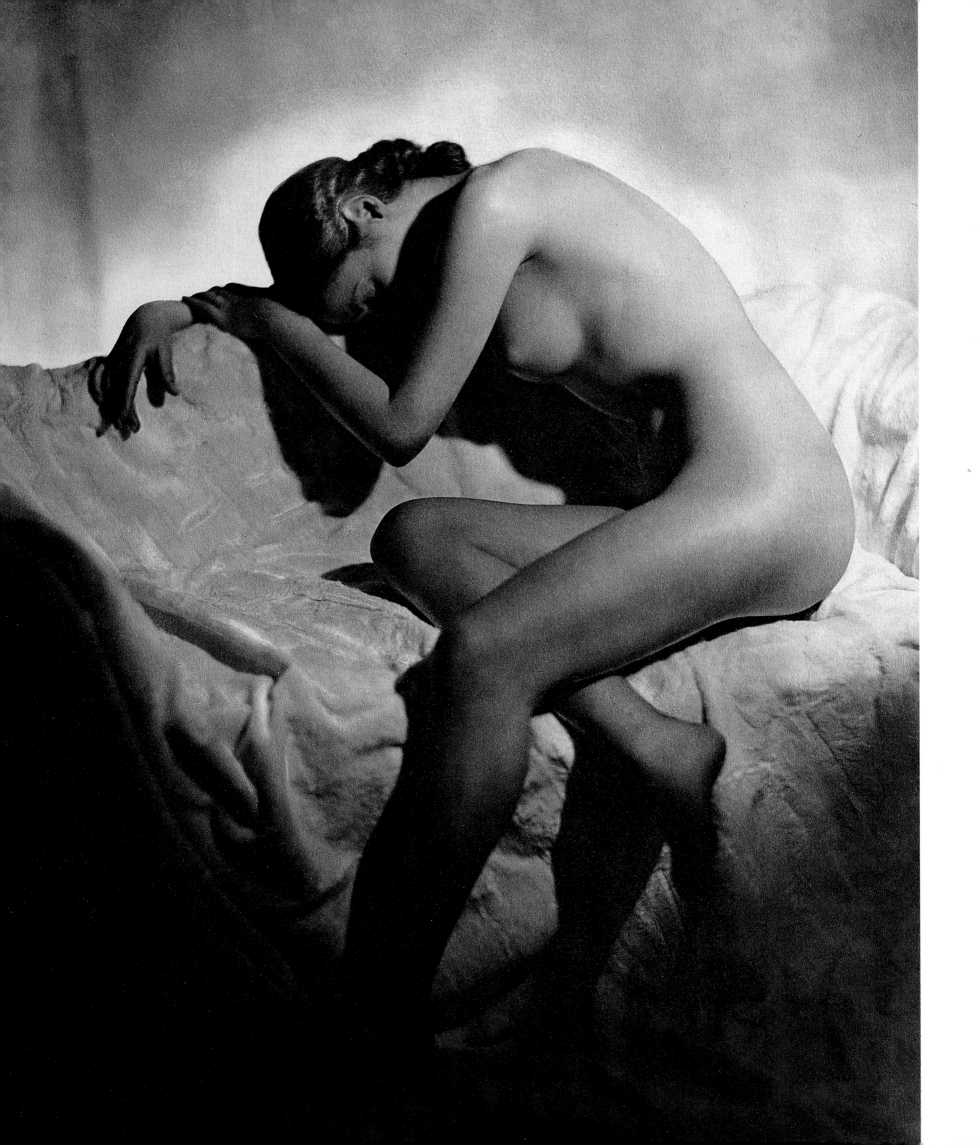

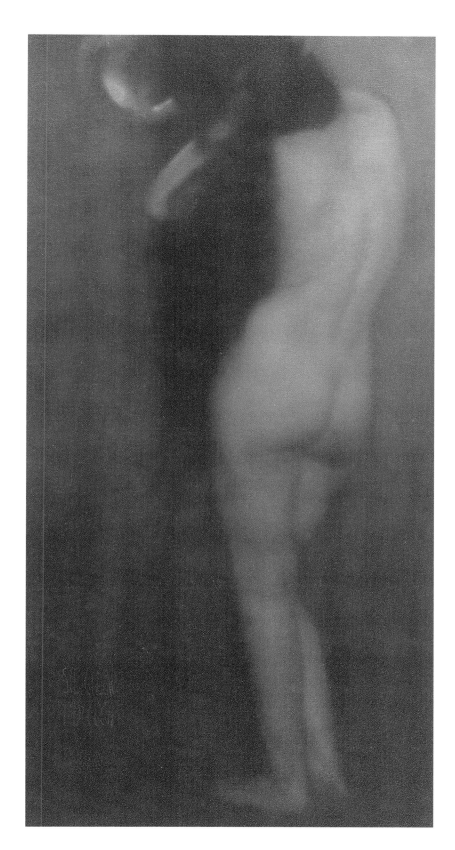

OPPOSITE | Australian Rosalind Maingot, according to the memories of those who knew her, was a large, extrovert and energetic woman who worked on a grandiose and prolific scale. Previously an actress (Rosalind Smeaton) on the London stage and in Hollywood films, she finally came to roost in one of the only penthouse apartments in London in Wimpole Street. Her photographic work ranged from precise medical photography (her husband was a famous surgeon) to beautifully lit and sculptural nudes, such as this one dating from 1939. She got the bodily sheen and highlights onto her nude studies by using oil crayons or paints and oiling the finished print with a mixture of turpentine and linseed oil to give an almost silken finish.

LEFT | The model for this photograph taken by Edward Steichen in 1902 is probably the same mysterious Rosa whom he photographed often in Paris between 1901 and 1902 (see page 46). Rosa committed suicide, seemingly, soon after these photographs were made, probably as a result of Steichen's engagement and marriage to Clara Smith and subsequent return to New York.

OPPOSITE | Miss Cramer-Thompson modelled initially for Clarence Hudson White alone, and then for White and Stieglitz working in partnership from 1906-09. This study was shot in 1906, probably in White's New York apartment. White could seemingly sculpt and bend lighting with ease.

BELOW | This unknown Chinese model appears in many Rosalind Maingot photographs in the early 1940s, her exquisite body portrayed as a precious carved object, such as 'Chinese Glass', 'Chinese Jade' and here as 'Chinese Ivory' in 1940. It seems Maingot may have had the tradition of Japanese *netsuke* carving in mind for the composition of this photograph, the Chinese connotations coming from the nationality of her model.

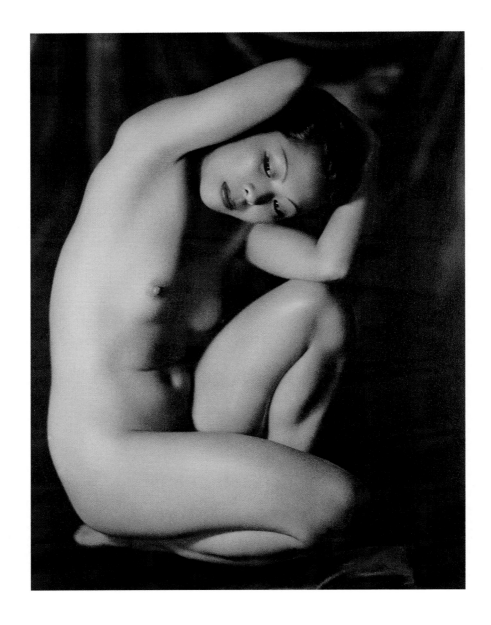

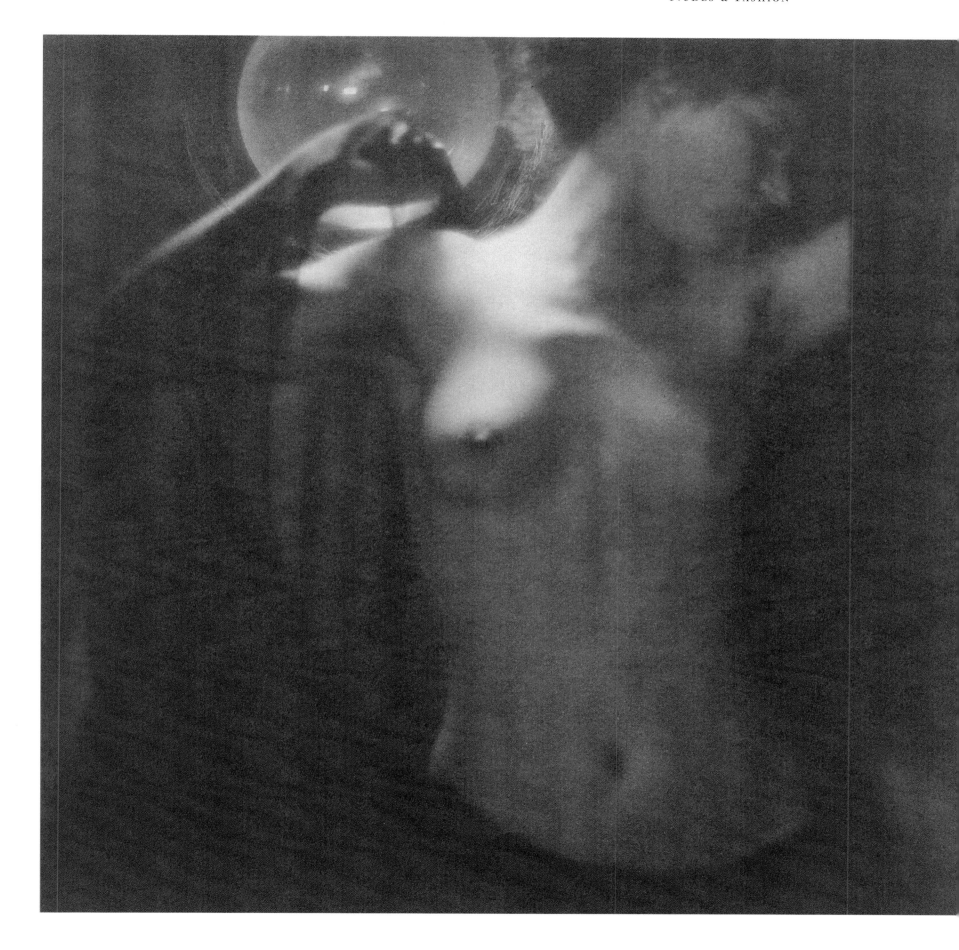

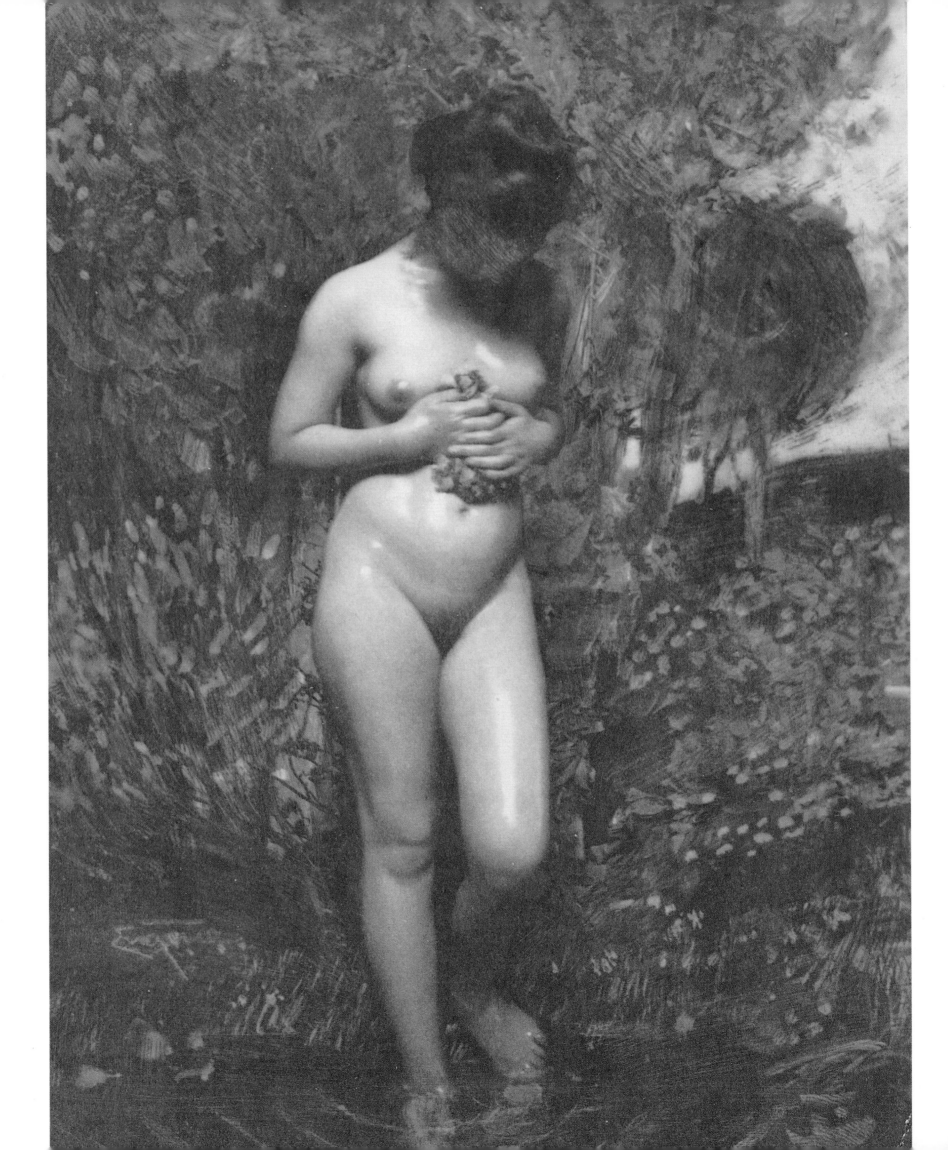

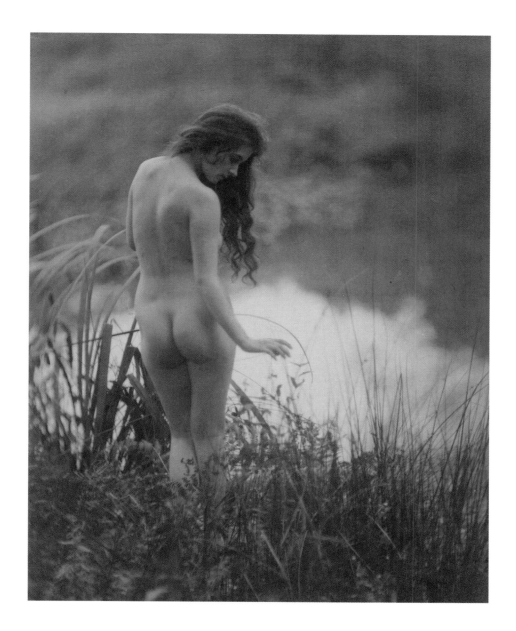

OPPOSITE | Frank Eugene seems to have used this same nude model on several occasions. In this photograph from around 1908, she is posed before a painted and etched backdrop, the slippery sheen on her skin more likely to have come from an application of oil than from a quick dip.

ABOVE | Bertram Park and Yvonne Gregory were married in 1916 and set up a photographic studio at 43 Dover Street, London, with financial backing from Lord Carnarvon, the archaeologist, himself a keen photographer. Their studio became one of the most successful of its time, using soft-focus lenses to flatter society beauties. This nude study may be a portrait of Gregory herself.

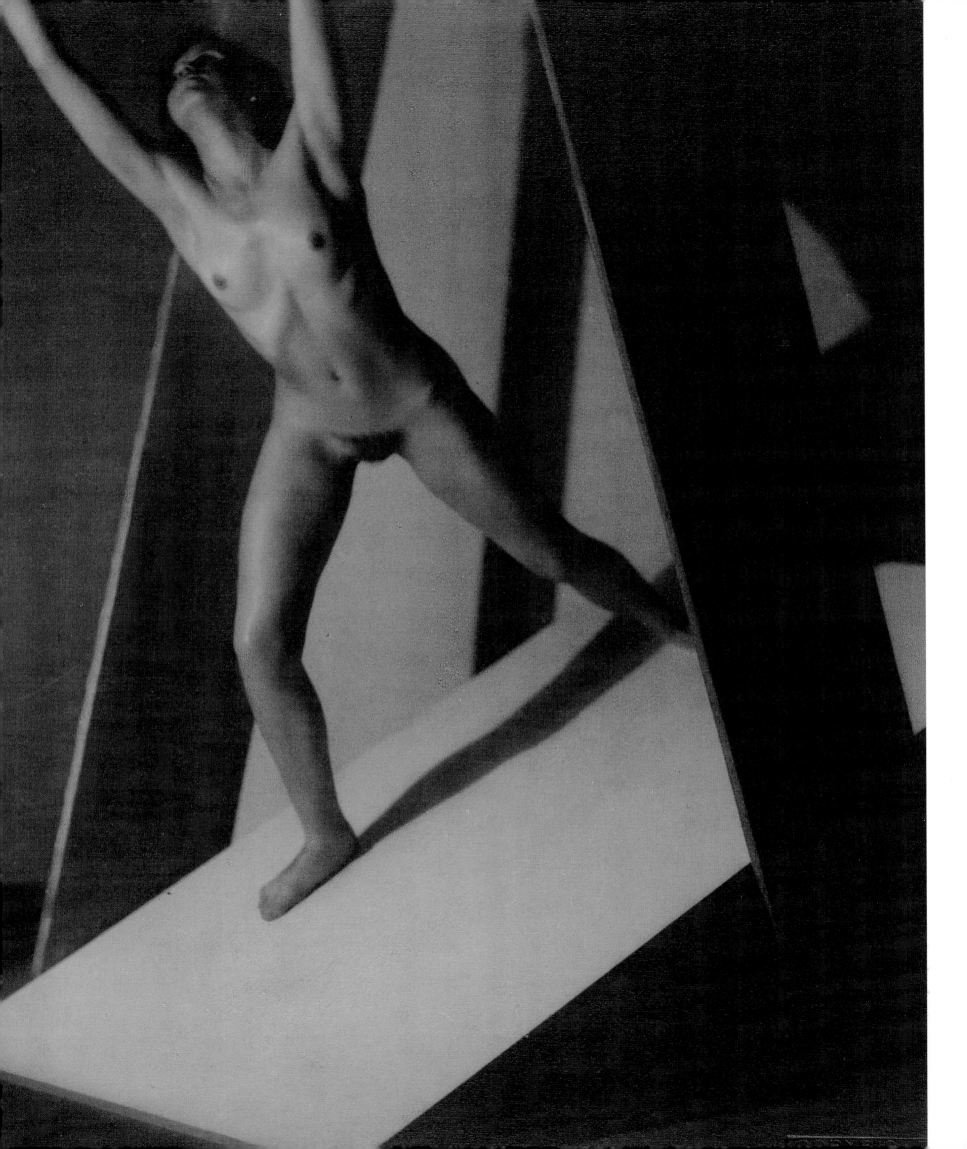

OPPOSITE | With this photograph of 1929, František Drtikol is working in futurist mode, filling the image with dramatic black and white diagonals and rectangles and posing his model as some dynamic force of nature within this geometrical structure. Whilst part of the construct of the image is that her body shape becomes part of the geometry, she is desperately striving to get out of it as it threatens to enclose and overwhelm her.

BELOW LEFT | Walter Hill, a British artist, photographer and consummate craftsman, was an expert printer of many photographic processes, as this carbon print from 1918 attests. Initially a press photographer, Hill then ran a studio in Stockton-on-Tees and served in the photographic section of the RAF during World War I. From 1921-38, he taught photography and photographic processes at Manchester College of Technology.

BELOW RIGHT | This 1938 print by Donald Herbert must take the record for being the most exhibited in the RPS Collection. Between 1938 and 1945 it was shown at 19 different exhibition venues across Britain and the US, as witnessed by the many exhibition stickers on the back of the print. Its popularity may have owed much to it having both a heterosexual and a homosexual appeal. Skilful retouching has emphasised the musculature of both men.

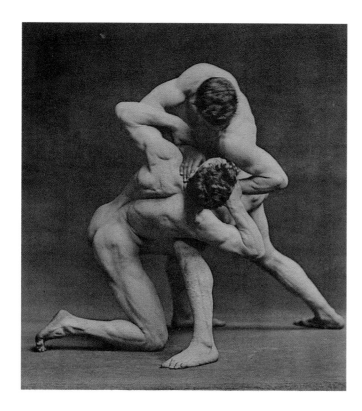 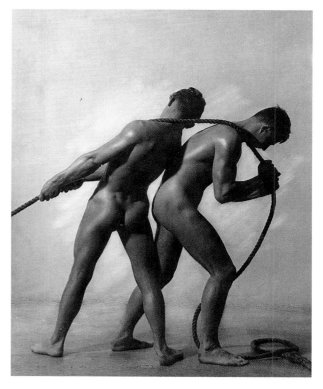

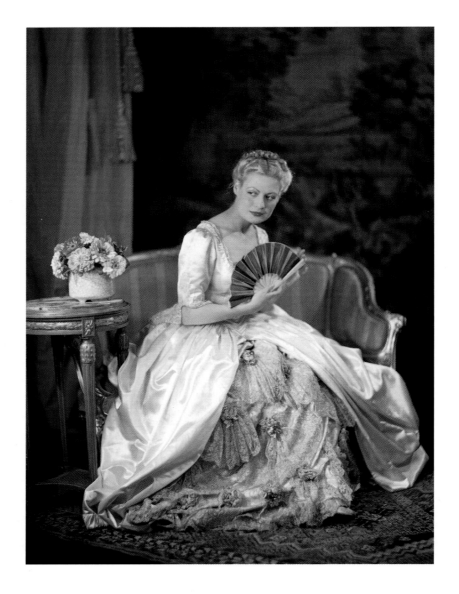

OPPOSITE | Walter Bird was one of the most distinguished British portrait
and advertising photographers from 1930-60, after which his personal style
went out of fashion. Less well known are his series of nudes, in both black
and white and hot colour, which have a superb style and exotic lushness about
them, including this one taken around 1938. Bird used the deep crimson red
of the curtains whenever he could in his Vivex prints as it reproduced so well.

ABOVE | Rae Fuller was one of Rosalind Maingot's long-time models.
Maingot made her colour exposures on half plate film, side by side in a Kodak
Studio camera. She would then cut these down to three-and-a-quarter inches
square for use as lantern slides for projection during her many lectures on
composition and colour photography.

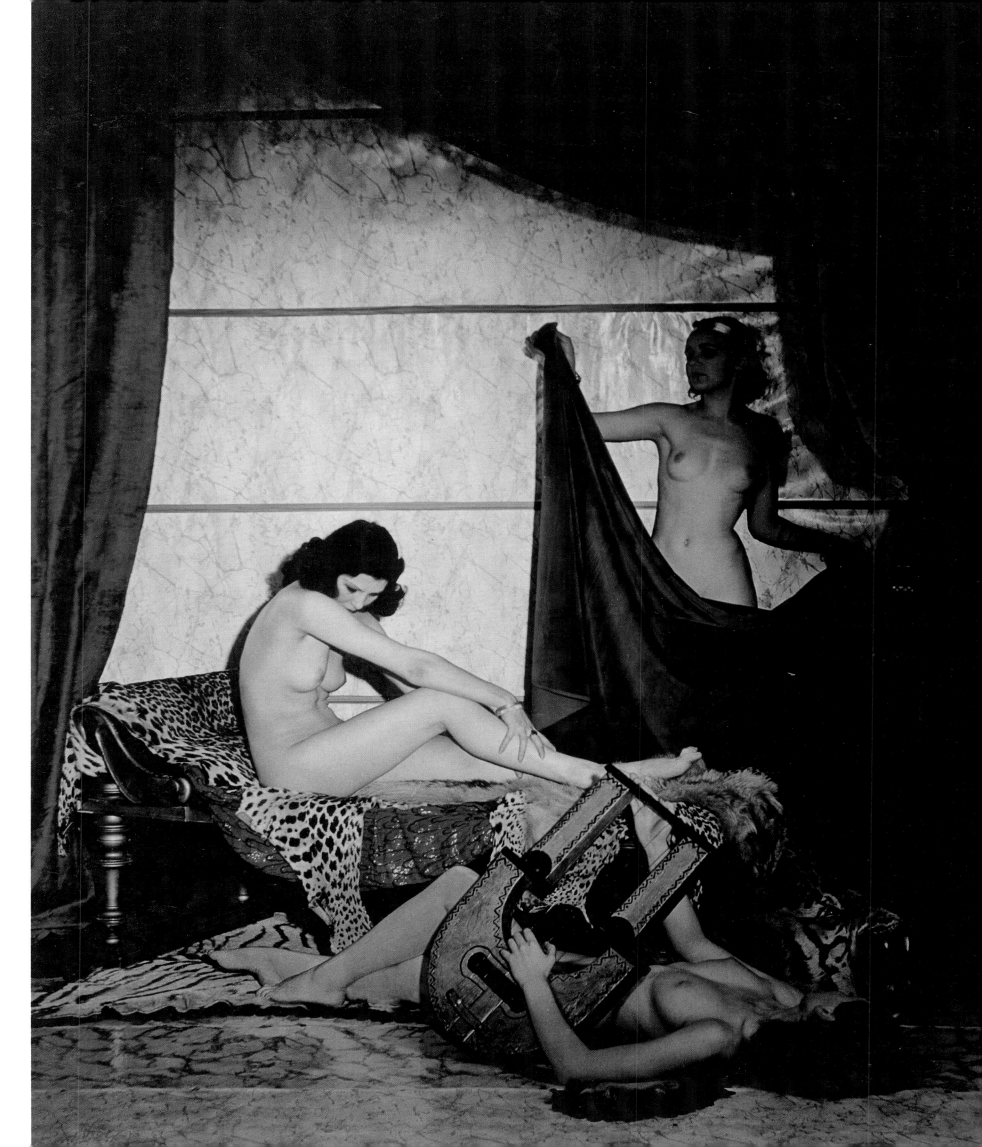

OPPOSITE | Norman Parkinson once said: 'I make women look beautiful, I have a kind camera'. He was one of the first fashion photographers to make his models move and look natural in outdoor locations, as here in 1955.

BELOW LEFT | John Swannell's photographs, this one from a generous donation to the RPS in 1992, embody timeless elegance. Like Edward Steichen, he makes the monochrome spareness of black and white work for him to capture the overall mood of the fashion rather than extraneous details.

BELOW RIGHT | Steichen photographed the model Marion Morehouse (married to E.E. Cummings) frequently in the late 1920s and early 30s, creating some of his best work for *Vogue*. This 1933 photograph (with Morehouse on the left in black with white fur trim) is a study in black and white, a medium Steichen explored with great drama in his fashion shoots.

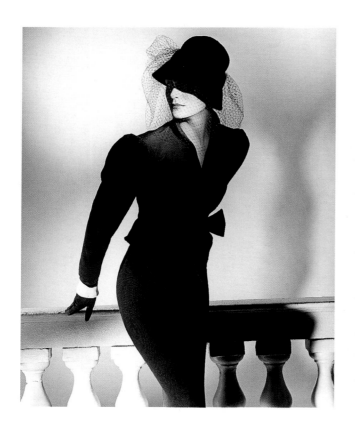

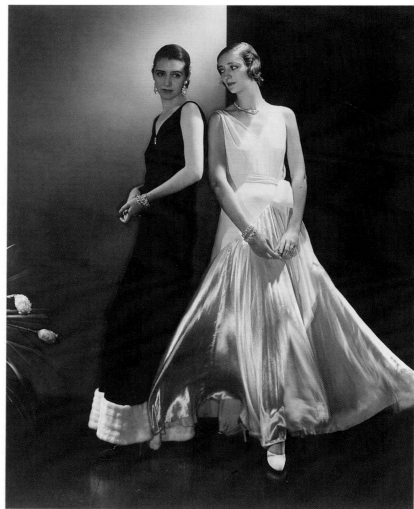

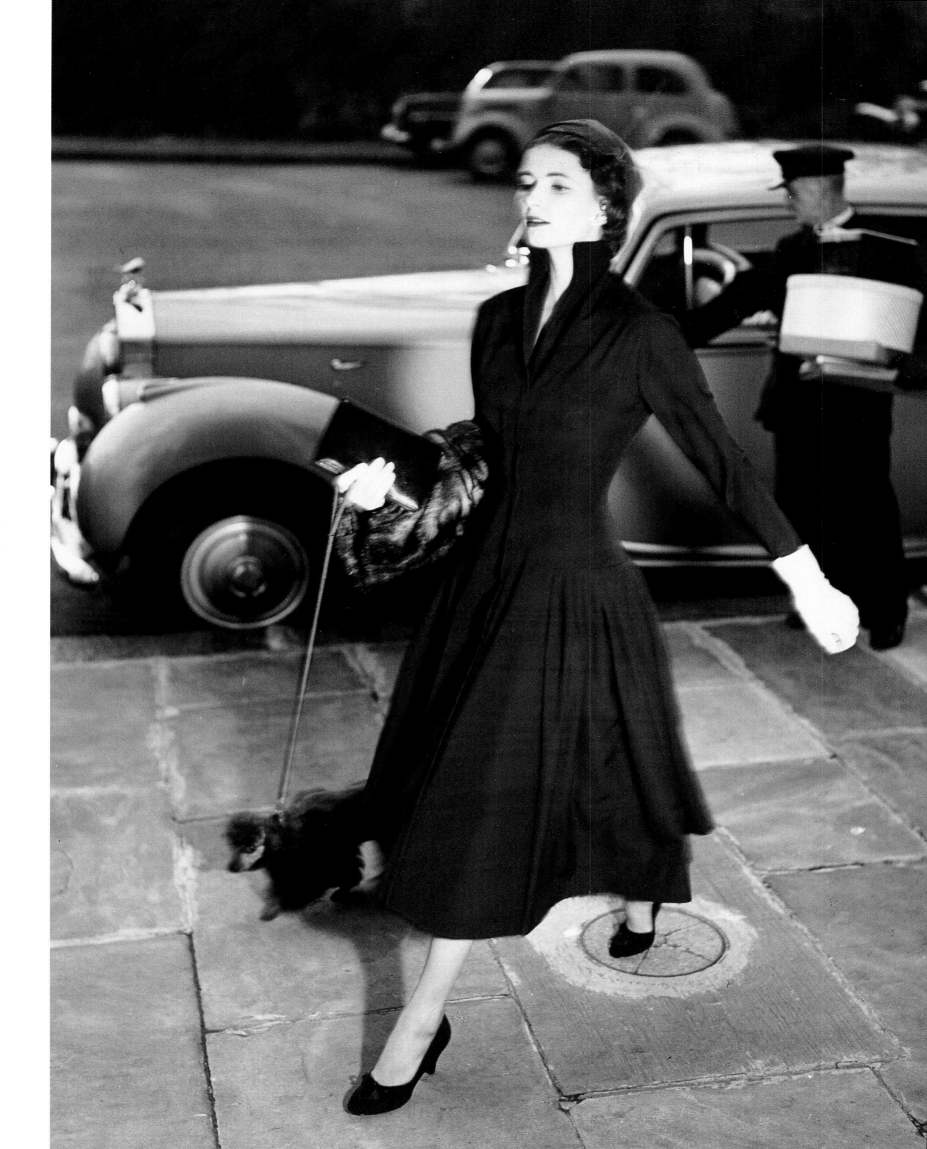

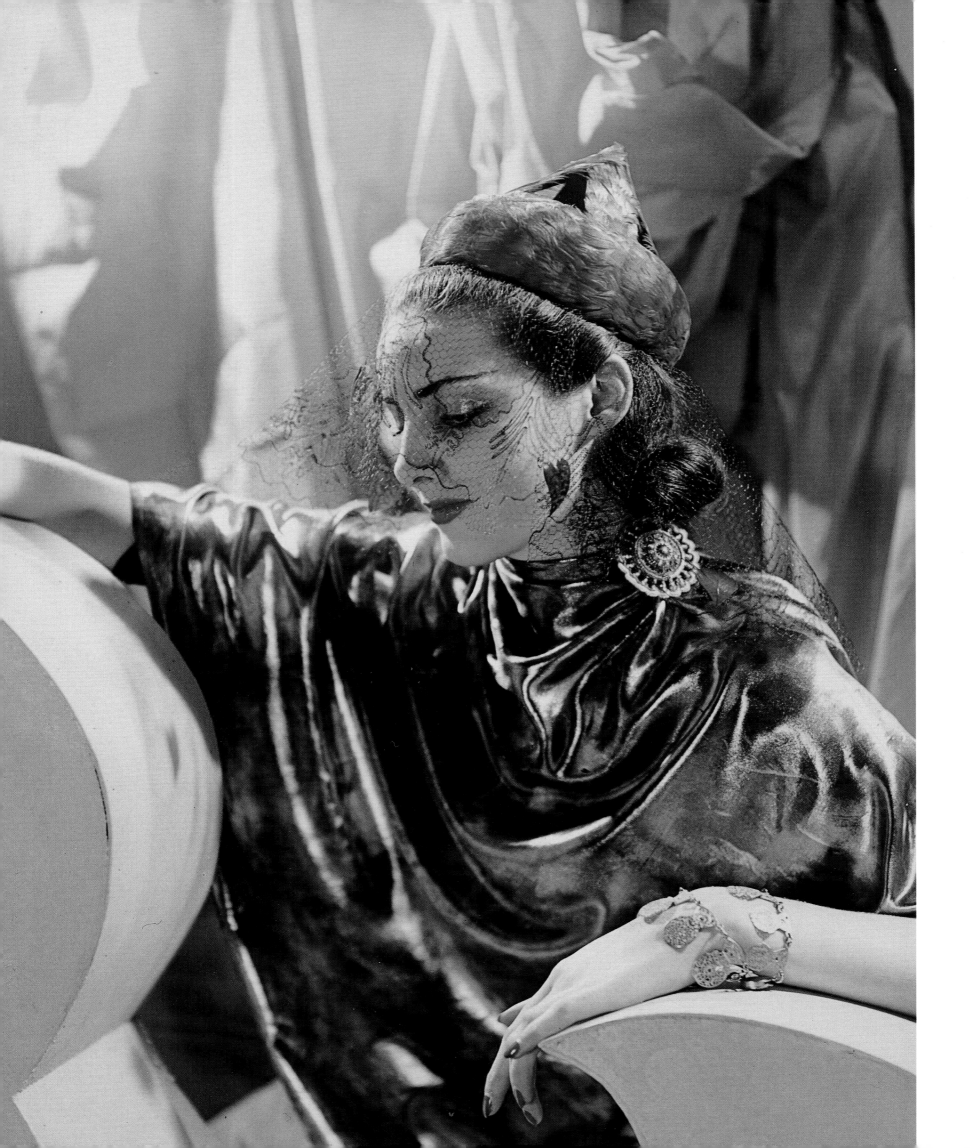

OPPOSITE | The strong, pure colours of the Vivex process were made for fashion photography and seem to have inspired a number of photographers who came and went very briefly in the mid-1930s. This image was taken around 1938 at Studio Doric, a little-known British commercial studio.

BELOW | Lady Anne Rhys was photographed in 1935 by Madame Yevonde as Flora, the Roman goddess of flowers and spring. Rhys was the daughter of Dorothy, Duchess of Wellington, who was also photographed by Madame Yevonde in her 'Goddesses' series as Hecate, in which mother and daughter both appear.

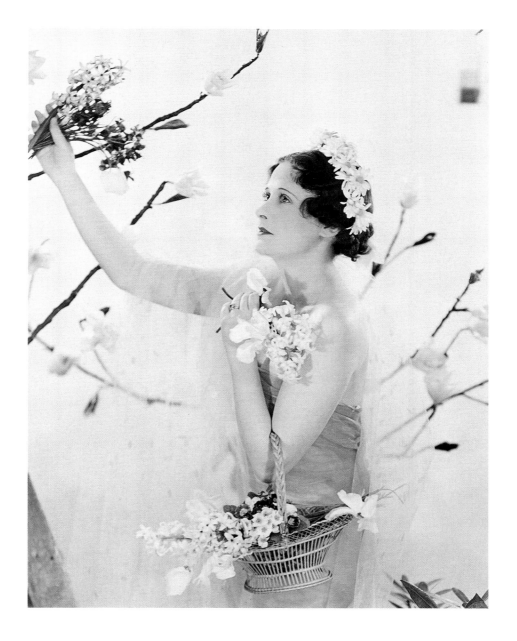

OPPOSITE | Wilding's preferred nude subject, Rhoda Madge Beasley, was an artist's model who was just breaking into fashion modelling when she was killed in a car crash three years after this portrait was taken in 1932. The background painting is by Thomas 'Rufus' Leighton-Pearce, Wilding's second husband from 1932 until his death in 1940. This photograph won the third prize in the 13th Annual Competition of American Photography in 1933.

BELOW LEFT | For a period in the early 1930s, Rosalind Maingot experimented with a variety of sparkling materials, lighting them to maximise reflection, glimmer and glitter. Work from this period by Walter Bird, Cecil Beaton and Dorothy Wilding also uses light-reflecting materials to great effect.

BELOW RIGHT | Dorothy Wilding often used turbans on her female subjects, both naked and clothed, to draw the emphasis away from their hair and onto their profiles. The use of the silvery material in this photograph of 1929 adds a luminous gleam to the image, emphasising the silken skin tones.

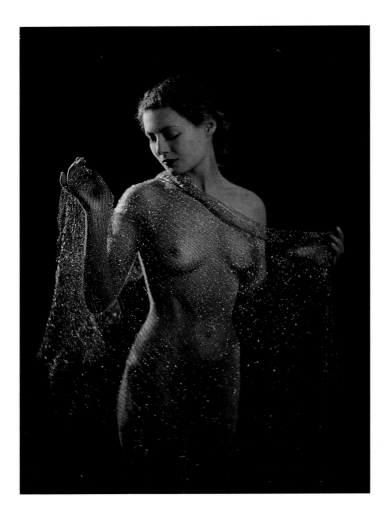

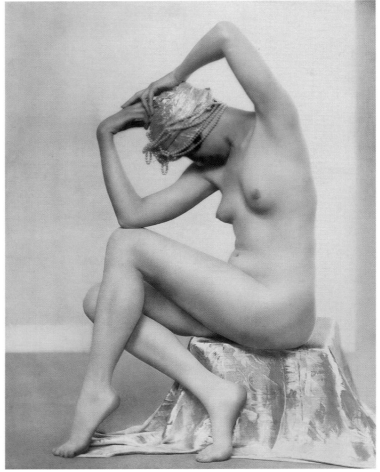

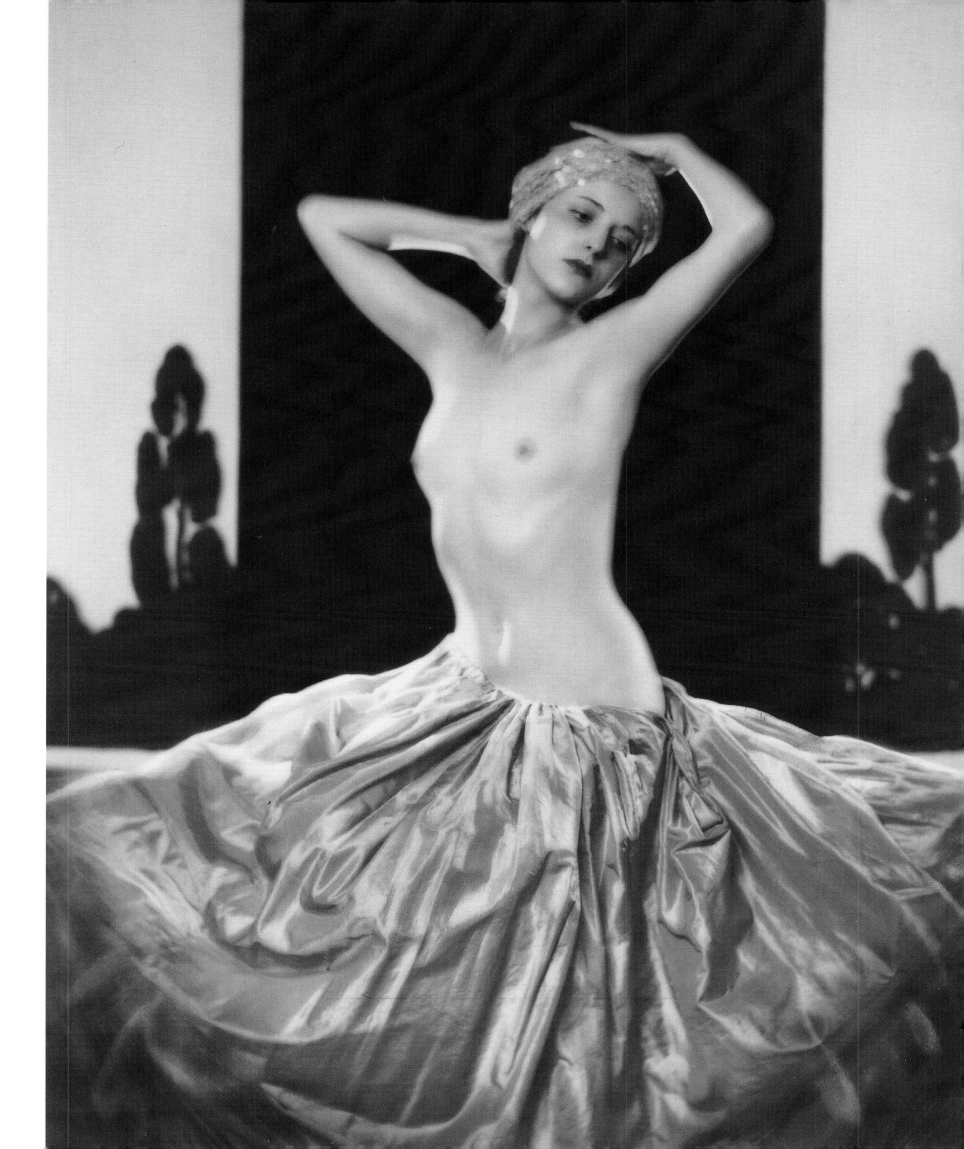

VII.

LANDSCAPE & ARCHITECTURE

VII.

T HE DESIRE TO CAPTURE HIS EMOTIONAL RESPONSES TO THE BEAUTIES OF NATURE laid out before him led William Henry Fox Talbot to search for a more reliable recording device than pencil and paint. He practised his new photographic art on the gentle landscape of the Wiltshire countryside in England as well as on the weighty architecture of Lacock Abbey and the domestic architecture of the small rural community surrounding it. Talbot did not have to move far to photograph his chosen subject matter. Most of it he owned. His forays into pure landscape beyond Lacock were few and far between.

The landscape presented many problems owing to photography's early inabilities to record the details of both land and sky simultaneously. If the negative was exposed to record the landscape correctly, then the sky would be over-exposed. If vice versa, then the landscape would be under-exposed against a bright sky. Many photographers solved this problem by making two exposures and then printing them together, often using the same sky negative for printing with a variety of landscapes.

Architectural detail or, most especially, architecture set within a landscape, was an easier subject, and pleasing and successful results could be attained. Such images were direct descendants of the British picturesque watercolour tradition of Constable and Gainsborough, whereby the landscape was seen as peaceful, harmonious and people-friendly. Calvert Richard Jones (1804–1877), trained as a painter, even 'coloured-in' many of his salted paper prints of architecture and landscape with watercolour paint, producing a hybrid medium between photography and painting.

Elsewhere in Europe, early photographers of landscapes and buildings were likewise inspired by the native artistic traditions as well as the character of the local terrain. In France, landscape photography was initially inspired by the Barbizon school of Corot and Millet and later by the Impressionists' passion for nature. Photographers like Gustave Le Gray, Henri Le Secq and Edouard Baldus made geographical and topographical expeditions both within France and worldwide. Le Gray produced a series of moody views of the Forest of

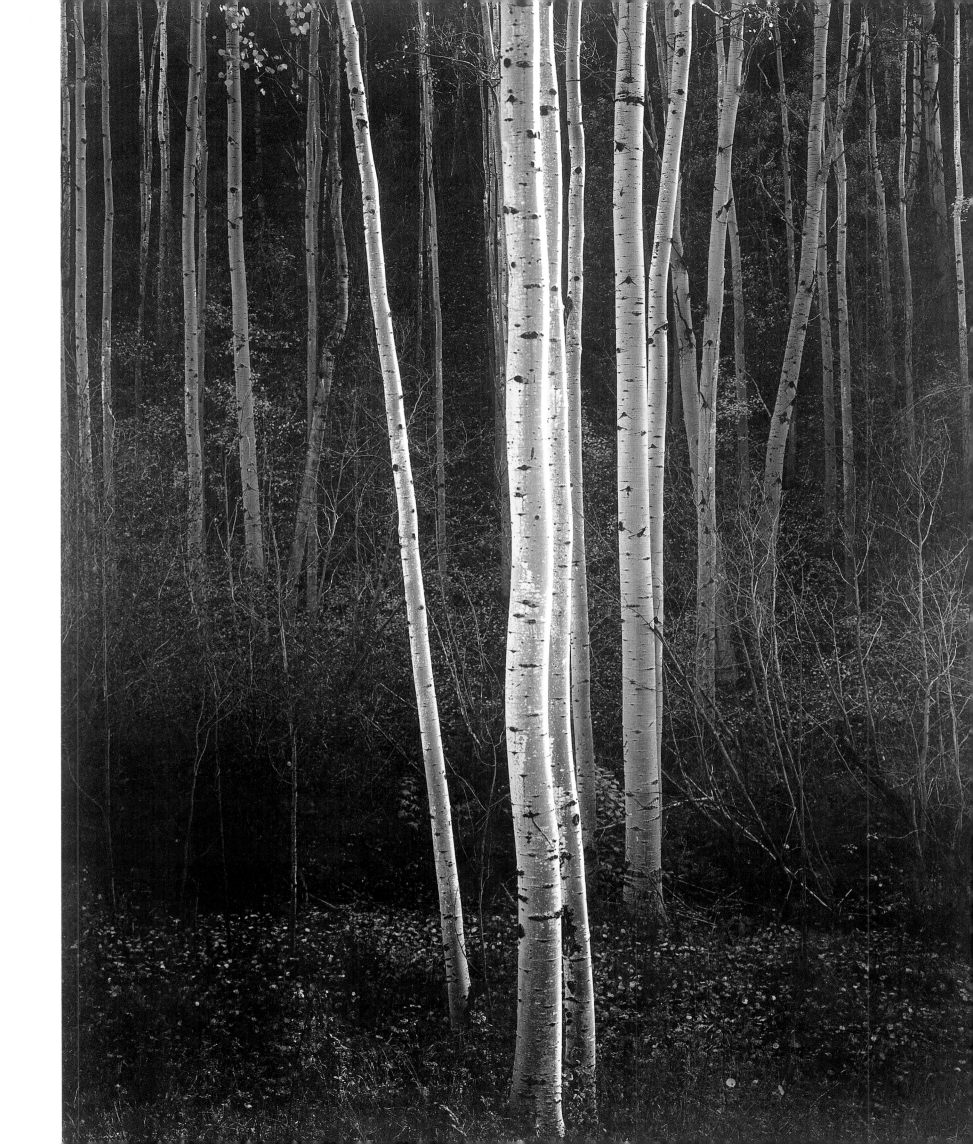

Fontainebleu as well as light-drenched sea and skyscapes. Baldus, working in Provence, produced spectacular views of epic proportions of the building of the railway from Lyons to the Mediterranean coast.

By contrast, the England depicted in mid-nineteenth-century landscape and architectural photography was socially and geographically well ordered, small and perfectly formed. Photography emphasised the neat, symbiotic and contained relationship between mellow stone buildings, thatched cottages, charming vistas, distant hills and idyllic meandering rivers. Gnarled ancient oak trees, trim avenues of pollarded willows, timeless rural hamlets, shady country lanes and ancient monuments were all represented in the mix. Moody blasted heaths, squelching marshlands and scrubby undergrowth were not considered suitable subjects, at least not until later in the century. What was not pictorially photogenic was excluded.

For more dramatic and romantic scenery, tinged with awe and mystery and the presence of a higher order, it was necessary to travel north, to the craggy majesty of the Lake District, Yorkshire, Northumberland and beyond to Scotland, or West to the gorges of Somerset and the mountains of Wales. British photographers did not have a Grand Canyon, a Niagara or a Yosemite to discover, but they made the most of what they had.

British, French and Italian photographers all displayed a foolhardiness and a wild bravery in their attempts to photograph mountain ranges and glaciers. Farnham Maxwell Lyte (1828–1906), Bisson Frères and Adolphe Braun (1812–1877) scrambled up the Alps and the Pyrenees, accompanied by posses of porters and guides weighed down and endangered by their heavy photographic equipment. The mammoth plate photographs produced by Bisson Frères from 1860–70 show climbing men as insignificant as small insects set against a startling and grandiose landscape.

For those interested in a less rural architecture and landscape, then there were, initially, the great cathedrals, gothic ruined abbeys and historic monuments of Europe to photograph. In the 1850s, Tintern Abbey on the border of England and Wales must have been swarming with photographers inspired by the

OPPOSITE | Although a modernist and avant-garde architectural photographer by profession, Briton Mark Oliver Dell preferred romantic and idealistic landscapes for his personal work. He attached great weight to the character of a landscape, and tried to express that character in broad simple masses of light and shadow with breadth of tone, as in this photograph of 1916.

poetry of William Wordsworth. Across the Channel in France, the Commission des Monuments Historiques set up the Heliographique Mission in 1851, employing the photographers Le Gray, Baldus, Le Secq and Bayard to document historic buildings and sites all over France.

In Britain, stately homes and royal palaces were favoured subjects, and, eventually, the lure of the behemoth of the city – London, Paris and, at the start of the twentieth century, the city for which photography was invented, New York. In London, Benjamin Brecknell Turner (1815–1894) and Philip Henry Delamotte (1820–1889) photographed, respectively, the dismantling in Hyde Park in 1852 and the rebuilding in Sydenham in 1855 of the graphically modern Crystal Palace. The rebuilding of Paris from the 1860s provided many years' work for French photographers, especially Charles Marville (1816–1879).

Roger Fenton was the supreme nineteenth-century landscape and architectural photographer, producing an astonishingly diverse body of work. His early compositions of wooden shanty huts in Russia in 1852, set to one side of a bleak and desolate landscape, are empty photographs of horizontal space and light. They have an excitement and a minimalist mood only matched by the 1854 Egyptian photographs of light, shadow, sky and horizon of the American John Beasley Greene.

Once back in Britain, Fenton reverted to type and seemingly found little in the busy British landscapes and buildings he photographed for the next eight years that engendered this same feeling of almost mystical void and emptiness. Or if he did, then he edited it down and composed his photographs, according to British pictorial traditions, and offered them for sale for mass consumption to a growing tourist audience. His photographs of the Rivers Ribble and Hodder in Lancashire show distant pastoral scenes, small cottages, a rich lush seductive countryside, dappled with hazy sunlight, glinting on pellucid watery reflections, where men had nothing to do but fish. A few miles away smoky chimneys belched the products of an industrial revolution that would blacken the valleys and pollute the waters.

Fenton's country house and royal palace landscapes are composed to reflect a harmonious social order. These were landscapes which had been designed and made by man to provide a suitable setting for his buildings. They were shifted, reordered and replanted to suit his whims, his aesthetic requirements and his purse. When ordered pictorial landscapes tired him, Fenton turned back to wilder landscapes and photographed natural forces. He filled every inch of his compositions with crashing, seething, spuming water, or thrust his camera up into scudding Biblical skies or up-front against massive expanses of dark, forbidding rock faces – a technique that he used equally successfully in his later architectural work to gain that same elemental shock. Fenton's cathedrals, taken in this confrontational mode, loom over the viewer with a threatening presence. Whilst never recapturing nor seemingly pursuing the void and surreal composition of his early Russian work, taken with a more fledgling and less responsive technology, Fenton took British landscape and architectural photography into two different directions: the conservatively pictorial and the daringly experimental.

Throughout the nineteenth century, British landscape and architectural photography largely progressed along the pictorial, picturesque route, making the myth of the rural idyll a visual reality. Outside Britain, British photographers travelled with their pictorial and social assumptions about landscape and architecture intact. They were acutely aware of what would appeal to their potential market back home, and tried to overlay these aspirations onto a foreign culture. This awareness of the tastes of the purchasing public back home also informs the work of other European photographers travelling abroad: Auguste Salzmann (1824–1872), Félix Teynard (1817–1892) and Dr. Jakob August Lorent (1810–1884), for example.

Working at roughly the same time in the US, American photographers such as Timothy O'Sullivan (1840–1882), Carleton Watkins (1825–1916) and William Henry Jackson (1843–1942) imbued their work with a frontier spirit, an awareness of the enormity of the vast and challenging spaces in front of them. This was a dramatic departure from most European photography.

OPPOSITE | Britain's Royal Air Force was responsible for aerial reconnais-
sance during World War I, producing images of trench warfare and troop
movements previously difficult to record by balloon surveillance. These
photographs show trenches near Blairville in around 1917 *(left)* and an aerial
view of Abbeville, June 1918.

FOLLOWING PAGES | British photographer Alfred Hind Robinson bought
a No.4 Panoram Kodak camera in 1903 and used it for the rest of his life.
His work includes these panoramas: of Scarborough on the Yorkshire coastline
(*circa* 1910) and the exotic sights of Egypt (*circa* 1920).

The grandeur of American landscape photography was far removed from its Lilliputian British ante-
cedents. Pictorialism, as practised on a small crowded island, did not work as an interpretative medium for the
empty American West. This landscape was more about sheer physicality, about land and sky, about geography
and geology and nature, and a complete lack of human influence, rather than about social expression and the
effects of human influence. Landscape photography found a whole new visual language, concerning the power
and life, symbolism and mysticism of the land itself. It echoed a new way of seeing that was emerging in the
transcendental writings of Ralph Waldo Emerson, Henry David Thoreau and Walt Whitman. Over the next
100 years, the landscape photographs of Eadweard Muybridge, Alvin Langdon Coburn, Edward Weston and
Ansel Adams, amongst many others, celebrated the religion of space and nature. These were metaphysical
landscapes rather than social ones.

The various Secession movements at the turn of the century veered in altogether different directions from
the pictorial norm. Landscapes were photographed as expressions of personal mood. Figures were introduced,
not as individuals dwarfed by their surroundings but as equal partners, symbolic figures in a symbolic landscape.
Henry Peach Robinson produced a series of landscapes, with and without figures, as well as romantic moonlit
seascapes, with superimposed seagulls and moons.

Peter Henry Emerson's photographs relating man and nature in the Norfolk Broads were hugely influen-
tial on his contemporaries, most especially the young Alfred Stieglitz who was awarded a silver medal by
Emerson in 1887 for the photographs he submitted to *Amateur Photographer* magazine's 'Holiday Work' com-
petition. Emerson interlinked the lives of his human subjects with the landscape, with the seasons, with nature
itself – a theme taken up by the Americans George Seeley, Annie Brigman, Clarence H. White and Fred
Holland Day. They produced a type of pagan symbolic landscape using family, friends or themselves as models
rather than Emerson's indigenous noble peasants.

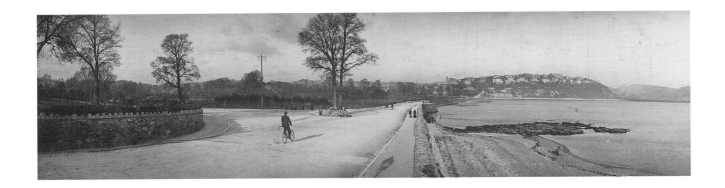

The overwhelming use of manipulative processes to achieve the desired effects of mood and tone was widespread internationally from the mid-1880s to 1914 and was applied to landscape and architecture, indeed to all subjects, equally. George Davison, Frederick H. Evans, James Craig Annan, Frank Meadow Sutcliffe, Alfred Horsley Hinton and Alfred Mummery in Britain, and Edward Steichen, Alfred Stieglitz and Alvin Langdon Coburn in the US, produced landscapes and architectural studies using gum, platinum, photogravure and carbon processes. Hinton's dark platinum prints, which invest the gentler landscapes of southern England with a brooding quality, and Steichen's series of multiple-coated gum platinum prints of the woods in Milwaukee are fine examples of the internal landscape of the mind and soul. The velvety richness and depth of the platinum process adds a further layer of mystery to already enigmatic images.

Frederick Evans began his photographic career in the mid-1880s producing small, intricate and precise photomicrographs. But he soon turned his camera on landscape, people and, most especially, architecture, achieving architectural studies of cathedrals that followed the tradition of Fenton's later work. Evans' formative landscapes and architectural studies of the early to mid-1890s have a detached and distant observational quality that disappeared in his work over the subsequent 10 years. His early twentieth-century work is remarkable for its purity of line and consummate mastery of light, space and composition. Evans cited William Blake, J.M.W. Turner, Odilon Redon and Aubrey Beardsley as influences, visionaries all. Although he followed his own pure path, only ever printing in platinum from (largely) unretouched negatives, he collected very different, more manipulated work by Fred Holland Day, Robert Demachy and Edward Steichen.

In Britain, Evans became the architectural photographer *par excellence*. His compositions have often been copied, but rarely bettered, over the last 100 years. His friendship with Fred Holland Day and Alfred Stieglitz, along with his exhibitions at Day's studio in Boston, at *291* gallery in New York and at the Albright Art Museum in Buffalo, meant that his very British style was also appreciated in the US.

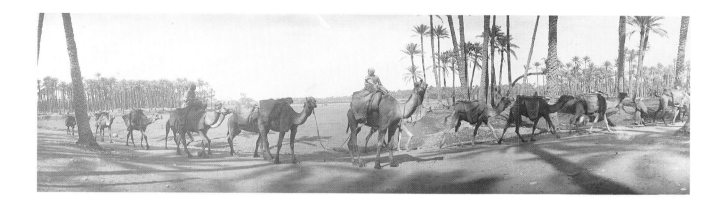

Around the turn of the century, photographers began to discover a new and thrilling subject matter – the city. From the 1840s onwards, cities had been closely documented: London by Talbot, Rosling, Blanchard and Fenton; Edinburgh by Hill and Adamson; Paris by Le Gray, Marville, and Durandelle amongst many others; Rome, Venice, Florence by Bisson Frères and Fratelli Alinari; and Madrid by Charles Clifford. These photographs had been taken with a more practical purpose in mind. They served as documents of important buildings, often of archaeological, religious, classical and touristic interest, rather than as landscapes, portraits or character studies of urban structures, spaces and moods.

Coburn began a project to photograph New York, London, Paris, Venice, Edinburgh, Manchester and Liverpool, inspired by the work of Alfred Stieglitz in New York. Stieglitz's early New York pictures concentrated on the effects of weather and atmosphere – rain, snow and stormy skies in a hostile city – showing humans adapting to an altogether different environment from the rural Arcadia photographed by his European counterparts, and by himself in the late-nineteenth century. Life is now a battle and is dominated by progress: by trains and ships belching smoke, by aircraft lurking in the skies and, most especially, by soaring architecture which rapidly becomes the dominating factor in Stieglitz's photography. As New York's skyscrapers rise into the sky, so Stieglitz abandons the streets, pulling the camera up above the human level, and starts to concentrate on the city itself as an organic growth in its own right, bereft of people.

Coburn's take on the city is initially much softer. Coburn's London and Venice and even his early photographs of New York are redolent with history. Sunlight filtering through leaves, and light reflecting on water create a strong sense of place, of peace and tranquillity. Flights of steps and bridges built for humans to ascend and cross are a recurring theme in his photography. If Stieglitz was about snow, rain and mist, then Coburn was about sunshine and shadow. Coburn's cityscapes embody a balance and division of space influenced by Whistler and the Japanese woodblock prints of Hokusai and Hiroshige. They have a zen-like calm and order.

OPPOSITE | In this Autochrome of around 1910, British photographer
John Cimon Warburg has chosen to photograph the famous Neptune
Fountain, which fronts Royscot House in Cheltenham, not to show the famous
figure of the macho sea god himself but to emphasise the atmospheric mood of
the dappled light and shade created by the water and the greenery.

Coburn's later cityscapes, like his Grand Canyon landscapes, become much more abstract compositions. He adopts a pigeon's-eye view, looking down on a graphic urban landscape. These two traditions coalesced in the work of Paul Strand, who took graphic abstracts of the city as pattern, as well as photographs of New York street people, rendering them, from below eye level, as an anonymous urban product, whilst giving them an incomparable personal dignity.

New York continues to be a city of exotic photographic imperatives, and images of New York are probably better represented in the RPS Collection than any other city, apart from London, by British, European and American photographers alike. The Collection's emphasis on British twentieth-century Pictorial photography at the expense of a wider collecting brief has, however, meant the acquisition of a wide variety of photographs of British urban and rural landscapes and architecture, as well as, not unexpectedly for an island nation, a concentration on seascapes.

The photographs of Francis James Mortimer (1874–1944) are the most extraordinary in this respect. A prolific contributor to, and editor of, photographic publications, as well as a vociferous lecturer, Mortimer had a passion for the sea that bordered on the lunatic, the obsessional and the personally heroic, only matched by his passion for photography. Lashed to the ship's mast on the dangerously stormy seas off the Scilly Isles where he was born, camera strapped to his body, he photographed waves and cloud formations which he would later print, separately or together, to achieve the desired image.

While Mortimer was endangering his life for his art in the crashing waves, Captain Alfred Buckham (1881–1957), a captain in the Flying Corps in World War I, was doing much the same in the skies above. Buckham took Coburn's pigeon's-eye view up to about 30,000 feet in the 1920s and 30s and photographed the landscapes and townscapes beneath him, as well as dramatic cloud formations. Back in the darkroom, he would print the land and the sky into a sleek and smooth whole and add – by paint or by yet another negative – a light

aircraft, such as he might have been photographing from, to complete the picture. Buckham was commissioned by *Fortune* magazine in the US in the 1930s to conduct an aerial survey. In doing so, he photographed from the air many of those same empty, transcendental landscapes that Jackson, O'Sullivan, Muybridge and Coburn had photographed some decades earlier, travelling by foot and packhorse.

Far removed from Buckham's detached bird's-eye view of the land, contemporary landscape and architectural photography now increasingly addresses social, cultural and environmental problems – the growth of urban, suburban and industrial sprawl and the rapid shrinking of the countryside – rather than solely the areas of outstanding historic, pictorial and natural beauty emphasised by nineteenth-century landscape photographers. Yet, like Talbot almost two centuries before, photographers cannot help but record their emotional response to the beauty of nature, where it can still be found. Landscape photography still retains something of the mystique of nature, of our longing for an environment – majestic, unsullied by human impact – that nineteenth-century photographers so took for granted. It would seem to be some measure of progress in landscape photography that both elements – the critical and the reverential – can now co-exist.

ABOVE | A. H. Blake, whose soubriquet when a member of the Linked Ring Brotherhood was 'Cockney', was renowned for his photographs of his native city of London – by day, as in this image of the fountains at Kensington Gardens, but especially by night. An early practitioner of night photography, Blake used both the artificial street and window display lights of the city as well as natural moonlight to light his atmospheric photographs.

RIGHT | Roger Fenton took a whole series of photographs of Harewood House in England, probably commissioned by the owners and designed to show their wealth and grandeur. This is the view its inhabitants would see every day from the windows on the upper terrace. The stone balustrade of the formal terrace dissects the photograph in two. Beyond are the romantically landscaped acres, nature brought into submission by expensive landscape gardeners. In the background cows can be seen which appear to have eight or more legs, suggesting an exposure time up to a minute.

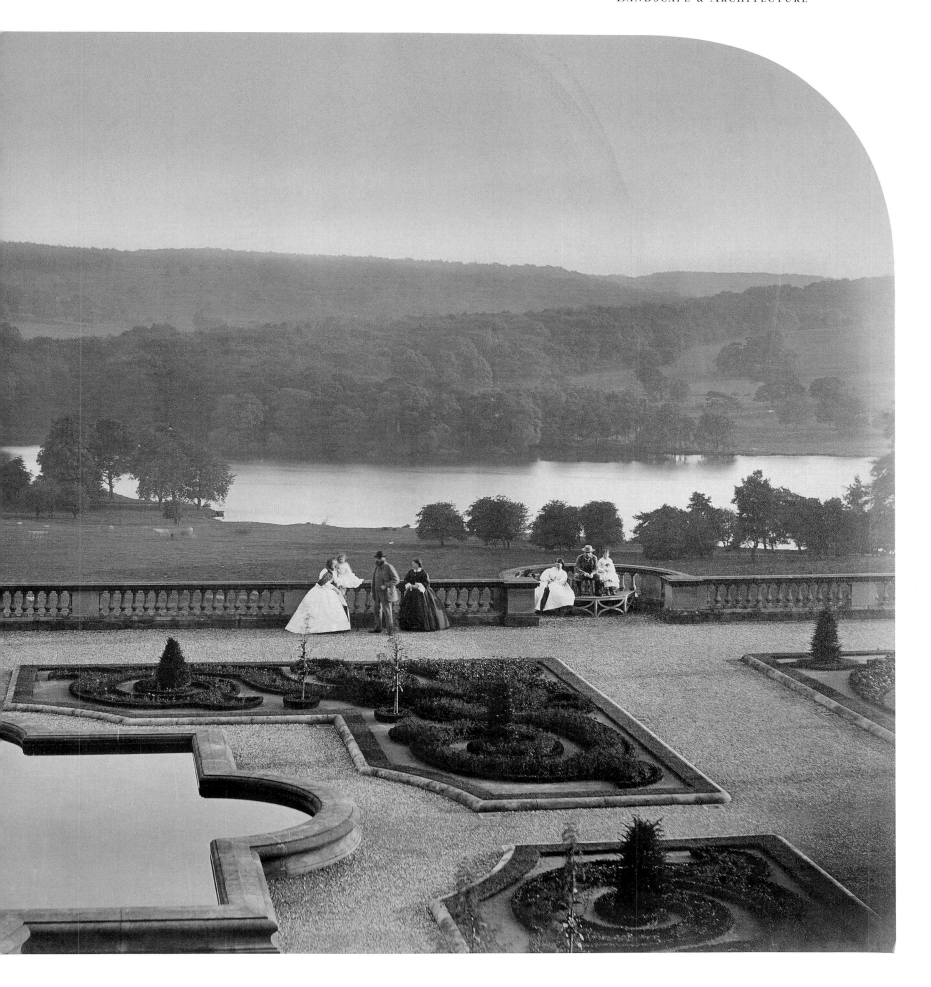

OPPOSITE | A group of tiny figures, one jauntily perched on the edge of the tower support, are using the 165-foot Niagara Falls as a backdrop in this anonymous photograph from around 1860. They may have been amongst the first to pose in this position but millions since have followed them.

ABOVE | Benjamin Brecknell Turner photographed the interior of the Great Exhibition Building, the Crystal Palace in London's Hyde Park, in 1852 after the exhibits had been removed and prior to the transfer of the building to a site on Sydenham Hill. This paper negative of the building's nave emphasises the complex series of roof supports designed by Sir Joseph Paxton.

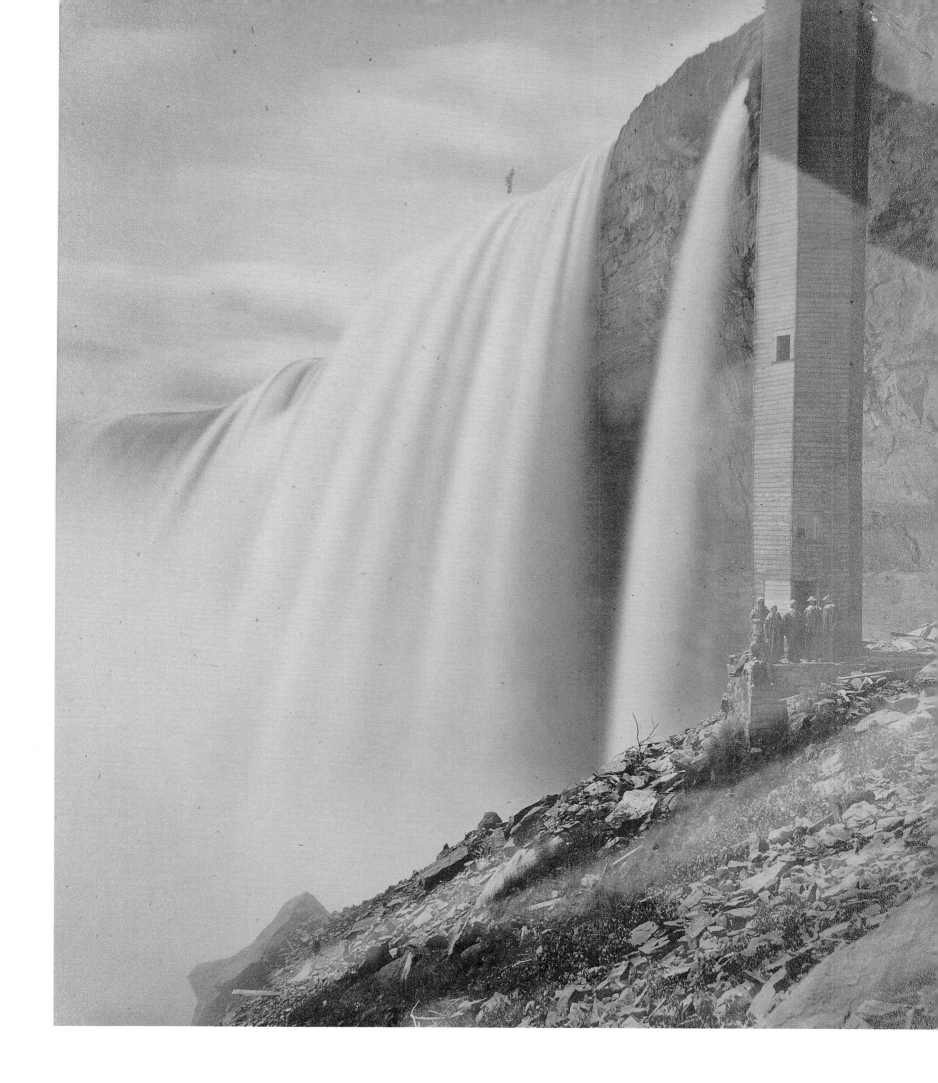

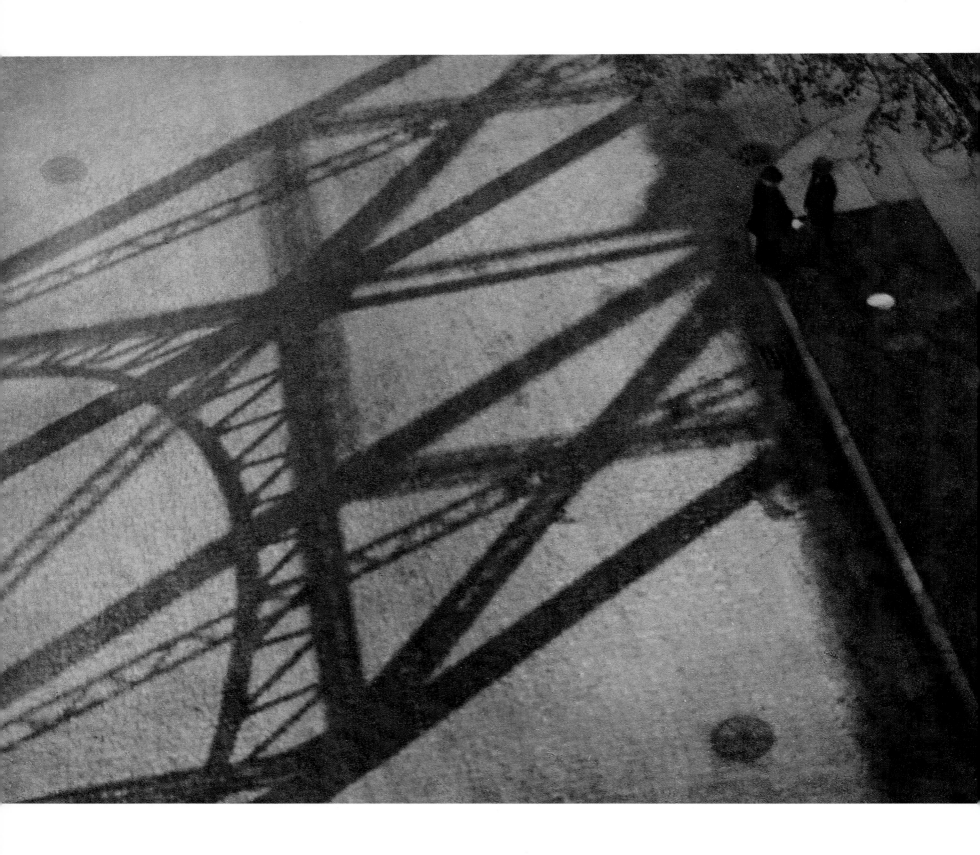

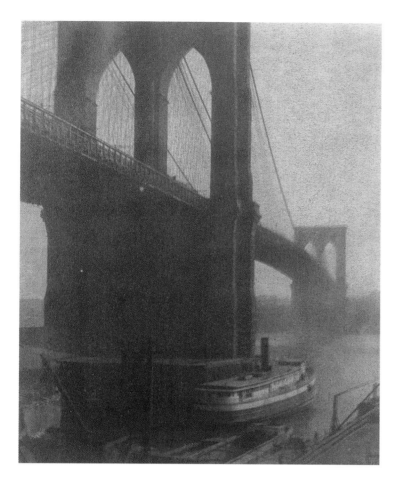
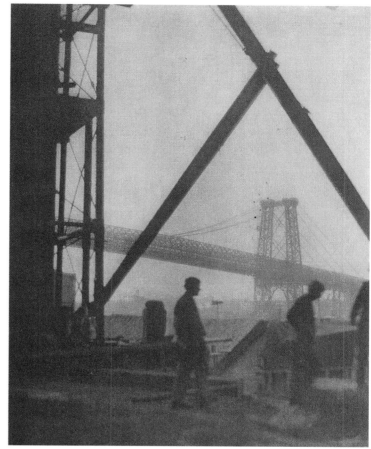

OPPOSITE | This soaring, abstract image by Paul Strand was reproduced in the final issue of *Camera Work*, no. 49/50, in 1917. In the same issue Stieglitz wrote: 'The work is brutally direct. Devoid of all flim-flam; devoid of trickery and any "ism" ... These photographs are the direct expression of today.'

ABOVE | Alvin Langdon Coburn's New York is a place of excitement and potential but a place in which humans can co-exist with buildings. He could see similarities between the bridge-builder and the photographer, writing in 1910: 'The one uses his brain to fashion a thing of steel girders, a spider's web of beauty to glisten in the sun, the other blends chemistry and optics with personality in such a way as to produce a lasting impression of a beautiful fragment. The work of both ... owes its existence to man's hold over nature.'

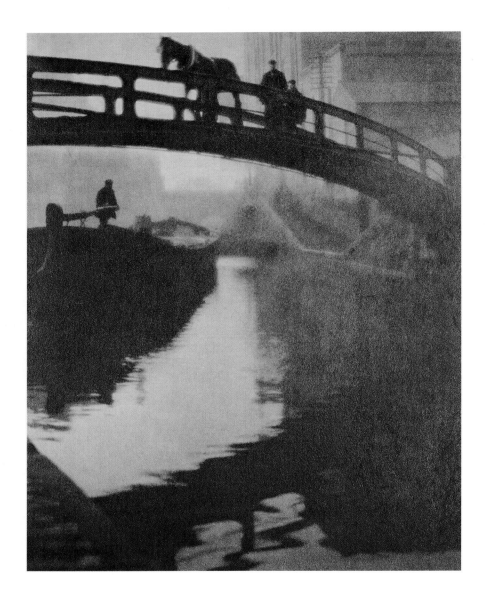

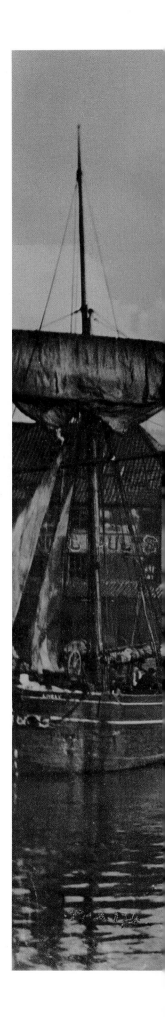

ABOVE | Alvin Langdon Coburn thought London the most photogenic city in the world and was fascinated by capturing its moods, as this image of Regent's Canal demonstrates. He would wait all day for the perfect moment, that perfect consummation of light, self-expression and mood when, according to Whistler, 'nature was creeping up a bit'. Sunlight and its play on water, mist and rain and their dissolving effect on stone and street light held him in thrall.

RIGHT | This 1880 carbon print of 'The Dock End, Whitby' is one of Frank Meadow Sutcliffe's most successful photographs, commercially and artistically. Possibly, so his daughter Irene thought, because this was the first view that visitors to Whitby would have of the old town and their last view on departure.

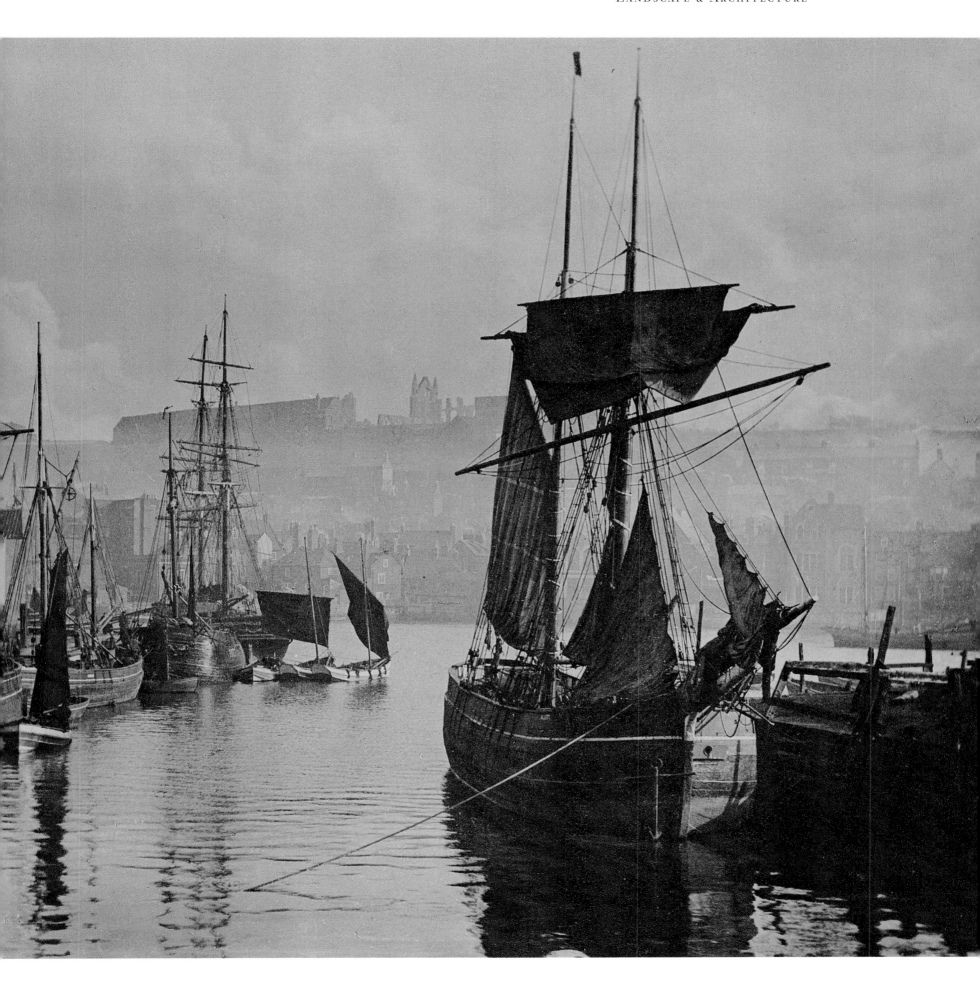

OPPOSITE | Dr Drahomir Josef Ruzicka, an expat from Czechoslovakia who graduated from New York University with a medical degree in 1891, became interested in photography through his use of X-Rays in his private obstetrics and paediatrics practice and bought his first camera in 1904. This chlorobromide of Lower Manhattan dates from 1936.

ABOVE | Harold Pierce Cazneaux's photograph, taken around 1935 in the Flinders Range north of Adelaide in his native Australia, suggests a painted make-believe backdrop to the Wizard of Oz or a Grimm Brothers fairy tale. It appears more like a rapidly sketched watercolour painting, a nuance, a suggestion, than a photographic reflection of reality.

OPPOSITE | During the spring and summer of 1911, Coburn spent several peaceful months photographing in the Yosemite Valley, California, often using a long focus lens. This photograph in particular seems to have affected him profoundly, as he writes in his autobiography: 'It has been my privilege to present my camera to very many things which have caused me to experience true wonder, and this is one of them, and I firmly believe that if we make the most of our opportunities we shall be granted further visions …'

BELOW | William Young specialised in railway photography. Having photographed the building of the Krishna Railway on the east coast of India, he moved to where the work was – Mombasa in Kenya. He followed the largely Indian work force who were employed for their expertise to build the Uganda Railway (later the East African). This photograph of 1901 captures the scale of the task and the difficulty of cutting through the harsh terrain.

OPPOSITE | Battersea Power Station, Britain's largest coal-fired generating station when it opened in 1934, was designed by architect Sir Giles Gilbert Scott. Known as the 'cathedral of power' (Scott also designed Liverpool Cathedral), its chimneys rose 337 feet like upturned table legs. Griggs' photograph shows a Modernist appreciation of this new soaring architecture.

ABOVE | New York's pedestrians are dwarfed by the monumental masonry of Wall Street's buildings. This photograph was taken by Paul Strand in 1915 from the courtroom looking down on Wall Street. Strand's pure, direct and brutally strong photographs were the final nail in the coffin of Pictorialism in America.

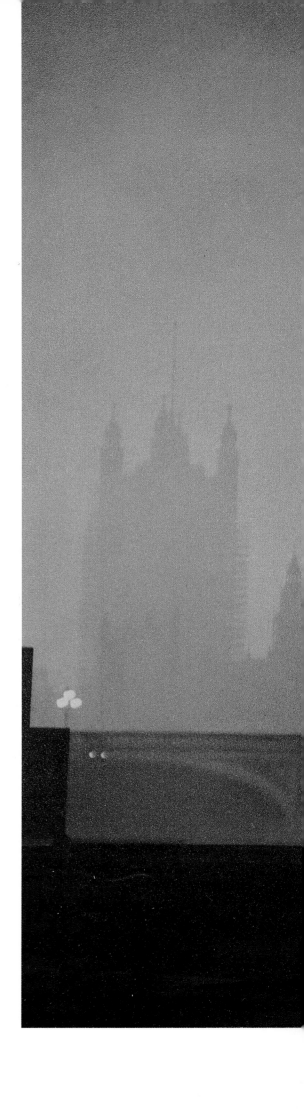

ABOVE | Alfred Rosling was the first Treasurer of the Photographic Society (now the RPS) and a more than competent photographer, having taken up photography in the mid-1840s. He fit this into his daily working life as a successful timber merchant in Hackney, London. Rosling's calotype negative of *circa* 1853 shows St. Paul's Cathedral in all its glory as well as what were once London's principal trading wharves for iron, lead and zinc.

RIGHT | Horace Murch was a banker by day and a photographer by night and weekends, much interested in romantic and picturesque lighting effects, or 'the poetry of light' as he eloquently phrased it. Taken in 1954, this photo-graph shows Waterloo Bridge, the Houses of Parliament and Big Ben looming through the gloaming. Murch was a consummate printer and this image, composed on purely Pictorial principles, has a wonderful tonal range that earlier photographers of London, like Coburn, would have envied.

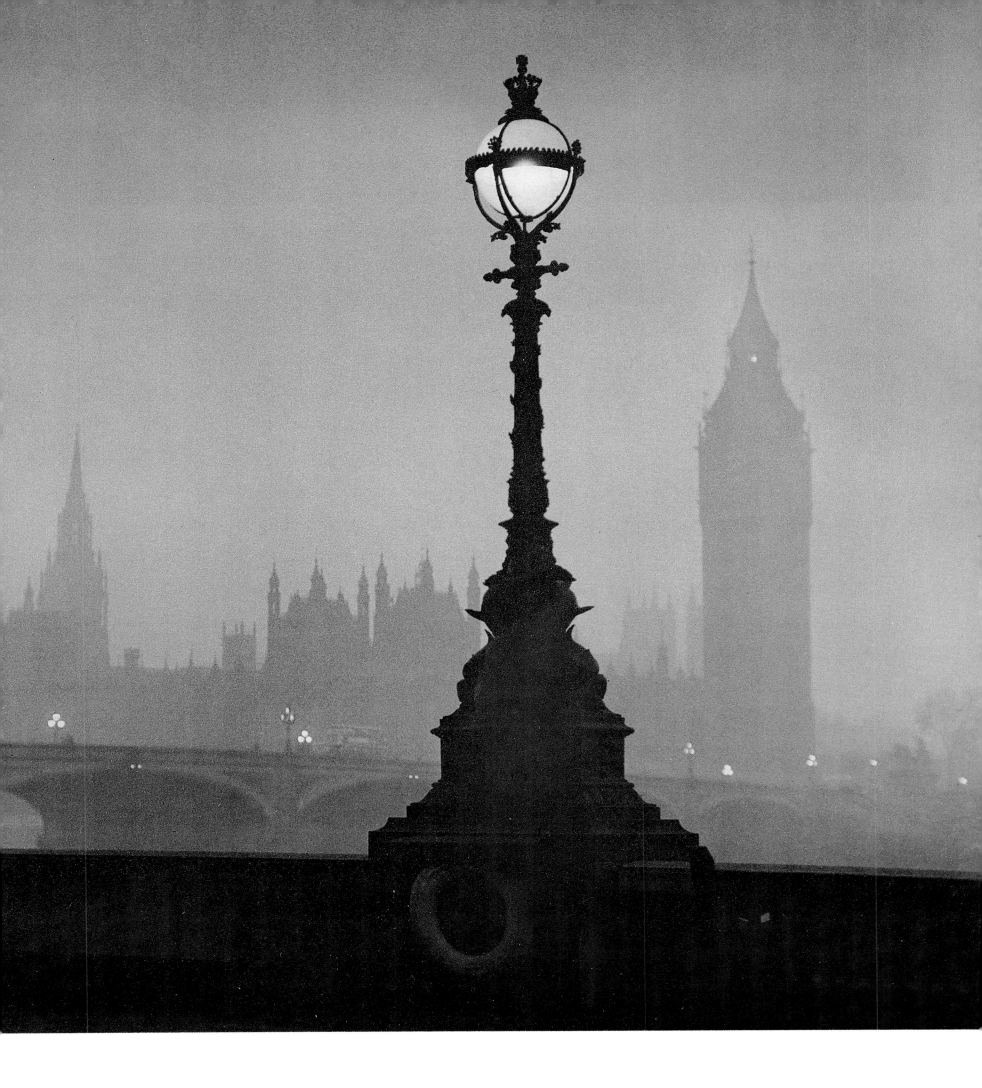

RIGHT | Roger Fenton accompanied his friend, the civil engineer
Charles Blacker Vignoles, to Russia in September 1852. He was commissioned
to photograph the erection of Vignoles's suspension bridge over the River
Dneiper near Kiev. Fenton took many other views, including this one of
St. Vasili's in Moscow. It had been renovated in 1845 after being sacked by
Napoleon's army in 1812.

BELOW | Stieglitz and Coburn had photographed the thrill of New York's
rocketing skyscrapers by looking downwards on the ever-soaring city. Two
decades later, in the 1930s, Dr. Ruzicka had adjusted the viewpoint to the man
in the street's definition, that of a pygmy dwarfed by looming giants.

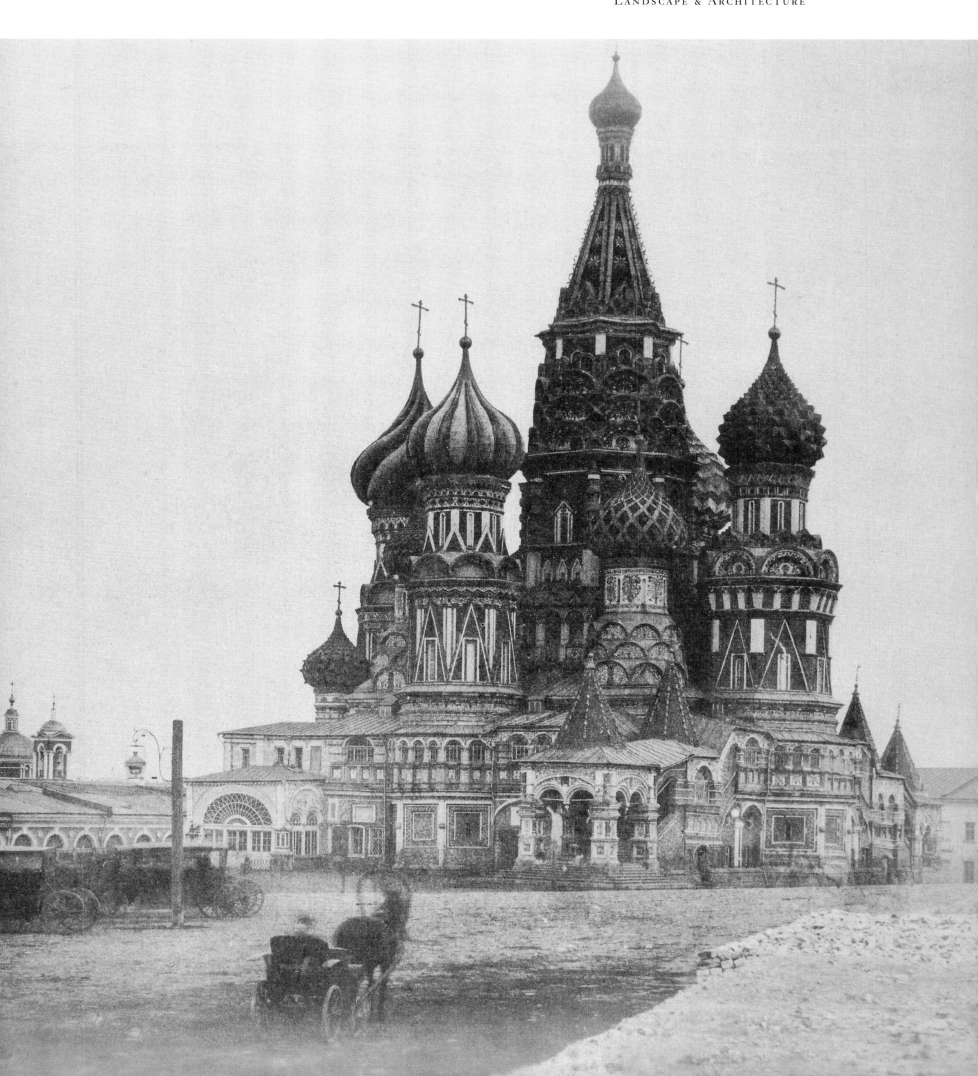

LEFT | In the late 1850s, Roger Fenton was particularly preoccupied with photographing the sky in harmony with land and water. This was best achieved by making two exposures, one for the sky and one for the land, as a negative properly exposed for the land left the sky bland and featureless, and *vice versa*. The two negatives could then be printed separately to make a composite whole. In this photograph, Fenton has deliberately made only one exposure for the sky, leaving the land dark and silhouetted. It is a brooding, intense and stormy image of great emotional power.

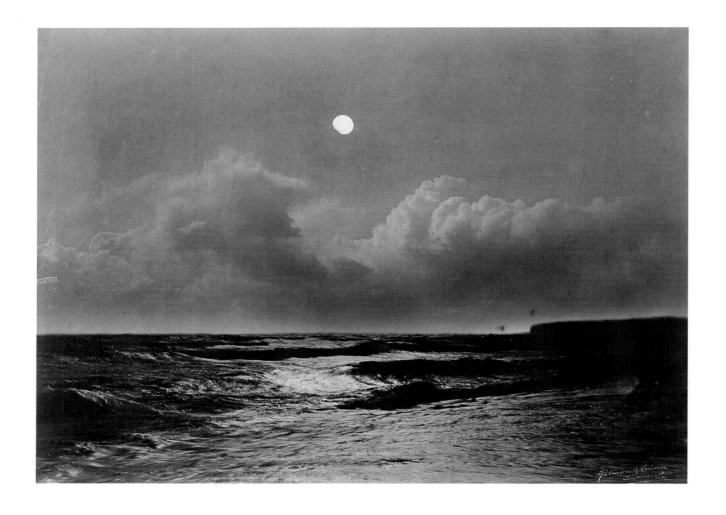

OPPOSITE | Frances Mortimer considered the camera 'the poor man's easel', and used a reflex camera with glass negatives. It was well equipped for photographing at sea, being waterproof and equipped with a pneumatic shutter, the rubber release ball of which could be mouth operated, leaving both hands free to hold onto the camera. Mortimer often had himself tied to the ship's mast so he was not swept overboard in stormy seas such as this.

ABOVE | Henry Peach Robinson and Nelson King Cherrill worked in partnership in Robinson's Tunbridge Wells Great Hall Studio from 1868–75, producing this seascape in 1870. This photograph was printed from two negatives, one for the moon and sky and one for the sea.

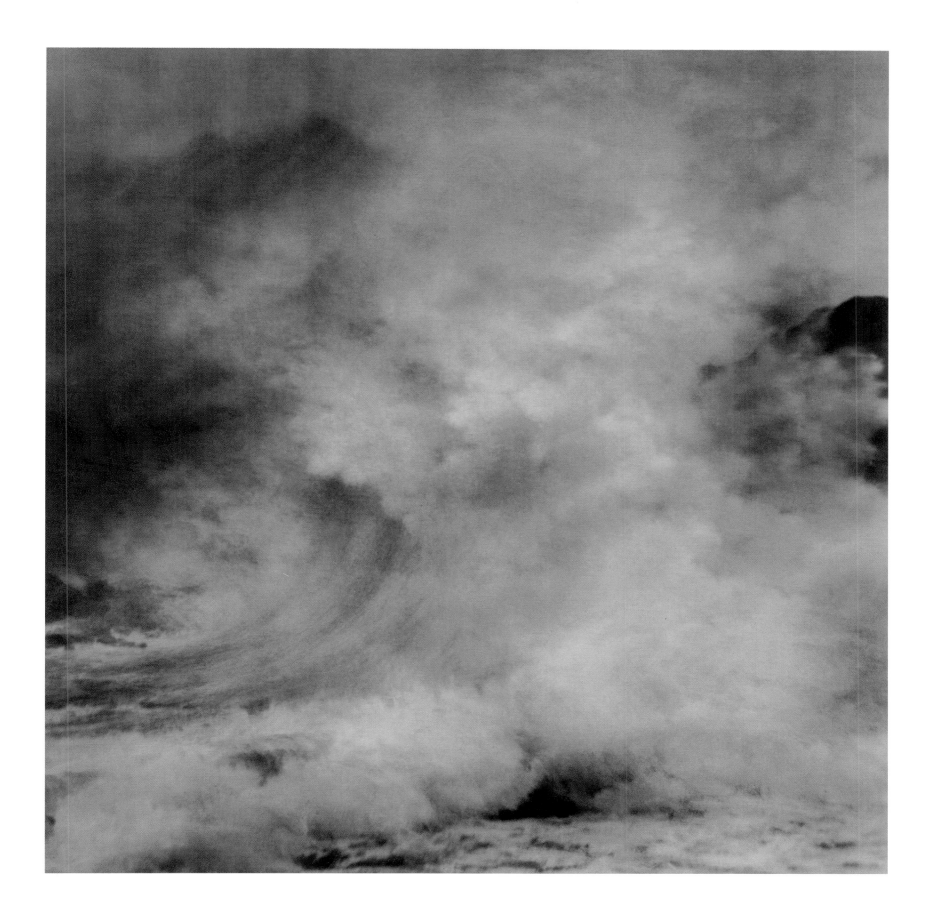

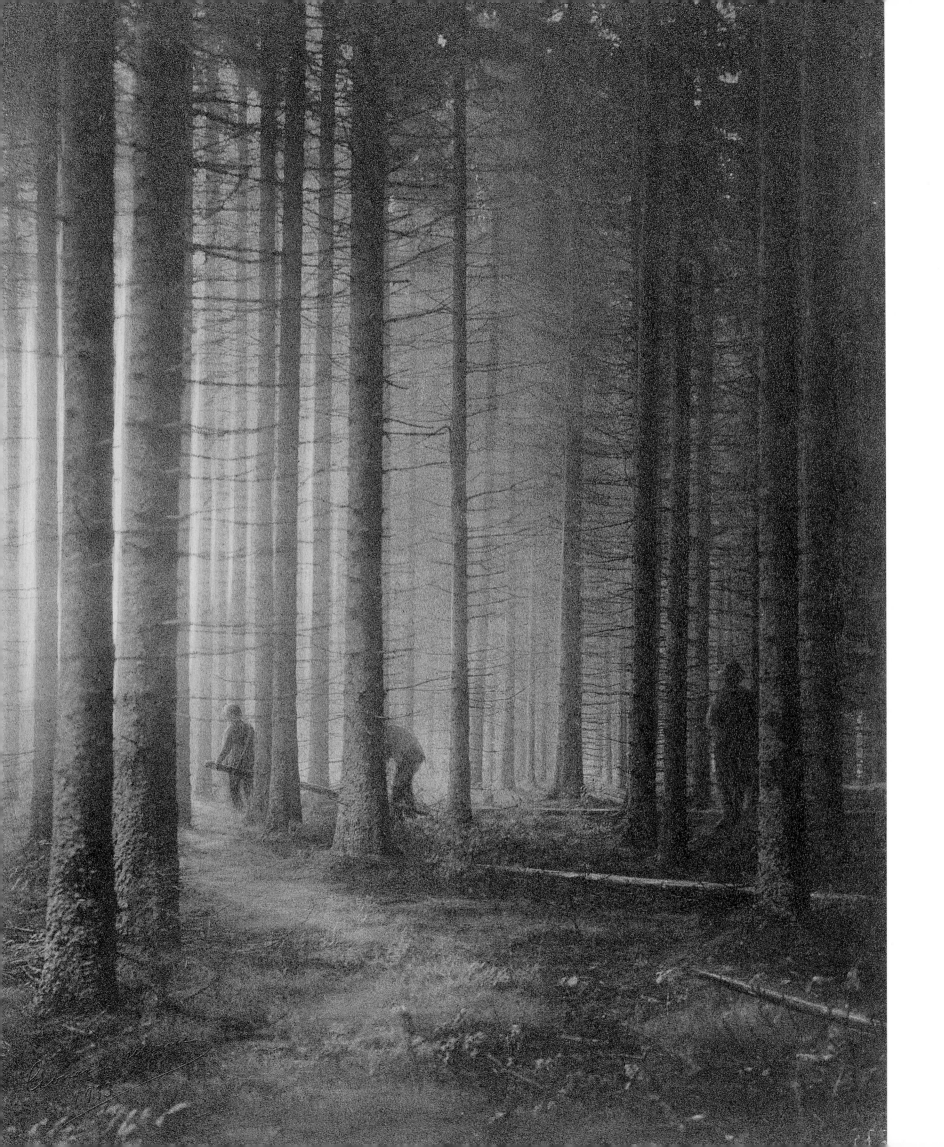

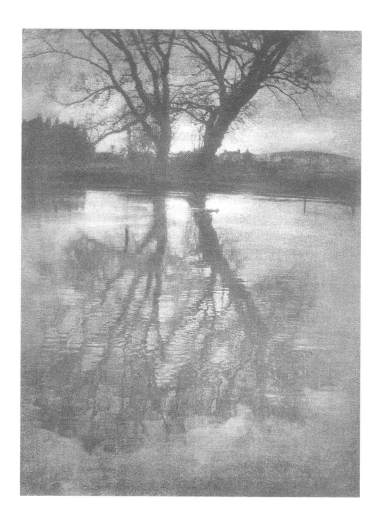

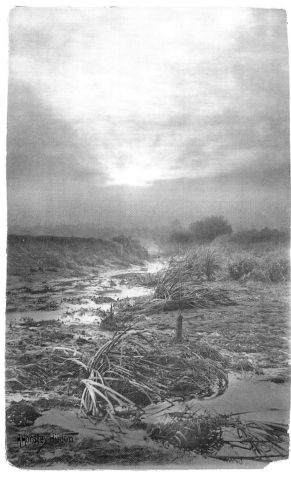

OPPOSITE | Léonard Misonne's photographs have an atmospheric, glinting magic that reveal him to be a master of bad-weather photography. *The British Journal of Photography* declared in 1912: 'His work is very distinctive, and by many is thought to reach the highest point of landscape work by the camera.'

ABOVE LEFT | In 1899, George Davison began the endearing custom of sending photogravures printed from his negatives to friends at Christmas, inscribed with a seasonal message. This example – of Weston-on-the Green, just north of Oxford – was sent to the photographer Paul Martin.

ABOVE RIGHT | Alfred Horsley Hinton's death at 45 robbed British photography of one of its most Impressionistic photographers. A champion of Alfred Stieglitz, he produced broody landscapes such as this one from 1896.

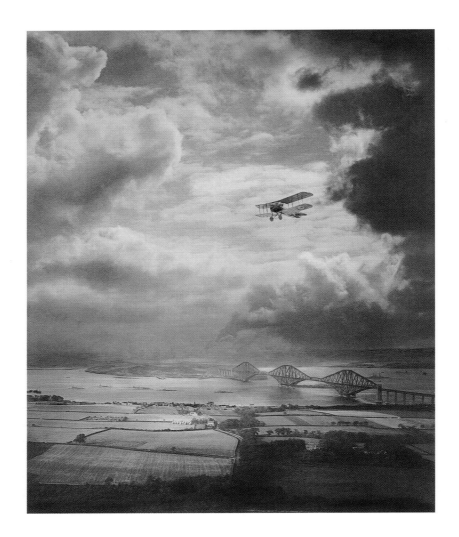

OPPOSITE | Buckham preferred to shoot on stormy, cloudy days, his aircraft lashed and buffeted by the elements, standing in an open cockpit in temperatures below zero. His cities are dark, dense, forbidding places only enlivened and humanised by the graphic detail of a particular building or, in this case, the shining serpentine loops of the Thames in London, the neat and compact arches of the river bridges and the toy boats chugging up and down the river. Taken in 1923, in an age before commercial air travel, Buckham's photograph must have seemed as exotic and as thrilling as a moon landing.

ABOVE | An intrepid flying ace, Captain Alfred George Buckham photographed cloud formations, other flying aircraft and aerial cityscapes from the heavens and then, back on earth, amalgamated them together in the darkroom, marrying art and craft into a composite whole. Nor did he hesitate to paint an aircraft onto a Biblical sky (as is probably the case here) if that is what the photograph needed. This image of 1926 is of the Forth Bridge.

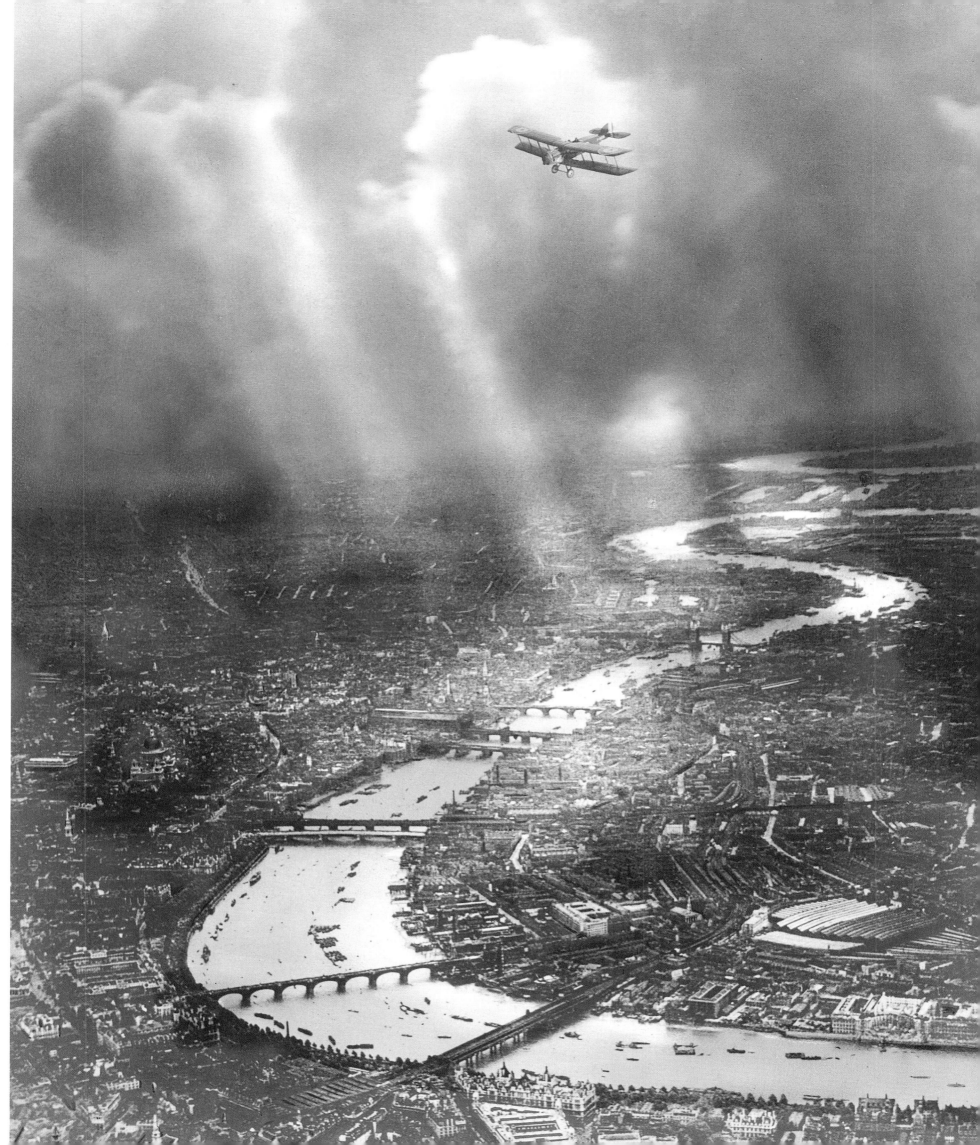

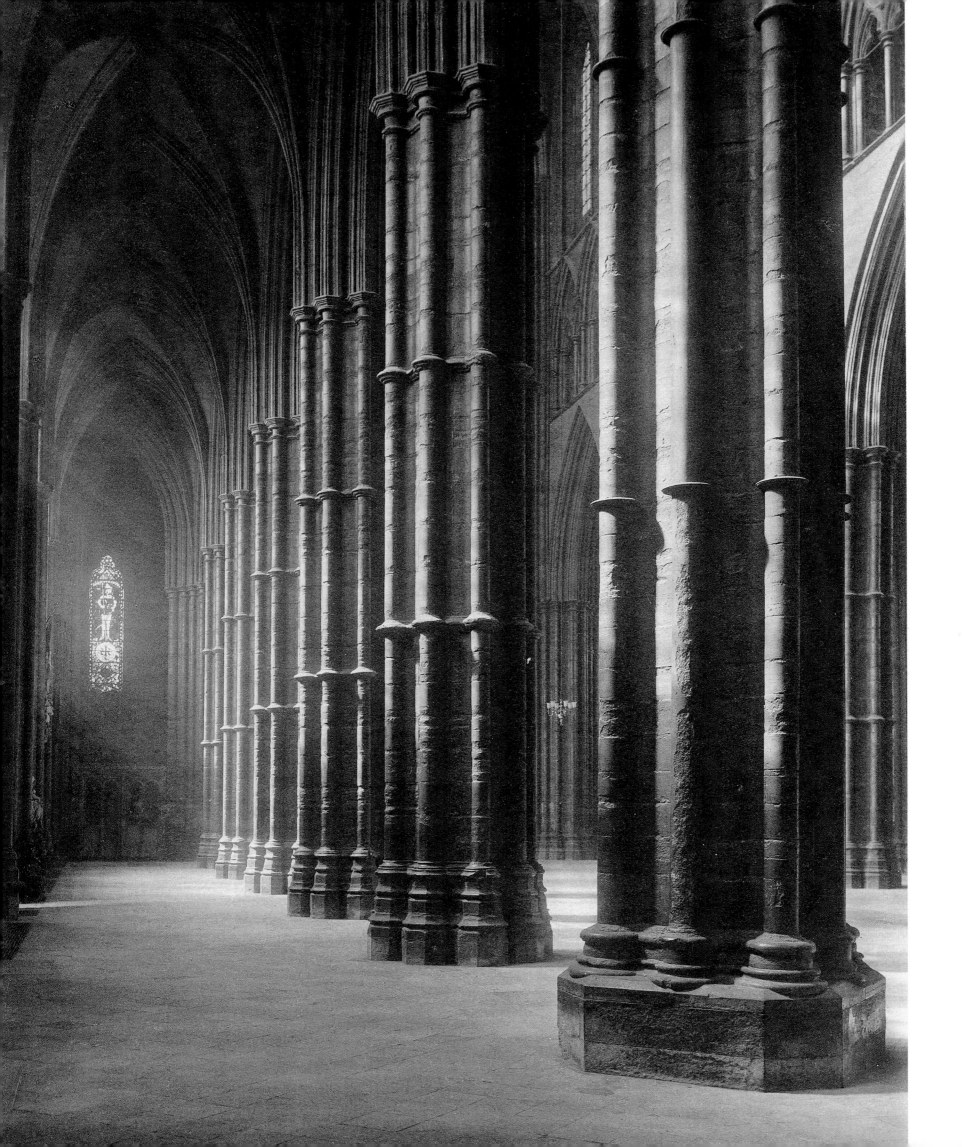

OPPOSITE & BELOW LEFT | Frederick Evans was well-known for his cathedral work. He was commissioned by *Country Life* magazine to photograph the interior of Westminster Abbey (opposite) whilst it was closed for renovation prior to the coronation of George V on 23 June 1911. Chairs, pews and other furniture were all removed, leaving Evans with pure, uncluttered space. This photograph has all the Evans' hallmarks of shimmering light, graceful, thrilling volume and perspective. Eight years earlier he photographed the thirteenth-century steps of Wells Cathedral (below left). The resulting image, Evans said, 'has contented me more than I thought possible'.

BELOW RIGHT | Tripe tamed the fierce Indian sun in his photographs and used it to get marvellous illumination flooding into dark temple interiors. He documents the structure and carved ornamentation of a building whilst also seizing upon its graphic possibilities and breaking up massive spaces and vaulted chambers with runnels of light. No other photographer seemed to get quite the print colours that Tripe achieved, especially in this one, a spine-tingling shade of rich aubergine-brown.

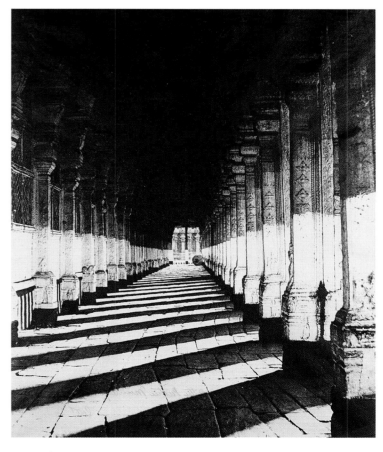

VIII.

TRAVEL

VIII.

ASK ANYONE WITH A CAMERA THE SUBJECT MATTER OF THEIR MOST recent photograph and, nine times out of ten, the answer will be 'my holiday'. It is a truism of photographic processing companies that the average roll of film processed starts and ends with a summer holiday. Whilst annual summer holidays – with sun, sea, sand and billions of holiday snaps – may be a twentieth-century development, the urge to travel, to explore, to discover – and to have a visual, tangible memory of those experiences – goes back much further, if only, initially, for a privileged elite.

Travel photography has its origins in the European Grand Tour, a sort of holiday in the sun but with didactic educational, aesthetic and geographical elements, which was considered an essential part of a wealthy young Northern European gentleman's upbringing from the seventeenth century onwards. Spending time in Europe, most especially Italy, whether for political, aesthetic, inspirational, health, climatic or purely escapist reasons, was a prerequisite for poets and writers – for Johann Wolfgang von Goethe, for the British Romantics Lord Byron, Percy Bysshe Shelley and John Keats and for Gérard de Nerval, who travelled as far as Cairo.

The only way to see Renaissance art, Roman ruins and the vertiginous peaks of Switzerland, Austria, France and Germany was to travel to them, expensively and slowly. The Napoleonic Wars in the early nineteenth century temporarily necessitated a change in route from Northern to Southern Europe, to the safer but more exotic territories of Greece, Malta and then, daringly, across the Mediterranean to its southern shores, to Egypt and to Jerusalem.

The only way to capture and retain memories of the trip was to draw or paint them, or, for the very rich, buy examples of them and ship them home. It was exactly this that William Henry Fox Talbot was doing when he tangled unsuccessfully with a camera lucida on his Grand European Honeymoon Tour in 1833.

Twenty years later, the tripartite proliferation of better transport (by rail and sea), better communications (by post and later telegraph) and, most of all, photography, meant that the world could, increasingly,

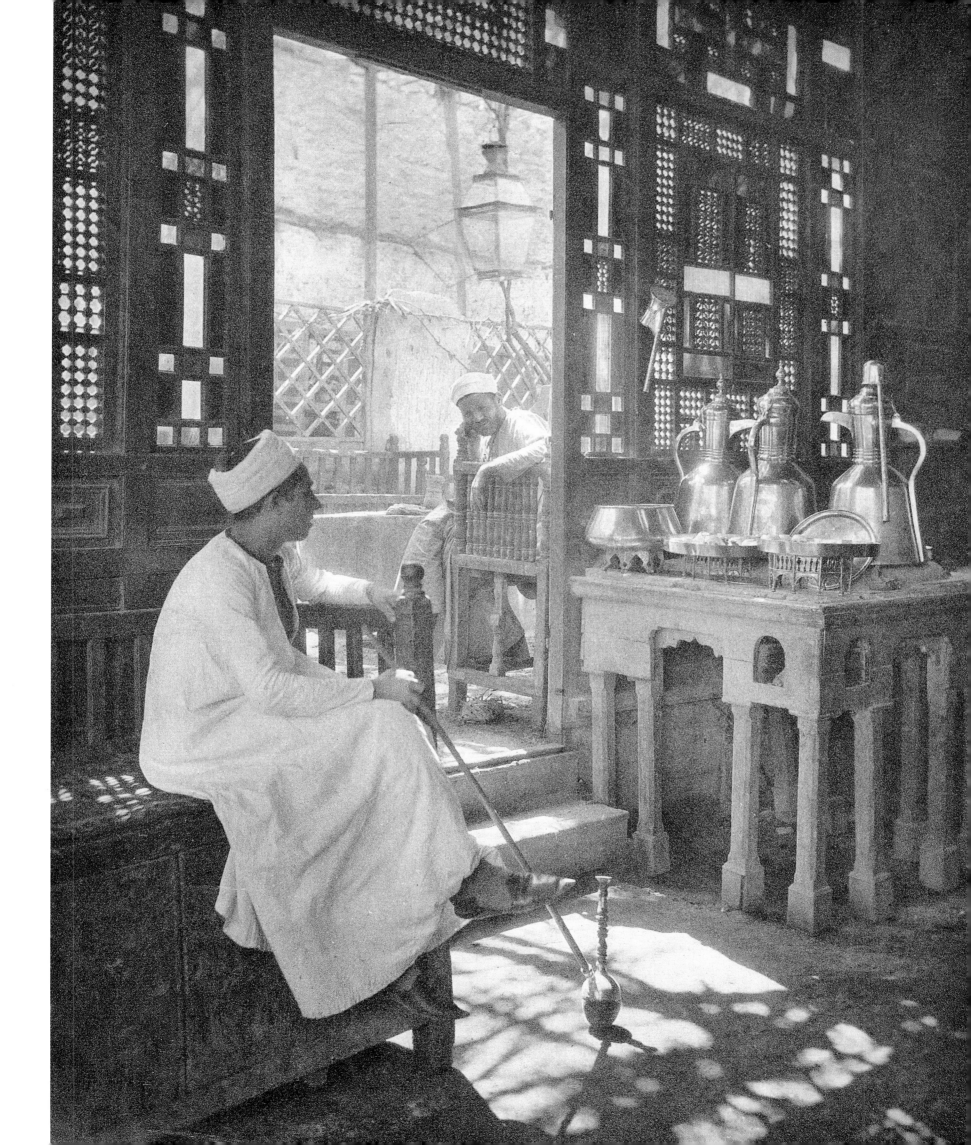

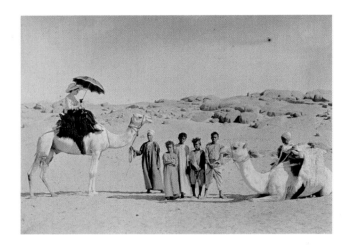

be delivered to one's very doorstep. Photographers rapidly realised that they could act as a conduit to bring this world directly into people's homes, at a price of course.

In 1858, the British photographer William Lake Price wrote: 'by its [photography's] means the aspect of our globe, from the tropics to the poles, its inhabitants … its cities, the outline of its mountains, are made familiar to us'. In the next hundred years, being more familiar with the world was about to become the requisite of the many rather than just the few.

The RPS Collection traces this extraordinary development through its holdings of travel and tourist photography, from the early forays into travel and exploration of the 1840s and 1850s, to commercial travel photography of the 1860s to 1890s, through to amateur snapshots and albums, colour and pictorial material from the twentieth century.

The world that initially most appealed to European photographers and travellers was Southern Europe and the northern shores of the Mediterranean, and then beyond, in an ever easterly direction, to the Middle East, India, China and Japan. The southern shores of the Mediterranean, where the edges of the mysterious East met the edges of the empirical West, exerted a huge and exciting draw for photographers. As the birthplace of many ancient and noble civilisations and religions, coupled with the exciting and tantalising lure of the exotic, erotic and sensual, the thrill of the unknown and the heady whiff of potential decadence, the Middle East attracted droves of photographers from the late 1840s onwards.

From 1848–50, Dr. Claudius Galen Wheelhouse (1826–1909) performed a double function as both ship's physician and photographer on board Lord Lincoln's Mediterranean cruising yacht, producing a couple of hundred paper negatives, an annotated album of prints and a detailed diary of the trip. In 1849–51, Maxime du Camp (1822–1894), commissioned by the French Ministry of Public Education to photograph Egyptian monuments, undertook a journey of discovery through Egypt, Syria and Greece along with the writer

OPPOSITE | Friedrich Paneth married Else Hartmann, daughter of the historian Ludo Hartmann, in Vienna in November 1913, and the couple spent their four-month-long honeymoon in Egypt. Their visit is documented by Paneth in over 50 Autochromes, including this one of Else on a camel.

Gustave Flaubert (1821–1880). During these travels their visual, literary and sensory appetites seem to have been satisfied in equal measure. Du Camp published 125 views in 'Egypte, Nubie, Palestine et Syrie' in 1852, an objective, scientific and documentary series of photographs. Flaubert transmuted his impressions of the Middle East, with all its contrasts between violent beauty and ugliness, speed and timelessness, into a minor masterpiece, *Salammbô*, published in 1862.

Much of early travel photography was achieved through trial and error. Although French daguerreotypists Horace Vernet and Frédéric Goupil-Fesquet made daguerreotypes in Egypt in 1839, they encountered problems with the performance of the process in such extreme climatic conditions. The paper negative eventually achieved far better results, albeit after many failures. British photographer Reverend George W. Bridges undertook a seven-year journey from 1845–52 around the shores of the Mediterranean to Egypt and Palestine, during which he produced some 1700 paper negatives using Talbot's calotype negative process. Calvert Richard Jones (1802–1877) did likewise on his trip to Southern Italy and Malta in 1845–6. Both Jones and Bridges were photographing with a commercial end in mind, hoping to produce their photographs in illustrated publications, although little seems to have come of this.

The advent of Gustave le Gray's waxed paper negative process in 1850, with its increased sensitivity, led to more predictable results. Extremes of heat and light rendered exposure times unpredictable. Insects were a problem. Water for washing negatives was often scarce or contaminated. Photographic equipment was large and unwieldy and had to be carried by native bearers, mules, donkeys or even camels. It is a wonder that there are so many surviving images from this period, let alone that they are often breathtakingly beautiful.

Prints from early paper negatives often have a two-dimensional flatness and a compositional imbalance and abstract quality, bred of an unfamiliarity with both the landscape and the process, that takes them into the realm of the excitingly experimental. Whilst they do not have the detailed definition of later albumen prints

OPPOSITE | In the summer of 1906, Alvin Langdon Coburn embarked on a Mediterranean cruise, calling in at Cadiz where this photograph was probably taken. It was almost obligatory for every tourist to witness a *corrida* but not every tourist took a photograph as minimal as this. The heat haze and printing process render the bull and the matador as silhouettes in a golden ellipse.

from wet collodion glass negatives, they have an ability to capture light and shadow, time and space, as exciting to see now as it must have been then. There is an emotional, subjective response in these early images that appears less frequently in later work. Early travel photography was a voyage of exploration in more ways than one, with photographers pushing the primitive technology to its limits, experimenting with a freedom and a naive excitement that would later be subsumed by a degree of familiarity as both the technology and the photographer become more experienced and the commercial market more demanding in its specific tastes.

During the 1850s, the wet collodion negative on a glass rather than a paper base, and the albumen print, gave a clarity and definition which made the end result more predictable, more familiar and comfortable. Photographers who attended meetings at, or corresponded with, The Photographic Society shared their experiences of photographing in extreme desert or tropical conditions. Knowledge of what to do and how to do it grew commensurately.

The new industrial wealth of a flourishing European middle class provided a new monied audience for photography, not so interested in purchasing the mammoth expensive limited edition albums of salted paper prints of the early 1850s but in acquiring smaller photographically illustrated books and albums. It was now possible to print multiple copies from more detailed and durable negatives and thus produce larger, more cost-effective editions, sold through fine art dealers and later through bookshops and print sellers. The rapid rate of colonial expansion, especially by the British, meant it became increasingly possible, indeed, desirable, to overlay European pictorial composition onto alien lands, scenes and cultures to make them understandable, more readily accessible, to the population back home.

By the mid-1850s, European interest in anything concerning the Middle East, especially Egypt and Jerusalem, was at such a height that a good photographer with a finely honed commercial sense attuned to what the public wanted was virtually guaranteed a licence to print money. Francis Frith (1822–1898),

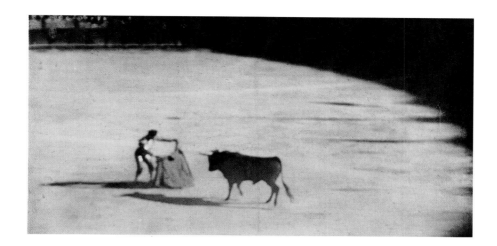

a successful Quaker businessman, a dauntingly competent and ruthlessly determined photographer, visited the Middle East, influenced by the style of objective documentary realism used in the very successful coloured lithographs published by the Scottish painter David Roberts in the 1840s. Frith was driven by the Ruskinian doctrine that 'the primal object is to place the spectator, as far as art can do, in the scene represented, and to give him the perfect sensation of its reality, wholly unmodified by the artist's execution'.

Frith also had a serious personal religious mission and his three trips to Egypt, Nubia and Palestine from 1856–60, were undertaken as harsh physical pilgrimages. He battled against photographically impossible temperatures of 130°F, dust, flies, bandits and a personal degree of colonial xenophobia bordering on the fanatical. Many of the photographs Frith produced were dull and matter-of-fact, but many were stunning, especially so when he forgot Ruskin's dictums about the objectivity of the artist and immersed himself fully in his subject.

Frith's photographic company in Reigate, England, printed 2000 prints from each negative, taken on three different sizes of camera. These were sold, with text, in a variety of published formats, including a photographically illustrated Bible, and made a tidy profit for Frith, supposedly in the region of £25,000 minus costs. *The Times* newspaper declared they were the most important photographs ever published. They were certainly amongst the most widely distributed.

In 1869, aided by the opening of the Suez Canal, the Middle East became the first great tourist destination outside Europe. British tour company Thomas Cook introduced ever growing hordes of travellers, some with their own cameras, to the area. A growing band of photographers from all over Europe had already set up studios, or sales points, to sell to those without their own photographic equipment, producing millions of images, of variable, often risible quality, for eager tourists to purchase, take home and glue into their personal albums. Quantity, rather than quality, of images was the impetus for most photographers attempting to make

a living from the fledgling industry. Amongst the better practitioners were Felice Beato operating in Cairo in 1862 and Luxor in 1872, W. Hammerschmidt from Berlin, who photographed around the Cairo area from 1860 and Desiré Ermé who recorded the construction of the Suez Canal. Some photographers even went as far afield as Syria and Lebanon. Tancréde Dumas and Félix Bonfils both opened a studio in Beirut in 1867, although Bonfils photographed far and wide around the Mediterranean.

Similar studios mushroomed all over Europe. In 1860, Francis Frith set up one of the world's most successful photographic supply companies with branches worldwide. It sent photographers out to capture every street in Britain, as well as views around the world. George Washington Wilson (1823–1893) and James Valentine's (1815–1890) companies also sent their photographers globetrotting to satisfy demand. In Italy, German-born, Naples-based, Georgio Sommer (1834–1914), Fratelli Alinari Studio (1852–1920) in Florence and Carlo Naya (1816–1882) in Venice sold prints which appear in practically every nineteenth-century travel album in the RPS Collection.

The photographic possibilities of the tantalising East may have been first exhaustively realised in the Middle East, comfortingly close to Europe, but, simultaneously, if rather more slowly, European photographers were gradually travelling east to India, China and Japan, even as far as Australia. Because of Britain's vast empire of the day, it was often British photographers who ventured furthest.

In 1852, 18-year-old Walter Woodbury (1834–1885) left Manchester for Australia, specifically the goldfields outside Melbourne, dreaming of fortune in an unknown land. By the time he arrived, the gold rush was over. Demonstrating the adaptability and acuity which was to stand him in good stead, Woodbury applied his knowledge of photography to his predicament and opened a studio in Melbourne. He later moved to Java, intending to progress to China, Japan and Manila. He ended up staying in Java for several years as the photographic business he created in Batavia proved to be extremely lucrative.

OPPOSITE | Helen Messenger Murdoch photographed this active volcano crater in Hawaii. 'It had begun to get dark and at first I held the little Una Sinclair camera … over the rim for ten minutes, nearly broke my back lying flat and then I found I had one more little plate so I tried once more and only gave it five minutes. Lucky I did! for that was the good one', she wrote.

It was in India that British photographers were most active and most inspired, and where, of course, there was a captive and long-established British market. Captain Linnaeus Tripe (1822–1902) worked as an official government photographer in Burma and Southern India during the 1850s, employed to photograph Indian architectural and archaeological remains and antiquities in place of the draughtsmen who had recorded them previously. He left behind an astonishing record of photographs of temples, forts, sculpture and land-scapes, taken on large-format waxed paper negatives and printed as deep glowing purple-brown prints, often presented in an expensive album format.

Samuel Bourne (1834–1912) spent only seven years photographing in India from 1863–70, but, like Frith in the Middle East, had an unshakeable and unquenchable belief in his own capabilities, allied with a keen commercial instinct and a perfectionist's zeal to get that one perfect photograph. He made photographic treks into Kashmir and the Himalayas, undertaken with military precision, accompanied by troupes of porters to carry the heavy equipment, and sheep and goats to eat and milk along the way. Bourne reached a height of 18,600 feet at the Manirung Pass on his third expedition in 1866, photographing at higher altitudes and at lower temperatures than anyone had done before. He still found the energy, time and conviction to report all his trips in a string of articles published in *The British Journal of Photography* between 1864 and 1870.

Bourne overlaid a British pictorial sensibility and a heady degree of romanticism onto a cold, cruelly beautiful and potentially deadly alien territory. That is to say, he made it comprehensible to his buying public whilst maintaining his own visual integrity. He sold the resulting photographs to archaeologists and botanists but mostly to British residents, civil servants and the military in India to take home as souvenirs when their tour of duty was over. By the time he returned to England, he had produced over 2500 large-format glass negatives of Indian scenery. His company, Bourne and Shepherd, also produced a series of stunning portraits of Indian nobility, many of them taken by Colin Murray who joined the company in 1869.

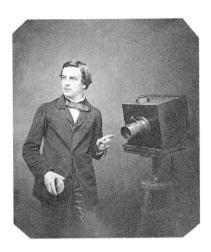

China and Japan were more difficult nuts to crack than India, but proved just as photographically rewarding. John Thomson (1837–1921) worked in the Far East for 10 years, photographing in Singapore, Thailand, Cambodia, Laos and Formosa, and eventually China, where he travelled from 1870–72, in constant danger. He published a four-volume work, *Illustrations of China and its People*, in 1873. Thomson photographed peoples from widely different racial and social backgrounds and the latter publication is as much about informed and affirmative anthropology and social documentary as travel and geography.

Italian-born Felice Beato (1825–1903) spent five years photographing the aftermaths of war and death (the Crimean War in 1855, the Indian Mutiny in 1858 and the Chinese Opium Wars in 1860), before arriving in Japan in 1862, only eight years after it opened up to the West. Here he concentrated on rather more peaceful subject matter for the next 15 years. His panoramas of Yokohama and his portraits of people and domestic Japanese scenes, subtly hand-coloured in water-colours by local artists, have a tranquil beauty and stylized dignity reminiscent of traditional *ukiyo-e* woodcuts. Most photographers working in the Far East at this time were British, but Beato eventually sold his business to Baron von Stillfried who then sold it on again to a Japanese photographer Kusakabe Kimbei.

In the US of the 1860s, tourist views took a rather different route. Initially, there were far fewer tourists so the commercial imperatives were not as compelling. The American Civil War, from 1861–6, absorbed many photographers but left them well-practised to photograph views that were infinitely more majestic and larger in scale than those available to their European counterparts. Stereo views of beauty spots, like Niagara Falls, existed from the 1850s, but the exploration of the American West in the 1860s and 70s by photographers like William Henry Jackson (1843–1942), Timothy O'Sullivan (1840–1882), Carleton E. Watkins (1829–1916) and Eadweard Muybridge (1830–1904) produced a body of work that was aimed at a richer and rather more discerning tourist than was found in Europe.

OPPOSITE | In May 1857, the 23-year-old Walter Woodbury sailed from Australia to Java where he was to run a successful photography studio until 1863. On 2 September 1857, he wrote to his mother back in Manchester: 'The portrait [of myself] I send has the date marked on it and in the future I shall always date them so that you can see if I improve in appearance or otherwise'.

Thus, the great age of tourist photography began. By 1897, the picture postcard with a divided back for a message and an address (so that images could be posted home along the route) had largely replaced print sales. In addition, an increasing number of tourists travelled armed with portable Kodak cameras.

As the nineteenth century ended, easier and speedier dry plate negatives, followed by hand-held and roll-film cameras enabled instantaneous pictures to be produced. These, together with the Autochrome, the first commercial colour process introduced in 1907, opened up travel photography to a wider audience.

Growing waves of tourists – amateur photographers equipped with their own Kodak cameras – were newly fascinated by the snapshot possibilities of the Pyramids, the Sphinx, the Parthenon and the Colosseum. In the days before environmental conservation, a personal element could be introduced into the photograph by posing a family member standing proudly beside a monument of ancient culture or even crawling over it.

Colour photography was made for travel and seems to have been especially seized upon by women. As women achieved greater independence, and some achieved greater wealth, they began to travel more. The Autochrome, the first available commercial colour process, was not cheap. Nor was it simple to use. Agnes B. Warburg (1872–1953) and her brother John Cimon Warburg (1867–1931) between them produced over 1000 colour transparencies on glass, in a variety of formats, including Autochromes and Dufaycolour, from 1908–30. They photographed family and domestic life, gardens and nature, and, in Agnes's case, her yearly Mediterranean cruise, during which she would document everything from the cruise liner in dock prior to departure, the deck games, ports of call in Naples, Sicily, Athens, and then, once back in London, give a lantern slide lecture about her travels. Although this might sound excruciatingly dull, she was a witty speaker and her photographs are of a calibre to have made these lectures successful and popular events.

Helen Messenger Murdoch (1862–1956) undertook a round-the-world trip from 1912–14, lugging the heavy and cumbersome Autochrome equipment with her, lecturing as she went using lantern slides of

Autochromes she had produced previously. She travelled from her home city of Boston to London and then down to Lyons to pick up stocks of Autochrome plates from the Lumière factory and then on through Egypt, India, China, Japan and Hawaii, returning back to Boston from San Diego. Whilst Murdoch had an easier trip than Frith, Bourne and Beato half a century earlier, she still endured difficult conditions, all noted in her detailed daily diary and letters home to her sisters back in Boston. Her insistence on being held by her ankles whilst she hung over the rim of an active volcano in Hawaii to photograph its activity shows an obsessive determination of which her predecessors, Frith, Bourne, Jackson *et al*, would have approved and understood. In her 60s, indomitable as ever, Murdoch went on to learn how to fly a plane and then proceeded to photograph the earth from an aerial perspective with great glee.

Now we can view and explore our world from many perspectives, often without ever leaving home. While we are all potential travel photographers, usually producing quantity rather than quality, few of us are truly intrepid explorers in the sense of Frith or Woodbury. And, if we are, we often have a film crew with us, as would they, given the technology. Photography and its descendants – film, TV and now the Internet – have enabled us to bring the world into our homes, and air travel has enabled us to deliver ourselves to any part of the globe within 24 hours. However, this seems to have done little to increase our understanding of a world we are so easily able to make into a microcosm. What photography has done is to enable us to occasionally personalise the world, make our own photographs of those private moments when, like Samuel Bourne in India or Felice Beato in Japan, we point our camera and see something quite remarkable before us.

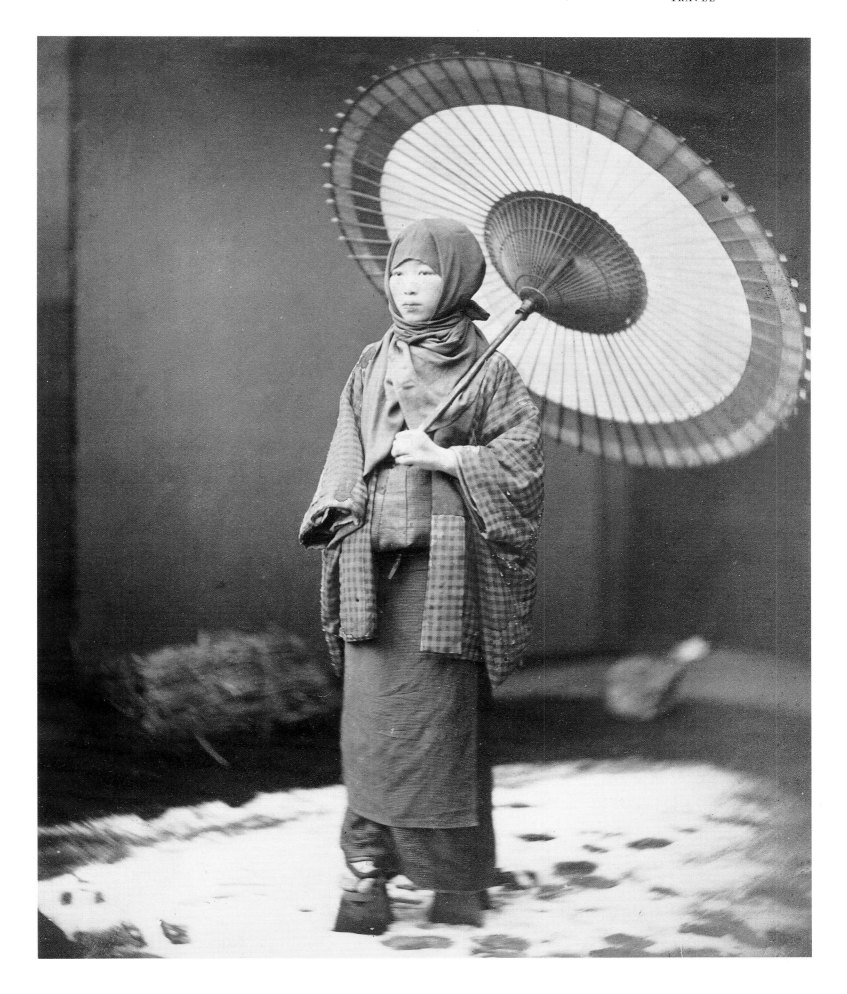

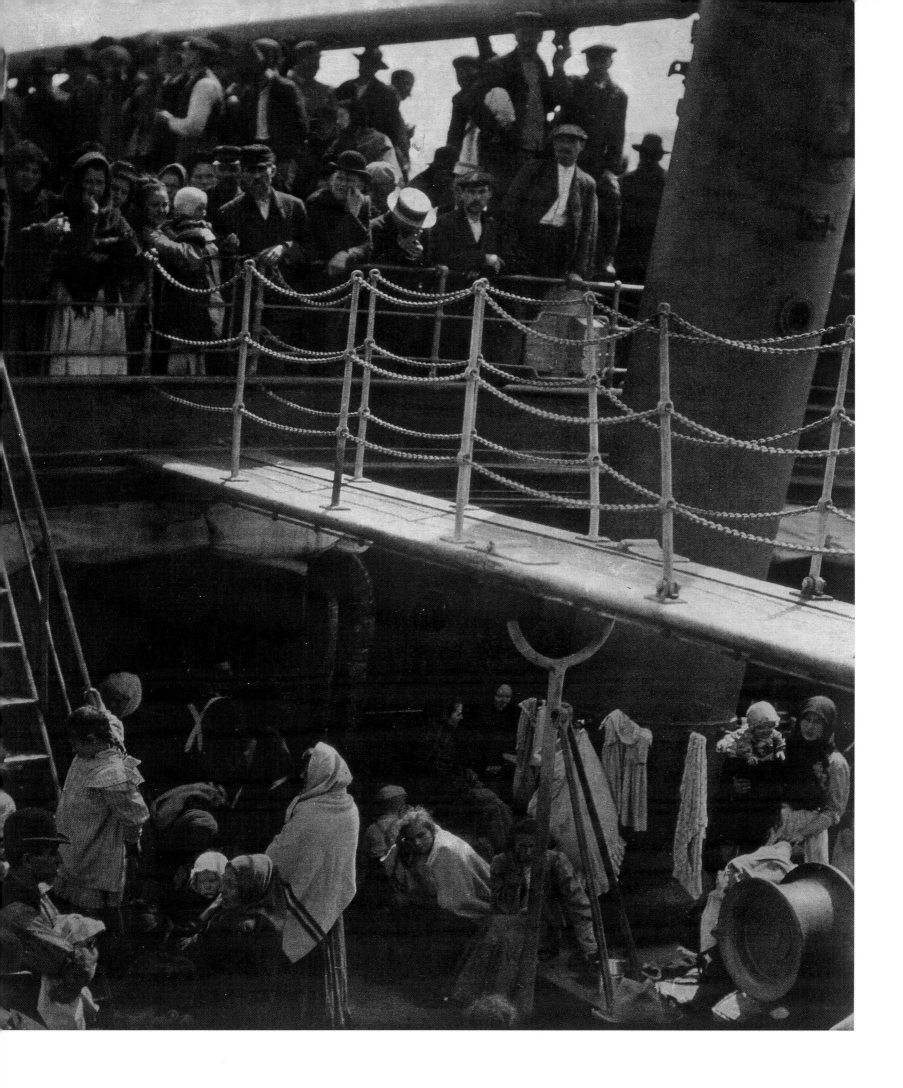

OPPOSITE | Perhaps Alfred Stieglitz's best-known photograph, taken on board a steamer sailing from New York to Europe. Glancing down, at the steerage class passengers on the lower decks, Stieglitz rushed back to his first-class cabin, grabbed his camera and took this exposure on his last negative.

BELOW | Else and Friedrich Paneth and their children Eva (b. 1914) and Heinz Rudolf (b. 1918) took frequent holidays in Europe – to the mountains, to beaches or to cultural cities such as Venice, where Paneth took this Autochrome of St. Mark's Cathedral in 1925. Eva Paneth remembered her father always carried two boxes, one containing his camera, the other his glass plates, slung across his shoulders, ever ready for the next photograph.

OPPOSITE | Dr E.G. Boon gave many of his photographs to the RPS
Collection throughout the 1930s. His work, taken whilst he and his family
were living in Alassio in Italy, centres around the family unit and the domestic
situation, in this case a family holiday in Venice around 1920.

BELOW | An Autochrome of St Mark's in Venice, taken by Friedrich
Paneth in 1925. Contemporaries described Paneth as a man of vitality, charm
and humour who managed to make everyone with whom he dealt feel that
they were interesting.

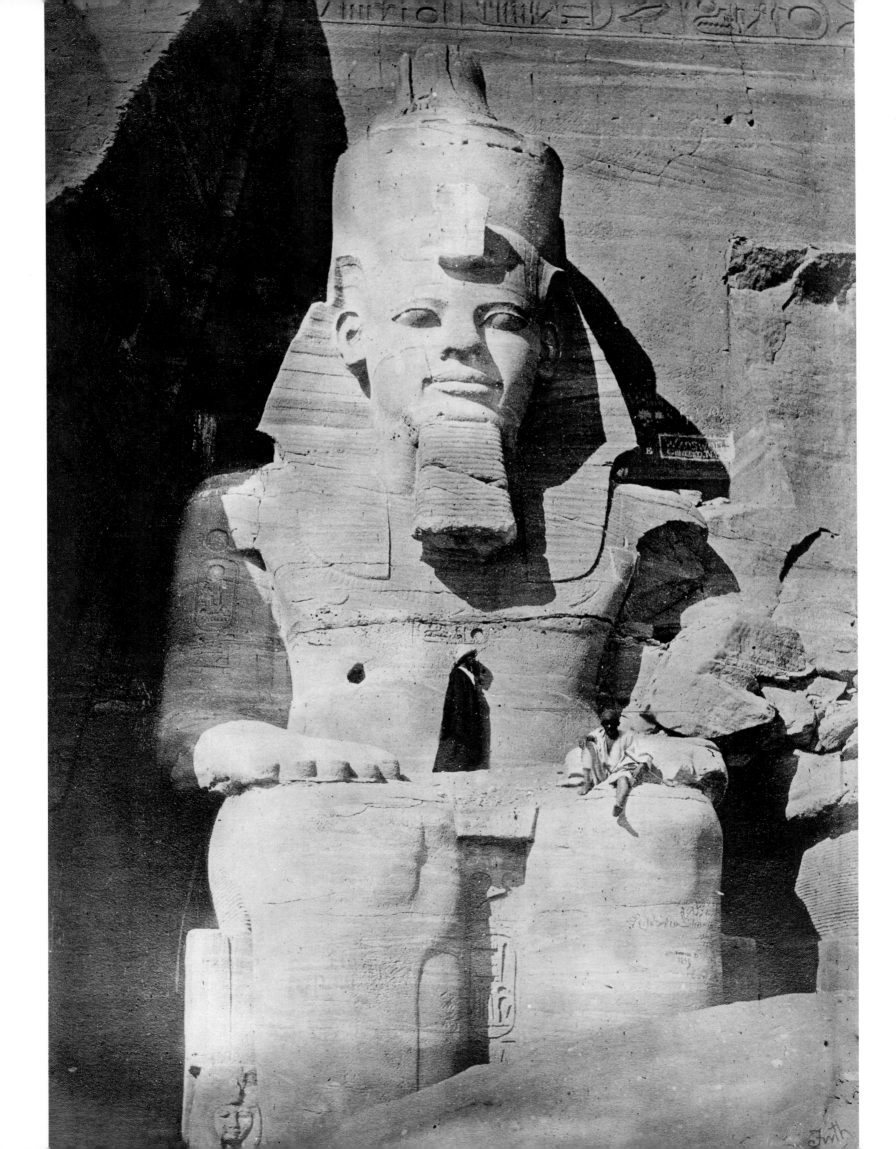

OPPOSITE & BELOW | Francis Frith made three photographic trips to the Middle East at the end of the 1850s with three different cameras, a mammoth plate, a full plate and a stereo camera. Battling against temperatures of 130°F, dust, flies, robbers, wild dogs, and collodion that boiled as it hit the glass plate, and using stone tombs as darkrooms, he brought back stunning archaeological and architectural studies which were published in book format with didactic text. Frith was bowled over by what he saw on his travels, writing in his diary: 'I don't want to know whether men or angels or demons built those glowing Temples ... I am more tempted to worship a crocodile thirty feet long and five hundred or a thousand years old, than to bow down to the God of Calvin.'

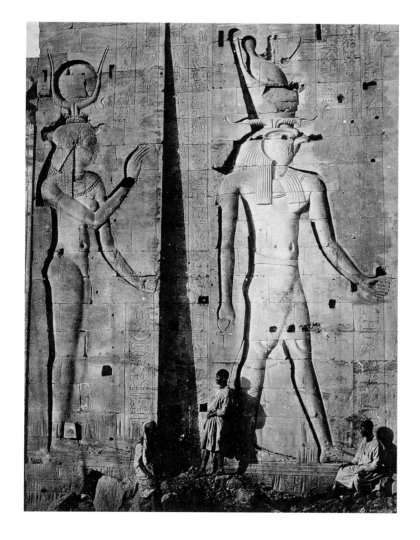

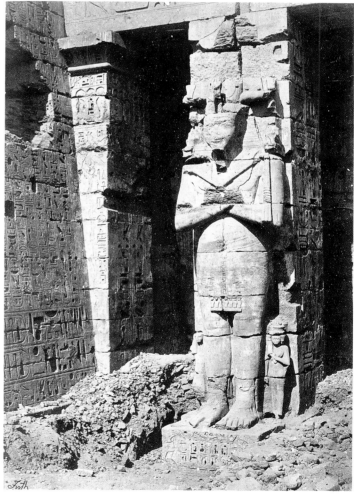

RIGHT | Captain Linnaeus Tripe was appointed Official Photographer to the Madras Presidency in India from 1856–60, and in early 1858 made a four- and-a-half-month tour through the Trichinopoly, Madura and Tanjore districts, publishing some of the resulting photographs in nine large albums. The graphic elements of this print, most especially the detailed stonework, the stripes of colour on the staircase and base of the building, and the superb printing – which rarely ever falters in Tripe's work – render this a photograph of immense archaeological and architectural detail and an image of fascinating compositional texture and complexity.

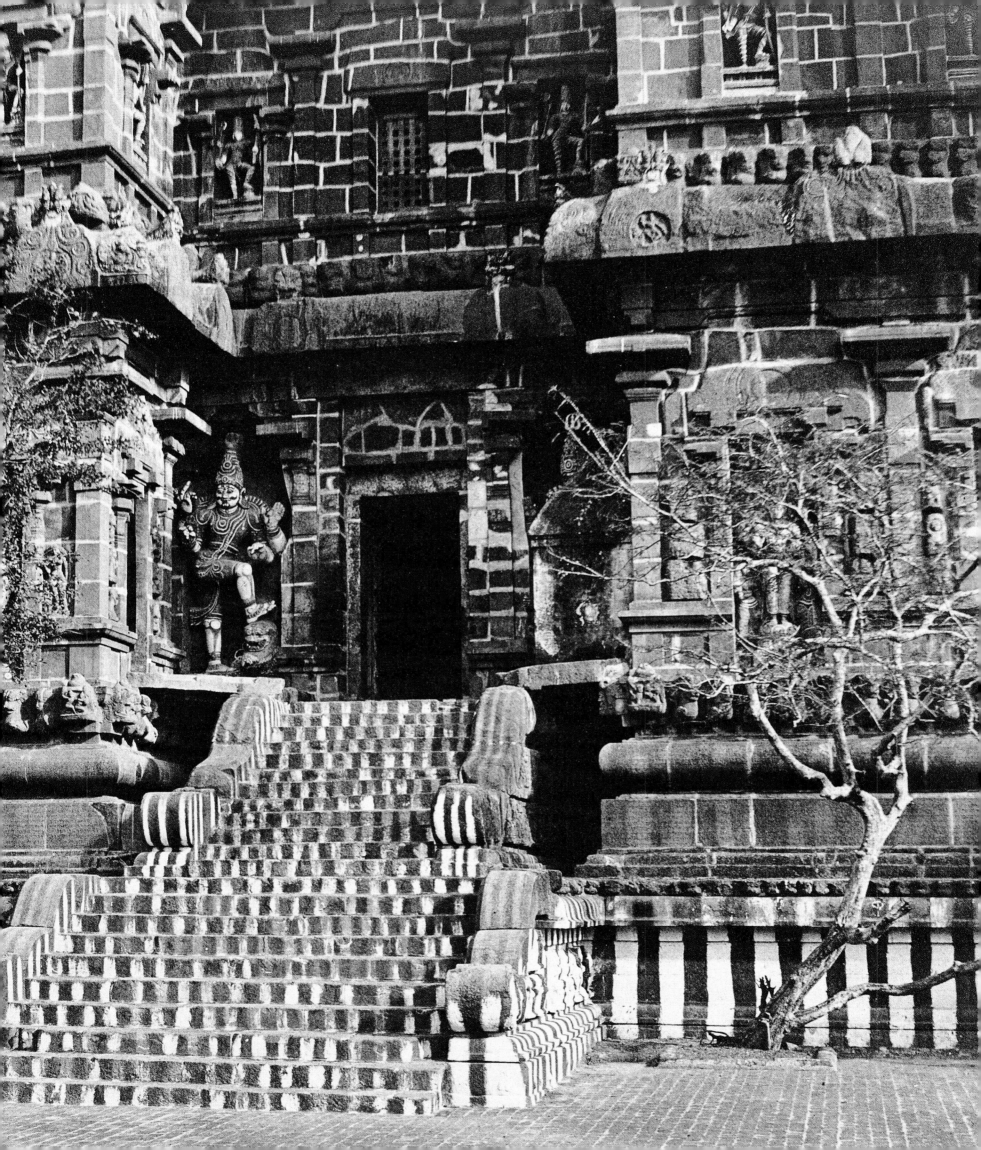

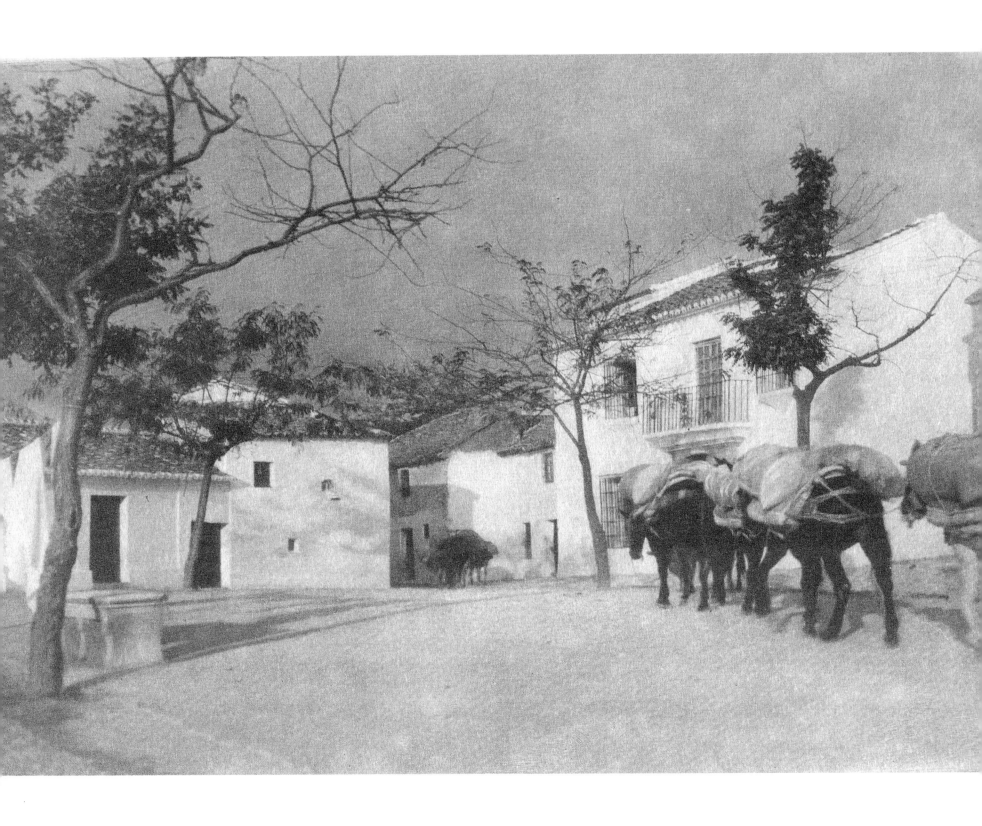

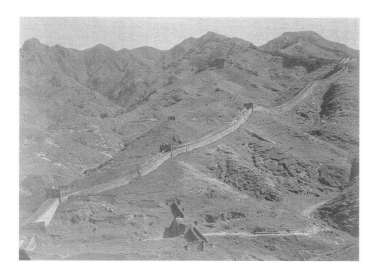

OPPOSITE | James Craig Annan often travelled abroad photographing with a hand camera, printing up his negatives as exquisite photogravures, of which he was one of the most skilful practitioners. He had learnt the craft from Karel Klîc, the inventor, in 1883. This photogravure of a village square in Southern Spain shows Annan's light, deft and precise touch, both in image composition and printing. His mastery earned him the respect and friendship of Alfred Stieglitz, who published 25 of his photogravures in *Camera Work*.

ABOVE | In a letter to her sister, Helen Messenger Murdoch wrote of the China she saw and photographed in 1914: 'Mr Zumbrum told me I *must* see the Ming Tombs and the Old Wall at the Nankow Pass … Great stone camels, elephants, horses and "fabulous monsters" … I got colour and black and white snaps all along … The next morning I got up very early, but very nearly missed the "goods train" for the Great Wall … My guide had sent up my chair-coolies with a chair for me … I got some pictures of the Wall they give such a good idea of the way it rambles up and down over the mountains, like a great serpent! and that's only a fragment of the 2500 miles that's left of it.'

RIGHT | Samuel Bourne returned to Britain for good in 1870 but the
company he had set up, Bourne and Shepherd, employed Colin Murray in his
place. Murray, as yet a much unrecognised and unacknowledged photographer,
was as competent at photographing landscape and architecture as he was
at portaiture. Many of the well-known and striking Bourne and Shepherd
portraits of Maharajahs and Indian nobility were taken by him c.1873. This
view of the Salween River, which flows into Eastern Burma from China (where
it is called the Nu Jiang), has a calmness and a tranquillity about it that
is timeless. The two figures on the outcrop over the river have been perfectly
placed to add an element of human interest to a sublime view.

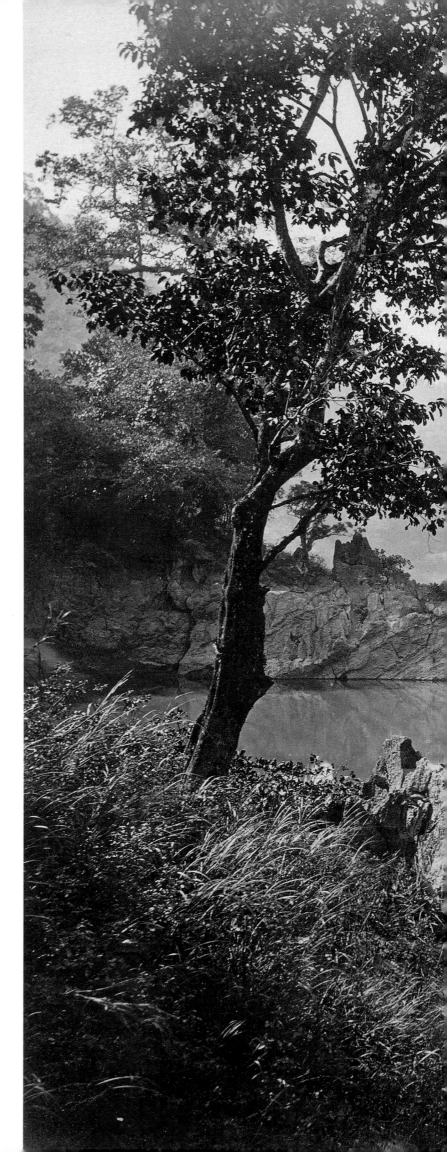

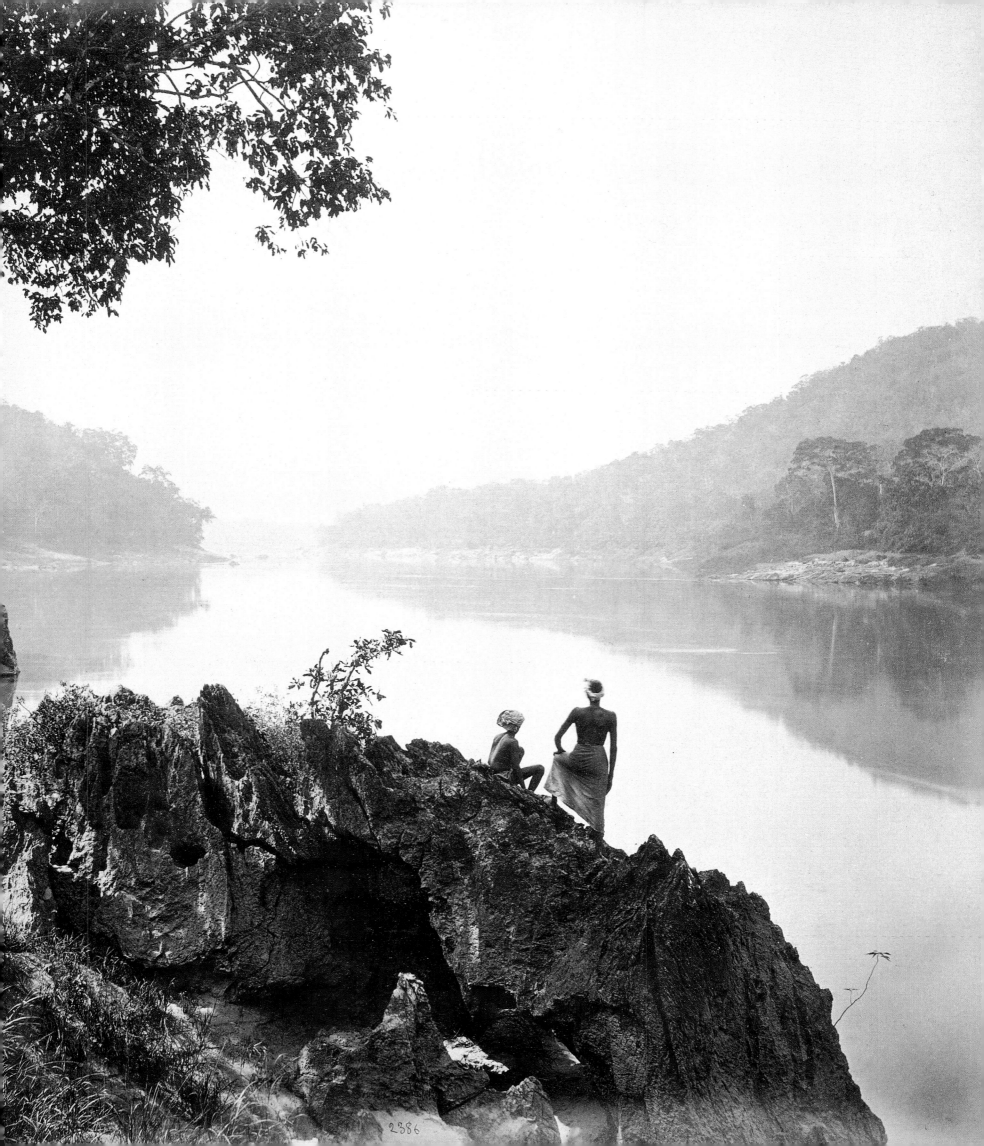

SELECTED BIOGRAPHIES

OPPOSITE | *(left to right)* William Fox Talbot's mousetrap camera (c.1835); David Octavius Hill's reflective mirror (c.1843); the first Kodak camera (1888).

Ansel Adams, USA *(1902–1984).*
Co-founder of the f/64 Group with Edward Weston, Adams is renowned for his landscape photography. He also invented the Zone System, published many books, and formed Friends of Photography in Carmel and the Center for Creative Photography in Tucson.

James Craig Annan, UK *(1864–1946).*
Son of Thomas Annan, successful Scottish professional photographer, and involved in Scottish art circles.

Arthur Clive Banfield, UK *(1875–1965).*
Banfield was very active within the RPS lecture circuit and wrote many articles for *The Photographic Journal.*

Felice Beato, born Italy *(1825–1903).*
One of the first war photographers, Beato worked in the Middle East and the Crimea, photographing the aftermath of the Indian Mutiny and the Chinese Opium Wars. He worked in Japan from 1862.

Walter Bird, UK *(1903–1969).*
Professional studio photographer, noted for portraiture, advertising and, in the 1930s, for a mastery of the newly available conmmercial colour processes.

Samuel Bourne, UK *(1834–1912).*
Intrepid explorer/photographer who left England for India in the late 1860s and made three trips into Cashmere and the Himalayas, photographing at higher altitudes and at lower temperatures than anyone had done before and reporting it all through a string of articles in *The British Journal of Photography* in the 1860s.

Anne W. Brigman, USA *(1869–1950).*
Born in Honolulu, Brigman moved to California with her parents in 1886. She married in 1894 and, became interested in photography in 1902. A friend and keen supporter of Alfred Stieglitz, she became a member of both the Photo-Secession in New York and the Linked RingBrotherhood in London. Her communication and friendship with Stieglitz was conducted entirely by mail as she did not visit New York and actually meet him until 1910 when the Photo-Secession was on the wane. He, in turn, admired her dedication to photography, pursued through pure love rather than for any commercial gain. Her 'symbolic nature' photographs of nudes as part of an allegorical landscape use either herself or her sister Elizabeth as the model. Stieglitz featured eleven of her photographs in *Camera Work* from 1909–1913. She abandoned photography in the mid 30s to devote herself to poetry. Brigman's photographs in the RPS Collection are the gift of Alvin Langdon Coburn, 1930.

Larry Burrows, UK *(1926–1971).*
Burrows was killed in Vietnam whilst photographing the war there for Time/Life. Shortly before this, he had donated prints to the RPS Collection.

Julia Margaret Cameron, UK *(1815–1879).*
Cameron's portrait style, of large head close-ups, is instantly recognisable. She took up photography at the age of 48, for 15 years, producing over 2,000 large format wet collodion negatives, photographing some of the greatest names in nineteenth century art and literature. Stieglitz rediscovered Cameron's 1860s portraits and published them as photogravures in *Camera Work* in 1913. Cameron's work was revered by many Photo-Secessionists, and her influence can be seen in the earlier portraits of Alvin Langdon Coburn.

Lewis Carroll (Reverend Charles Lutwidge Dodgson), UK *(1832–1898).*
Carroll is almost as well known for his photography as for his 'Alice' books, and not at all, for his numerous mathematical treatises.

Alvin Langdon Coburn,
naturalized UK, born USA *(1882–1966).*
By 1917, Coburn was a precursor of the Modernist movement in photography, having mastered, and improved, practically every form of photography available. For the first ten years of the twentieth century, he travelled between England and the USA, photographing notables such as Mark Twain, Yeats, Shaw and Matisse as well as New York, London, Paris, Edinburgh and Yosemite.

William Collie, UK *(1810–1896).*
Collie worked as an artist in Jersey and his photographs, like those of Hill and Adamson, may have been an aid to painting but, also like theirs, they are an early example of using the camera to document a small community.

George Davison, UK *(1856–1930).*
An early exponent of impressionistic photography, Davison was also a wealthy managing director of Kodak and a founder member of the Linked Ring Brotherhood. He was a great photographic catalyst to his contemporaries.

Fred Holland Day, USA *(1864–1933).*
A millionaire book publisher, aesthete and friend of Oscar Wilde and Aubrey Beardsley, Day organised an exhibition, 'The New School of American Photography', at The Royal Photographic Society in 1900. It caused complete uproar. A continuing argument with Stieglitz pushed him out of the mainstream of American photography but he continued to work closely with Clarence White.

Robert Demachy, France *(1859–1936).*
Artist, musician, writer, founder of the Photo-Club de Paris, and painstaking technician, Demachy was admired and criticised equally for his heavily manipulated prints.

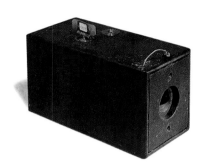

Frank Eugene, USA *(1865–1936).*
Merging the skills of a graphic artist with those of a photographer, Eugene etched his negatives to produce startling and beautiful prints.

Frederick Henry Evans, UK *(1853–1943).*
Evans, a former bookseller turned photographer, was a perfectionist, whose photography, both architectural and portrait, is remarkable for its purity of line and mastery of light, space and composition. When platinum became scarce after 1914, he stopped printing altogether rather than use an inferior product.

Roger Fenton, UK *(1819–1869).*
Founder and first Secretary of the Society, Fenton terminated his photographic career in 1861, after which his equipment and negatives were bought by Francis Frith. Prior to this, he had a varied photographic career and was one of the first British photographers to photograph scenic views, stately homes and art works with an eye to selling copies to the public.

Francis Frith, UK *(1822–1898).*
Frith made three journeys to the Middle East from 1857–59 and kept diaries of trips, highlighting the appalling conditions under which he worked. On his return to the UK, he set up a photographic company to photograph tourist views in the British Isles, which became a thriving family business lasting until the 1970s.

Noel Griggs, UK *(1890–1941).*
From an artistic and musical background, Griggs put drama and beauty into industrial and advertising photography.

David Octavius Hill, UK *(1802–1870)*
& Robert Adamson, UK *(1821–1848).*
Hill, the artist, and Adamson the chemist, formed one

of the most dynamic partnerships in the history of photography, tragically cut short after 5 years when Adamson died, his frail health probably made worse by the posionous chemicals used in photography.

Alfred Horsley Hinton, UK *(1863–1908).*
An artist who became editor of *Amateur Photographer* at the end of the century, Hinton produced moody and dramatic landscapes printed in heavy coated platinum.

Theodor Hofmeister, Germany *(1865–1943)*
& Oskar Hofmeister, Germany *(1869–1937).*
The Hofmeister brothers were businessmen from Hamburg whose interest in photography was purely amateur until they began exhibiting alongside the Viennese Secessionist photographers Henneberg, Kuhn and Watzek. They began to take their photography more seriously, hiking around the German countryside and having their work published as photogravures in a number of books on German landscape. Oskar was the photographer and Theodor the printer of large and beautiful gum bichromate landscapes in a variety of startling colours and up to a metre wide. Stieglitz published six of their photographs in *Camera Work* in 1904 but never met them. They abandoned gum printing in 1910 and concentrated on straight photography.

Frederick Hollyer, UK *(1838–1933).*
Hollyer ran a thriving business as a photographer of both works of art and portraits. Both pursuits brought him into close contact with the Pre-Raphaelites like Edward Burne-Jones and writers such as Ruskin.

Emil Otto Hoppé, UK, born Germany *(1878–1972).*
The ever changing Hoppé made his reputation through studio portraiture, but regularly ventured into other spheres, such as war reportage, travel and landscape.

James Jarché, UK *(1890–1965).*
One of the first photo-journalists, Jarché worked for practically every newspaper and photo agency, retiring from *The Daily Mail* in 1959.

Gertrude Käsebier, USA *(1852–1934).*
Käsebier came to photography, via painting, in her late thirties. Married with three children, Kasebier enrolled in a course of portrait painting and took up the camera to casually record family life in the early 1890s but then widened her scope, with great success, to studio portraiture. In 1897, she opened a portrait studio in New York which was an instant success, often because, with her painterly background, she produced photographs which looked like old masters. Käsebier, like White, became influenced by Whistler and by Japanese art and threw of the more sombre Rubensque studies for a lighter, more designed look with a simpler compositional style. After her successful showing in the Philadelphia Salon of 1898, she was given a one-woman show by Stieglitz at the Camera Club in New York and, in 1903, he paid her the compliment of launching the first issue of *Camera Work* using six of her photographs. One of these, 'The Manger', had sold in 1899 for $100, the highest price then paid for a pictorial photograph. Käsebier was the first woman member of the Linked Ring Brotherhood and, initially, a strong Stieglitz supporter and a founder member of the Photo-Secession. She travelled in Europe, cementing bonds between the European and American Secessionists and seems to have been well liked and respected by all photographers, something of an achievement. Inevitably, the relationship with Stieglitz tarnished and Käsebier resigned from the Photo-Secession in 1912 and in 1916, was instrumental in founding The Pictorial Photographers of America with White and others.

John Dillwyn Llewelyn, UK *(1810–1887).*
Llewelyn was connected to William Henry Fox Talbot

by marriage and took to photography early, producing Daguerreotypes, Talbotypes and his own oxymel collodion negatives, using honey in the process to increase the viscosity.

Rosalind Maingot, UK, born Australia *(1891–1957).*
Maingot studied photography at the London School of Photography after marrying a surgeon and settling in London but her previous career as an actress is apparent in her photography which encompasses costume and nude figure studies, still lifes and flowers. She also became an accomplished medical photographer, working with her husband and was instrumental in setting up the RPS Medical Group.

Paul Martin, UK, born in France *(1864–1942).*
Martin was an artistic snapshotter supreme, carrying a Fallowfield Facile detective camera, disguised as a parcel, and capturing the less formal side of Victorian life, often at night, using gaslight and 15 minute exposures. He also ran his own studio and worked as a freelance photo journalist.

Baron Adolph de Meyer,
German, UK & USA, *(1868–1946).*
De Meyer's photographic career took off in 1896 after his move to London from Dresden where he married into high society. His wife, Olga Alberta Caracciola, being, supposedly, the illegitimate daughter of the Prince of Wales, later Edward VII. He joined both the Linked Ring Brotherhood and The Royal Photographic Society and later, the Photo-Secession. His still life photographs, printed in platinum, were exquisite and used a Pinkerton-Smith lens, ground sharply in the centre and falling off around the edges to produce a soft and diffused focus. He exhibited with Seeley at the gallery *291* in New York in 1907 and with Coburn in London in 1908. A one-man show at *291* in 1912 was accompanied by a whole issue of *Camera Work* dedicated to de Meyer's work which was somehow exotic and classically pure at the same time. The de Meyers, as potentially suspect Germans, left England in 1914 after the outbreak of war and de Meyer worked for the Conde Nast organisation, especially *Vogue* and *Vanity Fair*, as a fashion photographer. He continued in he same line of work in Paris eventually working for *Harper's Bazaar*. Despite his undoubted success in the commercial world, de Meyer seems to have remained on friendly terms with Stieglitz until his death. The glamorous style and sophistication of his photography had a profound influence on the fashion world and on the early days of Hollywood. De Meyer's photographs in the RPS Collection are the gift of Alvin Langdon Coburn, 1930.

Francis James Mortimer, UK *(1874–1944).*
Editor of *The Amateur Photographer* and a founder mem-ber of The London Salon, Mortimer also worked closely with the London Camera Club and became President of the RPS. The sea was his favourite subject and he often risked his life, tied to a ship's mast, to get the most dramatic shots of crashing waves. He also resurrected the combination printing of the 1850s, producing dramatic, if impossible, images.

Helen Messenger Murdoch, USA *(1862–1956).*
Murdoch took up monochrome photography in the 1890s but is best known for her Autochrome work. From 1913–14, she travelled around the world, lugging the heavy and cumbersome autochrome equipment with her, lecturing as she went. In her 60s, she took up flying and began a second career as an aerial photographer and collector of all things to do with aviation.

Eadweard Muybridge, UK *(1830–1904).*
Worked in America for 40 years, photographing the Pacific Railway, Yosemite, Panama & Guatemala as well as a terrific series of panoramas of San Francisco. Series of photographs of a galloping horse to show that, at any one time, all four legs were off the ground, led to further work in photographing movement, anticipating film.

Horace W. Nicholls, UK *(1867–1941).*
Nicholls was one of the first photo-journalists, moving from South Africa, where he covered the Second Boer War, to London, where he covered the Edwardian English social scene and worked for the Imperial War Museum. He also photographed family and domestic life, holidays and some portrait work.

Joseph Nicéphore Niépce, France *(1765–1833).*
Niépce experimented with fixing an image from 1813–22, when he successfully produced an image on tin. By 1826/7, he was using a pewter base, etched with bitumen of Judea and lavender oil but lack of interest in his invention caused him to leave his three heliographs in Kew when he visited London in 1827, and from there, these exceedingly rare items made their way to the RPS Collection. His contribution to photography, has, until recently, been overwhelmed, by his partnership with Daguerre, who, after Niépce's death in 1833, took and improved his research and, in 1839, launched the Daguerreotype, effectively claiming that the invention was his own.

Friedrich Adolf Paneth, Austria *(1887–58).*
Paneth was a chemist by training but his career in Germany was abruptly ended by the accession of the Nazis and he left in 1933. Paneth moved to England and worked at Imperial College and Durham University in the chemistry faculties until 1953 when he returned to Germany. He practised photography all his life.

Richard Polak, Netherlands, *(1870–1956).*
Polak reconstructed Dutch interiors along the lines of Vermeer and Steen, using actors and fake room settings, and was very much an art photographer.

Walter Arthur Poucher, UK *(1891–1988).*
Walter Poucher combined three careers, as chief perfumer at Yardley cosmetics, as a mountain photographer and as an author and could easily have added a fourth as a concert pianist. His 50-year career, climbing and photographing the mountains of Europe was only halted by incipient blindness. The Society's Collection contains several thousand black and white sheet film negatives and contact prints, along with hightly detailed exposure notes.

Oscar Gustav Rejlander, born Sweden, UK *(1813–1875).*
Originally a painter, Rejlander learned photography as an aid to painting and produced many painterly studies, including the most famous 'The Two Ways of Life', painstakingly printed from thirty-two glass negatives. Worked with Charles Darwin, illustrating human expressions for Darwin's book.

Albert Renger-Patzsch, Germany *(1897–1966).*
One of photography's great realists, Renger-Patzsch brought a razor sharp, analytical vision to his photography, also working as a press, advertising and industrial photographer and war correspondent.

Henry Peach Robinson, UK *(1830–1901).*
Robinson was the godfather of Pictorialism and extremely influential in nineteenth century photography circles, shaping public opinion, both through the photographs he exhibited and the books he wrote. He learned combination printing from Rejlander but easily surpassed the teacher, producing definitive photographs printed from up to nine negatives. Led a secession group of photographers away from The Royal Photographic Society and was a founder member of the Linked Ring Brotherhood in 1892.

George H. Seeley, USA *(1880–1955).*
Seeley was from the small New England town of Stockbridge, Massachusetts, a town he rarely left all his life apart from trips to New York and Boston. In 1902, he met Fred Holland Day who encouraged and influenced Seeley's pictorial style. Stieglitz invited him to join the Photo-Secession in 1904 and published his photographs in *Camera Work* in 1906, 1907 and 1910. He shared an exhibition at *291* with Baron de Meyer in 1907 and was given a solo show in 1908, the first time he and Stieglitz met. He often used his sister Laura as a model, cladding her in flowing draperies in sylvan settings. He created his own allegorical and lyrical world, diffused with light and redolent of mystery. Seeley's

contentment with his situation, his lack of ambition, his reluctance to exhibit his work to a wider audience and his total disinterest in having his career masterminded by Stieglitz led to a break up of their friendship. After 1910, he photographed largely for himself and drifted out of Stieglitz's orbit.

Edward J. Steichen, USA,
born Luxembourg *(1879–1973).*
Steichen began his photographic career as an impressionistic artist and ended it as Director of Photography at Moma in New York. In between, he embraced every form of photography, abstract, straight, advertising and fashion, bringing his huge enthusiasm and energy to bear to enhance photography as a career, as an art form and as a Museum speciality.

Alfred Stieglitz, USA *(1864–1946).*
Stieglitz revolutionised American photography, opening The Little Galleries *(291)* in New York, showing art and photography in juxtaposition, creating the seminal photography publication *Camera Work,* encouraging young photographers like Steichen, Strand and Weston and creating work which gave photography the serious sophistication and the class it had never had before. It is hard to imagine in what direction photography would have gone had Stieglitz not been involved. He had the energy, the drive, the artistic vision and the determination of ten men and the enemies to prove it.

Paul Strand, USA *(1890–1976).*
Strand learnt photography at night school in New York from Lewis W. Hine but, initially, photographed in a soft-edged Pictorial style. Stieglitz encouraged him to abandon this and adopt a sharper, more graphic and abstract style, resulting in the confrontational New York portraits and geometric cityscapes and close-up patterns featured in the last issue of *Camera Work,* number 49/50. Stieglitz thought Strand the most important American photographer since Coburn. Strand relied on manipulating his camera rather than his negatives or prints and thus, after the painterly approximations of the previous twenty years, his photographs seemed shockingly modern and straightforward. After showing the 'brutality' of Strand's work in *Camera Work* and at the gallery *291,* Stieglitz closed down both the publication and the gallery. Strand, Stieglitz's chosen successor, went on, of course, to ever greater things, with a sixty year career in both film and still photography, producing high quality books and portfolios and communicating to a mass audience in a way that would have delighted his mentor.

Frank Meadow Sutcliffe, UK *(1853–1941).*
Sutcliffe was a portrait photographer by profession but is best known for his photographs of the people, the harbour, the boats and the sea of Whitby. There is great love in these sympathetic and informed studies which sold as well to the tourist trade of the late nineteenth century as they do today.

William Henry Fox Talbot, UK *(1800–1877).*
Talbot was a Renaissance man who researched and wrote on botany, astronomy and archaeology as well as photography. Frustrated by his attempts to draw scenery with a Camera Lucida, Talbot experimented with the action of light on certain chemicals, to capture by other means the view he was unable to draw. With the help of Sir John Herschel, he managed to control this action and 'fix' the image, finally producing a negative from which an infinite number of positives could be printed. Over the next thirty years, amongst many other hings, he worked on photoglyphic engraving, a forerunner of photogravure.

Captain Linnaeus Tripe, UK *(1822–1902).*
Tripe worked in Burma in 1855, and from 1869–72, and for the Madras Presidency in Southern India from 1856–60, documenting buildings and landscape and publishing his Indian photographs in six large format albums. He also worked in the stereo format. He eventually retired as Honorary Major General in 1875.

Benjamin Brecknell Turner, UK *(1815–1894).*
Turner, a painter turned photographer, photographed in the tradition of the English watercolour artists, much of his work being reminiscent of Constable's paintings. He had worked with Talbot in the 1840's and was an excellent practitioner of the waxed paper negative.

John Cimon Warburg, UK *(1867–1931).*
Warburg was able to devote his time wholeheartedly to photography because bad asthma stopped him from working in a full time job and a private income gave him economic freedom. He excelled at the Autochrome process, giving numerous lectures and writing extensively on the subject.

Agnes Beatrice Warburg, UK *(1872–1953).*
On the fringes of the Linked Ring Brotherhood, along with brother John, (never an actual member). Founded RPS Colour Group in 1927 and, prior to that, had experimented with many different forms of colour photography, inventing the Warburytype.

Edward Weston, USA *(1886–1958).*
Weston, like Steichen before him, experimented with photographing everyday objects, vegetables, nudes, dunes, using lighting and camera angle to show the item in a completely new light. He worked for the government on the Farm Security Administration project and set up the f/64 Group.

Clarence Hudson White, USA *(1871–1925).*
White worked closely with the Photo-Secession photographers and taught photography at university level. He was a master platinum printer, rarely using anything else. He set up his own schools of photography in New York, Maine and Mexico City and founded the Pictorial Photographers' Association.

Dorothy Wilding, UK *(1893–1976).*
Wilding was the most successful portrait photographer in Britain during the 1920s, 30s and 40s. She had studios in London and New York and commuted between the two by luxury liner. She popularised the profile portrait and stylised settings.

Walter Woodbury, UK *(1834–1885).*
Woodbury sailed to Australia, when he was 18, to make his fortune. He set up a photographic studio in Melbourne and, later, in Java. Returning to England in 1864, he invented a number of processes, including the Woodburytype, a pigmented gelatine image, which had wonderful clarity of detail, a 3D effect and great permanence.

Madame Yevonde, UK *(1893–1975).*
Yevonde was a competent portrait photographer who found her metier with the advent of colour in the 1930s using Vivex, the commercial tri-colour carbro process. Photographing society ladies as Roman and Greek goddesses, she moved on to minor Surrealism before WWII caused the demise of the Vivex factory and her creative years.

PHOTOGRAPHIC PROCESSES

Daguerreotype This 'mirror with a memory', unlike the calotype, was a unique image and if another copy was needed, the whole process had to be repeated. The daguerreotype is an image formed on a copper plate, coated with highly polished silver, vapourised with iodine, exposed in the camera, and then developed over mercury, fixed and toned. The resulting image, which, depending on the angle of light, can look like a negative or a positive, or a mirror surface, consists of a white silver mercury deposit which is very fragile and easily removed. The finished images were, therefore, enclosed in an air-tight case under glass. The image was clear and detailed, sitting on the surface of the copper plate and having none of the intrusive paper texture of the calotype. The end result was, however, laterally reversed, very expensive and, initially, had an exposure time of 10–20 minutes. Louis-Jacques-Mandé Daguerre's announcement of his process in 1839 gave little mention to the pioneering work of Joseph Nicéphore Niépce, inventor of the helio-graph in 1826 and with whom Daguerre had worked for some years. The daguerreotype was widely used for portraiture for almost 20 years, finally being replaced in France, as everywhere else, by the quicker, cheaper, collodion and albumen processes. It survived for much longer in America at the expense of the calotype negative and reached a peak of perfection in the work of Southworth and Hawes.

Photogenic Drawing William Henry Fox Talbot experi-mented with using light-sensitive chemicals to register an image from 1834/39. He produced silver chloride by soaking paper in salt solution and then brushing with silver nitrate. A leaf, or lace placed on the paper which was then exposed to sunlight, would mask the area covered, the rest of the paper darkening in the sunlight, producing a negative image. The image would then be fixed with salt to prevent further reaction. These papers could also be used in the back of the camera.

Calotype Negative After further work, Talbot patented the calotype process in 1841, the start of photography as we know it, a negative from which an infinite number of positives could be made, unlike the daguerreotype which was a unique image. As with the photogenic drawing, paper was brushed with silver nitrate but then floated in potassium iodide and another coat of weak silver nitrate, acetic and gallic acid to produce a mix far more light sensitive than previously. Exposed in the camera for several minutes, developed, fixed with hypo (sodium thiosulphate) and washed, this negative could then be exposed in a contact printing frame against another piece of coated paper to make a positive image. Because of the absorbency of paper, the image becomes inseparable from it and the paper texture is reproduced giving the image a grainy effect. To minimise this graininess, a clearer support, such as glass, was needed and from this came the wet collodion negative. The calotype, and other variations of paper negatives, endured for over 20 years, used freely by amateurs like David Octavius Hill and Robert Adamson in Edinburgh and William Collie in Jersey.

Wet Collodion Negative This was the most commonly used negative from the early 1850s until replaced by the dry plate or gelatin negative in the 1890s. It was invented by Frederick Scott Archer, who gave his discovery to the nation rather than patent it, in 1851. A piece of glass, the same size as the required finished print, would be coated with collodion (a mixture of cotton soaked in nitric and sulphuric acids, alcohol and ether). This sticky viscous liquid had to be thinly and evenly spread on glass before it dried, in a matter of seconds, and the whole glass plate was then coated with a light sensitive solution, like silver nitrate, and exposed in the back of the camera whilst still wet. Once exposed, the glass plate was devel-oped, washed, dried and varnished and was then ready for printing, usually as an albumen print. These plates could not be prepared in advance, were very vulnerable to temperature and were often fixed with potassium cyanide, hence the high mortality rate of photographers in the 1850s. Despite this, they were used in the heat of the Crimea by Roger Fenton, in Egypt by Francis Frith, as well as in the extreme cold of the Himalayas by Samuel Bourne, with spectacular results.

Albumen Print The most common nineteenth-century print, produced from 1850–1890, and often referred to these days as a 'sepia' print. Invented by Louis-Desiré Blanquart Evrard in 1850, it was made by floating paper in a mixture of albumen (egg white) and salt and then light sensitive silver nitrate. After being exposed to a negative (usually wet collodion), the coated paper would be left to print in the sun from a few minutes to an hour and then fixed, washed and dried. An albumen print is easily recognisable because of its rich brown colour and, often, yellowing in the highlights, caused by the silver grains on the surface reacting with sulphur in the air. Gold chloride toning was often used to prevent tarnishing and fading and to give the finished print a rich purple/brown sheen. Initially, hand made by the photog-rapher, albumen paper was eventually commercially produced.

Wet Collodion Positive (aka Ambrotype) An under-exposed, developed, wet collodion negative, when backed with a black cloth, black paint or varnish, appears as a positive image. One of the first cheap forms of portraiture for the man in the street, this was a unique image, like the daguerreotype, and could not be reproduced. It was enclosed in a small case under glass, which was airtight and also prevented the emulsion being scratched. They were often hand tinted, with jewellery being picked out in gold to emphasise wealth. They were largely replaced by the infinitely reproducible carte-de-visite.

Carte-de-visite This was the cheapest, most easily produced and most portable form of mass photography in the mid-nineteenth century. Invented by André Adolphe-Eugène Disdéri in 1854, these small albumen prints (4.5 x 2.5in) from wet collodion negatives were stuck onto backing cards bearing the photographer's name and address and the negative number so that extra copies could be run off when required. The main subject matter was portraiture, but landscapes, holiday views etc. were also popular. They were produced in their millions for over 20 years, but finally superseded by the larger format cabinet cards. Special albums, often very ornate, were produced so that collections could be shown off. Camille Silvy and Jabez Hughes were two of the photographers who made the carte-de-visite into an art form. It is also the nineteenth-century photo-graphy form with which most people are familiar.

Carbon The carbon print came into wide use after 1864, patented by Joseph Wilson Swann, although research in the 1850s by Alphonse Louis Poitevin and John Pouncy had established the principle. A thin paper

was coated with gelatine, potassium bichromate and a pigment. Any colour of pigment could be used although carbon black, Rembrandt brown and sanguine, as its name suggests, a dried blood colour, were the most popular. After contact with the negative and exposure to light to harden the gelatine, the carbon paper was squeezed, carbon side down, against another sheet of paper coated with gelatine and then the backing paper and unhardened gelatine washed away to leave the carbon image transferred onto the second sheet of paper. The whole lot was then washed in water containing alum to further set the gelatine. The image was thus laterally reversed but could be transferred by going through the whole process again. Very rich carbon prints have a raised surface where the image is darkest, giving a 3D effect. They are permanent, containing no silver, and the strength of colour can be very impressive. The carbon process was used extensively by Julia Margaret Cameron to make multiple editions of her prints.

Dry Plate Negative In 1871, Richard Leach Maddox wrote a paper on the possibility of coating a glass negative with a mixture of silver bromide salts dissolved in gelatine. This not only improved on the photosensitivity of the wet collodion method but meant that plates could be prepared, commercially, in advance. After further research by Maddox and others, dry plates came into common use in 1881 and meant that the long and tedious time spent coating a wet collodion plate was over and photography became a far more portable business.

Platinum Print Produced from 1878–1920, platinum prints have no black or white in them but are composed of infinite shades of grey. Invented by William Willis in 1873, paper was coated with platinum and iron salts, contact printed with a negative and then developed in a solution to dissolve the iron and leave an image in pure platinum. A final wash in hydrochloric acid and water removed all remaining iron residue. Tonal variations are very subtle and platinum is especially good at rendering light, water and texture, so was generally used for architecture, landscape and portraiture. Commercially made papers using platinum and the cheaper palladium were widely available but photographers like Coburn, Day and Steichen hand coated their own paper for extra depth and often used platinum in conjunction with the gum bichromate process. Platinum papers largely disappeared from public use after all supplies of platinum and palladium were diverted for the production of munitions during WWI. A recent revival in platinum/palladium printing is growing because of the tonal properties, permanence and archival qualities of this process.

Gum Bichromate Another permanent process, like carbon containing no silver, gum printing involves coating paper with a solution of gum arabic, potassium bichromate and a pigment. Contact printed with a negative, the gum hardened where it received most light. Unhardened gum was washed away but remaining gum could be easily manipulated to achieve certain tonal effects. The print could be recoated with different coloured gum layers, registered exactly under the negative, and re-exposed as many times as necessary to create dense or multi colour. Often printed on textured art paper, the finished print appeared very unphotographic and was much used by the Linked Ring Brotherhood and Photo-Secession photographers.

Lantern Slide The forerunner of the 35mm colour transparency, lantern slides are positive photographic images on glass, produced from a negative, and sandwiched in glass to protect the emulsion. Light can be shone through them via a projector for lecture purposes. Pre-photography, they were hand painted.

Photoglyphic Engraving Talbot's photoglyphic engraving process was a predecessor of photogravure. A tissue, coated with gelatine and potassium bichromate, was exposed under a positive, then pressed, emulsion side down, onto a copper printing plate. The tissue and unhardened gelatine, which had received little light, would be washed away, leaving hardened gelatine. The plate would then be etched in acid, inked and used as any other printing plate but giving a very fine detailed impression. Fine art editions of photogravures include Stieglitz's *Camera Work* which was printed on Japanese tissue and Coburn's books *Men of Mark, London* and *New York*.

Autochrome The Autochrome was the first accessible colour process, invented by the Lumière Brothers in 1904 and used exhaustively for the next 10 years but in production until 1940. Glass was coated with varnish, then with a randomly mixed layer of red, blue and green dyed potato starch, something like five million grains to the square inch. An orthochromatic emulsion was painted over and the plate was placed into the camera with the emulsion furthest away from the lens so that light would be filtered through the coloured grains before registering on the light sensitive emulsion. After a complex programme of developing, washing, bleaching, redeveloping, fixing and more washing, the result was an Impressionist's dream with subtle and beautiful stipled colour. Because of the softness and subtlety of its tones it was much used for domestic photography, especially of children, gardens, flowers, as well as for copying works of art. The future of colour photography was on paper rather than glass, because of the difficulties in viewing any image which needed to be held up to the light, and the Autochrome was soon superseded by a wide variety of other colour processes. It remains, however, the most beautiful of the colour processes.

Printing-out Paper A commercially produced paper which replaced albumen paper, coated with gelatine sensitised with silver chloride. It was very easy to process, needing only washing and toning and produced a rich, glossy brown print. Generally known as P.O.P., it was in use from 1880–1920 and was replaced by developing-out paper which needed chemical development but produced a paler, silvery tone, the forerunner of modern papers.

Halftones Halftones were used by Stieglitz in *Camera Work* to reproduce some photographs in colour. The original photograph is rephotographed through a screen, breaking the image up into dots of varying size, and then transferred to a metal printing plate and etched into relief for typographic printing. Separate plates were made for each colour which were then printed in exact register.

Oil Pigment and Transfer Prints A sheet of gelatine coated paper was sensitized with potassium bichromate and then exposed against a negative. The unhardened gelatine would then be washed off and, whilst wet, the raised image lightly brushed with an oily pigment, thus allowing much scope for artistic, as well as photographic, licence. A further possibility was to introduce multiple colour to a print with greasy, waxy crayons. The greatest proponent of all oil processes was Robert Demachy.

Ozobrome, Oil Ozobrome, Ozotype, Gum Ozotype Processes These more obscure processes were variations and modifications on carbon, bromoil, pigmented gelatine and pigmented gum processes, offering increased possibilities for manipulation and ever more painterly effects. Their use was fairly short lived.

Photogravure Invented by Karel Klíc in 1879, photogravure is a way of reproducing original photographs (like gum prints, platinums etc.) in books and journals by transferring the photographic image to a copper plate, etched like an aquatint, and printing from this, thus making multiple copies easily. A positive transparency, made from exposure against an original photographic negative, was contacted onto carbon tissue which was then transferred to a copper plate, prepared with resin. The copper plate and adhering carbon tissue which had received little light and had not hardened, would then be washed away and the plate etched in acid, leaving a relief image in hardened gelatine which could then be inked and used as any other printing process. Photo-gravures could be printed onto a variety of papers, like the Japanese tissue used in *Camera Work*, and gave a very finely detailed result. Steiglitz, Coburn and Annan were all masters of the photogravure process.

LIST OF PHOTOGRAPHS

All photographs copyright of The Royal Photographic Society of Great Britain unless otherwise listed below. Every effort has been made to obtain permisison to reproduce copyright material included in this book. Any errors or omissions are inadvertant and will be corrected in subsequent editions, provided notice is given to the publisher.

Abbreviations: top (T), bottom (B), left (L), right (R), centre (C).

AUS. *(Australia)*; A. *(Austria)*; B. *(Belgium)*; CDN. *(Canada)*; CZ. *(Czechoslovakia)*; D. *(Germany)*; F. *(France)*; H. *(Hungary)*; J. *(Japan)*; NL. *(The Netherlands)*; PL. *(Poland)*; S. *(Sweden)*; USA. *(United States)*; UK. *(United Kingdom)*.

p47. *Käsebier, Gertrude.* *(1852–1934).* USA.
Portrait (Miss N.)
From 'Camera Work' issue no.1, 1903.
Photogravure, 1903 (original print 1902).
197 x 147mm.

p48. *Coburn, Alvin Langdon.*
(1882–1966). UK.
Fred Holland Day in his darkroom,
25 Mortimer Street, London.
Gum platinum, 1900. 292 x 183mm.

p49. *Eugene, Frank.* *(1865–1936).* USA.
Frank Eugene, Alfred Stieglitz, Heinrich
Kühn and Edward Steichen admiring the
work of Eugene.
Platinum, 1907. 110 x 165mm.

p50.
(L) *White, Clarence Hudson.*
(1871–1925). USA.
Head of a young girl.
Platinum, 1903. 186 x 163mm.

(R) *Booth, Pamela.* *(1914–80?).* UK.
Profile of Frau Koppitz.
Courtesy of the Pamela Booth Estate.
Daylight portrait (contact print) on Gevaluxe
paper, 1933–4. 177 x 164mm (visible).

p51. *Hill, David Octavius* *(1802–70)*
and Adamson, Robert *(1821–48).* UK.
The bird cage. The Misses Watson.
Photogravure, c.1890 by James Craig Annan from
original negative, (c.1844) 208 x 157mm.

p52. *Steichen, Edward J.* *(1879–1973).* USA.
Self-portrait, Milwaukee, 19 years old.
Platinum, 1898. 192 x 83mm.

p53. *Steichen, Edward J.* *(1879–1973).* USA.
Solitude. Fred Holland Day.
From 'Camera Work', Steichen Supplement,
1906. Photogravure, 1906. 121 x 166mm.

p54.
(L) *Hill, David Octavius* *(1802–70).*
and Adamson, Robert *(1821–48).* UK.
Mary McCandlish.
Photogravure, c.1890 by James Craig Annan from
original negative (c.1844). 220 x 160mm.

(R) *Carroll, Lewis (Reverend Charles*
Lutwidge Dodgson). *(1832–98).* UK.
'Xie' Kitchin as a Chinese tea merchant,
'off-duty'.
Albumen print, 14 July 1873. 149 x 105mm.

p55. *Attributed Rejlander, Oscar Gustav.*
(1813–75). S.
Isabel Somers-Cocks (later Lady Henry
Somerset). *Albumen, c.1861. 190 x 147mm.*

p56. *Strand, Paul.* *(1890–1976).* USA.
Alfred Stieglitz.
Courtesy of Paul Strand Foundation.
Gelatin silver, 1924. 245 x 190mm.

p57. *Lendvai-Dircksen, Erna.*
(1883–1962). D.
Young boy. *Gelatin silver, 1938, 400 x 300mm.*

p58. *Coburn, Alvin Langdon.*
(1882–1966). USA
Self-portrait. *Autochrome, c.1910, 168 x 120mm.*

p59. *Warburg, John Cimon.*
(1867–1931). UK.
Peggy in the garden.
Autochrome, c.1909, 165 x 126mm.

p60. *Dührkoop, Rudolf* *(1846–1918)*
and Diez-Dührkoop, Minya *(1873–1929).* D.
Clotilde von Derp-Sakharoff.
Bromoil, 1912, 270 x 220mm.

p61. *O'Gorman, Lieutenant-Colonel Mervyn.*
(1871–1958). UK.
Christina. *Gelatin silver, 1913, 264 x 250mm.*

p62.
(L) Yevonde, Madame. *(1893–1975).* UK.
Florence Lambert. © Yevonde Portrait
Archive. *Gelatin silver, 1933, 375 x 295mm.*

(R) *Wilding, Dorothy.* *(1893–1976).* UK.
Margaret Bannerman.
Chlorobromide, 1925, 437 x 347mm.

p63. *Wilding, Dorothy.* *(1893–1976).* UK.
Helen Wills Moody.
Chlorobromide, 1928, 440 x 325mm.

p64. *Crocker, Gordon.* *(dates unknown).* UK.
Woman's head.
Vivex Colour Photograph, 1938, 501 x 378mm.

p65. *Muray, Nickolas.* *(1892–1965).* USA.
Two Kitties. *Kodak wash-off relief process,*
c.1940. 400 x 300mm.

II. SOCIAL DOCUMENTARY

p69. *McCullin, Don.* *(1935–).* UK.
Refugees from East Pakistan on
the Indian border.
Courtesy of Don McCullin.
Gelatin silver, 1971, 510 x 350mm.

p70. *Martin, Paul Augustus.*
(1864–1944). UK.
London street with crowd and policeman.
Carbon on glass, 1892, 78 x 104mm.

p73. *Jarché, James.* *(1891–1965).* UK.
Boys caught bathing in the Serpentine.
Gelatin silver, 1924, 280 x 350mm.

p74. *Dell, Mark Oliver.* *(1883–1959).* UK.
Gipsies. *Lantern slide, c.1930. 52 x 65mm.*

p77. *Rejlander, Oscar Gustav.* *(1813–75).* UK.
A night out homeless.
Platinum print (printed by FW Edwards
c.1892/3 from an original wet collodion negative,
c.1857. 203 x 153mm.

p78. *Sutcliffe, Frank Meadow.*
(1853–1941). UK.
Retired from sea.
Carbon, 1890. 204 x 151mm (visible).

p80. *Anonymous.* UK.
World War II American Curtiss Kittyhawk
fighter aircraft and RAF airmen from
112 Squadron stationed at Bari, S. Italy.
From Daily Express Appeal archive.
Gelatin silver, December 1943. 53 x 80mm.

p81. *Anonymous.* UK.
Soldiers and families. From Daily Express
Appeal archive.
Toned gelatin silver, 1914–18. 136 x 87mm.

p82. *Hinde, John* *(1916–97).* UK.
Children watching firemen in training
exercises. Courtesy John Hinde Estate.
Tri-colour carbro, c.1943. 209 x 155mm.

p83. *Anonymous.* UK.
Bomb damage in a London street.
Dufaycolour, c.1943. 112 x 80mm.

p84. *Anonymous.* UK.
Taff St, Pontypridd. Guarded by Glamorgan
and Metropolitan Police, 20 December 1910.
Signed WR. *Gelatin silver, 1910. 88 x 138mm.*

p85. *Churchill, C.* *(dates unknown).* UK.
Relief of Ladysmith Day.
Lantern slide, 1900. 70 x 71mm.

p86–87. *Fenton, Roger.* *(1819–69).* UK.
The Harbour at Balaclava.
The Cattle Pier, Crimea, Russia.
Salted paper print, 1855. 280 x 360mm.

p88. *Burrows, Larry.* *(1926–71).* UK.
Mekong Delta. Dead Vietcong beside their
flag. The dead lying like large colour star-fish.
Courtesy Katz.
Colour print, 1963. 321 x 488mm.

p89. *Burrows, Larry.* *(1926–71).* UK.
Operation Prairie, South Vietnam, 1966.
GI retrieving a comrade's body under fire.

Courtesy Katz.
Colour print, 1966. 328 x 485mm.

p90. *World Missionary Society*
Slide Depot. UK.
Great Deeds no.78.
Pegoud–the daring French aeronaut.
Hand-coloured lantern slide, c.1913. 74 x 68mm.

p91. *Farmer, Howard.* *(? –1926).* UK.
On board ship.
Hand-coloured lantern slide, c.1905. 59 x 75mm.

p92. *Ahern, John.* *(1904–62).* UK.
Street crossing.
Gelatin silver, 1935. 447 x 350mm.

p93. *Anderson, John H.* *(1862–1938).* UK.
Piccadilly in 1902.
Platinum, 1902. 218 x 149mm.

p94. *Day, William J.* *(1854–1939).* UK.
The *Titanic* sails on her only voyage.
Carbon, 10 April, 1912. 98mm diameter.

p95.
(L) *Mortimer, Francis James.*
(1874–1944). UK.
The American flag.
Gelatin silver, c.1933. 450 x 350mm.

(R) *Mortimer, Francis James.*
(1874–1944). UK.
The life boatman, Isles of Scilly.
Gelatin silver, 1911. 456 x 355mm.

p96. *Hughes, Karl M.* *(dates unknown).* UK.
La Ronde. *Gelatin silver on textured paper,*
1959. 386 x 322mm.

p97. *Rothstein, Arthur.* *(1915–85).* USA.
Cimarron County, Oklahoma Dust Storm.
Courtesy of Rothstein Estate.
Gelatin silver, April 11, 1936 (later print).
183 x 186mm.

p98.
(L) *Strand, Paul.* *(1890–1976).* USA.
Photograph– New York.
From Camera Work, issue no. 49/50, 1917.
Photogravure, 1917 (original neg. 1916).
160 x 173mm.

(R) *Strand, Paul.* *(1890–1976).* USA.
Photograph–New York.
From Camera Work, issue no. 49/50, 1917.
Photogravure, 1917 (original neg. 1916).
221 x 166mm.

p99. *Nicholls, Horace W.* *(1867–1941).* UK.
Woman coke heaver, London.
Printing out paper, 1917–18, 100 x 51mm.

p100. *Nicholls, Horace W. (1867–1941).* UK.
The Derby.
Printing out paper, c.1909. 143 x 107mm.

p101.
(TL) *Nicholls, Horace W. (1867–1941).* UK.
The Derby. Crowds. *Part of montage.*
Printing out paper, c.1909. 126 x 256mm.

(TR) *Nicholls, Horace W. (1867–1941).* UK.
The Derby. Stadium.
Part of montage. Modern print from original
quarter plate glass negative, c.1909.

(B) *Nicholls, Horace W. (1867–1941).* UK.
The Derby. Umbrellas. *Part of montage.*
Printing out paper. c.1909. 68 x 256mm.

p102. *Nicholls, Horace W. (1867–1941).* UK.
Hyde Park. *Modern print from original quarter*
plate glass negative, 1907.

p103. *Parr, Martin. (1952–).* UK.
Badminton Horse Trials.
Courtesy of Martin Parr.
From the 'Cost of Living' series, 1986–9.
Colour print, 1986/9 267 x 330mm.

III. DOMESTIC

p107. *Fenton, Roger. (1819–69).* UK.
Prince Arthur (1850–1942), in the undress
uniform of the Grenadier Guards.
Albumen print, 1854. 225 x 177mm.

p108. *Steichen, Edward J. (1879–1973).* USA.
On the house-boat 'The Log Cabin'.
From CameraWork, issue no.22, 1908.
Four-colour, half-tone reproduction from an
autochrome, 1907. 147 x 196mm.

p110. *Helme, James. (1800–90).* UK.
The chess game. *Albumen print, c.1860–5*
(page from an album inscribed by Richard Helme,
14 May 1894). 112 x 101mm.

p113. *Williams, Thomas Richard.*
(1825–1871). UK.
Soldier in red ceremonial jacket.
Hand-coloured stereo daguerreotype, 1855.
68 x 56mm (each image).

p114. *O'Gorman, Lieutenant-Colonel*
Mervyn. (1871–1958). UK.
Christina.
Autochrome, c.1912–13. 165 x 119mm.

p116. *Claudet, Antoine François-Jean.*
(1797–1867). UK.
Portrait of a young girl, possibly a member

of the Houghton family.
Daguerreotype, c.1845. 78 x 65mm (visible).

p117. *Boughton, Alice. (1866–1943).* USA.
Prunella Group.
Carbon, 1914. 378 x 287mm.

p118. *Collie, William. (1810–96).* UK.
Dr. Wolfe. *From an album. Salted paper print,*
1852. 170 x 142mm.

p119. *Anonymous.* UK.
Two sisters.
Ambrotype (collodion positive) in gilt frame,
c.1860–5. 92 x 65mm (visible).

p120. *Beard, Richard. (1802–1888).* UK.
Unknown man in hat.
Daguerreotype, c.1842–3. 50 x 40mm (visible).

p121.
(TL) *Anonymous.* UK.
Dr. Robert Moffatt, African missionary.
Daguerreotype in simple passepartout frame,
c.1844. 63 x 48mm. (visible).

(TR) *Anonymous.* UK.
Nine photographic pendant designs, displayed
in blue velvet lined case showing different
styles, sizes and prices available, c.1870–80.
150 x 240mm (open).

(CL) *Claudet, Antoine François-Jean.*
(1797–1867). F.
Display of bottles of chemicals and
equipment. *Stereo daguerreotype, c.1852.*
57 x 45 mm. visible (each image).

(CR) *Claudet, Antoine François-Jean.*
(1797–1867). F.
Young boy reflected in mirror.
Hand-coloured stereo daguerreotype, c.1855.
67 x 58mm visible (each image).

(BL) *Anonymous.* UK.
Portrait of unknown woman.
Hand-coloured ambrotype (collodion positive) inset
into velvet lined case, c.1863. 93 x 67m (visible).

(BR) *Anonymous.* UK.
Two women.
Relievo process (variation on collodion positive)
in simple frame, c.1860. 70 x 57mm.

p122. *Pfenninger, Otto. (dates unknown).* D.
Beach scene, Brighton. 16 June 1906.
Tri-colour carbon print, 1906. 60 x 85mm.

p123. *Paneth, Friedrich Adolf.*
(1887–1958). A.
Beach scene with flag.
Autochrome, 1925. 79 x 109mm.

p124. *Day, William J. (1854–1939).* UK.
Girls on the beach.
Carbon, 1910. 110 x 175mm.

p125. *Käsebier, Gertrude. (1852–1934).* USA.
The lesson. *Platinum, 1903. 156 x 205mm.*

p126. *Price, William Lake. (1810–1895).* UK.
An interior. From 'The Photographic
Exchange Club Album for the year 1855'.
Albumen print, 1855. 165 x 170mm.

p127. *Barton, Emma. (1872–1938).* UK.
Self and family. An Indoor Group.
Carbon, 1908. 200 x 222mm.

p128.
(L) *Warburg, John Cimon. (1867–1931).* UK.
Children drawing.
Autochrome, c.1909. 120 x 165mm.

(R) *Warburg, John Cimon. (1867–1931).* UK.
Peggy reading.
Autochrome, c.1909, 155 x 112mm.

p129. *Arbuthnot, Malcolm. (1877–1967).* UK.
By the sea. *Platinum, 1910. 337 x 218mm.*

p130–131. *Wood Album. (1860s).* UK.
Hand-decorated album of cartes-de-visite portraits
in albumen with watercolour paint, assembled
c.1868. Page size 310 x 245mm.

p132. *Anonymous.* UK.
Photographs of the Duchess of York and
her children Princess Elizabeth and Princess
Margaret Rose with their nanny at Glamis
Castle, from a family album.
Gelatin silver prints, 1929–30. 58 x 55mm.

p133. *Bassano Studio.* UK.
From England's Beautiful Women.
Photogravures, 1909. Page size 375 x 268mm.

p134. *Martin, Paul Augustus.*
(1864–1942). UK.
Smithfield porter. *Modern print from original*
quarter plate glass negative, c.1893.

p135. *Sinclair, James A. (1865–1940).* UK.
Haymarket – Winter.
Photogravure c.1913. 139 x 165mm.

p136–137. *de Rakocij, Baron Nicholas.*
(dates unknown). PL.
Five prints from a family album of over 200.
Gelatin silver, 1938. 58 x 55mm.

p138. *Poucher, Walter Arthur.*
(1891–1988). UK.
New York diner.
Modern print from original 35mm negative, 1949.

p139. *Pardoe, Dr J.B. (active 1920–40).* USA.
Waiting for the train.
Chlorobromide, 1923. 335 x 260mm.

IV. NATURE & SCIENCE

p143. *Talbot, William Henry Fox.*
(1800–77). UK.
Leaf. *Photogenic drawing negative, 1843–5.*
96 x 79mm.

p144. *Cadby, Carine. (1866–1957).* UK.
The Fairies' Hammock.
Gelatin silver, 1908. 111 x 162mm.

p147. *Rejlander, Oscar Gustav.*
(1813–1875). S.
A young naturalist.
Albumen, 1860. 200 x 150mm (arched top).

p148. *Rutherfurd, Lewis Morris.*
(1816–92). UK.
Moon, New York, 6 March 1865.
Albumen, 1865. 545 x 410mm.

p150. *Lumière, Auguste. (1862–1954)*
and *Louis (1864–1948).* F.
Scientific equipment.
Stereo bichromated gelatin glue, 1900.
70 x 66mm (each image).

p152. *Talbot, William Henry Fox*
(1800–77) UK, and *Henneman, Nicolaas*
(1813–98). NL.
The Reading Establishment.
Calotype negatives, c.1846.
185 x 225mm (above), 185 x 225mm (below).

p153. *Talbot, William Henry Fox*
(1800–77) UK, and *Henneman, Nicolaas*
(1813–98). NL.
The Reading Establishment.
Two salted paper prints, c.1846. 185 x 225mm.

p154. *Glendening, Frederick T.D.*
(dates unknown). UK.
Curvature of the spine. *Albumen, 1892/4.*
148 x 107mm (left) 150 x 106mm (right).

p155. *Diamond, Dr. Hugh Welch.*
(1808–86). UK.
Mental patient. *Lightly albumenised salted paper*
print, 1855. 132 x 96mm.

p156. *Banfield, Arthur Clive.*
(1875–1965). UK.
Cat and dog jumping.
32 single transfer carbon prints,
consequently reversed, 1900.
Average size 61 x 82mm. (each print).

p157. **Muybridge, Eadweard.**
(1830–1904). UK.
Contortionist.
Photogravure, 1887. 185 x 421mm.

p158. **Banfield, Arthur Clive.**
(1875–1965). UK.
Life history of a splash.
36 blue carbon prints, 1900.
58 x 55mm. (each print).

p159. **Edgerton, Dr. Harold E.**
(1903–90). USA.
Bullet going through balloon.
Courtesy Dr. Harold E. Edgerton Estate.
Dye transfer print, 1950s. 400 x 497mm.

p160. **Steichen, Edward J.** *(1879–1973).* USA.
Sunflower. Courtesy of Joanna T. Steichen.
Toned gelatin silver print, c.1920. 348 x 269mm.

p161.
(L) **Cadby, Carine.** *(1866–1957).* UK.
Shirley poppies. *Carbon, 1901. 278 x 199mm.*

(C) **Seymour, Edward.** *(1857–1942).* UK.
Oats. *Carbon, 1908. 191 x 110mm. (visible).*

(R) **Seymour, Edward.** *(1857–1942).* UK.
Shirley poppies.
Platinum, 1905. 149 x 102mm.

p162.
(L) **Renger-Patzsch, Albert.** *(1897–1966).* D.
Heterotrichum macrodum.
Gelatin silver, 1924. 381 x 281mm.

(R) **Renger-Patzsch, Albert.**
Sempervivum Percarneum.
Gelatin silver, 1922. 384 x 281mm

p163. **Kono, Asahachi.**
(active 1920-40). J.
Pond Fantasy.
Gelatin silver, 1931. 328 x 268mm.

p164. **Crook, Stanley F.** *(1874–1959).* UK.
Young tawny owls.
Gelatin silver, c.1930. 300 x 254mm.

p165.
(L) **Hems, Harold Arthur.** *(1921–).* UK.
Spawned-out frogs resting amongst
masses of spawn. Nature Conservancy
Council Collection. Courtesy of H.A. Hems.
Gelatin silver, 1960. 298 x 375mm.

(R) **de Meyer, Baron Adolph.**
(1868–1946). D.
Four trout.
Autochrome, 1908. 102 x 127mm.

p166.
(L) **Kearton, Cherry** *(1873–1940)*
and Richard *(1862–1928).* UK.
Cherry Kearton in photographic hide.
Nature Conservancy Council Collection.
Gelatin silver, 1899. 369 x 290mm.

(R) **Kearton, Cherry and Richard.**
Cherry and Richard Kearton photographing a
nest, Cherry standing on Richard's shoulders.
Nature Conservancy Council Collection.
Gelatin silver, 1900. 373 x 300mm.

p167. **Llewelyn, John Dillwyn.**
(1810–87). UK.
Piscator No. 2.
Lightly albumenized print from an
oxymel negative, 1856. 239 x 191mm.

p168. **Anonymous.** UK.
The hairs on the
wings of a house fly x450.
Toned gelatin silver, c.1900. 168 x 120mm.

p169. **Anonymous.** UK.
The sucking tubes on the tongue of
the blowfly x300.
Toned gelatin silver, c.1900. 158 x 114mm.

V. ART

p173. **Von Gloeden, Count Wilhelm.**
(1856–1931). D.
Boy with lilies.
Salted paper print, 1904. 218 x160mm.

p175. **Robinson, Henry Peach.**
(1830–1901). UK.
Sleep. *Albumen print made up from 4 separate*
wet collodion negatives, 1866. 381 x 552mm.

p176. **Rejlander, Oscar Gustav.**
(1813–75). S.
The head of John the Baptist on a charger.
Albumen, 1856. 107 x 151mm (oval).

p179. **de Meyer, Baron Adolph.**
(1868–1946). D.
Still life study of flowers.
Autochrome, c.1908. 102 x 127mm.

p181. **Enslen, Johann Carl.**
(1859–1936). D.
Christ's head superimposed on an oak leaf.
Photogenic drawing, 1839, 162 x 131mm.

p182. **Collie, William.** *(1810–96).* UK.
Untitled still life.
Salted paper print, c.1848. 123 x 94mm.

p185. **de Meyer, Baron Adolph.**
(1868–1946). D.
Still life. Hydrangea.
Platinum, 1907. 333 x 275mm.

p186. **McCullin, Don.** *(1935–).* UK.
Still life with bird's nest, February 1991.
Gelatin silver, 1991. 510 x 350mm.

p187. **Fenton, Roger.** *(1819–69).* UK.
Flowers and fruit. *Gold-toned albumen print,*
1860-1. 350 x 430mm.

p188. **Cameron, Julia Margaret.**
(1815–79). UK.
The passing of King Arthur.
Carbon, 1874. 336 x 251mm.

p189.
(L) **Cameron, Julia Margaret.**
(1815–79). UK.
Cupid considering.
Albumen, 1872. 265 x 288mm.

(R) **Cameron, Julia Margaret.**
I Wait. *Albumen, c.1873. 315 x 250mm.*

p190. **Koppitz, Professor Rudolf.**
(1884–1936). A.
Andacht (Devotion). *Bromoil transfer, 1927*
(neg. taken before 1923). 177 x 300 mm.

p191. **Carroll, Lewis (Reverend Charles**
Lutwidge Dodgson). *(1832–98).* UK.
The Dream. *Albumen, 1863. 194 x 251mm.*

p192. **Kühn, Heinrich.** *(1866–1944).* D.
In der Dune.
Photogravure, 1905. 327 x 418mm.

p193. **Koppitz, Professor Rudolf.**
(1884–1936). A.
Höhenluft. *Bromoil transfer, 1928.*
(neg. taken before 1923), 340 x 240mm.

p194. **Polak, Richard.** *(1870–1956).* NL.
The artist and his model.
Photographs From Life in Old Dutch Costume.
Platinum, 1914. 210 x 170mm.

p195. **Fenton, Roger.** *(1819–69).* UK.
The British Museum. Gallery of Antiquities.
Albumen, c.1857. 262 x 293mm (arched top).

p196. **Demachy, Robert.** *(1859–1936).* F.
Vitesse (Speed).
Gum bichromate, 1903. 150 x 240mm.

p197. **Coburn, Alvin Langdon.**
(1882–1966). UK.
Vortograph (2).
Gelatin silver, 1917, 276 x 205mm.

p198. **Moholy-Nagy, Lászlo.** *(1895–1946).* H.
The cat. *Lantern slide, c.1926. 63 x 46mm.*

p199. **Eugene, Frank.** *(1865–1936).* USA.
The horse. *Photogravure, c.1898. 90 x 115mm.*

p200. **Brigman, Anne Wardrope.**
(1869–1950). USA.
The Wondrous Globe.
From 'Camera Work' issue no.38, 1912.
Photogravure, 1912. 121 x 199mm.

p201. **Käsebier, Gertrude.** *(1852–1934).* USA.
The Magic Crystal.
Platinum, c.1904. 240 x 190mm.

p202. **Coster, Howard Sydney Musgrave.**
(1885–1959). UK.
The Lost Pleiad.
Gelatin silver, 1931. 274 x 214mm.

p203. **Drtikol, František.** *(1883–1961).* CZ.
The Soul. *Chlorobromide, 1930. 280 x 220mm.*

p204. **Day, Fred Holland.** *(1864–1933).* USA.
The Crucifixion. Self-portrait as Jesus Christ.
Platinum, 1898. 144 x 62mm.

p205. **Barton, Emma.** *(1872–1938).* UK.
The Awakening. *Carbon, 1903. 357 x 266mm.*

p206. **de Meyer, Baron Adolph.**
(1868–1946). D.
Waterlilies. *Platinum, 1907-8,*
(negative 1906). 262 x 352mm.

p207. **Yevonde, Madame.** *(1893–1975).* UK.
Geraniums. © Yevonde Portrait Archive.
Vivex Colour Photograph, c.1933. 242 x 294mm.

p208.
(L) **Yevonde, Madame.** *(1893–1975).* UK.
Mrs Edward Mayer as Medusa. 'Goddesses'
series. © Yevonde Portrait Archive.
Vivex Colour Photograph, 1935. 363 x 297mm.

(R) **Yevonde, Madame.**
Lady Milbanke (nee Sheila Chisholm)
as 'The Dying Amazon'. Penthesilea,
Queen of the Amazons, slain in battle by
Achilles. From the 'Goddesses' series .
© Yevonde Portrait Archive.
Vivex Colour Photograph, 1935. 373 x 279mm.

p209. **Yevonde, Madame.** *(1893–1975).* UK.
Self portrait, 1940. © Yevonde Portrait
Archive. *Modern dye transfer print (1990) from*
original tri-colour negatives. 410 x 310mm.

p210. **Seeley, George H.** *(1880–1955).* USA.
The Glow Worm. Also known as The Firefly.
Gum platinum, 1907, 243 x 194mm.

p272. **Strand, Paul.** *(1890–1976).* USA.
Photograph – New York.
From 'Camera Work', issue no.49/50, 1917.
Photogravure, 1917. 165 x 214mm.

p273.
(L) **Coburn, Alvin Langdon.**
(1882–1966). UK.
Brooklyn Bridge, New York.
Gum platinum, 1909. 239 x 190mm.

(R) **Coburn, Alvin Langdon.**
Williamsburg Bridge, New York.
Photogravure, 1909. 192 x 152mm.

p274. **Coburn, Alvin Langdon.**
(1882–1966). UK.
Regent's Canal, Camden Town, London.
Gum platinum, 1904. 275 x 216mm.

p275. **Sutcliffe, Frank Meadow.**
(1853–1941). UK.
The Dock End, Whitby.
Carbon, 1880. 232 x 302mm.

p276. **Ruzicka, Dr Drahomir Josef.**
(1870–1960). CZ.
Lower Manhattan.
Chlorobromide, 1936. 347 x 270mm.

p277. **Cazneaux, Harold Pierce.**
(1878–1953). AUS.
The road up the hill.
Flinders Range. (Australia).
Bromoil, 1935–7. 172 x 277mm.

p278. **Coburn, Alvin Langdon.**
(1882–1966). UK.
The Half Dome, Yosemite.
Toned gelatin silver, 1911.
310 x 398mm.

p279. **Young, William D.** *(date unknown).* UK.
Cutting the approach to the
Morandot River, Uganda Railway.
Printing out paper print, c.1901.
152 x 202mm.

p280. **Griggs, Noel.** *(1890–1942).* UK.
Battersea Power Station, London.
Gelatin silver, c.1934. 502 x 399mm.

p281. **Strand, Paul.** *(1890–1976).* USA.
New York (Wall Street).
From 'Camera Work' issue no.48, 1916.
Photogravure, 1916 (original neg. 1915).
127 x 163mm.

p282. **Rosling, Alfred.** *(1802–1880).* UK.
St Paul's from London Bridge.
Calotype negative, c.1853.
163 x 200mm.

p283. **Murch, Horace.** *(1895–1969).* UK.
Westminster, nightfall. Houses of Parliament.
Gelatin silver, 1954. 359 x 443mm.

p284. **Ruzicka, Dr Drahomir Josef.**
(1870–1960). CZ.
New York: The Gothic and the Modern Age.
Chlorobromide, 1937. 345 x 236mm.

p285. **Fenton, Roger.** *(1819–69).* UK.
Church of St. Vasili, Moscow.
Albumen, September 1852. 183 x 218mm.

p286–287. **Fenton, Roger.** *(1819–69).* UK.
September clouds.
Albumen, 1859. 206 x 287mm.

p288. **Robinson, Henry Peach** *(1830–1901)*
and **Cherrill, Nelson King** *(?).* UK.
Seascape at night.
Albumen, 1870. 275 x 394mm.

p289. **Mortimer, Francis James.**
(1874–1944). UK.
Spirit of the storm.
Gelatin silver, 1911. 403 x 400mm.

p290. **Misonne, Léonard.** *(1870–1943).* B.
Bucherons. *Bromoil, c.1934, 390 x 290mm.*

p291.
(L) **Davison, George.** *(1856–1930).* UK.
A pond at Weston Green.
Photogravure, 1899. 248 x 176mm.

(R) **Hinton, Alfred Horsley.**
(1863–1908). UK.
The Wild Waste.
Platinum, 1896. 496 x 293mm.

p292. **Buckham, Captain Alfred George.**
(1881–1957). UK.
The Forth Bridge.
Gelatin silver, 1926. 410 x 335mm.

p293. **Buckham, Captain Alfred George.**
(1881–1957). UK.
The Heart of the Empire.
Gelatin silver, c.1923. 460 x 380mm.

p294. **Evans, Frederick Henry.**
(1853–1943). UK.
Westminster Abbey No.1,
South Nave Aisle and across Nave.
Platinum, 1912 (from a 1911 negative).
240 x 185mm.

p295.
(L) **Evans, Frederick Henry**
(1853–1943). UK.
'The Sea of Steps'. The Stairway to
the Chapter House and Vicar's Close,

Wells Cathedral.
Platinum, 1903, 240 x 190mm.

(R) **Tripe, Linnaeus.** *(1822–1902).* UK.
Aisle on the South Side of
the Puthu Mundapum, Madura,
from the Western Portico.
Lightly albumenised salted paper print, 1858.
367 x 290mm.

VIII. TRAVEL

p299. **Ashton, Ernest R.** *(1867–1952).* UK.
Cafe Cairene.
Photogravure, 1896. 188 x 145mm.

p300. **Paneth, Friedrich Adolf.**
(1887–1958). A.
Eingang in die Menkewren Pyramid.
(Honeymoon at the Pyramids)
Autochrome, 1913. 79 x 109mm (visible).

p303. **Coburn, Alvin Langdon.**
(1882–1966). UK.
El Toro.
Gum platinum, 1906. 187 x 363mm.

p304. **Murdoch, Helen Messenger.**
(1862–1956). USA.
At the edge of the pit of the
Kilauea Crater, Hawaii.
Autochrome, 1914. 72 x 97mm (visible).

p306. **Woodbury, Walter Bentley.**
(1834–85). UK.
Self-portrait with camera.
Albumen, June 1857, 116 x 96mm.

p309. **Beato, Felice.** *(1825–1903).* UK.
Japanese girl with parasol.
Hand-coloured albumen, c.1864/7.
183 x 167mm.

p310. **Stieglitz, Alfred.** *(1864–1946).* USA.
The Steerage.
Photogravure, 1907. 333 x 265 mm.

p311. **Paneth, Friedrich Adolf.**
(1887–1958). A.
Venice. St. Mark's Cathedral.
Autochrome, 1925. 109 x 79mm.

p312. **Paneth, Friedrich Adolf.**
(1887–1958). A.
Venice. St. Mark's Cathedral.
Autochrome, 1925. 78 x 107mm.

p313. **Boon, Dr. E.G.** *(1875–1959).* UK.
A Venetian by-way.
Carbon, c. 1920. 200 x 149mm.

p314. **Frith, Francis.** *(1822–98).* UK.
Colossal figure of Rameses II at the grand
temple in Abou Simbel. From an album,
Upper Egypt and Ethiopia, volume III.
Albumen, 1857. 226 x 152mm.

p315.
(L) **Frith, Francis.** *(1822–98).* UK.
Colossal sculptures, Horus and Isis,
at Philae, the Great Temple. From an album,
Upper Egypt and Ethiopia, volume III.
Albumen, 1857. 210 x 156mm.

(R) **Frith, Francis.**
Thebes, Osiride Pillar at Medinet Haboo.
From an album Lower Egypt, Thebes and
the Pyramids, volume II.
Albumen, 1858/9. 216 x 152mm.

p316–317. **Tripe, Captain Linnaeus.**
(1822–98). UK.
Side Entrance to the Temple of the Great
Bull, Tanjore with Stairs, Sculptured Walls
and Dwarapalas (Guardians of the Entrance).
From an album, Photographic Views in
Tanjore and Trivady.
Salted paper print, 1858. 247 x 372mm.

p318. **Annan, James Craig.**
(1864–1946). UK.
A square, Ronda, Southern Spain.
From Camera Work, issue no. 45, 1914.
Photogravure, 1914 (original neg. 1913).
137 x 189mm.

p319.
(L) **Murdoch, Helen Messenger.**
(1862–1956). USA.
The Great Wall of China at Nankow.
Autochrome, 1914. 71 x 97mm (visible).

(R) **Murdoch, Helen Messenger.**
Ming tomb effigies.
Autochrome, 1914. 72 x 97mm (visible).

p320–321 **Murray, Colin.**
(Dates unknown). UK.
A view on the Salween River near the
Rope Station, near Moulmein, Burma.
Albumen, c.1873. 241 x 296mm.

acknowledgments

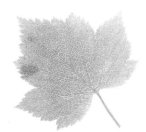

From the author:

Many thanks are due to Sir Paul McCartney for writing the Preface to this book and to Sue Prochnik at MPL for her help. I would also like to thank all my colleagues at the RPS who have helped me in a variety of ways. Barry Lane, who allowed me the time to research and write the book for the RPS, Gill Thompson, Sam Johnson, Claire Bertrand and Kate Rouse in the RPS Collection, Carole Sartain, Charlotte Eager, Tony Smith, Andrew Pendrick, Liz Williams and Melissa Smart.

I also owe a huge debt of gratitude to many friends and colleagues who patiently answered my abstruse enquiries, provided information, and listened to my ideas, my theories and my anxieties, most especially Roger Taylor, Larry J. Schaaf, Ken Jacobson, Gerardo F. Kurtz, Will Stapp, Paul Caffell, Russell Roberts, Pete James, Joanna Sassoon, Janice Hart, Therese Mulligan and, especially, Del Zogg whose generous and cheerful help has been of inestimable value. Others who have, knowingly or unknowingly, kindly helped with knowledge, information and advice, published or unpublished, are, in alphabetical order:- HJP Arnold, Gordon Baldwin, Gail Buckland, Peter Bunnell, Graham Clarke, Brian Coe, Trevor Crisp, Verna Curtis, Malcolm Daniel, Janet Dewan, Bodo von Dewitz, Alan Elliott, Monika Faber, Roy Flukinger, Colin Ford, Alison Foster, Anne Fourcroy, Michel Frizot, Robin Gibson, Mike Gray, Sarah Greenough, Andre Gunthert, Maria Morris Hambourg, Anne Hammond, Margaret Harker, Mark Haworth-Booth, Francoise Heilbrunn, Manfred Heiting, Michael Hiley, John & Judith Hillelson, Amanda Hopkinson, Bill Jay, Ian Jeffrey, Stephen Joseph, Martin Kemp, Terry King, Hope Kingsley, Lilly Koltun, Hans P. Kraus Jr., Bob Lassam, Joanne Lukitsh, Polly McBride, Elizabeth Anne McCauley, Don McCullin, Barbara Michaels, Molly Mortimer, Luis Nadeau, Weston Naef, Gael Newton, Doug Nickell, Isabel Ortega, Colin Osman, Judy Palmer, Martin Parr, Christian Peterson, Terence Pepper, Stephen Perloff, Ulrich Pöhlmann, Michael Pritchard, Phillip Prodger, Jeff Rosenheim, Joan Schwartz, Joel Smith, Joanna Steichen, John Stevenson, Sara Stevenson, David Stone, John Taylor, Ann Thomas, Jane Van Nimmen, Edward Wakeling, John Ward, Mike Ware, Mike Weaver, Mike Wigg, Clark Worswick.

My thanks go to all at Co & Bear/Scriptum Editions, for their investment in, commitment to and enthusiasm for this project and for enabling me to bring a Collection I love to a wider audience on these gloriously illustrated pages – to Beatrice Vincenzini, David Shannon and David Mackintosh, but most especially to Alexandra Black, my editor, whose calmness, tranquility and unflappability at all times, and in trying circumstances, have been very much appreciated by her often less than calm and tranquil author!

Finally, my love and thanks also go to Martin Roberts who lost his wife to a computer screen and piles of books and papers for several months.